7000511103

D1349627

HARVARD HISTORICAL STUDIES · 175

Published under the auspices
of the Department of History
from the income of the
Paul Revere Frothingham Bequest
Robert Louis Stroock Fund
Henry Warren Torrey Fund

FACES OF PERFECT EBONY

ENCOUNTERING ATLANTIC SLAVERY IN IMPERIAL BRITAIN

Catherine Molineux

HARVARD UNIVERSITY PRESS

Cambridge, Massachusetts

London, England

2012

Library of Congress Cataloging-in-Publication Data
Molineux, Catherine.
Faces of perfect ebony : encountering Atlantic slavery in imperial Britain /
Catherine Molineux.
p. cm.
Includes bibliographical references and index.
ISBN 978-0-674-05008-2 (alk. paper)
1. Blacks—Great Britain—History. 2. Blacks in popular culture—Great Britain—
History. 3. Imperialism in popular culture—Great Britain—History. 4. Slavery—
Great Britain—History. 5. Slavery—Great Britain—Public opinion. 6. Public
opinion—Great Britain. I. Title.
DA125.N4M65 2012
306.3'6209171241—dc22 2011013285

For my parents,
and in memory of Emily

CONTENTS

ILLUSTRATIONS

FIGURES

COLOR PLATES

Following page 52

Following page 236

FACES OF PERFECT EBONY

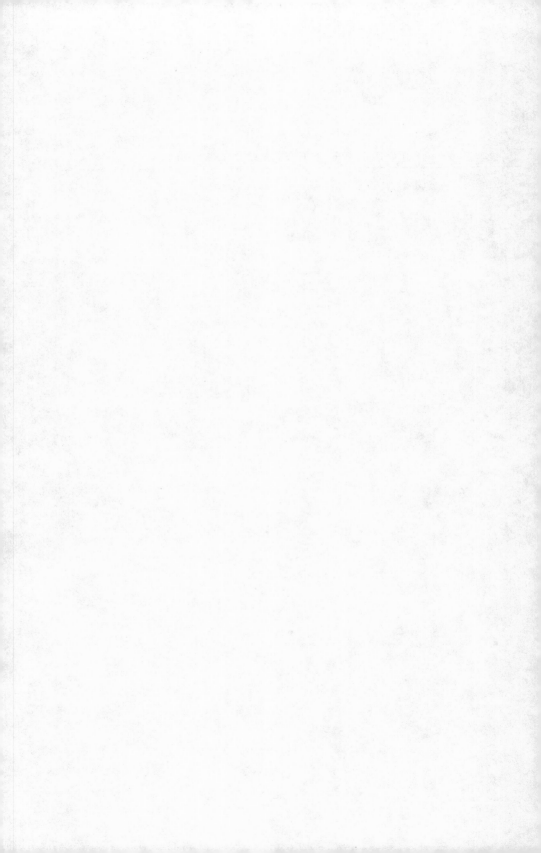

> We carry within us the wonders we seek without us: There is
> all Africa and her prodigies in us; . . .
>
> —Sir Thomas Browne, *Religio Medici* (1682)

London, 1750s. A painter, perhaps a coach-maker's apprentice, created a watercolor sketch for a shop sign (Plate 1). Before street numbers were widely adopted in the middle decades of the eighteenth century, signs such as this one of the "Black Boy" were the primary means of locating shops in British towns. During the sixteenth and seventeenth centuries, African, Turkish, and Native American figures joined crowns, crosses, and other more traditional imagery. In this case, the artist intended to paint a black boy that the general populace would recognize, but doing so did not mean replicating the realities of such a figure. Making the boy intelligible to people on a London street apparently involved taking a classical cherub, coloring him black, and giving him the accoutrements of primitivism and exotic commodities, such as pearls, that entered Britain through foreign trade. Hundreds of versions of the Black Boy signboard appeared across the urban landscapes of Georgian Britain.[1] In its rendering lay a simple and yet profoundly complex expectation about the sign's intelligibility: that a Briton on an eighteenth-century street would recognize it as a Black Boy, regardless of whether they had encountered a black child.

This book is about explaining that cultural intelligibility and the popular racial and imperial consciousness it presupposed. It focuses on the decades between 1680 (the rise of slavery in English colonies) and 1807 (the closure of the British slave trade) to capture an era in which Britain emerged as the leading imperial power in Europe.[2] Metropolitan Britons navigated the implications of imperialism—especially those concerning race and slavery—through many forms of literary and visual media. Studies of British imperialism, especially those describing the Restoration and

1

early Georgian eras, have typically focused on high art and elite writings. But the expansion of cheap print and visual materials during this period makes it possible to study popular, rather than principally elite, responses to Britain's imperial turn.[3] This book recovers a popular consciousness of empire, mostly neglected by other cultural historians, while also probing fundamental shifts and rifts in British thought and society. We have much to learn, especially about how that consciousness was expressed through imagined relationships with cultural or racial others.

Using methodologies from history, literary criticism, and art history, this book seeks to answer a curious question: why did metropolitan Britons, who could have left their reliance on African slavery in their imperial pursuits "out of sight, out of mind," instead produce and consume a wide array of representations of blacks? Some were depicted as slaves; many appeared to be servants; and others resembled the Black Boy shop sign in that the stereotype of the exotic obscured the power relationships that generated it. Thousands of images of blacks appeared in Britain during the seventeenth and eighteenth centuries. Explicating the cultural function of this imagery in a society that came to rely on African slavery is critical to understanding how this early modern empire worked to obscure its imperial violence, how the objectification of African peoples generated far-reaching social and cultural change, and how notions of racial difference came into being. Metropolitan Britons conceived of their relationship to Africans during the height of their involvement in the Atlantic slave trade and the expansion of slavery on colonial plantations in different ways at different times. Visual and print media provide a lens into the development of these popular beliefs about slavery, race, and imperialism.

Extending the Contact Zone

During the seventeenth and eighteenth centuries, the British Empire emerged from disparate New World settlements primarily based on indentured servitude to become colonies sustained by the labor of millions of African slaves. Decades of challenging Iberian and Dutch control over Atlantic commerce, settling colonies, extending trade routes, and establishing West African and East Indian factories paid off in the eighteenth century. A nation that began in the 1500s by sending pirates to chip away at formidable Iberian empires had, by the 1730s, established a global network of trade and colonial settlements driven by slave labor.[4]

From the perspective of Britons at home, this transformation was directly linked to changes in the metropolitan landscape. The wealth produced by African labor fueled the development of domestic infrastructure and financed wars abroad. Products or by-products of slave labor changed how individual Britons relaxed and socialized with each other. Sugar, rum, tobacco, tea, and other goods arrived from colonies or through foreign trade, giving rise to coffeehouses, tobacco shops, and other new spaces of consumption. London and other port cities more than doubled in size. Their increasingly cosmopolitan populations sought goods, servants, and news from abroad. Active social networks transmitted these urban fashions to the countryside. "Look around," suggested the politician Charles Fox on the eve of the American Revolution: "Observe the magnificence of our metropolis—the extent of our empire—the immensity of our commerce and the opulence of our people; Survey . . . every shopkeeper of any consideration, with his elegant villa . . . our territories occupy *no more* than the largest, the most valuable space of any European dominion in the four quarters of the globe."[5] When Fox spoke, Britain had ousted France from North America and claimed sovereignty over much of the West Indies. That his vision of imperial prosperity elided the slave labor that produced it only makes the artist busily sketching a Black Boy shop sign more interesting.

Fox's invocation of this imperial space was a political act, a collective visual fantasy sanctioned by his instruction to look around, to observe, to survey—not the colonies, but Britain within the colonizing venture. If the object of his fantasy, the extensive power gained from mid-eighteenth-century wars, was still a novelty, the dream of heroic conquest was not. Nearly a century earlier, an anonymous Londoner had made a more personal confession of his fantasies of conquest. Writing to a local periodical, he admitted to having repeated daydreams about defeating the French king, routing entire Turkish armies, and fighting monsters as St. George or Hercules had. This daydreaming Londoner never failed to declare himself "conqueror" (the journal editors diagnosed him with an overly optimistic "Constitution" and prescribed temperance). But his imagined encounters suggest that he fell into this "transported" state while reading the newspapers, which were littered (in the 1690s) with accounts of monsters, battles against Turks, and William III's European conquests. He was not alone in aggrandizing his heroism. Even as natural philosophers and travel writers disparaged medieval and classical fantasies of the world beyond home, satirist Tom Brown mocked sailors and merchants who frequented

coffeehouses, he thought, only to spin ever more fanciful tales of the regions they had visited.[6] In the eighteenth century, such imagined heroic conquests increasingly shifted westward as battles for European supremacy took place in Atlantic colonies that were themselves products of a European race to lay claim to hitherto unknown parts of the globe.

Empire, in this iteration, was a fantasy, a daydream. It was forged from tales made available by the spread of print and the breakdown of English insularity that began with the Renaissance. As Lisa Moore writes, albeit in a different context, "Fantasy and desire, 'fond imagination,' are crucial to the articulation of a national identity."[7] Such fond imagination or fancy was also critical to the articulation of an imperial consciousness in Britain and to the formation and maintenance of empire.[8]

Since the 1970s, historians have given greater weight to this nationalistic agenda of expansion, often describing it in terms of religious and political disputes that followed from the Protestant Reformation. Competition with Catholic Europe, and its claims to New World, West African, and East Indian possessions, engendered a sense of nationhood, a shared Protestant animosity that proved especially important after England united with Scotland in 1707. Paying attention to European rivalries has deepened our understanding of how imperialism glued together (tendentiously) the disparate regional and ethnic identities that characterized early modern Britain. It has also generated a conception of the empire as a frontier of the nation, a borderlands or middle ground in which metropolitan notions of the self were contested and confirmed.[9]

Ironically, however, as the empire became central to histories of Britain, Britain became less relevant to histories of the colonies. The concomitant rise of Atlantic frameworks within colonial studies challenged older imperial histories that gave primacy to the influence of Britain and British institutions on colonial development. So-called on-the-ground interactions between the various ethnic and racial groups that came to constitute colonial societies became the main focus. Decentering the metropole has illuminated the extent of African, Native American, and creole participation in the creation of the Atlantic world. It has also led to a better sense of how the histories of European countries cannot be extricated from those of colonial settlements.[10]

Yet because the numbers of Africans and Native Americans who lived in or visited Britain were small, the turn to Atlantic models of exchange and encounter in colonial studies has also tended to take the metropole out of the picture. Living largely beyond what Mary Louise Pratt has

usefully termed the "contact zone," Britons at home often appear generally immune to the work of European imperialism, except in the sense that empire was celebrated as a virtuous enterprise and that those who traveled abroad had their beliefs challenged. Envisioning the metropole primarily as a source of elite abstract thought and white colonial populations, however, often perpetuates the hierarchical relationship between the Old and New Worlds that Atlantic histories were meant to subvert. Despite growing knowledge of the effects of imperialism on early modern British society, the diffusion or transplantation model will remain the paradigmatic view of the relationship between imperial center and colonial periphery as long as Britain and other European countries remain conceptually outside the Atlantic world they helped to create.[11]

This book reconsiders Britain's imperial turn from an Atlantic perspective, taking the decentering of the metropole to its logical conclusion. The empire was a frontier of Britain, but Britain was also a frontier of the emerging Atlantic world. Imperialism rendered Britain a periphery to the interactions between Native Americans, Africans, and Europeans that characterized the development of colonial societies. The small numbers of Africans and even smaller numbers of Native Americans who lived in or visited Britain were one manifestation of this peripheral position. Their limited presence allowed Britons at home to maintain, for most of the eighteenth century, the fluid race relations characteristic of colonial slave-owning societies.[12] At the same time, an active, popular imagination of interracial relationships, far outweighing the internal African or Native American populations, sought to elide the distance between the metropole and the colonial spaces that supported it. Metropolitan Britons made and consumed thousands of representations of Atlantic peoples in the seventeenth and eighteenth centuries, only some of which were based on identifiable people. Although emerging notions of evidentiary truth inflected these conversations, imagination still shaped the reports of events and peoples beyond the Isles and their integration into domestic conversations. These fantasies were possible because metropolitan Britons faced in print and visual forms the slave revolts and Indian wars that pushed colonists to develop stricter legal definitions of racial status and sociocultural strategies of racial segregation. The news of African and Indian resistance, alongside the growing numbers of black servants in Britain, critically and persistently destabilized these imaginative constructions of contact, but in ways that inscribed the geographical fact of distance.

5

What is an encounter?[13] Is it restricted to the physical encounter and delimited to the coasts of Africa, colonial plantations, ship decks, or households of elite British masters who imported exotic servants? Or can it extend to the daydream, to seeing a shop sign, singing a ballad, purchasing a textile, playing a board game, or reading a newspaper? Fantasy was both a form of experience and a framework through which to experience imperialism.

Exploration and colonization transformed elite culture as new knowledge contested biblical and classical narratives and as Africans and other foreigners came to live as servants or slaves in elite homes. How common Britons perceived themselves and their place in an ever-widening world was also irrevocably altered. Many men and women went voluntarily or involuntarily to colonies or factories abroad, toured the Continent, or worked on ships. Most never left the Isles. But the untraveled sought access to contact with foreign peoples and lands. An imperial street theater emerged in response to maritime ventures as Britons incorporated Atlantic and Eastern peoples into pantomimes, fairs, pageants, and processions, including those informal ones in which a slaveholder paraded down the street in the company of his or her black pageboy. Colonial reports, pamphlets, travelogues, and sketches provided sources of iconography and ideology for shop signs, prints, textiles, ceramics, playing cards, board games, and other forms of material culture. As the Earl of Shaftesbury famously griped, "barbarian customs, savage manners, Indian wars, and wonders of the *terra incognita,* employ our leisure hours and are the chief materials to furnish out a library . . . Monsters and monsterlands were never more in request." His characterization of elite reading habits applied more broadly than he realized. Imperialism generated popular commentary on exotic others that extended the imagined community.[14]

Many of these interracial encounters were of British invention. Some were along the lines of daydreams that rarely register in the archive. Some occurred through the circulation of racial imagery produced by domestic, colonial, and foreign authors or artists. Others were, in a sense, real as white Britons met people of color in Britain, though the experience and recording of these encounters also involved preconceptions about the meaning of blackness, personal desires, and artistic and literary license. Authors and artists struggled against, embraced, and brought into being this enlarged and racially plural Atlantic space in Britain through the circulation, appropriation, adaptation, and recirculation of stories and ico-

nographies about British relationships with black or shaded people. Their works reveal a history of cultural exchange in an imperial center whose political economy came to depend on the oppression of peoples who lived, for the most part, abroad.

My primary focus is on London because it was the production center for print and visual materials in the Isles. Tracked more carefully, provincial and colonial variations of this imagery could potentially provide insight into the differentiation of colonial interests and local experiences of interracial encounter.[15] But provincial and colonial Britons imitated London fashions and actively sought current publications and graphic art produced there; reconstructing these perspectives requires a base knowledge of what was emanating from this metropolitan hub.

Including Britain within the contact zone produces a deeper sense of how Atlantic interactions reverberated far beyond their initial site. It also suggests that the black presence in Britain was both broader and more important to the development of metropolitan culture than a head count would necessarily suggest. Expanding the term "encounter" to include fantasies of racial others reveals the growing centrality of people of color to the construction of imperial identities—to notions of mastery, fraternity, salvation, racial difference, or bondage. Imperialism engendered a sense of connectedness, a new intimacy with racial and ethnic others that produced deep social and cultural conflicts even among Britons who had few or no actual encounters with Africans or Native Americans. That many writers and artists sought to counter that new intimacy by reasserting distance only highlights how Britain was also Atlantic ground. Taking their fears and fantasies seriously not only creates greater theoretical space for studies of how cross-cultural and interracial encounters occurred in Britain itself, but also emphasizes how events and processes at work in the empire shaped metropolitan culture, in ways that will require us to rethink the nature of transatlantic and circum-Atlantic exchange.

Enslaved Experiences in Britain

This book explores one aspect of this Atlantic frontier: how metropolitan Britons thought, debated, and fantasized about the Atlantic slave trade and the turn to African slavery in colonization, how those conversations informed the abolition of the slave trade in 1807, and how these broader imperial ambitions attached social values and ideational associations to the color of skin.

The most critical factors shaping metropolitan experiences of blackness and slavery were the literal distance of the Isles from the New World and the fact that African slavery never became the economic institution in Britain that it turned out to be in the West Indies and southern North America. Even though British merchants became leading players in the Atlantic slave trade in the early decades of the eighteenth century, the metropolitan market for African labor remained predominantly urban and largely luxury.[16] Estimates of the numbers of blacks in 1770s London range from 3,000 to 15,000, depending on whether one takes the word, respectively, of a West Indian planter or London newspapers. In very general terms, Britain looked like New England, with the majority of blacks living in urban centers. Limited demand for African labor meant that Britons at home experienced the transitions to slave labor that defined the plantation colonies from a distance, and it produced a peculiar fuzziness between domestic servitude and slavery that shaped metropolitan perceptions of British-African relationships. More often than not, Britons at home referred to enslaved Africans as servants, a linguistic and visual slip that reflected the fact that bondage in Britain visually resembled other more common forms of servitude.[17]

Historians have often assumed, as a result of the small internal black population, that metropolitan Britons did not think very much about black slavery until the late eighteenth-century movement to close the slave trade brought it to popular attention. A few scholars have chipped away, indirectly, at that persistent myth, resurrecting the relevance of perceptions of Africa for British understandings of their imperial role, the links between the seventeenth-century Caribbean and the development of English culture, and the importance of African Britons to the abolitionist movement. They have stressed the centrality of slaving to the rise of Liverpool and other provincial ports and to the creation of Georgian Britain's fiscal-military complex.[18] Literary critics and art historians, who have been at the vanguard of studies of race in Britain, have also demonstrated how marking racial difference linked power and patriarchy with whiteness. They have highlighted how racial identity inflected a variety of visual and literary discourses and social behaviors in early modern Britain.[19] But these studies rarely connect these broader social, imperial, aesthetic, and literary phenomena to the black presence in Britain, and thus the assumption that there were too few blacks to have had a significant impact on cultural development persists.

However many thousands lived in London, blacks constituted a significant portion of the servant class by the last decades of the eighteenth cen-

tury.[20] Our knowledge of their experiences is limited by the scattered nature of the sources and because the abolitionist agenda in the 1780s disseminated, quite effectively, the idea that British soil did not support slavery. This free soil myth highlights Britain's peripheral position to the major British centers of slave labor in the Caribbean and southern mainland of North America. Although a few court cases were brought to force a definition of the status of "negroes" in Britain, until the Somerset case in 1772 (and to an extent, even then), the courts tended to defer making decisions about whether slaves were property. Lord Mansfield was generally correct in 1772—chattel slavery did not legally exist in England, though involuntary servitude or "slavish servitude" was recognized. Judges, from the seventeenth century onward, generally avoided defining black subordination in Britain, a reluctance that kept free soil ideologies intact. Statutes passed that acknowledged that Africans were "goods" or "merchandize" to facilitate the slave trade, but what property rights a master held in black servants in Britain remained unclear. To allow the sale of slaves in Britain, courts turned to the differentiation of colonial and metropolitan laws, asserting a contractual precedence set in the colonies. Domestic slaveholders' economic rights strengthened in the eighteenth century: the Yorke-Talbot decision in 1729 denied slaves were emancipated upon their arrival in Britain and rejected the idea that baptism, a particular sticking point, conferred freedom. Three years later, Parliament reaffirmed that slaves were a hybrid form of property, with the aim of bolstering investment in the slave trade. But the Somerset case, which freed an American slave whose master attempted to ship him from England to be resold, revived the ambiguity of black status under common law and asserted that only positive law could introduce slavery. Chattel slavery was again denied, despite being fundamental to colonial plantation societies. Mansfield laid the groundwork for Parliament to take up the issue of slavery, and he gave black subjects the protection of English law, which set limits on the power of masters at home. Legal historians point to this latter decision as a radical universalizing of rights, though in some respects it formalized rights to which blacks in Britain had sporadically laid claim. They had appeared as defendants and plaintiffs in court cases, sought out and received baptism, and married.[21]

Rather than introduce positive laws to reinforce racial hierarchies and the exclusion of blacks from the body politic, metropolitan Britons ultimately sought to abolish the slave trade. Since David Brion Davis's groundbreaking study in 1966 on the intellectual origins of antislavery thought, many scholars have sought to explain the emergence of an anti-slave-trade

movement in Britain in the late eighteenth century. New labor relations that emerged with the Industrial Revolution, new consciousness of the connection between metropolitan consumption and the brutalities of slavery, new and sentimental forms of sensibility—these are only a few of the cultural contexts reconstructed to illuminate this sea change in British attitudes toward African bondage. Recent attention to the crucial role of the American Revolution as a catalyst for abolitionist success has also shown how the colonial revolt destabilized ideas about nation and empire, allowing antislavery sentiment to become broadly appealing as a form of "moral capital."[22]

These legal negotiations of slavery masked the long and intimate involvement of some metropolitan Britons in owning or hiring blacks who arrived in Britain through the slave trade or the connections of slaving merchants. In practice, merchants, absentee planters, and landed gentry purchased slaves and brought them to the metropole. Returning ships deposited slaves in informal labor markets (sometimes run through coffee shops), which distributed them into aristocratic and middling households scattered through port cities and the countryside. Whether enslaved, in "near slavery," or free, Africans worked as footmen, maids, butlers, stable hands, barbers, cooks, and in a variety of other positions within households or businesses. Others were assigned to the musical outfits of army regiments, though how they got into these positions or what life would have been like in them has not received much attention. Newspaper advertisements for lost or runaway blacks in the 1670s and 1680s suggest that, even at this early date, shopkeepers bought or hired them. Graphic artists also depicted black servants working in coffeehouses, taverns, surgeries, and other urban settings. Still other Africans worked on the docks, mingling with sailors from many nations.[23] A variety of foreign peoples regularly came to London in the company of ambassadorial retinues; while the ambassadors often stayed in elite circles, the servants, sometimes black, that they brought with them mingled in local society as they acquired food and other necessities for their stay.

Runaway advertisements tell us that blacks in Britain were a motley group: some came directly from Africa; others were recognized as Dutch, Spanish, or Caribbean, indicating that they had experienced periods of bondage or free life in other colonial or European contexts. They were, perhaps, Atlantic creoles—Africans who had acquired linguistic and cultural dexterity as a result of their liminal position within the Atlantic world. They were overwhelmingly male and typically young, a product

again of the particular type of luxury market for black servants in Britain, which favored boys.[24] Especially in the late seventeenth century, these Africans entered a society that also kept Native Americans, South Asians, East Asians, and Turks in servitude.

Although Kathleen Chater has recently made a strong case for the predominance of free or freed Africans among the black population, some were involuntary servants, and many white Britons saw black servants as slaves. David Eltis has argued that slavery was soon identified with non-European peoples in Britain, because it had never housed the substantial Eastern European and Mediterranean slave populations that preceded the introduction of black slavery in southern Europe.[25] But what "slavery" did they identify with blacks? The chattel status of African slaves in colonial settings or the involuntary servitude or near slavery of blacks living in the metropole? Especially in the seventeenth century, when colonization relied on shipments of white bond slaves as well as the developing Atlantic slave trade, the slippage between these types of involuntary labor allowed Britons at home to project redemptive notions of human bondage onto Africans caught in the system. Conceptualizations of the slave trade as a means to African salvation, the Royal African Company's description of slaving as a trade in "perpetual servants"—these cultural and rhetorical euphemisms obscured the trade's brutal realities.[26]

That this fuzziness around slavery did not translate into a racially blind experience of servitude in Britain is evident in that white servants were rarely forced to wear iron or silver collars (as some black servants were), or at least they were not generally associated with this social practice. This physical experience, which was not ubiquitous, appears to be the only concrete differentiation of African slaves from other servants. Britain was a slave-trading, slave-owning society that had no need to create legal and institutional barriers to racial integration. Any assumption about the status of blacks in Britain elides contemporary investment in keeping it unclear.

The archival imprint of this Atlantic frontier records the multiplicity of meanings of blackness and slavery. One consequence is that the sources used in this book raise certain problems of terminology, some of which are common to slavery and race studies and some of which reflect issues particular to visual culture and the ambiguity of black slavery in Britain. Authors often did not explicate the status of the "blackamoors," "Negroes," "Moors," or "blacks" of whom they wrote.[27] These terms were sometimes, but not always, synonymous with slavery. Retaining these uncertainties in

my analysis has been necessary to reconstruct the world in which metropolitan Britons lived. I have generally chosen to use the term "black," which was used by contemporaries to refer to people of color (not just Africans or those of African descent), unless I can identify the figure as an African. In cases where the social status of a black individual is unclear, I have opted to use both "slave" and "servant," in an effort to hold onto the ethical consequences of the language of slavery while capturing the uncertain position of black servants under English law. Visual imagery adds to these problems, because artists rarely delineated a figure as a slave or black. Only context can tell a scholar what meanings a shaded figure brings to an image. Discourses of blackness and bondage overlapped in complex ways and have to be analyzed in situ; the relationship between blackness and slavery was not as firm in early modern Britain as it became in the colonies.[28] Multivalent meanings of bondage also provided Britons with a range of ways to understand black subordination. Ideas about racial difference and black slavery developed from a far broader array of texts and experiences than simply published tracts about Africa because blackness was a fluid category that more often signified the generally exotic than the specifically African. These terminological problems ensue from the legal uncertainty of black slavery and the consequently sociocultural definitions of black servitude in early modern Britain.

Fantasy and Slavery

Understanding how Britons at home perceived and experienced their relationship with a racial other whose enslavement in the Atlantic world determined their imperial success requires moving beyond these legal discussions about slavery, while bearing them in mind. A richer story can be recovered from the proliferation of black characters in shop signs, plays, prints, novels, and other forms of literary and visual media. These figures reflect widespread and heterogeneous responses both to the black presence in Britain and to the centrality of African slavery within the empire. Rather than hiding the violent margins through straightforward projections of ignorance, Britons actively imagined their relationship to Africans, entangling metropolitan society and culture in the contact zones of Atlantic slavery.

Painters and their apprentices, potters, textile manufacturers, ballad singers, playwrights, novelists, graphic artists (especially the popular William Hogarth), slaveholders, and other metropolitan Britons commis-

sioned, produced, and consumed imagery of blacks in ways that centrally shaped domestic experiences of empire. These individual and collective fantasies, despite their interpretive difficulties, can illuminate Britain's cultural and social development, especially in the context of an empire that was fundamentally a product of speculation and fantasy. Roger Chartier argues that "collective representations . . . support a cultural history of the social realm that has as its goal the comprehension of configurations and motifs—of representations of the social sphere—that give unconscious expression to the positions and the interests of social agents as they interact, and that serve to describe society as these social agents thought it was or wished it to be."[29] Collective representations, however, also encoded these social agents' fears, which described social formations that they wished to avoid. How Britons at home thought about and debated the meaning of African slavery and racial diversity reveals the deep social and cultural conflicts engendered by the turn to colonization.

The absolute distance of Britain from its far-flung empire, the enduring strength of preconceptions about British involvement in the Atlantic slave trade and colonial mastery, and the seemingly irresistible desire to break down the distance to the colonies through fantasy shaped how Britons at home imagined their relationship to Africans. Postcolonial arguments tend to stress metropolitan denial of imperial violence, but these imaginings reflect a productive refashioning of it, a play in constructions of mastery that elided the violence of enslavement through the heterogeneity of notions of contact. What made this variety of imagined encounters possible was the simple but irreducible fact of geographical distance—which created time and space for imperial violence to be rhetorically or visually transformed. That transformation lessened its threat (and reinforced celebrations of British imperial power), but it did not prevent the integration of African slaves into metropolitan culture. As Peter Stallybrass and Allon White argue, when there is "psychological dependence on others that are being rigorously opposed and excluded at the social level . . . what is *socially* peripheral is frequently *symbolically* central."[30] African slavery was not out of sight, out of mind for Britons who were not directly engaged in the slave trade or colonization, but its presence in Britain was different from the more familiar forms of African slavery in the Americas.

General daydreams of heroic conquest expressed the simplest form of imperial desire as a narrative of domination. But such straightforward narratives were rare in visual and literary representations of blacks.

Occasionally one finds them included in coats of arms as objects of merchant or pirate conquest, but the act of conquest was usually in the past in metropolitan imagery. On the one hand, by erasing the act of enslavement, metropolitan artists and authors echoed ship captains who argued that Africans were already slaves in their own kingdoms before being brought under British supervision. Fantasies about British relationships with Africans began on the coasts of Africa as European merchants' abductions of Africans and their role in fulminating West and Central African wars got conveniently forgotten in the Atlantic voyage.[31] On the other hand, presumptions of black subordination exposed how Britons held an essentialist notion of racial difference long before they purchased slaves. It took more than two centuries to justify that presumption with biological arguments for racial inferiority; the fact that the naturalization of racial hierarchy occurred at the moment that slavery came to be widely perceived as an unnatural condition emphasizes the deep resistance to making race an outright claim to status.[32] Britons indulged a desire to conceive of their imperial project as something other than conquest, which derived from their late arrival to an Atlantic world already shaped by Iberian imperialism and its dependence on African slave labor.

Growing numbers of blacks in Britain and constant challenges from slave resistance abroad intersected with the imperial destabilization caused by the American Revolution to render the developing metropolitan consciousness of domestic racial diversity a source of anxiety. Historians of blacks in Britain have recognized that increasingly racist sentiments emerged in the 1760s and 1770s, arguing that the social value of black servants declined as the population of free, poor blacks expanded.[33] The production of grotesque racial imagery looks odd in light of the coterminous popularity of the abolitionist movement (indeed, they have not been fully appreciated as connected phenomena). But an Atlantic perspective illuminates how colonial revolt unsettled the significance of the black presence in Britain, producing anxieties, formulated in terms of fears of miscegenation, that reflected Britons' subordination to the forces of exchange and encounter shaping the early modern Atlantic world. In a society that had relegated its economic dependence on slavery to its colonial peripheries, this Atlantic Moment of racial consciousness led both to a market for racial imagery that reduced blackness to a sign of servility and to the empire-oriented effort to close a slave trade that in the end proved a moral liability.

Reconstructing white and, to a minor degree, black Britons' conflicting notions about the meanings of empire and the multiracial societies that

14

the empire brought into being provides a needed cultural context to examine the experiences of Africans who found themselves in Britain. As Frantz Fanon remarked in "The Lived Experience of the Black," the self-knowledge of the black in a society constructed predominantly by the white is often third person: "the White, who has woven [him] out of a thousand details, anecdotes and stories" then "deafened" him with "cannibalism, intellectual deficiency, fetishism, racial defects, slave-ships."[34] This book focuses on white constructions and experiences of these fantasies, but the symbolic world produced through these imagined encounters also surrounded black Britons who walked down these streets and encountered Black Boy shop signs. Before we can reconstruct their experiences, we have to resurrect the deafening narratives that they confronted about the meaning of their presence. This was an Atlantic frontier in an overwhelmingly white society. It is my hope that this book raises new areas of inquiry into how black authors negotiated and engaged this racial imagery and into the lived experiences of Africans in Britain.

I also intend for this book to raise new questions among Atlantic historians about how these metropolitan fantasies intersected with colonial formations of racial slavery and shaped negotiations of metropolitan power. This story integrates colonists and colonial reports when they directly intervened in metropolitan conversations, but the importance of these fantasies would also lie in their reverberations in colonial interactions and ideas about interracial relationships. Colonists who carried metropolitan notions of race and slavery with them and the transatlantic circulation of print and visual media extended and transformed the conversations discussed here. Caribbean planters, Jamaican maroons, New England missionaries, colonial agents, travelers, slaving merchants, Indian embassies, and other people living in or near British colonial settlements appropriated and contested these metropolitan visions of contact, but the consequences of that engagement for colonial societies is a question raised but not answered here.

Some of the complexities of metropolitan responses to blacks can be briefly introduced by a closer look at the 1750s sketch of a Black Boy shop sign (see Plate 1). The boy's bright red lips, pearl drop earrings, and necklace give him a macabre synthetic quality that clashes with the Italianate natural landscape in which he stands. His foreshortened limbs, suggestions of breasts, and ornamentation produce a gender indeterminacy that alienates the viewer as it renders the boy grotesque, even as the artist accentuated his genitalia to suggest fertility or manhood. Feathers and arrows

testify to the persistence of tropes typical of images of Native America despite the decimation of coastal and Caribbean native communities by the 1750s.[35] The artist also transformed classical iconography: a cherubic figure became black and muscular, and the arrow of Eros became the arrow of the New World primitive. Several histories could be fruitfully explored through this image's polysemic structure; my interests in this book reside in how Africans were incorporated as slaves or servants and as exotic bodies into popular culture. From this perspective, the tensions in this rendition of a "Black Boy" arose from the fusion of classical conventions with a European iconography developing in response to Atlantic exploration and settlement, but that hybridity was only made possible by colonization and the transportation of millions of Africans to the Americas. The sale of the black body and bondage on British plantations surfaces indirectly. The boy mediates between the natural landscape and the commodities that bedeck him; he is emblematic of the fertility of nature and the riches produced from it.[36]

This sketch of a shop sign embodies the complex internalization of meanings of blackness, slavery, and empire in Britain, but its future display demonstrates how simple the integration of those complex forms could be. Although I situate these representations within broader visual and literary discourses in order to draw out their iconographic and cultural work, all that a Briton had to do to internalize that work was to recognize this bizarre figure as a Black Boy. The circulation of an image tells us little about what it meant for individual viewers, but investigating how artists and authors responded to earlier images and texts tracks the evolution of cultural constructions of the black body as slavery became central to the empire.[37] Artists tended to borrow indiscriminately from multiple iconographic traditions. Blackness became a mapping mechanism for those who sought primarily to represent the exotic other and who were less interested in ethnic or racial specifics than in a general symbol of the external world. In whatever form, these fantasies eroded the insularity of Britons living in the Isles. Until the late eighteenth century, this erosion occurred through representations that exhibited a fluid hybridity that sometimes generated the grotesque and that often, in ways reminiscent of the legal discussions of slaves in Britain, avoided any clear reduction of the black body to crudely defined British interests.

The chapters in this book explore, in different ways, the consequences of the ambiguity of slavery in Britain for popular ideas about race and slavery, and the multiple and related elisions of the violence of empire. Early chapters explore the idealization of black servitude in visual con-

structions of imperial mastery, dramatization of the exotic danger of slave resistance, curiosity about the origins of blackness, and fantasies of imperial benevolence and slave gratitude that were disrupted by slave rebellions. Subsequent chapters turn to the imagination of interracial fraternity and contact around the sensual pleasures of tobacco, the appropriation of black servants for critiques of metropolitan consumption and fashion, the growing identification of blackness with political and moral corruption in the last decades of the eighteenth century, and the emergence of the black working-class Londoner in satires of British society. I have sought in each of these stories to retain a sense of the irresolvable multiplicity of meanings attached to black subordination, while also illuminating the cultural consequences of that entanglement. The archival resistance to disentanglement speaks to how Britons at home creatively silenced their connection to black trauma, and to the brutal, if unstable, consequences of such constructions of distance.

1

His face was not of that brown, rusty black which most of
that nation are, but of perfect ebony or polish'd jett.

—Aphra Behn, *Oroonoko* (1688)

A 1720s fresco painted on King George I's Grand Staircase at Kensington Palace documents his servants posing on a duplicate, imagined staircase (Figure 1.1). Among them stand two men of color: Mustapha, who youthfully dangles his leg over the banister, and the trusted personal servant Mahomet. The British court variously deemed these two servants the "slaves," "body servants," or "procurers" of the new king. In 1714, George I had arrived in Britain still uncertain as to whether the populace would recognize a Hanoverian with remote claims to the throne as their king. Some Tories, who only reluctantly accepted him, pejoratively described his slaves as "Turks," invoking popular associations of black slavery with the perceived barbarism and tyranny of the Ottoman Empire. For Whigs, the two slaves, presumably still infidels, seemed to fit celebrated images of a powerful, rich, and Protestant imperial king.[1]

The slaves' Muslim names suggest that they may have come from the Ottoman Empire or Islamic regions of Africa, though subsequent writers would give them a more immediate Hanoverian past and yet another ethnicity by labeling them "German negroes." Given that black slaves came into eighteenth-century Britain through the Atlantic and Mediterranean trades, the conflation of Turks and Africans is not especially remarkable.[2] What matters, considering the limited number of people with darker skin living in early Georgian Britain, is that politicians used blackness to characterize the king and his agenda. Politicians recognized the multiple meanings of black attendants, rendering them contested political symbols. The

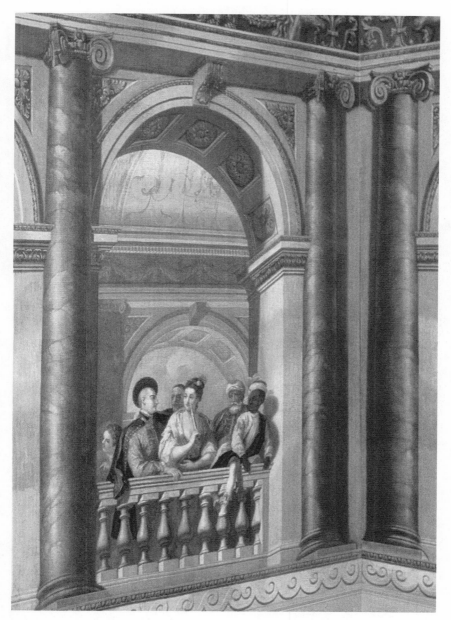

Figure 1.1. Detail of William Kent, fresco on the King's Grand Staircase (1725–1727), Kensington Palace, London/The Bridgeman Art Library International.

master who construed the black servant as fortunate for his or her removal to the British Isles and the Turkish slave who embodied a master's tyranny were two sides of the same coin.

For a wealthy merchant, king, or aristocrat, enslaving or employing an African often meant nothing more than adding an exotic figure to an already lavish equipage. In some respects, this elite practice paralleled that of rich West Indian planters, whose equipages drew the satirical attention of Britons at home. It was also a form of slavery practiced throughout Europe, a fact that will occupy our attention in this chapter. But the rapid expansion of print in the seventeenth and eighteenth centuries meant that the meanings of black servitude were never solely the province of elite masters. By the 1670s, runaway advertisements challenged gratifying descriptions of blacks thankful for their translocation into Britain. Reports of slave resistance in Barbados, Jamaica, or South Carolina continually undermined arguments that imperialism gave Africans the opportunity to find good government and religious conversion. Meanwhile, slavery in non-British societies and mixed perceptions of darker skin tones complicated popular responses to holding black servants in Britain. Questions about the morality and legality of slaving kept the significance of African servants open to debate. Debates about the implications of racial variety and the incorporation of blacks into Protestant communities continued throughout the early modern period. By the time Mustapha and Mahomet arrived in the company of a new king, black attendants had acquired local associations with despotism and commercial virtue, as well as with other fantastical desires.

Before turning in subsequent chapters to critiques of racial slavery in popular culture, introducing the extent to which Britons, most of whom did not own slaves, encountered and internalized elite models of mastery is important. Although scholars have recovered how British discussions about colonial slavery became part of a broader attempt to define the nature of empire, much less is known about how black domestic servitude, which was the most visible form of African labor to Britons at home, also became a framework in which to make sense of social transformations resulting from growing colonial investment. Since the 1960s, historians have reconstructed the lives of a few Africans enslaved in Britain, emphasizing the paradox of a society that championed ideals of liberty while holding slaves in bondage. That paradox has been explained by the idea that Britons either did not care about African bondage or that they perceived it differently from white bondage.[3] Both were true to a certain

extent, but the wide dissemination of elite formulations of mastery suggests a more fundamental explanation.

The rise of the British slave trade and emergence of slave societies in the British New World during the seventeenth and eighteenth centuries accompanied the development of a metropolitan art world. This visual culture, financially enabled by new imperial wealth, played a critical role in shaping domestic experiences of empire. Artists expanded the black presence by displaying images of black servants in textiles, ceramics, fans, prints, shop signs, and other visual media. These representations derived largely from elite art and social displays. As black subordinates and their white and sometimes black masters circulated on everyday objects, becoming integrated into the material and visual culture of middling homes and public venues such as coffeehouses, taverns, and shops, this formal relationship became disassociated from slavery abroad or at home. An idealized, hierarchical relationship became vernacular, inoculating the general public from the responsibilities of slave ownership as artists turned mastery into an iconographic formula. The fashion of black servitude in Britain emerged through not only the acquisition of Africans themselves, but also growing familiarization with an idealistic vision of imperial mastery.

Imitating Europe

Beginning in 1651, Parliament passed a series of Navigation Acts designed to bolster England's control over its colonial possessions. The Acts registered a new approach to empire that Britons pirated largely from the Dutch (and that led to a few wars with the Netherlands): commerce and agriculture took over from exploration and conquest as the "crucial location for the display of national pride." Competing with European countries meant opening trade routes, limiting shipping of colonial products to English ships, stimulating domestic production, and creating the influence abroad necessary to support a growing re-export trade. *The Craftsman,* in good company with other newspapers, plays, and pamphlets, assured readers in 1728 that "the fate of the whole Kingdom depends, in great Measure on the Welfare of the British Merchants." The kingdom depended on an immense expansion of citizenry involved in imperialism, from the political and mercantile elite who controlled colonial trade, to the sailors, surgeons, and chaplains who served on merchant and navy galleons, to the craftsmen who built ships, to the populace that purchased colonial produce. As English settlements in the West Indies and southern North

America evolved into slave societies, control over Atlantic trade also required maintaining a steady stream of African captives into sugar, tobacco, and rice plantations. From 1677 onward, the crown recognized that Africans had been defined as goods under the Navigation Acts. When colonial agent Joshua Gee observed in 1729 that domination of blacks was the "great Cause of the Increase of treasure," slavery had become central to the agricultural and commercial economies of empire.[4]

Intensification of slave-based colonial agriculture during the Restoration encouraged elite and aspiring Britons who lived in the Isles to seek opportunities in West African slave markets. In addition to transporting captives to Barbados or other English colonies, merchants could profit from selling slaves, legally or illegally, in Spanish, Portuguese, French, or Dutch colonial ports, especially after the disruption of Portuguese shipments to Spanish colonies in 1640.[5] Metropolitan landholders did not turn to plantation slavery as an agricultural model, so the demand for African labor in Britain remained a small and mostly luxury servant market.

Aristocratic investors in slaving voyages instructed captains to purchase slaves for their households. Other clients emerged through aristocratic channels and through informal urban sales. In 1707, for instance, William Abbot of London offered to "dispose" of a "lusty Black Man, about 22 Years of Age, and a handsome East-India Boy, about 18," both of whom were thought "fit for a Person of Quality, Gentleman's, or any other Persons Service." Elite displays of black servitude played on a widely held belief that trade, especially slaving, would prevent Britain from, as Malachy Postlethwayt put it, "lagging behind" Europe. Captains and merchants included Africans as part of their retinues and incorporated black bodies into their coats of arms.[6] For Britons who could afford to buy or hire them, Africans who had been sites of conquest abroad became desirable commodities in London, Bristol, or Liverpool, where their market value had little to do with a capacity for plantation labor.

Despite their limited numbers, Africans who were dressed in livery that further set off their skin tone made a striking appearance in a predominantly white society. Skin color and expense, rather than ethnicity, distinguished Africans and their servitude from white servants. By 1675, the practice of owning a "Blackmoor" was common enough to be included in a literary satire about modish women. In 1710, a German visitor to London remarked: "there are . . . such a quantity of Moors of both sexes in England that I have never seen so many before." In 1723, the *Daily Journal* told its readers, with some alarm, " 'Tis said there is a great num-

ber of Blacks came daily into this City, so that 'tis thought in a short Time, if they be not suppress'd, the City will swarm with them." Charles Dunster composed a verse about wealthy Britons parading down London's St. James Street:

Sometimes at their head,
Index of Rank or Opulence Supreme
A sable Youth from Aethiopia's climes,
In milk-white turban dight, precedes the Train.

Employing black servants represented one conspicuous form of involvement with the fashions and fashioning of empire. If colonial planters presented themselves as landed gentry by building imitations of British country homes, elite Britons at home had sought similar Atlantic connections, incorporating African servants into their households because their rarity, expense, and imperial origin elevated their master or mistress.

Long before slaving became central to the British state, trade with West Africa generated interracial exchanges based on the notion that Africans could be brought to England to learn the language and manners and then become interpreters. That Renaissance idea of instruction was never displaced: even at the height of the slave trade during the eighteenth century, colonial relatives and merchants sent African children to their families or clients in Britain. Elite Britons saw themselves as elevating these children by offering them a place in their homes. But some contemporaries saw these displays for what they also were: such "sable Youth" signified, as Dunster bluntly put it, "Rank or Opulence Supreme."[7] Purchasing or employing these servants or slaves meant buying into and associating oneself with an exotic fantasy of power.

Although scholars have recognized that the black servant in livery became a hallmark of eighteenth-century urban life, a sought-after possession, and a motif in contemporary visual and material culture, the European origins of this ultimately Atlantic figure have not been fully appreciated. English advocates of colonization had argued that Protestants had a divine mandate to curb Catholic expansion into New World territories, but, in practice, Britons pirated most of their ideas about and practices of empire from their European neighbors.[8] The introduction of African servants into Britain similarly involved imitation and adaptation of European precedents. From the perspective of Britons living in the Isles, black bondage did not begin with the arrival of twenty-odd African slaves in 1619 Virginia or with the spread of African slavery in the Iberian

empires in the late fifteenth and sixteenth centuries. It began instead with the fourteenth- and early fifteenth-century introduction of black slavery in Muslim and Christian Mediterranean countries and the subsequent inclusion of slaves in the gift exchange that occurred between royal families in various parts of Europe. These slaves, who often arrived through trans-Saharan routes, adorned harems and courts or became soldiers, and only rarely saw agricultural labor.[9] The association of black servants with courtly displays of wealth and military power shaped British ideas about an empire that would be driven by plantation slave labor. Although the figure of the liveried black servant became central to ideologies of Atlantic imperialism, its origins lay with elite Britons who sought to imitate not only the practice of slavery in European courts but also the visual apparatus that translated those social practices into structures of meaning.[10]

Neither the social displays of black servitude nor the artistic records of them in Britain reflected a blank slate. A long history of European contact with North Africa and the early Iberian and Dutch establishment of trade with and in West and Central Africans provided Britons with a variety of visual models for how white and black people related to one another, as well as with a range of Christian, classical, and courtly symbolism attached to black bodies. Anyone who has visited a major European art gallery or church will have encountered early paintings that include people with dark skin. Sometimes they are tiny figures amid panoramic scenes of Venice or Madrid, working as gondoliers or soldiers or accompanying a white European. Other times they are central or supporting figures in biblical or classical history paintings, appearing in scenes of religious martyrdom or baptism and alongside Roman emperors or classical gods. Often they are supporting actors in court scenes or aristocratic portraiture, in retinue in the company of dwarfs who were also objectified and traded in early modern Europe.[11] These pictures reached the Isles through the spread of copperplate engravings and woodcuts, the migration of artists in both directions across the Channel, and the activities of early art collectors. Major European artists, recognizing the potential profit of emerging print markets, facilitated matters by hiring engravers to reproduce hundreds of their works for broader circulation.[12]

A complete picture of these myriad European traditions, migration into Britain, and adaptation by British artists is impossible here, but recognizing the body of iconography available to Britons is important. This aesthetic inheritance critically shaped vernacular understandings of African servitude and the black presence in Britain by associating them with a

courtly refinement and military prowess (often characterized in Christian or classical terms) that was then projected onto Atlantic interactions.

Antecedents for exotic black servants in Restoration and Georgian visual culture lie in medieval and Renaissance paintings of the Adoration of the Magi, St. Maurice, and other biblical figures. In the later Middle Ages, the three magi embodied the three known parts of the world. Gold, frankincense, and myrrh (symbolically, kingship, divinity, and death) were part of the ancient trade between Arabia and Africa. Beginning in the fifteenth century, illuminated manuscripts, paintings, winged altarpieces, jewelry, and triptychs depicted Balthazar, the third magus, as a person of color who varied from Turkish to African to Native American, reflecting artists' access to portraits of dark-skinned individuals or to the individuals themselves. A sixteenth-century Portuguese Adoration painting, for instance, portrayed the third magus as a Tupi Indian who was probably based on one of the southern American Indians brought to the Lisbon court. In the seventeenth century, Peter Paul Rubens derived some of his multiple Balthazars from a sixteenth-century portrait that he owned of Mulay Ahmad, King of Tunis. The majority of early Adoration paintings emerged from European studios, though Renaissance English alabaster sculptures of the magi also replaced the third magus with a black man in a turban who represented the continent of Africa.[13] Artists integrated racial others through Christian narratives, reinventing the faraway place from which the third magus came as different parts of the world came into focus. Painters who included black youths bringing flowers to white British subjects and graphic artists who imaginatively recorded black servants offering chocolate, tea, and coffee drew on Balthazar, who presented his gift to the Christ Child, acknowledging his divinity. What began as a symbol of an ancient trade between Arabia and Africa in religious iconography morphed into a symbol of new exotic trades—in goods and people—resulting from European expansion.

If the Adoration had been the only racialized story in Christian thought, perhaps the uncertainties around the meaning of racial plurality would have been different. But blacks inhabited ambiguous positions in the Christian imaginary, functioning as important sources of confirmation and as potential sources of subversion within European narratives. Vague knowledge of black Christians generated pictures, especially in Germany, of the purported third-century Christian leader of the Roman Theban legion, St. Maurice, as a black Moor, a trend that declined with the rise of the Portuguese–West African slave trade in the sixteenth century. Most artists,

however, placed blacks in observation of or opposition to Christianity. A broad survey of religious painting (which neglects context) reveals a black youth serving the wine that Christ has made from water, a black soldier watching as Christ lets the adulteress go free, a black executioner wielding the knife in St. Justine's martyrdom, a black soldier dragging St. George through a cityscape, a black youth observing the martyrdom of St. Sebastian, another serving the feast at which Salome calls for St. John's head, a black slave attending to the discovery of baby Moses; the list goes on.[14] Often placing darker figures in proximity to white Christians, these painters differentiated racial others through some type of servitude. Some European artists were undoubtedly working out ongoing or lingering fears of the Moorish invasion of Spain, but such conflicted perceptions of the historical and biblical roles of people of color make clear a fundamental uncertainty about the meanings of human diversity. This uncertainty persisted in British perceptions of blacks well into the eighteenth century, as evidence for a long history of black saints and martyrs proved difficult to ignore, but the expansion of the slave trade necessitated a persistent hierarchy of white Christians over black Africans.[15]

Classical allegories of the Continents, which were popular in Europe, also provided bodies that stood metonymically for the four parts of the globe. European artists produced allegories of Africa and America as male or female black or shaded bodies, dressed in feathers or loincloths and surrounded by emblematic objects, plants, and animals that described their native lands from a European perspective. British book illustrations, board games such as the Circle of Knowledge, maps, shop signs, plays, textiles, war memorabilia, and ceramics elaborated upon these geopolitical constructs, disseminating similar visions of Britain's relationship to the external world.[16] Some allegorical representations blended Native American and African attributes in one body, registering the combined importance of these continents to British imperialism and the lack of specific knowledge about them (see Plate 2 and Chapter 5). These geopolitical constructs, and their depicted obeisance to British figures or Britain, bolstered broad imperial ambitions and reinforced the connection of blackness to a space beyond the Isles—over which Britons, such as William Pitt, wished to imagine themselves exerting influence.

As African slaves arrived in European courts, painters began to include them in portraits of elite men and women. Italian, Iberian, and Netherlandish artists transmitted this form of visual culture to their European neighbor as their royal patrons were conveying slaves. In their depictions

of black retinue and their use of the aesthetic contrast of white/black or brown/pink skin, British artists and authors especially tapped an influential Venetian and Flemish tradition that incorporated black servants into colorful representations of contemporary court life. From Florentine, Dutch, and German iconography, Britons also inherited depictions of blacks involved in informal, local life, while the eighteenth-century French rococo school placed black servants in intimate and sensual domestic scenes.[17]

The origins of vernacular iconographies of racial slavery in Britain lay in the appropriation and redeployment of these varied European iconographies of racial difference. Although the richness of Catholic Continental imagery would not be reproduced wholesale in this Protestant country, reliance on foreign artists in the seventeenth and early eighteenth centuries (and elite desire for their works) ensured the importation of certain models of master-servant or mistress-servant relationships, especially within portraiture. Britons borrowed European renderings of the biblical and classical meanings of skin color in their constructions of the symbolic value of black servitude, but the form of the black servant that recurred across multiple genres of aesthetic production in Britain derived principally from European portraits. Because elite Britons imitated European fashions, portraiture became part of the display of black servants in Britain and, to a lesser degree, in the colonies. Hung above doors or on the walls of wealthy and eventually middling homes, abutting neighboring paintings as well as an imagined genre of portraiture that visitors and family members would have understood, these portraits connected sitters to the politics of high society, including the politics of slavery.[18]

The young black servant dressed in the rich livery of the elite became a not uncommon supporting character in British portraiture by the late seventeenth century.[19] Often decorated with pearl earrings and carrying a salver or parasol, this European figure soon became Atlantic as British aristocrats and merchants borrowed the black page to record their engagement with imperial ventures. Involvement in settlement schemes in Africa or investment in the Royal African Company yielded portraits with black servants, especially in the seventeenth century.[20] Popularizing these idealistic, elite visions of imperial rule involved a series of exchanges between artists, aristocrats, merchants, black servants, artisans, and middling consumers.

Models of Mastery

The socializing function of portraiture complicated the transmission and formulation of individualism that scholars have attributed to this genre of art. Painters, often at the behest of patrons, adapted earlier depictions of royalty or aristocracy, borrowing templates that were stylish and communicated power. British artists, as a result of their late arrival on the European art scene, derived their motif of the black page from Anthony Van Dyck, Peter Paul Rubens, and a number of European artists who visited or lived in early seventeenth-century London. The latter were, in turn, influenced by Venetian traditions of using black bodies to construct aristocratic authority and to convey the sensuality and flamboyancy of the court.

Titian's early sixteenth-century portrait, for instance, of Laura de' Dianti, the mistress of Alfonso I d'Este, Duke of Ferrara, represents one of the earliest known portraits that included a black page. Laura places her hand on the child's shoulder, calmly laying claim to her subject. The image draws viewers to the mistress who dominates the frame and then, through the child's slightly fearful gaze, to a more nuanced and humanized sense of her solidity. This painting accompanied one of Titian's portraits of Alfonso: as Herbert Cook described, "the action of the arms in both [is] singularly balanced, the duke leaning on a piece of artillery (of which he was a famous inventor), the duchess on her Ethiopian page." Between 1675 and 1688, publisher Richard Tompson reproduced Titian's portrait of Laura in mezzotint for broader circulation in London (Figure 1.2). Although originally embedded in Italian celebrations of elite women's power, Titian's template for mastery proved useful for male and female English sitters, including Lady Dorothy Percy, Countess of Leicester (1598–1659), and a male member of the Greville family who had ties to Barbados (Plate 3).[21] Restoration and Georgian portraitists began to differentiate male and female expressions of mastery, but followed Titian in a more general sense as they used black servants to connote the status and wealth of British sitters.

In addition to Tompson's mezzotint, Titian's portrait of Laura reached Sir Peter Lely and other artists in England through the mediating works of the highly regarded Flemish painter Van Dyck. When Van Dyck visited England briefly in the early 1620s, he became engrossed with Titian's ability to render movement, tone, "flesh and fabric in a subtle play of light and shadow."[22] From 1632 until his death, he worked primarily in London,

Figure 1.2. After Titian, *Admodum Illustri Lucae Van Vffele* (1675–1688), published by Richard Tompson. Portrait of Laura de' Dianti. © The Trustees of the British Museum. All rights reserved.

where his attention to psychological relationships had a remarkable legacy. He supplied English artists with two influential models for depicting female relationships with black servants—his 1634 portrait of French aristocrat Henrietta of Lorraine, and his 1623 portrait of Elena Grimaldi Cattaneo, wife of a prominent Genoese merchant.

29

Van Dyck's *Henrietta of Lorraine,* which was in Charles I's collection, depicted the French widow of Louis de Guise, Prince of Phalsbourg stopping a black page who heads out of the field of the painting (Plate 4). Her hand on the boy's shoulder, an echo of Titian's *Laura de' Dianti,* delays his exit, while the page's upward glance toward his towering mistress expresses an absolute subservience. Scholars have read into this portrait a relationship between "Child Colony" and "Mother Country"; though subsequent portraits based on this template would take on colonial connotations, that reading has limited use for this 1634 portrait, especially as Henrietta never came to England except in reproduction. It also has the effect of narrowing the signification of black servitude to its association with colonial practices.[23] Reconsidering *Henrietta of Lorraine* in its European context centralizes a courtly rather than specifically colonial commentary. A rosebush in the background offers buds the same color as those that lie on the page's silver salver, as if either he or Henrietta has just finished clipping buds that were destined for someone else. Roses, which symbolized the pains and pleasures of love, as well as mortality and chastity, provided a fitting emblem for Henrietta, who had recently lost her husband. It is as if she, with her rigid gaze, commandeered both roses and exotic servant for her self-image, aware that their symbolism would elevate hers. Van Dyck completed the sequence in his companion portrait of Henrietta's younger sister, Marguerite, which replaced the servant with a drape echoing the color of his livery.[24] Marguerite carries an identically colored rose, perhaps from the salver itself. Side by side, as Van Dyck clearly meant the portraits to be displayed, the black page and roses connect one sister to the other in a poignant commentary on the younger sister's recent marriage to the duc d'Orleans in the midst of Henrietta losing her husband and court in Lorraine.[25] Together the paintings transfer love and court from Henrietta to Marguerite through the medium of the pageboy, but his presence in Henrietta's portrait reflects the fact that both sisters were refugees in Brussels at the time of their sitting and Marguerite's expectations of marriage had yet to be fulfilled. The black servant invoked the politics and social experience of a European court: his impending departure, stilled for a moment by Henrietta's active possession of him, spoke to her struggle to keep her status.

The emphasis on movement, exotica, color, and remote elegance that marked Van Dyck's arrival in the Caroline court persisted in British depictions of imperial mastery, integrating aristocrats and wealthy merchants into modes of courtly display first formulated on the Continent.[26] The black page with pearl earrings and salver of flowers had a particular

legacy in English portraits. Around 1640, Van Dyck's studio used *Henrietta of Lorraine* as a template for an English woman, now unidentified, who delays a black page with pearl earrings and a salver of flowers; in this image, the boy is arriving rather than departing.[27] Versions of this model then reappeared in Adriaen Hanneman's painting of Maria Henrietta Stuart, wife of Prince William II of Orange, Peter Lely's portrait of Elizabeth Murray, Countess of Dysart, Duchess of Lauderdale (ca. 1645–1650), Godfrey Kneller's portrait perhaps of actress and royal mistress Nell Gwynn, a portrait, perhaps by Lely, of Lady Elizabeth Noel, First Countess of Gainsborough (before 1680), Mrs. John Verney's portrait with her husband's slave, Peregrine Tyam (1692), and other Restoration and Georgian portraits of identified and unidentified sitters.[28] Similar portraits with South Asian, Turkish, and Chinese children also appeared in the seventeenth century, though they were not nearly as common as those with Africans.[29] A few artists depicted adult male or female African servants, but overwhelmingly these images produced a vision of child servitude, which would have consequences for eighteenth-century artists who challenged the meanings attached to black servants.

The Restoration era appears to have been this template's zenith in portraiture, perhaps because Charles II invested in the Royal African Company and, through his own gifts of African slaves to his mistresses, instituted a fashion for black servants at court. By the late seventeenth century, African children had become a form of social currency, consumed and displayed in a semiotic system of status. The repetition of Van Dyck's mistress-servant relationship in subsequent portraits suggests that the template itself was, at least at first, most important. Such iconographic continuity has often led to the indiscriminate application of the same portrait to different moments of colonization and indeed to different European countries. Paying greater attention to the moment of production should lead to better identification of sitters and painters and, hopefully, to more information about specific African experiences in elite British or European households. A few African children have been more or less identified, but most remain unknown and archival records for known sitters have not proved forthcoming. Limited historical knowledge about these black servants accentuates the objectifying effects of representation; but seeing these portraits only as evidence of the denigration of the slave, the "loneliness" of the African servant, or any other modern projection onto the past overlooks the fact that they are staged images that cannot be read as direct transcripts of black experiences of

service.[30] Portraits tell us only that these servants suffered a particular visual status due to their social desirability.

Analyzing the patterns of representation, however, allows us to investigate how elite Britons wished viewers to understand and remember their imperial roles, which can provide an indirect lens into the kinds of expectations that Africans confronted. Portraits took fantasies of mastery and made them tangible, shaping social experiences and cultural perceptions of slavery by influencing the display of blacks in metropolitan life and art.[31] The impulse to attach these fantasies to any moment of colonization or any European country should be resisted, however justified by the interchangeability of these images in modern perceptions of African slavery and reflective of the ideological continuity of notions of imperial mastery. Such elisions obscure the role of social imitation in aesthetic displays of black servitude, subtle changes in elite understandings of mastery, and how black servants became commodities in visual culture.

Expansion of the art market after 1650 led portraitists to develop strategic shortcuts, especially when financial success enabled them to support large studios. By the late seventeenth century, major artists often produced portraits on an assembly line, using specialists to create landscape or drapery backgrounds. Some artists even had their apprentices create generic bodies onto which they subsequently attached particular heads.[32]

The Lely portraits of Elizabeth Cooper and Charlotte Fitzroy suggest how such manufacturing may have shaped the formulation of female mastery. Lely painted the young Elizabeth Cooper, who was probably the daughter of Edward Cooper, a prominent publisher who also sold paintings and was widely recognized in London for his expertise in art. He cultivated a relationship with Kneller and Lely, which may have led to the Restoration portrait of his daughter. Elizabeth is seated, taking grapes from an Asian boy about her age. William Faithorne Jr.'s mezzotint reproduction of Lely's *Elizabeth Cooper* (Figure 1.3) entitled it "Beauty's Tribute." He attached the following lines (which, incidentally, provide a rare glimpse into how these servants were seen by some viewers as slaves):

Beauty commands Submission as its due,
Nor is't the slave alone that owns this true,
Much fairer Youths shall this just Tribute pay,
Nor Fate deplore, but thankfully obey.

Lely, who frequently asked sitters to select from stereotypical designs, based the original portrait of Cooper on his circa 1672 portrait of Lady Char-

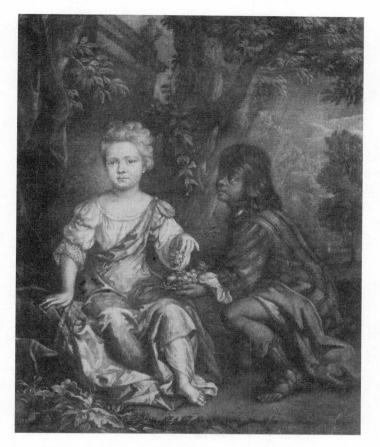

Figure 1.3. William Faithorne Jr. (after Sir Peter Lely), *Elizabeth Cooper,* published by Edward Cooper. Mezzotint (late seventeenth century). NPG D1523. © National Portrait Gallery, London.

lotte Fitzroy, daughter of Charles II (Figure 1.4).[33] Both pictures include the same servant in stunningly identical poses. Although the difficulty of establishing the production histories complicates matters, the portraits' remarkable similarity suggests that Lely inserted one or both of these girls into canvases that had already been prepared with the figure of the "slave." Regardless of whether the servant worked for Lely, the Fitzroy family (most likely), or the Coopers (least likely), the repetition indicates that depicting oneself alongside a subordinated person of color had become

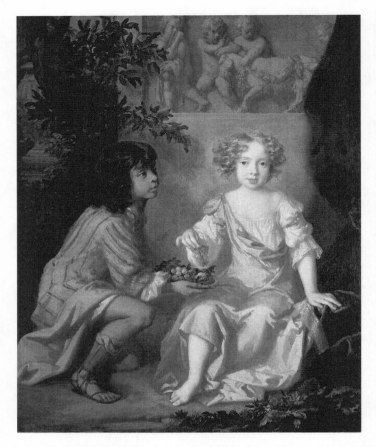

Figure 1.4. Sir Peter Lely (1618–1680), *Lady Charlotte Fitzroy (1664–1719), later Countess of Lichfield* (oil on canvas, ca. 1672). © York Museums Trust (York Art Gallery), UK/The Bridgeman Art Library International.

more a fashionable formula to express a white woman's beauty and status than a direct indication of slave ownership. Van Dyck's template had become more background than foreground, the body of a "slave" (in Horace Walpole's description of Faithorne's mezzotint, "A black") more a broad signifier than a particular representation, and slaves or blacks had become commodities in art as well as in life.[34]

Specific iconographic elements varied from sitter to sitter, but these portraits, unsurprisingly, emphasized the beauty of central white subjects. That

black servants set off the whiteness of a British sitter is a commonplace of modern scholarship. But more than aesthetic contrast conveyed white female beauty. On the one hand, Kim Hall has pointed out the Petrarchan aspects of these portraits, showing how black servants enhanced their mistresses' whiteness not only through their contrasting skin tones but also through their offerings of coral, pearls, and other objects used in the beautification of white female bodies.[35] Roses, flowers, fruits, shells, Bacchic elements of sculpture, and other emblems of sexual desire also surrounded and contextualized mistress-servant relationships. Such associations of black bodies with sexual desire had developed in sixteenth- and seventeenth-century travelers' accounts of African societies, which circulated among the same group of elites who sought portraits with black servants.

Portraitists also constructed a mistress's beauty through the status conferred by the subordinated black presence. As Faithorne remarked, "Beauty commands Submission." The addition of a supporting character created a visual display of power by hierarchically arranging the mistress and servant in space and through their attitudes toward each other—all of which portrayed the central subject in an agreeable light. This function echoed the role of white servants who were occasionally included in portraits as supporting figures, but the "Submission" of the exotic servant conveyed, as Dunster observed, "Rank or Opulence Supreme."[36] The composition of white women's beauty in terms of black servants' obeisance was one of the first integrations of Africans into English culture.

Restoration artists began to paint a more intimate picture of this relationship as two versions of Van Dyck's template became popular: a three-quarter-length portrait in which the female subject stood closer to the black servant and a full-length or three-quarter-length portrait, such as Lely's *Charlotte Fitzroy,* in which the female sitter sat beside the servant. Both reduced the spatial differential characteristic of Renaissance portraits that stressed the black page's absolute subservience; the overlapping bodies generated a new sense of emotional intimacy that fit new social conventions and emerging racial and imperial sensibilities. These images placed greater emphasis on reciprocity, often depicting the black servant making some sort of offering to his or her white mistress, while the mistress displayed her affection (and the civilizing consequences of that affection) for the black child.

Pierre Mignard's well-known 1682 portrait of Louise de Kéroualle, Duchess of Portsmouth (Charles II's favorite mistress in the 1670s), for instance, set up this kind of relationship (Plate 5).[37] The girl offers the

duchess a piece of red coral (a component in cosmetics) and a shell filled with pearls, a gesture that echoed classical iconography of Prosperity and Fertility with her Cornucopia. Her offering is echoed in the pearl earrings adorning the duchess, which may have been a present from the French king, and in her own pearl choker that recalls the slave collar. That the young servant actively provides materials with which to accentuate her mistress's skin color doubles her own function in the painting as a source of color contrast. Although scholars have drawn attention to this portrait's emphasis on consumption and display, the reciprocity of this relationship has not been recognized: in exchange for these objects and for the child's deference, the duchess bestows her preferment, intimately drawing the child into her portrait, indeed into her physical space, and placing her in English finery, a stage in the process of acculturation.[38] That circular relationship intensified the symbolic position of black servants within developing ideologies of imperial mastery.

Mignard's depiction of a physical embrace, constrained by the duchess's gaze out at the viewer rather than toward the child, was unusual, perhaps because most female portraits included black boys. But other Restoration and early Georgian painters, often drawing on Madonna and Child iconography, moved toward representations of emotional investment. A Kneller portrait from the later 1680s, for instance, depicted a mistress chucking a black boy under his chin (Figure 1.5). Another unidentified woman appeared holding a fruit at her bosom, while her black servant imitated her behavior, holding another fruit in an identical pose.[39] Emphasis on the exchange of fruits or the presence of fruits in many mistress–black servant images alluded to Marian iconography in which different fruits symbolized different religious themes. Imitation, intimacy, and reciprocity also modeled behaviors patterned on Madonna portraits, linking specific domestic forms of sociability to a visual rhetoric of imperial virtue. Such elite representations of mastery characterized the black servant's subjection in terms of the mistress's care, a form of implied intimacy (even if manufactured) that eighteenth-century satirists parodied.

Although the earliest and most persistent justification of such relationships was the idea that heathen Africans would be brought into the Protestant faith through bondage, the realities of conversion never matched colonial promoters' assiduous reference to it. Some African slaves and servants were baptized in Britain (and some sought it themselves), but Restoration and Georgian portraitists never, to my knowledge, depicted metropolitan Britons actively engaged in teaching the Bible or converting their servants.

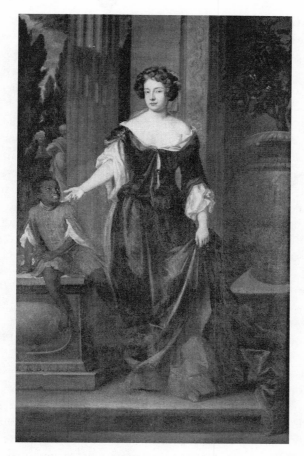

Figure 1.5. Sir Godfrey Kneller, portrait perhaps of Mary Davis with page (ca. 1685–1690), oil on canvas. © English Heritage.

Instead, they translated an image of opulence into a myth of benevolence and care, attributes that Britons lauded as Christian virtues. In mistress-servant portraits, this ideological self-fashioning drew on both Adoration and Marian iconography to construe the servant as both recipient of virtuous love and bearer of signifying gifts. Such typological efforts, which recurred in various ways across multiple genres of representation, betray the deeply self-referential nature of these imagined relationships.

Blurring the physical separation of mistress and black servant highlighted a concatenation of transactions—imperial, racial, economic, and

sexual—involved in or invoked by such interracial intimacy. Many female portraits were commissioned for the occasion of marriage; symbolism of the union sometimes appeared in the form of a female sitter donning or touching bracelets. A few artists portrayed a woman sitting while a black servant attaches a bracelet to her arm. Hall proposes that these pictures referred to the Genesis story of Rebecca at the well: when Rebecca offered water to Abraham's servant Eliezer and his camels, Eliezer identified her as Isaac's future bride by giving her bracelets and other jewelry in return for her hospitality.[40] The allusive vocabulary of portraiture makes it difficult to confirm that every portrait of a woman, bracelet, and black servant referred to this tale, but an eighteenth-century textile that explicitly depicted the biblical scene at the well does suggest that some Britons imagined Eliezer as a black servant and black servants through this biblical servant (Plate 6). Moreover, that these servants functioned to identify the female sitter in a portrait as the center of the viewer's attention and as the object of sexual desire for an unrepresented husband or lover echoed Eliezer's formal role in the Genesis story.

That several women depicted with black servants were married to or mistresses of Royal African Company investors (including Charles II) suggests that black slaves became erotic currency, including bridal gifts. Satirical and political commentaries that recognized how these images associated two forms of property (women and slaves) and criticized the substitution of the black youth for the husband or lover exposed the multiplicity of transactions involved in these displays of elite hospitality.[41] In the early eighteenth century, popular satirist Tom Brown rendered such transactions explicit in an imagined letter from a Frenchman who had sent his mistress a black slave. He warns her to "be sure to look him frequently in the Face":

> Our Blacks in France, turn tawny, and become of an Olive Complexion; which is enough to scare Lucifer out of his Senses. The Physical Reason of this, is, because the Sun is not strong enough in our Climate to keep up that charming Black which it gives them in Africk: But Madam, your Eyes, that are so lively and piercing, will supply the Defect of the Sun, and will not let him lose an Ace of his primitive Complexion. I am extreamly [sic] glad, that you will always have a Slave in your Presence, to represent me: He is not more yours, than I am.[42]

This lover bought a "primitive Complexion" for his mistress's pleasure, in direct substitution for himself. The slave's retention of his blackness,

and thus his otherness, signified the mistress's beauty. The language of slavery embedded in discourses of love and the Petrarchan elements of female portraits suggest that these transactions mobilized a range of social and symbolic uses of blackness and slavery to figure a white woman's beauty.

These imperial portraits belonged to a broader cultural context in which unclothed and clothed black figures adorned cameos, earrings, rings, mirrors, fans, and other luxury objects that circulated through lines of patronage, inheritance, and resale. Seventeenth-century England witnessed massive growth in luxury trades. Through the development of shops, practices of shopping, and global networks of consumers, merchants, and producers, products from the Americas, Africa, China, and India flowed through the warehouses of trading companies and hands of individual merchants and into elite and eventually middling households. Britons fashioned new identities and competed for social status by putting varied decorative objects on display—sugar boxes, bed hangings, pictures, porcelain, fruit dishes, and "Indian" toys, among other things, were meant to be admired. Black servitude formed part of this material self-fashioning. In a sixteenth-century bed furnishing, a small black child holds on top of his head the musical score for a group of female musicians. English candlesticks sported kneeling slaves. Silver forks, spoons, and knives featured "Black-a-Moor" Heads.[43] Black figures adorned white Britons as jewelry; they appeared in country estates and urban homes regardless of the slaveholding status of the occupants and they became integrated into elite forms of social exchange. Portrait miniatures, such as Joseph Lee's of Lady Dorothy Percy and an African servant, were given as gifts to friends, family, or lovers. Britons encountered these fabricated representations of obeisance and imperial benevolence alongside actual black servants; during the long eighteenth century, the audience to these fantasies expanded far beyond the elite.

What was new to the Georgian era was the availability of these models of mastery for popular consumption and the deepening association of black servants with trade goods and domestic prosperity. By the eighteenth century, the black page with pearl earrings (with or without the salver) had become an established literary and visual motif. Repeated depictions across multiple genres of imagery rendered this courtly figure a stereotype, an immediately recognizable explication of the African subordinate. Calico printers reproduced versions of graphic prints describing popular theatrical scenes that included black pageboys. Transfer print

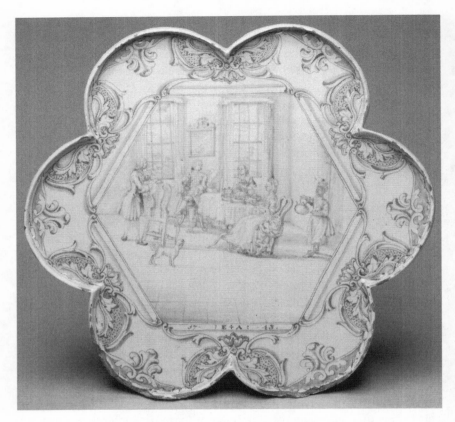

Figure 1.6. Tea tray (1743). © V&A Images/Victoria and Albert Museum, London. This delftware tea tray portrays a black servant bringing a kettle to a tea party.

engravers introduced imagery of master-servant relationships onto glazed earthenware developed for drinking Asian tea, selling such image objects into middling households. These material representations of black obeisance modeled new forms of sociability, inviting users to identify with such polite imperial relationships. If North American colonists fashioned themselves into subjects of a British Empire by purchasing tea pots and other imported manufactures, metropolitan Britons fashioned themselves into imperial masters by consuming tea trays, pots, and bowls that depicted black servants as part of the fashionable display of domestic wealth (Figure 1.6).[44]

Although not generally considered trade imagery, plays, cheap prints, and ceramics that depicted black servants bearing goods to white Britons replicated the source of imperial prosperity in black labor even as they blended the African, American, and Eastern sources of these exotic commodities. As both an exotic emblem of wealth and a subject bearing other emblems of wealth, black servants doubly represented an expanding imperial trade widely perceived to be one of the primary sources of revenue. Reconfiguring the origins of that wealth so that it appeared to result from the labor of black domestic servants silenced the actual work of plantation slaves. That surrogation or substitution sanctioned a vision of imperial mastery that derived, not from the colonial plantation, but from the refinements of the European court. The black servant's (especially the black boy's) wide cultural purchase reflected his embodiment of a courtly relationship, borrowed from European models, that was repeatedly projected onto an imperial relationship born of Britain's Atlantic empire. Replication and circulation of these idealistic visions of mastery created widespread visual confirmation of preconceived ideas about the meaning and form of imperial contact.

Variations on a Theme

A developing art market, broader discussions of black bondage, and greater numbers of African servants gave rise to more variation in models of mastery. British artists inherited another template from Van Dyck and his contemporaries—the parasol-holding black servant who depicted the elevated status of masters and mistresses through his efforts to protect them (from the sun). This figure appeared in images and social displays of black servitude in Britain, integrating elite Britons into social conventions that they also ascribed to elite members of Atlantic and Eastern societies.

Numerous early modern societies perceived protection from the sun to be a sign of status. Perhaps for this reason, European iconography of the continents often depicted personifications of Africa and Asia with a parasol, while biblical paintings sometimes surrounded the Eastern magus with a retinue of parasol-holding servants. Van Dyck and other European painters may have drawn this motif from these classical or biblical allegories, or from travel writers who described parasols and umbrellas in use in other parts of the world.[45] The racial slippage in the subject under the umbrella universalized this model of aristocratic status. The

imagination of a shared practice worked to mask the violence that underlay these hierarchical visions of contact.

Van Dyck's 1623 *Marchesa Elena Grimaldi Cattaneo* drew particular attention to this motif's classical associations and to its construction of power in terms of control over nature. *Elena* depicted this Genoese woman's almost martial stride and self-assured importance as the black servant rushes to protect her by keeping a bright red parasol in place (Plate 7). Van Dyck portrayed her status through classical symbolism and notions of whiteness: the black page, doubling as a satyr (his ears are pointed) and dressed in a metallic gold, mediates between the contemporary commercial world in which Elena lived and the classical symbolism that surrounds and contextualizes her.[46] With the enduring Corinthian columns in the background and the attentive classical satyr whose lust is displaced into his desire to prevent the sun's heat from reaching her, this portrait presents a merchant's wife whose powerful and controlled character is meant to be admired and perhaps somewhat feared.

Common associations of pagans and satyrs with bacchanalian excess enabled the aesthetic exchange of the dark-skinned satyr with the Moor early in the seventeenth century. The slippage between satyr and black servant in portraiture reflected their shared function as emblems of sexual desire and the fluidity of ideas about blackness. Renaissance sonnets, travelogues, and other forms of elite media connected blackness to lust. On the one hand, this slippage allowed black servants, like satyrs, to construe the white female subject as Venus—a variation of erotic imagery that reinforced cultural constructions of the black servant as a sign of sexual favor.[47] On the other hand, the subduing of that lust—the displacement of it, as in *Elena*, into a trope of civility (as the satyr's phallus becomes the suggestive parasol)—inscribed mastery in the containment of an energy and desire associated with a state closer to nature. Restoration and Georgian satirists deployed this association in baser ways, sometimes broadly drawing on black male servants' signification of lust and other times directly invoking their iconographic connections to satyrs to satirize white and black behavior. In the left background of John June's 1747 *The Sailor's Fleet Wedding Entertainment,* for instance, a black sailor tries to kiss a white bawd who sets fire to him, in a parody of Rubens's earlier depiction of a satyr's passions for an unappreciative nymph (Figures 1.7, 1.8).[48] June's print and accompanying text reread the nymph as a whore ("Experience'd in the Trade, and void of Shame, / To her the Man in Crape imparts his Flame"), burlesquing social constructions of white female desirability through the (unsolicited and ultimately resisted) attentions of

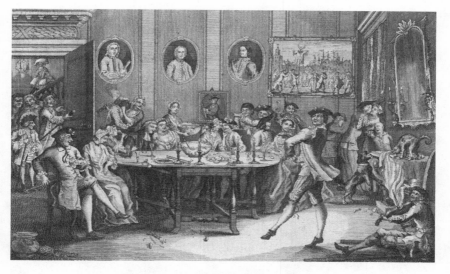

Figure 1.7. John June, *The Sailor's Fleet Wedding Entertainment* (1747).

dark males. Until the late eighteenth century, painters and graphic artists used the representation of black male desire to heighten white women's sexual appeal by keeping it at a charged distance from white female receptivity. The slave collar, parasol, livery, or salver—these emblems of servitude figured sitters' civilizing capacity in the constraint of a person perceived to be closer to a state of nature.

Parasol-holding black servants had an enduring life in British visual culture, spreading into public and private spaces. Engravers recorded this social practice in views of London, while painters incorporated it into local portraiture and shop signs, craftsmen engraved it onto luxury objects, and dramatists put it on stage.[49] By the 1720s, the trope had become common, and was even projected onto classical and biblical pasts. In the embroidered panel of Isaac and Rebecca, a distracted black page in pearl earrings has comically forgotten to keep the parasol over Rebecca's head (see Plate 6). History painters projected these early modern forms of black servitude onto classical Rome and Egypt, depicting emperors and elite women alongside black servants with parrots, pearl earrings, and parasols.

As this motif became popularly recognized as an exotic sign of status, hybrid forms of the black attendant appeared that blended the iconography of Africa and Native America. In the late seventeenth century, for instance, William Vincent depicted the well-known actress Anne Bracegirdle

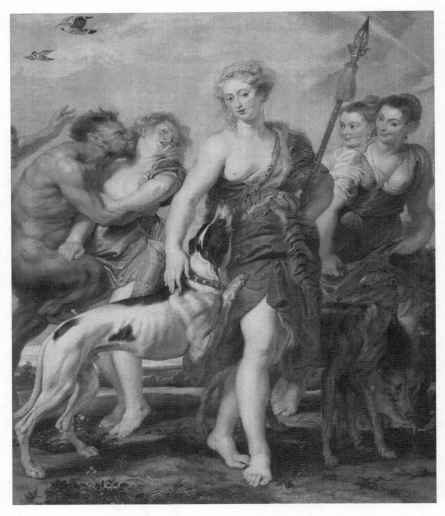

Figure 1.8. Peter Paul Rubens (Flemish, 1577–1640) and workshop, *Diana and Her Nymphs Departing for the Hunt* (ca. 1615). Oil on canvas; 216×178.7 cm. The Cleveland Museum of Art. Leonard C. Hanna, Jr. Fund 1959.190.

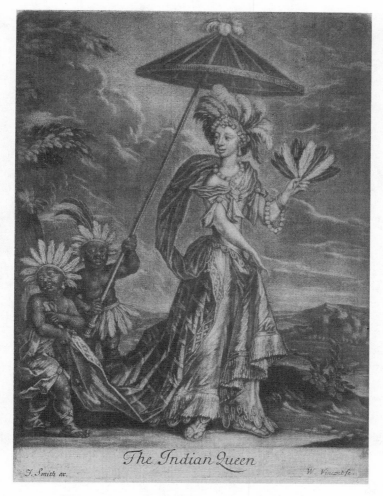

The Indian Queen

J. Smith ex. W. Vincent fe.

Figure 1.9. William Vincent, *The Indian Queen* (Anne Bracegirdle), published by John Smith. Mezzotint (published ca. 1683–1729). NPG D19498. © National Portrait Gallery, London.

as the "Indian Queen," or Sermenia from Aphra Behn's *The Widow Ranter* (Figure 1.9). Behn's play about Nathaniel Bacon's rebellion in 1676 Virginia gave Bacon a native lover, Sermenia, who may have been based on Pocahontas or perhaps on a chief's daughter imprisoned, according to some accounts, by Bacon.[50] Vincent probably produced this portrait from

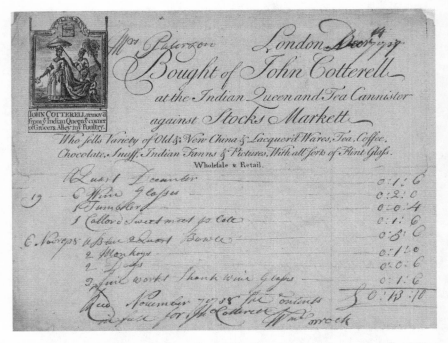

Figure 1.10. Indian Queen shop billhead for John Cotterell (December 14, 1737). © City of London, London Metropolitan Archives.

its debut, given that the play flopped immediately. Bracegirdle, the famous "Romantic Virgin," appears dressed in feathers and followed by two black boys who carry a parasol above her head. Although Behn's play ended with Sermenia's death, the Indian Queen lived on in metropolitan visual culture, becoming an appealing addition to shop signs, billheads, and trade cards from the 1730s through the early nineteenth century.[51] Shop signs often depicted the Indian Queen as a black woman. A 1737 receipt from John Cotterell's tobacco and chinaware shop displayed his version of the Indian Queen shop sign: three black attendants in feathers carry an umbrella for a black Indian Queen (Figure 1.10). Cotterell's trade card advertised chinaware, coffee, tea, chocolate, snuff, Indian Tea-tables and Fans, and glasses; his customers bought sugar dishes, blue plates, monkeys, dogs, sweetmeat plates, chocolate cups, and other fashionable items. By the eighteenth century, the exotica once reserved for the elite had become available to Londoners for perusal, if not for purchase, at shops whose insignia associated them with theatrical representations of the

New World. Toward the end of the century, graphic satirists used this motif to parody the moral laxity of white Britons in places as far afield as St. James's Park and the East Indies.[52] This model of mastery traveled from European and foreign social practices, to paintings, to the stage and back through portraiture, and onto the streets where it could be targeted by the eighteenth-century satirists' eye for social folly.

Male masters occasionally appeared beneath parasols, but portraitists typically located master-servant relationships in the context of hunting and war. British men appeared less often in portraiture with black servants than women did, but in the late seventeenth and eighteenth centuries growing numbers chose this form of social display. The emphasis on sexual desire and civility in female portraits was also evident in those with men. Van Dyck's 1623 portrait of English diplomat and art collector George Gage played with associations of blackness and desire to construct Gage's refinement (Plate 8). In this early conversation piece, Gage deals with a Spanish merchant as, behind and between them, Gage's black slave points lasciviously at the female bust for sale.[53] As a commentator on this exchange and an object of exchange himself, the black slave occupies a central, mediating position between Gage's aesthetic interest and the merchant's monetary interest in the bust. He invites viewers to experience his lurid appreciation of the female figure, his phallic gesture motivating his skin tone's association with uncontrolled lust. Van Dyck's *George* differentiated among different forms of desire by contrasting degrees of skin color and physical refinement, linking connoisseurship and thus civility with whiteness and tying Gage's gentlemanly refinement to his possession and display of this black servant.

In the 1640s and 1650s, more soldiers, captains, and merchants purchased portraits or added Moorish heads to their coats of arms. By depicting themselves alongside African servants, Prince Rupert of the Rhine, Willoughby d'Eresby, Cecil Calvert, and other aristocratic adventurers memorialized their involvement in colonizing projects, Atlantic skirmishes for naval or trade supremacy, or the slave trade. Some travelers displayed themselves in the private realm, where the emblematic emphasis lay on the acquisition of knowledge and the black servant evoked faraway Africa. But the majority of male masters chose to appear in military or hunting scenes, in part reflecting the incorporation of Africans into retinues of soldiers and into the social displays involved in hunting. When *The Gentleman's Magazine* argued in the 1730s that African slaves were fortunate to be in the colonies where they had a "generous Master whose Life it was [their] Duty to defend," it expressed the relationship that these portraits often portrayed.[54]

Artists mobilized Roman imperial iconography to classicize such displays of military prowess, connecting early modern sitters to an illustrious imperial past. Around 1733, for instance, an artist (perhaps Placido Constanzi) painted George Keith, Tenth Earl Marischal, a Jacobite soldier (Plate 9). Marischal had commanded cavalry at the battle of Sheriffmuir and headed the failed Spanish Jacobite expedition in Scotland. His Scottish castle appears in the background and the black groom may be Ibraham, a member of the earl's retinue. Marischal sports a suit of armor and an ermine-edged cloak; a helmet and a shield inscribed with "Placit [Veri] Tas Vincit" (Truth Is Pleasing and Conquers) lie in the left foreground. Such visual quotations of Roman imperial iconography, echoing the use of Virgilian epic in contemporary descriptions of the British Empire, evoked and reinforced contemporary perceptions of imperialism as an extension of classical precedents. Journalists reveled in the idea that British conquests outstripped those of Caesar or Alexander, while some Britons enacted this domination by calling their slaves Marcus Aurelius, Cato, Pompey, Caesar, or Scipio. Visual representations of male mastery emphasized this imagined imperial past that buttressed and glorified current expansion.[55]

Such masculine imperialist claims persisted into the late eighteenth century even as Britain's New World began to suffer challenges from North American colonists and domestic critics of empire. The mythology that supported British imperialism construed black servants offering allegiance and service in exchange for being incorporated into the substance of British families and the regiments of armies.[56] A spectacular rendition of this iconography of the master-slave relationship occurred in John Singleton Copley's *The Death of Major Pierson, 6 January 1781*, which portrayed Pierson's heroic martyrdom in his defense of the island of Jersey through his avenging black servant's loyalty. Drawing crowds to its first exhibition in Britain, this work by an American painter captured more than a key British victory over France during the American Revolution; it mobilized fantasies about the relationship between British and African men in which black masculinity, as in female portraits, became an extension of the white man's. This painting, which was engraved and circulated as a print, captured a view of British masculinity that supported heroic visions of imperial power.[57]

Visual constructions of masculinity located imperial mastery in the Briton's emotional and physical distance from his black attendant. Hunting portraits sometimes emphasized a domestic familiarity less evident in military pictures (see, e.g., Plate 10), but in general images of male mastery did

not replicate the intimacy of mistress-servant relationships. Thanks perhaps to a rogue draftsman, however, the erotica of this distancing was not left unarticulated: Lucas Vorsterman, a well-known engraver who worked in 1630s London, produced a three-quarter-length portrait of an unknown nobleman. His near-frontal stance echoes one of Titian's formulas, but the black pageboy suggestively positioning a bouquet of flowers directly over his crotch was a new invention. It is difficult to imagine that the sitter directed this design; one wonders, for instance, whether the original work was not paid for and an artist, either the original painter or Vorsterman, took his revenge.[58] Its crude commentary on mastery, however, provides some insight into the popular reception of these portraits, some of which deployed variations on this homoerotic iconography in only slightly more subtle ways (see, e.g., Plate 3).

This model of mastery relied not principally on opposition to blackness but on an attachment of imagined value to it, a process that deeply entangled black servitude in how Britons interpreted their imperial role. Male and female portraits articulated alternative but complementary visions of an imperial mastery in which black servants were educated and "civilized" in domestic spaces, while also providing powerful support to expansionist agendas.[59] Simultaneously exotic stranger and domesticated servant, the figure of the anglicized black servant in British livery had deep symbolic resonance in imagery that connected metropolitan Britons to the work of empire. The placing of livery or fashionable attire on the black heathen signified, as it did in Robinson Crusoe's clothing of his Native American or African slave Friday, the civilization of the exotic other.[60] This elite display sold an image of the black youth privileged for his or her position in British courts and wealthy homes, a gift that some masters thought required gratitude. Some freed Africans, such as the London grocer Ignatius Sancho, were also occasionally featured as subjects in portraiture.[61]

Elite Britons fashioned their imperial presence through an already subordinated black presence. Rather than directly portraying themselves in pursuit of slaves or actively clothing them (as pirates, travelers, and economic writers did), visual images placed such conquest in the past, constructing the present imperial moment as already buttressed by black subservience. The seemingly voluntary subordination of liveried blacks or the anglicized refinement of free Africans suggested that they indeed felt "fortunate" for British interests in imperial trade, as Sancho noted facetiously.[62] From early travelogues to eighteenth-century fictional ac-

counts, notions of barbaric Africa and Catholic tyranny reinforced this fantasy of mastery.

Adding a black attendant allowed painters to construct British power by synthesizing courtly, Christian, and classical narratives. Lely, Mytens, Mignard, Kneller, and other painters in seventeenth-century Britain studied Titian and Van Dyck and imitated their attention to psychological relationships, the possibilities of classical or biblical allusion, and the sensuality of color. An iconography of the black servant as a minor character who set off the central subject was well established by the time Richardson, Hayman, Zoffany, Reynolds, and other eighteenth-century British portraitists painted dark youths admiring Lady Mary Wortley Montagu, Charles Seymour, George Keith, or Charles Calvert.[63] Painters and engravers appropriated Van Dyck's use of the black servant to identify the object of desire, to communicate the sitters' virility or beauty, and to classicize or Christianize their courtly authority. Black boys bearing salvers, carrying parasols, and gazing with admiration or trepidation framed later sitters and, through these images, were incorporated into popular representations that often, in the process, gave them an American headdress. Titian's and Van Dyck's works introduced the figure of the black page into the general vocabulary of portraiture as a member and motif of the court, a figure attached to European colonization but not necessarily speaking directly to it. While the rococo imperial portraits of the later seventeenth and eighteenth centuries have much in common with earlier baroque portraits, the imperial climate in which these pictures were commissioned, conceived, and displayed changed markedly.

In the eighteenth century, new painting styles and subjects extended the spaces in which black servitude appeared. French and Dutch influences on eighteenth-century British art and the growing popularity of city views and other domestic scenes led to pictures that included black servants involved in daily activities. A 1746 genre painting, attributed to Francis Hayman, portrayed a middling woman waiting while her black servant calls for a sedan chair to collect her. A few years later, Samuel Scott painted a lively market scene at Covent Garden, including among the attendees (in the left foreground) a black pageboy who carries a basket, perhaps for the lady nearby looking at wares or perhaps for his own errand (Plate 11, Figure 1.11). Decorative textiles displaying gentlemen walking in their gardens with black servants did work similar to genre paintings in that they rooted these relationships in local spaces.[64] Engravers also

Figure 1.11. Samuel Scott (ca. 1702–1772), detail of *Covent Garden Market and Piazza* (1758). Oil on canvas. © Museum of London, UK/The Bridgeman Art Library International.

depicted black servants in the company of their masters; as icons of fashion, pages dot graphic views of St. James, Vauxhall, and other public gardens or estates, transforming these spaces, where new ideas about sociability were put on display, into sites where polite imperial relationships were expressed and controlled. The black servant's function as bearer of goods and source of color did not change. Only these representations sustained scenes of wealth and variety that embraced much more than a court. Artists, in a sense, peopled a country with black servants and slaves. Their role as ostensive gestures—figures who pointed out attributes of Britons for Britons themselves to take pleasure in—became vernacular. This seductive vision of authority that Britons borrowed from Europe critically shaped how common Britons understood their relationship to African slaves.

Aesthetics of Mastery

Such imagined encounters revealed an aesthetic preference for dark black African servants that differentiated metropolitan Britons from colonists who gave higher social status to those with lighter skin tones. The Bristol merchant James Laroche warned his agent, Captain Richard Frankard, to "observe that the Boys and Girls you buy be very black and handsome." By the late seventeenth century, Britons searching for slaves through newspaper advertisements also called for those with "deep black complexion."[65] Inscribed in these aesthetic preferences (which translated into a higher

market value of darker-skinned African servants in Britain) were both the protracted exoticism of blackness in this Atlantic frontier and the importance of that exoticism in fantasies about imperial mastery.

The desire to possess and display darker servants was, on the one hand, quite simple. Deepening the visual contrast drew more attention to the white subject, enhancing social displays of status on the street and in art. As black bodies humanized and filled out dark backgrounds, they participated in what Samuel Johnson described as "the magic pow'rs of light and shade." The contrast of black and white skin was a form of chiaroscuro. As George Bickham wrote in 1747 on the nature of contrasts in his introductory essay on drawing, darkness sets off light:

> This arises from the Contrast between Things of a different Degree of Darkness; the least obscure setting off the others with a superior Lustre, and the brighter rendering the others . . . more obscure, and less obvious to the Sight. As any two things of unequal Whiteness, when play'd, by way of Contrast, one against the other, the superior Whiteness reflects a Foil on the other, beyond its native Darkness.

As black servants set off the whiteness of a British subject, whiteness also set off the black body "beyond its native Darkness."[66] Both bodies then set off the brilliant reds and blues and greens that painters used to create variety and to direct attention to certain elements of their works.

The sensual appeal of this contrast lay in the juxtaposition, as much as the opposition of color. The sensuality of flesh tones created a tactile intimacy in the female-female and female-male relationships in which they occurred. Classical and biblical paintings of white and black women depicted the erotica of contrasts particularly vividly. Rubens's painting of Venus, for instance, composed her beauty by juxtaposing her face with a black woman's (perhaps a black Venus?) facial structure and skin tone (Plate 12). Images of Bathsheba or of the chaste Diana also deployed contrasts of skin color to construct sensuality, bringing white and black female bodies into intimate relationship with each other.[67] Eighteenth-century graphic artists projected such aesthetic constructions onto exotic societies, as in William Hogarth's early engraving of a Turkish bath, while also using them to parody London debauchery. The juxtaposition of a white and black harlot in Hogarth's *A Rake's Progress III*, for instance, contributed an ironic aesthetic commentary on the sensuality of a local tavern scene (Plate 13).

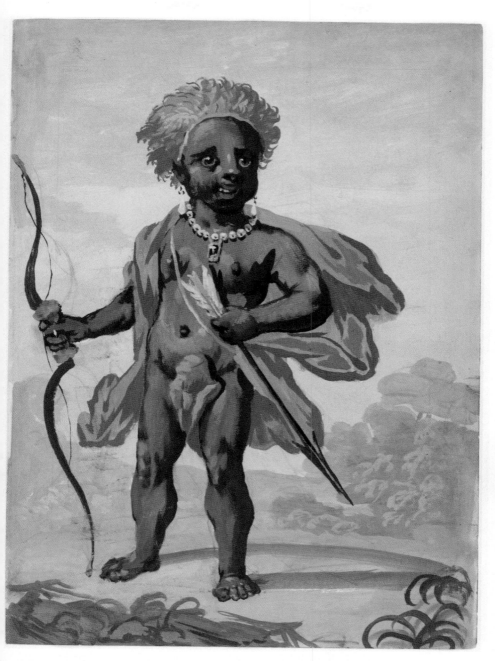

1. Anon., *Design for a Black Boy Shop Sign* (ca. 1750), watercolor. © V&A Images/Victoria and Albert Museum, London.

2. *Lord Chatham* (ca. 1767), English Derby. © V&A Images/Victoria and Albert Museum, London. This Derby porcelain figurine may have commemorated British victories in the Seven Years' War. William Pitt holds his hand out to "America," a young black prince or boy wearin a feathered headdress.

3. Circle of Gerard Soest, *Member of the Greville Family with African Servant* (seventeenth century). © Warwick Castle, United Kingdom. The sitter is either Robert Greville, 2nd Baron Brooke (1607–1643) or his son, Francis Greville, 3rd Baron Brooke (1639–1658).

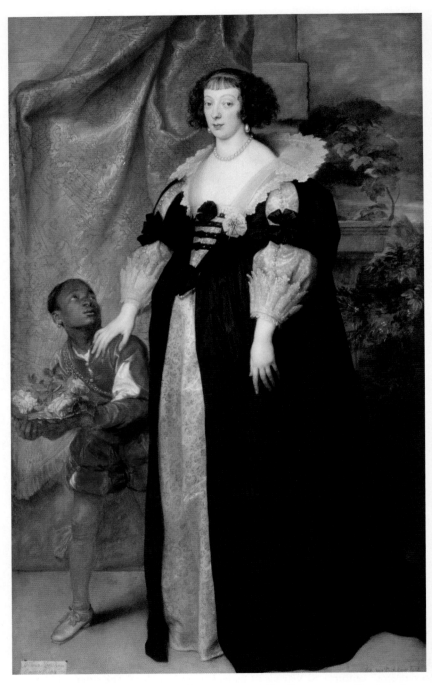

4. Anthony Van Dyck, *Henrietta of Lorraine* (1634), oil on canvas, Kenwood House, London. © English Heritage.

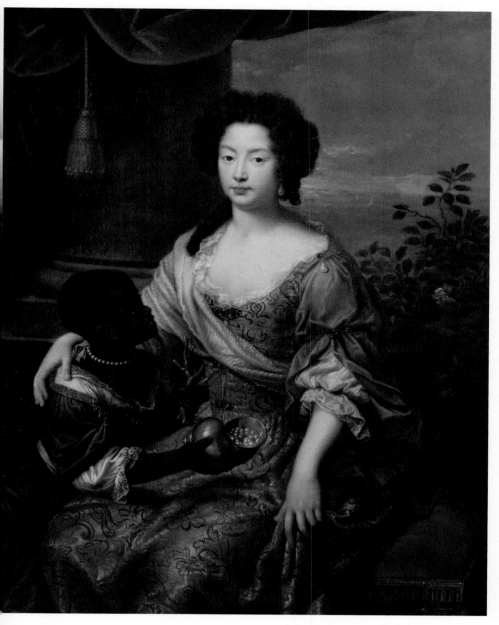

5. Pierre Mignard, *Louise de Kéroualle, Duchess of Portsmouth* (1682), oil on canvas. NPG 497. © National Portrait Gallery, London.

6. *Isaac and Rebecca* (1700s), embroidered linen. © V&A Images/Victoria and Albert Museum, London.

7. Anthony Van Dyck, *Marchesa Elena Grimaldi Cattaneo and a Black Page* (1623), oil on canvas, 2.429×1.385 (95⅝×54½). Widener Collection, 1942.9.92. (688)/PA. Image courtesy National Gallery of Art, Washington.

8. Anthony Van Dyck (1599–1641), *Portrait of George Gage with Two Attendants* (probably 1622–1623), oil on canvas, 115 × 113.5 cm. Bought 1824 (NG49). © National Gallery, London/Art Resource, New York.

9. Placido Costanzi, attrib., *George Keith, Tenth Earl Marischal* (ca. 1733), oil on copper. NPG 552. © National Portrait Gallery, London.

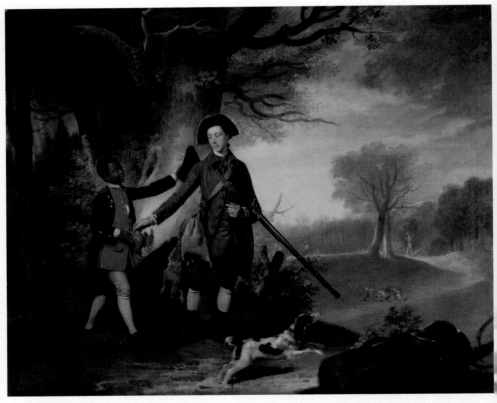

10. Unknown artist; formerly attributed to Johan Joseph Zoffany (1733–1810), *The Third Duke of Richmond Out Shooting with His Servant* (ca. 1765), oil on canvas, 45¾ × 54 inches (116.2 × 137.2 cm). Yale Center for British Art, Paul Mellon Collection, B2001.2.18.

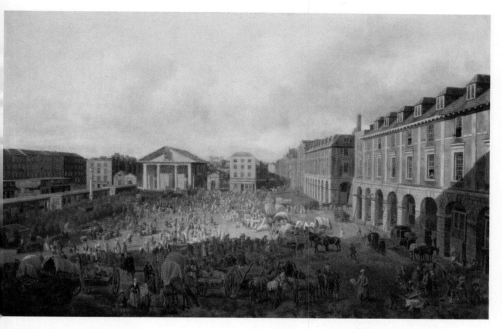

11. Samuel Scott (ca. 1702–1772), *Covent Garden Market and Piazza* (1758), oil on canvas. © Museum of London, UK/The Bridgeman Art Library International.

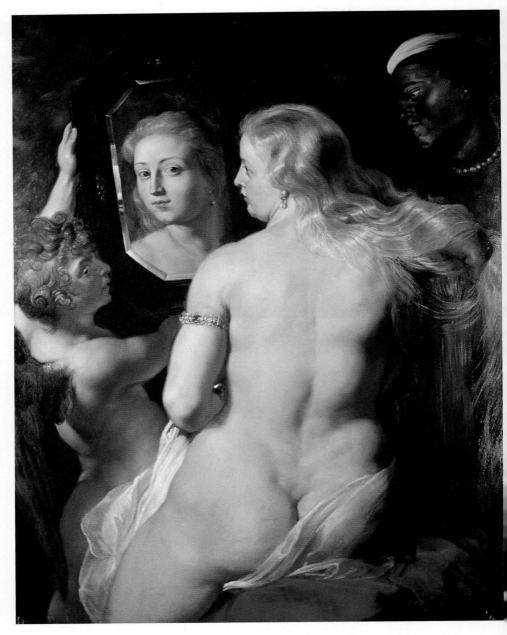

12. Peter Paul Rubens (1577–1640), *The Toilet of Venus* (ca. 1613), oil on canvas. Private Collection/Giraudon/The Bridgeman Art Library International.

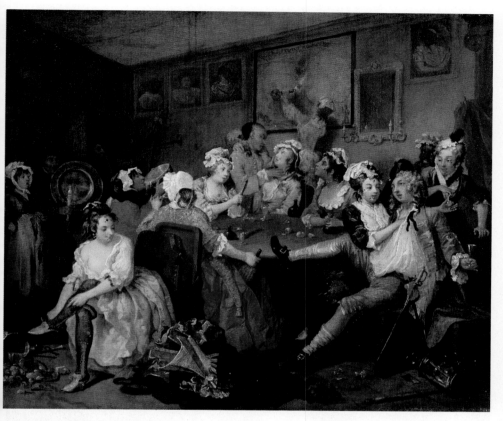

13. William Hogarth (1697–1764), *A Rake's Progress III: The Rake at the Rose-Tavern* (1734). Courtesy of the Trustees of Sir John Soane's Museum, London/The Bridgeman Art Library International.

14. William Jones (fl. 1769–1782), *The Black Boy*. Oil on canvas. © Victoria Art Gallery, Bath and North East Somerset Council/The Bridgeman Art Library International.

In portraiture, artistic emphasis on dark skin reflected its Venetian origins, where the motif of the black page contributed to the colorful and sensual imagery that conveyed notions of courtly wealth. The sensuous golds, silvers, greens, and reds that often accompanied a black/white or brown/pink skin contrast in art echoed some colonial discussions of the beauty of empire: as Richard Ligon rhapsodized in 1657 about his trip to Barbados, "But 'tis a lovely sight to see a hundred handsome Negroes, men and women, with every one a grasse-green bunch of these fruits on their heads [plantain], every bunch twice as big as their heads, all comming [*sic*] in a train one after another, the black and green so well becomming [*sic*] one another."[68] The association of visual variety with prosperity produced an aesthetic sensibility that valued contrast in the master-servant relationship. That sensibility accompanied and opposed a simultaneous imperial impulse to erase such distinctions, creating tension in visual representations that also stressed the incorporation of blacks into British society.

Literary sources confirm that the appeal of darker-skinned youths reflected a belief that darker skin represented the most elite form of the black body. This belief subtly hid domestic ideas about opulence in fantasies about the connection between social status and skin tone in Atlantic societies. In Aphra Behn's 1688 novella, royal African slave Oroonoko boasts a skin of "perfect ebony" or "polish'd jett," which differentiates him from the "brown, rusty Black which most of that Nation are." Along with Roman features, his darker skin signifies his royalty and makes him an appropriate figure to adorn the narrator's colonial entourage. In Daniel Defoe's *Robinson Crusoe,* the beautiful olive coloring of South American slave Friday separates him from the general population of Indians.[69] Exceptional coloring distanced these fictional slaves from other Africans and Native Americans whom the authors, typically, denigrated at the same time. Displacing imperial and sexual desire onto the singularity of these bodies, which encoded their elite social status within African or Native American societies, heightened their commercial value and bracketed any British desire for them. Rather than acknowledge the origins of that desire in the aesthetic work of black servants in social displays of domestic wealth, Britons naturalized the market value of "perfect ebony" by pointing to its social and political signification in African societies.

Such imagined encounters relied on an awareness that different societies held different standards of beauty. Joseph Spence's *Crito: Or, A Dialogue on Beauty* (1752) remarked: "every body may be beautiful in the

Imagination of some one or other. As I have said before, some may delight themselves in black Skin, and others in white . . . In short, the most opposite Things imaginable may each be looked upon as beautiful, in whole different Countries; or by different People, in the same Country."[70] Such expressions of relativity worked during the seventeenth and eighteenth centuries to mask assumptions of racial hierarchy. From a modern perspective, the stark hierarchies that animated these displays of imperial mastery are no longer hidden. But understanding the complex symbolism of the black servant recovers how portraits, by producing an idealized black subject, in fact effaced and reinterpreted those hierarchies as something other than imperial violence. Scholars have argued that portraits reinforced negative stereotypes of Africans that originated in Stuart travelogues, while objectifying them and conflating them with other forms of property. Portraits certainly reified black subordination, but assuming that the aesthetic opposition of white and black skin created a "negative stereotype" or made a pejorative commentary on black skin elides the black servant's cultural meanings.[71] The Platonic foundations of portraiture encouraged artists to smooth away the blemishes of nature, to create an ideal: the "polish'd jett" or "perfect ebony" that also happened to denote material luxury.

Such aesthetic constructions of mastery would not have been possible if European and British artists had not nurtured a curiosity in the variety of skin tones, generating studies of heads and half-length portraits of individual Africans. Rembrandt, Van Dyck, Rubens, Jordaens, Watteau, and other artists made studies of African men.[72] In the late seventeenth or early eighteenth century, Charles Beale II, who trained by copying Van Dyck's and Lely's works, produced a rare sketch of a black woman (Figure 1.12). These individual portraits reflected artists' exploration of coloring, physiognomy, and, in Beale's case, class. Artists who literally "studied" African bodies in homes or studios and those who sketched Africans they encountered in public spaces generated a new awareness of human variety that imagined relationships with these racial others worked to control.

Britons valued those Africans whose skin was most different from their own because doing so aided their own imagined encounter. The black servants who populated portraits and wealthy homes became emblems of an imperial mastery constructed from their perceived elevation, but their particular appearance reflected what some Britons considered to be the most elite or desirable form of the black body. Eighteenth-century journalists argued that such "glossy countenances" signified Africans' inherent virtue or

Figure 1.12. Charles Beale II, *A Young Woman Resembling a Negress*
(ca. 1676–1726). © The Trustees of the British Museum. All rights reserved.

the benevolence of British rule, but the commodity of lustrous black skin
reflects how, in elite taste, the blacker the better became the most powerful
imperial ideal.[73] Rather than insult the black body, metropolitan artists
and slaveholders put it on a pedestal—as William Hogarth, mockingly,
quite literally did in *Taste in High Life* (see Chapter 6). In the process of
fashioning themselves into imperial masters, Britons thus also fashioned
themselves an idealized black body and gaze. This valuable commodity as-
sociated Britons with their own fantasies of imperial mastery.

In individual portraits of blacks the naturalization of these fantasies
comes into sharp relief. Two portraits from a follower of Kneller recorded

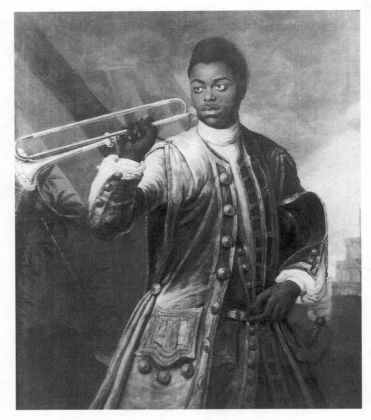

Figure 1.13. After Sir Godfrey Kneller, *Portrait of a Negro Trumpeter* (eighteenth century). CAP00317. © Reserved; photograph National Portrait Gallery, London.

the integration of black men into British regiments and visual discussions of military heroism, liberating the black subject from the constraints of specific servitude only to generalize his loyal service to Britain (Figure 1.13).[74] In late eighteenth-century Bath, still-life painter William Jones rendered a "Black Boy" simply by removing the British mistress from Van Dyck–inspired iconography of a gift-bearing black slave (Plate 14). Erasing the black gaze of admiration allowed more room for the individuality of these Africans to emerge, but it did not mitigate the need for these black subjects to support certain ideas about imperial mastery. Still products of a desire to master and contain, even when they reflected genuine curiosity

about racial others, attachment to a favorite servant, or admiration of a popular black literati, individual portraits modeled ideal enslaved and free Africans that confirmed narratives of imperial benevolence. Jones's "Black Boy" was the face of perfect ebony, the naturalization of a utopian, racial fantasy of mastery that both produced and reflected the market for black servants in Britain.

The development of an empire based on African slavery coincided with the emergence in Britain of an art market. The improved Vauxhall Gardens, Foundling Hospital, and other new public sites provided free or restricted access to contemporary works of art. Galleries and print shops expanded access to elite paintings and copies of them. Portraiture grew in social value, even as contemporaries derided the ability of "uninteresting obscure persons" to commission portraits of themselves and their families. European hierarchies of art traditionally placed portraits on the level of "face-paint[ing]" (a critique rooted in the idea that they did not display general principles of humanity), but Restoration and Georgian aristocrats and merchants found greater pleasure in them than in universal history paintings.[75] New, however, to this era's partiality for portraiture was its growing philosophical support.

Portraits came to be admired for their ability to elicit an emotional response and to provide a moral example that could bring about social improvement. Early eighteenth-century artists and philosophers transferred the value of moral restoration, conventionally attributed to history painting, to the portrait. Jonathan Richardson, for instance, concentrated on subjects and color schemes engaging to the imagination, believing that images only made a "forcible impression upon the imagination" through visual pleasure. To attain this effect, he tried to impress on viewers a general principle of harmony by highlighting "Friendship, and Paternal, Filial and Conjugal Love, and Duty." A well-composed portrait or conversation piece, in his view, stimulated the emotional care of familial relations or, as Samuel Johnson subsequently put it, diffused friendship and revived tenderness. For Richardson and others who believed that "beautiful images" inspired "Virtue," portraiture reaffirmed and propagated a society's moral character. Critics of this position recognized its reflective appeal: as Bernard Mandeville satirized, "The Painter has nothing to do with the Truth of his History; his Business is to express the Dignity of the Subject, and in Compliment to his Judges, never to forget the Excellency of our Species."[76] Elite Britons sought portraits that portrayed their status

in these subtle emotional terms: one way to achieve such exhibitions of virtue was to include a subject whose gaze helped to construct the qualities that the sitter wished to display. Adding a black servant enabled painters to express the sitter's relationship to a foreign-born subject, and thus the portrait emerged as a new source of proper sensibilities, including racial and imperial ones. Possessing both the exotic servant and the model of mastery, elite Britons generated a particular vision of their involvement in the slave trade and colonialism.

European and British travel illustrations of African and New World societies also contributed to popular consciousness of empire, especially to trade imagery and shop signage, but my choice to begin with portraiture reflects the wide dissemination of this vision of mastery in less elite media. It also flags the importance of recognizing that Britons' immediate experience of black servitude was primarily as an aristocratic relationship. The fact that England entered the Atlantic late by European standards and that artists looked to Europe for their inspiration meant that the earliest formulations of mastery were indebted to models of slavery fashioned by Catholic Continental neighbors. Liveried slaves hardly conjured up the reality of enslaved life on colonial plantations, but they illustrated ideological foundations on which Britons built the "imperial framework."[77] The adoring young servants who inhabited the walls of wealthy homes and the public halls of government buildings, and were exhibited at London art shows represented to Britons their own refinement, working to obscure the violent origins of imperial wealth. As this model of mastery became vernacular, black servants' role as an ostensive gesture, which flowed from their value as a source of visual contrast, increasingly integrated them into how Britons saw themselves as an imperial nation. This social and cultural labor (rather than an economic form) directly reflected the market for African slaves in Britain, highlighting how involvement in the slave trade and slave-based colonization entangled Britons at home in the contact zones of Atlantic slavery.

Investing the activities of merchants or the consuming classes with virtue generated new ideologies of commerce that focused on its potential to bring about refinement or "politeness."[78] The benevolent mistress or master whose concern for an African's welfare was reciprocated by his or her tribute of even more symbols of wealth was one synthesis of this dialectical process. This performative and imaginative claim to empire depended on the cultural and physical distance between the Briton and the black slave remaining intact. Individual and family portraits inscribed

this racially encoded distance either in the physical separation of slaves from white sitters, the lack of eye contact, the visual singularity of the black body, or the position of servitude projected onto the African.[79] These sociocultural reproductions of geographical distance were not stable, because the process by which Britain became an Atlantic frontier worked to erode such fantasies of imperial mastery.

Portraiture imbued permanence, derived from an artistic legacy, into a domestic relationship that runaway advertisements suggest was much more tenuous. As Norbert Schneider observes, "The portrait resembles a record of something which is subject to continual change, and which the painter, or sitter, wishes to commit to memory, or preserve . . . as if appearances could replace reality, or, indeed, be a substitute for life altogether."[80] Many Britons encountered black slaves without the fact of their enslavement, through images that erased ethnicity, supplied an affirming relationship, and placed the act of conquest in the past. Questions of origins become lost in these images; and the profound silence of the slaves is marked. Even the Muslim headdress that adorned some African slaves in portraiture could have been a prop designed to connect white sitters to an orientalism that persisted into the eighteenth century. The replication of these figures in popular media compounded such erasures of cultural and individual identity. Such visible invisibility reflected how the visual secured a sense of status or innocence that reinforced structures of enslavement. Abstracting the formal master-slave relationship from portraiture removed it from that genre's "intimate sense of lived presence," literally cheapening that relationship, turning it into an ornamental stamp, and divorcing it from questions of responsibility.[81]

It was thus not that Britons at home were unfamiliar or unaware of African slavery, but that they looked at the practice of bondage through their own desires. Appropriating the black body for the construction of white identity had far-reaching consequences: as the philosopher Frantz Fanon reminded us, "The white man is all around me; up above the sky is tearing at its navel; the earth crunches under my feet and sings white, white. All this whiteness burns me to cinder. I sit down next to the fire and I discover my livery for the first time. It is in fact ugly. I won't go on because who can tell me what beauty is?" Becoming a slave-owning society, a society that traded in slaves, and an imperial center for the products of slave labor financially enabled the momentous change in the nature of viewing art that Solkin and other scholars link to the birth of "culture" as an object to be consumed for its own sake.[82] Ironically, that culture

included simulacra of imperial relationships that introduced an idealistic vision of black servitude into public and private venues, creating a popular consciousness of empire that critics of slavery would have to confront. For Fanon, that consciousness, embodied for him in his "livery," made his body unknowable to himself. But this idealistic vision of imperial refinement never achieved complete acceptance at home or abroad, among white Britons or enslaved Africans who challenged and destabilized this mythology from a variety of perspectives. There would always be those who questioned the symbolism of black servants in a country that defined itself against the perceived tyranny of other societies, whether Muslim, Catholic, or pagan. Critics of portraiture, indeed, denigrated the genre for being indulgent to the self, for being Narcissus's mirror.

2

Death, that common revenger of all injuries . . .

—Aphra Behn, *Oroonoko* (1688)

When Ottobah Cugoano appealed to Britons in 1787 to relinquish their involvement in that "Evil and Wicked Traffic of the Slavery and Commerce of the Human Species," he argued that replacing the slave trade with commerce in nonhuman goods would make Africa "a kind of first ornament" to Britain. He believed that Africans, if not perpetually threatened, killed, and corrupted by the slave trade, would welcome the opportunity to convert to Protestantism and to learn from British knowledge. This new relationship would bring "great supplies of men in a lawful way, either for industry or defence," and the affections of large populations, the source of any nation's strength.[1] This reiteration of imperial hierarchy by a formerly enslaved African can trouble the modern reader. But Cugoano's "ornamental" Africa functioned similarly to other abolitionist imagery circulating in late eighteenth-century Britain. Advocates for ending the slave trade encouraged audiences to accept their message by attaching it to fantasies about imperial authority. Such popular abolitionist images as the Kneeling Slave, for instance, replicated and reaffirmed racial hierarchies by depicting an African male in "a supplicating posture" (see Figure 7.7). But the disembodied caption ("Am I Not a Man and a Brother?") forced British viewers to acknowledge the humanity and Christian brotherhood of African men, partly through a rhetorical question that expected them to have already acknowledged it. Disseminating this kneeling slave via ceramics, medallions, or hairpins modeled a form of moral consumption for Britons who purchased them, detaching objects of luxury from the fruits of the slave trade and reattaching them to the trade's closure. Olaudah Equiano, another spokesperson for the abolitionist movement and Cugoano's friend, also modeled a new British-African

relationship through his "sale" of himself in his autobiography *The Interesting Narrative*.[2] These strategies capitalized on the fashionable consumption of popular representations of British-African relationships, but transformed mastery into patronage.

To buy Cugoano's image of Africa as a "kind of first ornament" to Britain was to accept a similarly new and old relationship. In his vision, the alliance of African populations would manifest itself through the creation of an international community that recognized slavery as a violation of Christian morality and natural law.[3] Cugoano's ornament reconstituted British intervention in African lives; it was predicated on the appeal of narratives of imperial virtue being stronger than commitment to the slave trade. That reconstitution resurrected philanthropy- or charity-based visions of British superiority, but in so doing forced Britons to grant that Africans could be a resource for national strength not as slaves, but rather as full members of a universal society based on natural liberty. For the African to retain his symbolic status in British culture, he had to signify a relationship that would turn the slave trade's carnage into living partnership.

Although Cugoano's vision owed much to late eighteenth-century abolitionist conversations, his critique extended a long popular English tradition of destabilizing the symbolic value of Africans in elite narratives of imperial virtue. Beginning in the seventeenth century, ballad singers, playwrights, novelists, and artists worked through the meaning and implications of relationships with Africans. Justifications for empire (and slaving) repeatedly stressed conversion and the incorporation of racial others into British societies. But Britons proved unable or unwilling to imagine a racially plural British community. As long as the distancing of Africans remained intact, this conflict did not necessarily prove problematic. But some Britons, very early on, presumed that Africans would prefer freedom to bondage. Africans themselves, by resisting their condition aboard ships, in plantation colonies, and in Britain, articulated their lack of gratitude.[4] Acts of resistance continually renewed this fundamental tension in the ideas about and practices of empire.

Metropolitan explanations for slave resistance typically focused on colonial planters' failure to fulfill their civilizing, converting role, an individual African slave's natural propensity to wickedness, or a particular African ethnic group's tendency to rebel, but some Britons also inhabited African perspectives to explore the nature and source of resistance.[5] Doing so, on the one hand, allowed ordinary Britons to question aristo-

cratic forms of authority in Britain by exploring the "gratitude" of the en-slaved. Integrating slave resistance into broader discussions of authority in Britain, however, also invested the African rebel with an agency that, if not controlled, threatened to subvert assumptions of racial difference. If Cugoano recognized the impossibility of resolving that contradiction without shifting the foundation of British-African relationships, metropolitan Britons responded by repeatedly narrating the ends of empire in violence. Imagining rebellious slaves enabled Britons to control the meanings of resistance.

Disruptions

From a metropolitan perspective, the turn to African slavery as the primary source of labor in the Caribbean and southern mainland colonies was a haphazard and often regrettable process. Even as independent merchants eagerly chipped away at the Royal African Company's monopoly on English trade to West Africa in the late seventeenth century, growing reliance on slave labor concerned newspaper writers and journal editors, as well as English visitors to the West Indies. Criticisms of the turn to African slavery were not overwhelmingly moral, but rather focused on the consequences of racial imbalances for colonial stability.[6] That African slaves did "not commit some horrid massacre upon the Christians, thereby to enfranchise themselves, and become masters of the island," struck such early commentators as Richard Ligon as needing explanation: he sought answers in their lack of weapons, high levels of surveillance, and linguistic differences. Britons who felt impelled to contemplate the possibilities of resistance recognized the importance of demography to social control.[7]

Yet they also revealed an expectation of rebellion even before the emergence of fully fledged British Caribbean slave societies. African slaves, lacking affective, racial, political, or religious ties to the metropole, were not as safe a "Merchandize" as "White-men," even if writers ultimately argued that they were necessary to colonization and if transported white felons proved just as resistant to plantation labor.[8]

Building an Atlantic empire involved forcibly transporting millions of Africans to colonial societies and a few thousand to Britain during the seventeenth and eighteenth centuries. Central to this process was the reproduction of physical, social, and cultural distance from the enslaved. Treating Africans as objects with market value involved multiple forms

of distancing, from shipbuilders who located captains' quarters away from slave cargoes, to planters who fostered animosity between white servants and African slaves, to portraitists who displaced mastery into abstract notions of conversion or civilization. In Britain, one of the most critical factors shaping metropolitan engagement with racial difference and colonial practices of slavery was geographical distance. Those at home never faced the intimate threat of slave revolt that thoroughly permeated southern and Caribbean plantation societies. Fictions of imperialism that tended to break down or become strained in colonial societies remained intact in Britain, where challenges to imperial rule were absorbed partly by controlling the significance and form of resistance.

By the second half of the seventeenth century, Africans conspired to rebel and rebelled on British slaving ships and in the West Indies, especially Barbados and Jamaica.[9] They resisted, rejected, and negotiated slavery by throwing themselves overboard, starving themselves, running away, committing suicide, and organizing revolts. What type of colonial geography they lived in, what possibilities existed for cooperation with other laborers, what cultural strategies for resistance they brought with them from Africa, and myriad other factors shaped the choice and manifestation of resistance. Their actions contributed to the unsettled, embattled state of the seventeenth-century Caribbean as masters, officials, servants, slaves, merchants, and pirates fought for freedom, wealth, power, or control.[10]

How metropolitan Britons responded to these violent societies varied: many viewed the islands with distaste; most consumed their products.[11] Reports of colonial slave rebellions and conspiracies appeared in metropolitan newspapers from the seventeenth century onward and played an important, and underappreciated, role in continuing to raise questions about colonization. As surrogates (to borrow Joseph Roach's terminology) or replacements for the rebellions themselves, these accounts suppressed as well as reanimated initial acts of resistance, extending the effects of master-slave negotiations in the Caribbean and the southern North American mainland into the Isles.[12] Colonial slave resistance intensified metropolitan discussions of mastery, requiring authors to reinforce and, at times, subtly alter ideologies that explained African slavery in terms of British benevolence.

At the same time, black resistance in Britain manifested itself primarily through runaway servants. From the 1670s onward, with the rise of the popular press, advertisements listed runaway blacks as part of a larger social effort to control unruly elements of society.[13] On January 3, 1704,

a "Black Boy" called Pompe, about sixteen years old, "went away" from his master William Steavens, a London merchant, wearing a blue waist-coat, light-colored cloth breeches, and an iron collar. Two weeks later, seventeen-year-old Jack, a short "Negro Man, blaber [sic] Lip'd, sharp shin'd, and long heel'd, mark'd with WB on one shoulder and W on the other" ran away wearing a coat and breeches, but was spotted near Hol-born. His master offered a guinea reward to anyone who brought him to the Jamaica Coffeehouse in Miles Alley. A twenty-one-year-old lame Af-rican man ran from the Royal African Company in 1707. Mingo, who had changed his name to John, was given eight days to return and still be "kindly receiv'd." He had an unusually high two-guinea price on his head. Sixteen-year-old Pripee ran from Tobias Bowles of Deal in July 1707 and was still missing two months later, though he had been seen in Dover and was thought to be on his way to London.[14] Many more ad-vertisements appeared in local newspapers.

Black servants ran primarily toward London, occasionally in the com-pany of white servants and often taking with them other possessions (at times, slaveholders appear more interested in recovering their lost silver than their lost servant, perhaps reflecting the primarily ornamental func-tion of slavery in Britain).[15] More research needs to be done on recon-structing the networks of retrieval and flight, but running away in Britain appears to have been similar to running away in the northern mainland colonies, where port cities also proved the greatest draw. The physical cataloguing of body marks (scars, bald spots, brands, etc.), distinctive body movements (limps or expressions), or clothing was a common fea-ture of runaway advertisements in general (not just those referring to black servants). Masters typically offered a guinea or less for the return of a black slave or servant, a practice that by the 1780s had become so well known that a fleeing minister bemoaned the fact that he had been treated like a "runaway negro," having a "price put upon [his] liberty."[16] Masters from outside London asked shopkeepers (especially coffeehouse patrons) or friends to act on their behalf, collecting information about the run-away or the caught slave. These disruptive Africans circulated through newspaper advertisements, involving a broader public in the enforcement of bondage but also bringing black resistance to popular attention.

Rejection of the master's authority also came from nonslaveholding whites and other forms of slave resistance. On the one hand, by the early eighteenth century, satirical prints made fun of white women's use of black servants to enhance their beauty. On the other hand, pragmatic

responses to the symbols of mastery also disrupted their value: in 1716, for instance, Anne Smith was indicted for assault and robbery, having tricked a young African servant belonging to William Jordan into letting her remove his silver collar, valued at fifteen shillings. Richard had apparently spent too long doing an errand and "fear'd to go home," when Anne told him that his "Collar would betray him, and therefore advis'd him to let her take it off." Taking him to a fruit cellar, she and another woman "gnaw[ed]" it off, and then left the boy to go home and tell his master.[17] Some Britons saw the silver rather than the symbolic collar when they encountered liveried slaves (and one wonders how innocent Richard was in this transaction). Other enslaved Africans, such as Jeffery Morat, servant to the Duke of Manchester, expressed their resentment by rejecting the model of civility offered to them. Brought from Guinea when he was a young child, Morat grew up to be, according to the Newgate prison chaplain, "of a perverse unthinking Disposition, naturally vicious, and extremely wicked; for altho' he was liberally allow'd, well kept, and wanted for nothing, yet he kept the vilest Company, went to bad Houses, and lately (as he himself confess'd) abus'd and robb'd a Gentleman of a Guinea." Despite the "good Care," education, and Christian instruction he had received, Morat died, in his late teens, in a prison cell awaiting execution for breaking into a neighboring aristocrat's house and assaulting the housekeeper, whom he had known for years.[18]

Britons often sought explanations for such behavior, especially in the late seventeenth and early eighteenth centuries, anywhere but in the captive's natural desire for freedom.[19] Early advocates for an Anglo-American empire had argued that Africans and Native Americans oppressed by the Spanish and Portuguese would "desire nothinge more than freedom," as the younger Richard Hakluyt had put it. Such imagined desires for freedom, however much explained in the initial context to be a reflexive response to "subjection," actually meant the opportunity to replace Iberian with British oversight. Ostensibly the benevolence of British mastery would prevent slaves who would "cutt the throates" of Spanish masters from doing likewise to them.[20] Populating elite homes and portraits with black children allowed elite Britons to naturalize imperial hierarchies (similar familial metaphors also legitimated an unequal relationship between the metropole and its colonies). But in practice such examples of benevolence and gratitude proved elusive.

If colonial planters and metropolitan advocates tried to sweep resistance under the proverbial rug, other Britons who were less invested in the

maintenance of those hierarchies found collective and individual acts of slave rebellion entertaining. Seventeenth- and eighteenth-century ballad singers, playwrights, novelists, and artists who imagined rebellious Africans echoed Ligon in that they engaged similar questions about the propensity to free oneself and invoked similar identifications between British audiences and the enslaved. Such conversations were possible where the retention of master-slave hierarchies was not critical to maintaining social order. Fears of rebellions had little immediacy to them (at least, not in comparison to those of colonial masters).[21] Slave resistance provided a source of fantasy because it heightened the already exotic dangers that made for good imperialistic reading and could be used to interrogate forms of authority. This latter function concerns me: thinking about black rebels allowed metropolitan Britons to talk about authority, both at home and abroad.

Subversive Fantasies

Two popular tales circulating in the seventeenth and eighteenth centuries demonstrate how the appropriation of African resistance reflected unresolved questions about the logic of imperialism. "A Lamentable Ballad of the Tragical end" and *Oroonoko* narrated violent ends of empire in the white master's death or subversion and the African rebel's suicide or execution. That imagined resolution of mastery suggests that Britons recognized the internal conflict between justifications for and practices of slavery. Both tales, at their inception, may have recorded the actions of actual Africans, though their repeated narration constructed an end to black resistance in the rebel's death that performed a critical function in controlling the meanings of resistance.

English ideas about freedom derived from feudal traditions that defined men without obligations to a lord as free. In the seventeenth century, this conception of freedom was based on a particular understanding of the proper distribution of political power. Subjects of absolute rulers, such as the French, appeared to exist in a state of slavery, whereas in England, the rule of law purportedly circumscribed executive power and guaranteed certain rights and privileges to freeborn Englishmen. As Amussen observes, this notion of slavery as the product of illegitimate power structures differed from, though was related to, the "set of social relations that denied not only freedom but also personhood to a class of people" in plantation societies.[22] Experiences of these forms of oppression were

indeed markedly different, but metropolitan Britons did not always make clear theoretical distinctions, especially when they lacked a particular investment in doing so. In the seventeenth century, domestic structures of political and social authority offered one framework in which to understand the practice of slavery, while fantasizing about African bondage, especially acts of rebellion, facilitated interrogations of aristocratic forms of social power. Associations of slavery with tyranny were thus, for self-involved reasons, applied to resistant African servants and slaves.

First written in the sixteenth century and then published multiple times in the seventeenth and eighteenth centuries (including 1658, 1690, 1700, 1750, 1760, 1774, and 1793), a popular broadside ballad bore a long but illuminating title: "A Lamentable Ballad of the Tragical end of a Gallant Lord and Vertuous Lady, with the Untimely end of their Two Children, wickedly performed by a heathenish blackamoor their servant: the like never heard of. The Tune is, The Ladys [*sic*] Fall."[23] The story may have been based on some event, but it also conformed to genre conventions, being "intensely dramatic, involving an explosive situation, highly volatile characters and a short time-span." An African servant, angry about being punished, decides to take revenge on his master. We are not told the servant's original offense, though he thinks it was not very "great." Disregarding his family's prescient concerns, the lord goes out for his daily hunting expedition and leaves the shamed servant behind.[24] At this point, the narrator intrudes, setting the stage for the violent end of the tale by drawing attention to his witnessing role:

> But now my trembling heart it quakes
> to thinke what I must write;
> My senses all begin to fail,
> my soul it doth affright:
> Yet I must make an end of this
> which here I have begun,
> Which will make sad the hardest heart,
> before that I have done.

The following stanzas described the African servant's rape of the wife—her screams rouse the local villagers to come to her aid, to join the witnessing role:

> Some run into the forest wide,
> her lord home for to call,

68

And they that stood still did lament
this gallant Ladies fall.

When the lord arrives belatedly to find his castle locked, he is forced to stand outside and watch the blackamoor, who has emerged on the parapet, murder his children. Begging his servant to spare his wife, he receives an ultimatum: if he cuts off his nose, his wife will be set free. But the offer proves merely another act of violence: the noseless lord dies, his "senses all did fail," as he watches his wife fall to her death. The "savage Moor" laughs, saying to the villagers:

I know you'll torture me,
if that you can me get,
But all your Threats I do not fear,
nor yet regard one whit.
Wild Horses shall my body tear,
I know it to be true,
But I'll prevent you of that pain,
and down himself he threw.

Any desire for revenge is denied fulfillment as the black servant commits suicide by throwing himself into the moat.

Whether hung on a cottage or tavern wall or circulated among friends, the ballad invited Britons to identify with the narrator and villagers. The narrator's intrusion just before the rape provides the response that was expected from the audience both internal and external to the text: his "trembling heart" is echoed in the villagers' "lament" and asks for resolution in a sentimental response from the ballad's audience. Sentimentalism reconfigured the vicarious experience of violence; it was the response that marked civility, rearticulating the exteriority of the witness and thus his or her lack of moral culpability.

The ballad, however, also invited Britons to identify with the blackamoor who is the epicenter of the catastrophe. The racial othering of the servant facilitated such voyeurism by masking it in the rejection of this "savage" stranger: the black rapist and murderer is monstrous; he is the "outragious [sic] filthy rogue" and "vile wretch" who embodies the desire to reclaim potency.[25] But he is also responding to a perceived act of tyranny, a punishment for a transgression not so very great. Winthrop D. Jordan argued that the recurrent image of the black male rapist in colonial sources reflected white male attraction to black women, but, in this

case, black male violence was attributed to male competition within a fixed hierarchical structure.[26] The audience's sentimental response makes safe the transgression that occurs in an experience of aggression that is ultimately directed, not at the wife, but at the lord.

The ballad's enduring popularity suggests that associations of black servants with elite authority in Britain made those servants available for fantasies about the disruption of social hierarchy. Ballads frequently expressed popular discontent with local elites, and this tale of vengeance that left the lord symbolically castrated indulged fantasies about turning the world upside down.[27] Sung to the tune of "The Ladys Fall," the performance centered attention on the corruption of female virtue, but it centrally undermined masculine displays of aristocratic power. In a sense, this ballad accepted the meanings of mastery that underlay elite portraits but invested the black servant, the "Villain void of fear," with the means to their inversion. The blackamoor's masculinity becomes both cause and explanation for why that violence occurred. His self-annihilation critically prevents the villagers (and the ballad's audience) from having to inflict "that pain" on him, enabling them to maintain their witnessing role by taking the act of resolution from them. That formula echoed broader mechanisms of distancing that sustained practices of slavery, even while the ballad itself allowed Britons to experience vicariously and temporarily the subversion of distance.

This revenge tragedy, brought to closure through the servant's suicide, was reanimated by the crude woodcut illustration that usually accompanied the broadside (see, e.g., Figure 2.1). Various versions appeared during the seventeenth and eighteenth centuries, all of which foregrounded the lord begging for his servant's pity. In typical fashion, many of these woodcuts collapse the temporal narrative, depicting in the left background the preceding hunting scene and, in some versions, the lord's subsequent death. None of them depict the blackamoor's suicide; instead, his larger-than-life presence dominates the scenes. Dressed in a loincloth, he stands on the parapet, holding the wife by her hair and one of the daughters by the leg. The other daughter falls into the moat. Below, the lord kneels, his hands clasped together asking for mercy from a servant whose ill-defined black body varies between an enormous classicized form and one more common to British travel illustrations of Africa. These images emphasized the reversal of hierarchy through the servant's exaggerated blackness and spatial position above the kneeling lord. One eighteenth-

Figure 2.1. "A Lamentable Ballad of the Tragical end . . ." (London, [1690?]), Woodcut. © The British Library Board (Rox.I.220).

century exception minimized the offending servant and introduced the villagers (Figure 2.2).[28] This version carried a publisher's advertisement of "finer cuts . . . cheaper than in any other place in England" and thus was probably intended to display his printmaking abilities. It more clearly invited viewers to identify with the lord's perspective, whereas the side views placed the viewer as a removed spectator of the unfolding event. Regardless of which version was on display, the viewer of the image was the final audience to the horrific events described, caught forever in the unresolved tension surrounding the lady's "Fall" and in the reversal of social, racial, and imperial hierarchies.

The ballad, at its inception, may have recorded the actions of an actual African servant, but its repeated narration suggests that some Britons enjoyed its particular working through of the implications of resistance. Distance from African revolts on slaving ships or in the New World, as well as the local nature of resistance by blacks in Britain, meant that white Britons could fantasize about black subversion without necessarily fearing a broader challenge to imperial rule. "A Lamentable Ballad of the

Figure 2.2. "A lamentable ballad of the tragical end . . . To the tune of, The lady's fall, &c." (London: printed and sold in Bow Church-Yard, [1750?]). Courtesy of Houghton Library, Harvard University. EB75.P4128C no. 109.

Tragical end" dwelled on sex and violence within patriarchal structures in order to capture an audience; it reflected developing visual and literary conventions in which the black servant, rebellious or not, was a source of entertainment. Fascination with this revenge tragedy suggests that the black servant caught popular imagination; his imagined end in death proved critically conventional.

Perhaps the most famous death of a rebel African slave in eighteenth-century Britain was that of Oroonoko, the tragic hero of the playwright Aphra Behn's 1688 novella. Oroonoko's fictional, failed rebellion against the English Surinam slave system won him numerous followers and several reincarnations on the stage and in graphic art.[29] Adapted by Thomas Southerne in 1696 for the stage, the story of Oroonoko's and his lover Imoinda's violent demise captivated metropolitan audiences for most of the century. The various versions of *Oroonoko* map shifts in perceptions of slave resistance. Susan Iwanisziw points out that the royal slaves "underwent radical changes: Oroonoko's heroism increased, but he was also softened as a character and his agency limited to reaction; correspondingly, Imoinda's pathos increased."[30] Comparing Behn's and Southerne's late seventeenth-century accounts of Oroonoko's enslavement, rebellion, and death highlights the importance of New World institutions of labor to domestic critiques of authority and again demonstrates the tenuous nature of imperial narratives through their imagined ends. If "A Lamentable Ballad of the Tragical end" targeted the aristocratic virtue displayed through black servitude, *Oroonoko* questioned the virtues of slave-based colonization.

Although the stage versions proved even more popular, Behn's *Oroonoko* was a success: newspapers and other publications advertised it well into the eighteenth century and multiple editions sold from Covent Garden's and St. Paul's bookshops.[31] Set in the Gold Coast and colonial English Surinam, the narrator related the misfortunes of Oroonoko, a West African warrior prince who falls in love with a beautiful African woman, Imoinda. His grandfather, an old and impotent African king, disrupts their marriage when he also falls in love with her, sending her the royal veil and placing her in his harem. The young lovers' resistance to his interference, which should have resulted in their deaths, leads first to Imoinda's and then to Oroonoko's enslavement in colonial Surinam (16, 18–19). Imoinda is sold as a "common Slave" because the king cannot brook Oroonoko's secret "ravish[ing]" of her; to be sold was a fate, Behn wrote, worse than death (24, 26–27). Oroonoko's enslavement, on the other hand, occurs because he is hoodwinked into getting on a European slaving ship under the pretext of a ceremonial dinner (31). The slave trader gets Oroonoko drunk and claps him into irons, along with his lieutenant and friend Aboan and the rest of his retinue. The prince's belief that others will respect his social status makes him susceptible to the English trader's flattery.

Behn's novella rooted the causes of the royal Africans' bondage in a tyrannical king (16, 18), in impotent rage stemming from sexual and social constraints (17–18, 23), in the subjection of the female body to competing male desires (15–28), and in gullibility to flattery (31). These complex acts of enslavement occur in a discursive context that mobilized multiple meanings of bondage, from Oroonoko's "present" to Imoinda of 150 enslaved captives (14), to his "Love-sick slave[ry]" to Imoinda (16–17, 29), to his retinue being "entirely Slaves" to his princely "Merits and Vertues" (19), to Imoinda's forced "Captivity" in the harem, against which it is "vain for her to resist" (17–18, 20). In the sexualized and gendered context in which these myriad forms of enslavement occur, the result is as inevitable as the events in "A Lamentable Ballad of the Tragical end." Various characters attempt to manage the tension between the king and Oroonoko through flattery and dissembling (war also proves a useful device of delay), and the young lovers repeatedly "vent" their anger or grief through moans, sighs, and tears (19). But in Behn's construction of impotency, the release of "Rage" was unavoidable (16–17, 19–22). The prince's "rape" of a royal wife, which satiates his "just Desires," exposes the king's impotence and leads to Imoinda's sale into slavery. The sacrifice of her body to masculine power struggles foreshadows the closing scenes in the novella, when Oroonoko "sacrific[es] Imoinda" (killing her) to have "Revenge" against the deputy Surinam governor, William Byam (20, 61).

The deaths of the royal slaves occur in 1660s Surinam, the short-lived English colony in South America (which Behn may have visited).[32] The narrator encounters Oroonoko and Imoinda here, where the lovers reunite, rediscover their love and their desire to be free, and stage a mass slave revolt against the unsavory English planters (many of them historical personages) who rule the colony. The explicit causes of Oroonoko's uprising include his wife's pregnancy (and the threat of his heir being enslaved) and the prolonged absence of his master, the Lord Governor Willoughby of Parham (the actual lieutenant-governor of the British West Indies), who is always coming and never arriving to give him his "Liberty" (40). The underlying causes of revolt, however, lie in sociosexual drives: Oroonoko and Imoinda pledge to live "with joy and pleasure" in "Fetters and Slavery" because they "possess" each other, but even love cannot assuage their desire for liberty (39). Once they discover the pregnancy, Oroonoko begins to think that love has kept him a slave: "he accus'd himself for having suffer'd Slavery so long; yet he charg'd that weakness on Love alone, who was capable of making him neglect even

Glory it self; and, for which, now he reproaches himself every moment of the Day." Oroonoko's thirst for "Glory" begins to displace Imoinda (she encourages that effacement) and the stage is set for the same progress of impotent rage that shaped the West African section of the novella (42). This time, the narrator and Oroonoko's benevolent overseer, John Trefry, attempt to "Delay" and divert him, but Imoinda and other slaves flatter his anger and he leads an unsurprising revolt to its inevitable demise. Most of the field slaves desert the rebellion, leaving Oroonoko, Imoinda, and Tuscan (an Aboan surrogate) to fend off the planters. The slaves, who had before "Ador'd him as something more than Mortal," whip Oroonoko brutally and rub pepper into his wounds to complete their "Cruelty" and "Revenge" (57).

The prince's critique of slavery in his speech to incite the slaves, which subsequent dramatists invested with antislavery sentiment, allowed Behn to invoke the degeneracy of Britons:

> we are Bought and Sold like Apes, or Monkeys, to be the Sport of Women, Fools and Cowards; and the Support of Rogues, Runagades, that have abandon'd their own Countries, for Rapin, Murders, Thefts and Villanies. Do you not hear every Day how they upbraid each other with infamy of Life, below the Wildest Salvages, and shall we render Obedience to such a degenerate Race, who have no one Humane Vertue left, to distinguish 'em from the vilest Creatures? (52–53)

Behn reached toward a critique of metropolitan forms of slavery (which made Africans the "sport of Women, Fools and Cowards") and colonial bondage beneath those "Rogues and Runagades." But the slaves' betrayal of Oroonoko provides the answer to his question: those "Dogs," he thinks, have lost the "Divine Quality of Man" through their conversion to Christianity. With him dies the idea that the common slaves would be fit for something nobler (52, 56). His death thus functions to restore the status quo, but also to explore and discard the question of whether most slaves deserved their bondage to this degenerate race.

The royal slaves realize that "liberty" is not possible in English Surinam; they reject the option of maroon life for a death pact and reunion in the African ancestral realm (60). Oroonoko disembowels and dismembers Imoinda's body, killing their unborn child and severing Imoinda's face. As in "A Lamentable Ballad of the Tragical end," male competition within a fixed hierarchical structure leads to black male violence, though in this

case Oroonoko rages against the surrogate of his absent master, the deputy governor. Pulled out of despair for Imoinda by the prospect of glory, Oroonoko attempts to kill Byam but fails to do so. His rebellion thus ends in his mutilation of Imoinda's body, his rending of his own body, and the planters' vengeful mutilation of him in a rough equivalent of the English manner of criminal punishment (60–65).

Oroonoko's dishonorable death in dismemberment parallels an earlier scene in which native Surinam war captains ritually self-mutilate, the "Dismemberings" that elicited Oroonoko's curiosity about "how they all came by those frightful marks of Rage or Malice, rather than Wounds got in Noble Battel." No longer able to fight in war, a captain competed to display his worth by cutting "off his Nose" or some other part and throwing it away. Needless to say, the "Debate" often ended in death. Oroonoko expressed his "Esteem of 'em," even though such "Courage" was "too brutal to be applauded by our Black Hero" (50). This so-called Passive valour mirrored active military honor but did not enact its liberation, except through death. In Oroonoko's last stand, he embodied this form of courage: " 'tis not life I seek, nor am I afraid of Dying; and at that Word, cut a piece of Flesh from his own Throat and threw it at 'em," before disemboweling himself (62–63). Such "Passive valour" reflected attempts to maintain potency in the face of sociosexual impotency. Behn linked that emotional impulse to a natural absolutism, a desire to possess oneself, and attributed it to a particularly male response to oppression. She thus offered a critique of the type of romantic hero that Oroonoko was: despite his heroism, his rebellion ultimately turns inward to the perhaps admirable but savage destruction of himself.

Critical differences and similarities between Oroonoko's death and the death of the male African servant in "A Lamentable Ballad of the Tragical end" illuminate how such imaginings worked through conflicts in the logic of imperialism. Behn invited identification with Oroonoko's gallant portrait: the classicized, dark male who fights, on the surface, for all the right reasons—honor, love, allegiance, and freedom—against an African king who places himself above the law and a colonial planter class that abuses its authority. As in the ballad, Oroonoko engaged Britons in an investigation of African responses to subordination but imagined the roots of resistance in chivalric terms. Behn also built a number of sources of tension into the colonial society that lead to the royal slaves' deaths: the manipulations of a white female narrator or "Great Mistress" whose "Eye-Witness" authority becomes suspect as she attaches Oroonoko's

fame and gallantry to her self-portrait (8, 41); the failure of idealistic visions of benevolent mastery, articulated by the overseer John Trefry and planter Colonel Martin, to sway the colonial elite; and the corruption of colonists who, following Byam's "Example" of "Tyrany," engage in petty battles that echoed the Caribbean's state of perpetual warfare (58–59).[33] All of these characters pursue their own interests; in so doing, they disrupt visions of slavery as a civilizing process and the slave as an ornament to English female virtue and masculine power.

In this anarchic world, Oroonoko's masculinity provides the central driving force for the violence that ensues: he is a "Lion" who can only be caught in his death (31). Idealistic visions of the slave owner who "cou'd govern his Negroes without Terrifying and Grieving them with frightful spectacles of a mangl'd King" are not manifested and thus the cycles of violence, moving through passive grief and active rage, conclude in the rebel royal slaves' deaths (65). Both the ballad and *Oroonoko* dwelled on conflicts between ideas about and instances of imperial relationships by fantasizing about black masculinity, explaining resistance as acts of rage and violence against an intolerable disempowerment. Although opening up space for an interrogation of failures in imperial control, the construction of an end in African death resolved and anesthetized the threat posed by the rebel African's rejection of his assigned place in the social order.

Although prince Oroonoko would have to wait until the second half of the eighteenth century to embody abolitionist sentiments, *Oroonoko* was a critique of the ideologies of mastery that sustained slavery.[34] By investing the prince with an unquenchable thirst for "Liberty," Behn explored the limits of enslavement in the incommensurability of ideas about natural desires for freedom and the practice of slavery in English Surinam. Various ideological attempts to smooth over that conflict appear and fail to manage it: the ornamental status of Oroonoko on the Parham plantation, echoing metropolitan more than colonial bondage, fails to assuage him: Oroonoko "suffer'd only the Name of Slave, and had nothing of the Toil and Labour of one, yet that was sufficient to rend him Uneasy" (42). The image of the benevolent master also offers a suggestive, but ultimately unsuccessful counterpoint to the anarchic factions of power. This figure, an extension of precolonial differentiations of Protestant from Catholic rule, focused criticism on the proper treatment of slaves and their conversion. But, in Oroonoko's view, conversion made slaves; the narrator fails to convince him of its worth. Oroonoko was the

civilized heathen slave (his "Civility" derives, we are told, from contact with Europeans in West Africa), but he could not embody the end of empire that would sustain myths of the benevolence of English rule.

If the ballad provided a vicarious experience of the subversion of local mastery, *Oroonoko* dwelled on the potential inversion of the plantation social order. That potentiality, however, is controlled through the narrator's spectator position to Oroonoko's execution (she is not there when it happens; we are to believe that had she been there, she would have intervened). Like the ballad, the resolution of the conflict in African death also happens primarily as a result of African agency. Oroonoko's "necessity of Dying" leads to his death (60). That act of displacement mitigated the rebel slave's threat to imperial hierarchies at the same moment that readers were invited to empathize with him.

Thomas Southerne's theatrical production of *Oroonoko* brought this story of slave resistance to a wider audience, though with significant alterations. Oroonoko's overseer again represented an idealized English benevolence, though his new name, Blanford, suggests potentially comic undertones ("bland" meaning smooth and suave or mildly soothing, or to mix, intermingle, blend).[35] Southerne also turned the African beauty, Imoinda, into a white woman, which Roach aptly observes reflected the "pronounced tendency on the part of Africans in this story to turn white" through the "relentless assimilation of African identity into European ideology." The consequently interracial love story provides a tragic counterpoint to a new comic subplot of two English women husband hunting in the colonies. The play also maintained the fluidity of ideas about bondage that contextualized the royal slaves' deaths in Behn's story, comparing "the sexual barter of marriage and the institution of slavery."[36] The emphasis, however, was now on feminized connotations of bondage, especially the domesticating effects of love, rather than masculine discourses of impotency. This change radically altered the psychological portrait of Oroonoko and thus the overall commentary on the nature of enslavement.

Southerne placed Imoinda at the heart of the struggle between Oroonoko and the deputy governor. In Behn's novella, Trefry had originally found Imoinda captivating but relinquished his claim once he realized that Oroonoko was her long-lost love. In the play, the deputy governor has his sights on her and, as "Love stops at nothing but possession," eventually attempts to rape her. That act, which constitutes the only discussion of male desire comparable to Behn's, renders the parallel between the English deputy governor and the tyrannical African king more

explicit (2.3.52). But the struggle over Imoinda diminishes the issue of the governor's refusal to liberate Oroonoko. The change characterizes Oroonoko's enslavement in terms of the emasculating costs of love, rather than the intolerable nature of slavery for a warrior prince. And even his love is not particularly heroic (Blanford, not Oroonoko, saves Imoinda from the governor—inserting the embodiment of English benevolence into the space of the noble black prince). Instead of relinquishing his attachment to Imoinda to facilitate his revenge on the planters, Oroonoko remains, for much of the play, caught in conflicting bondage to honor and love: as he exclaims, "To Honour bound! and yet a Slave to Love!" (5.1.1).

Other instances reinforce this diminished picture of Oroonoko's potency. The planters mistakenly perceive him as a threat when the natives attack the colony. They (not including Blanford, of course) seize him as "an Enemy to the Government" and "bosom Enemy," with the "malice of a Slave" who "wou'd be glad to be cutting his Masters' Throats" (2.4.49, 53–54, 58). But, in the play, Aboan incites Oroonoko to rebel; otherwise he might have remained a slave, believing his wife to be "Dearer than Liberty" (2.2.58–60). Oroonoko's murder of Imoinda is also practically forced upon him, as she clasps his hand to stab herself. Such reluctance to resist undermines the threat that the planters perceive in him, providing a parodic commentary on white fears of slave resistance. Oroonoko himself warns the planters that "Fear" itself is "the Villain's Curse, and will revenge my Chains" as he has "no pow'r to hurt" them (1.2.200–202).

Southerne's play suggested that the problem with enslaving a prince was not the injustice of it, but rather that he could potentially provide a focal point for broader rebellion. In contrast to Behn's novella, the play initially emphasized the field slaves' "common Cause" of freedom: they wanted only a "Soul of fire" to "animate" them and turn them into a "body" (3.1.20–22). Such a soul would transform their state of cursing (an invocation and revision of Shakespeare's slave, Caliban) into active resistance (3.1.14). But Oroonoko's ornamental status does not weigh heavily on him in the play. As Aboan attempts to rouse him, he argues for the planters' innocence:

These men are so, whom you wou'd rise against:
If we are Slaves, they did not make us Slaves,
But bought us in an honest way of trade:
As we have done before 'em, bought and sold

Many a wretch, and never thought it wrong.
. . . We ought not to complain. (3.2.121–134)

Aboan reminds him that the other slaves are not so well used and that he has a "God-like Office" to "draw the Sword against Oppression, and set free Mankind," "a brave resentment" that "wou'd become you better than your Love" (3.2.80–84, 152–153). He points to the example of the Indians, who here embody the "attempt" for "Liberty" rather than "Passive valour." The slaves' demographic dominance, Aboan believes, will also ensure successful "self-defence, and natural liberty" (3.2.86–99). But it takes Imoinda martyring herself to this vision, rejecting her role as the "only cause; The Fountain of these flowing miseries" for Oroonoko to decide to rebel (3.2.177–178). Southerne thus depicted rebellion as highly unlikely in the first place, deriving from grassroots resentment, and ultimately ending in the fearfulness of common slaves. As those who have spoken loudly for revolt turn to betrayal, the emasculated field slaves from Behn's novella reemerge. At their wives' behest, the male slaves submit to the planters and to their domestication.

Southerne's *Oroonoko* offered a masculine image of resistance, but only through African death. Oroonoko admits it is "Death or Liberty" (3.4.34); Aboan confirms,

Death is all
In most conditions of humanity
To be desir'd but to be shun'd in none:
The remedy of many; wish of some;
and certain end of all. (3.4.57–65)

Death is a "Friend" in "this cause of Honour," whereas slavery is "servile Fears." It is "nobler to dye, / Than drag the galling yoke of slavery" (3.4.134–135). Oroonoko's irresolution, however, means that only Aboan, who commits suicide, embodies these ideals. It is striking that late eighteenth-century prints depicting this story invoked this moment, attaching Oroonoko's line, "Death is security for all our Fears," visually to the dead inciter of rebellion (Figure 2.3).[37] Imoinda's suicide "Recover'd" Oroonoko's waning courage, as the slaves' "common Cause" of freedom transformed into the lovers' "Common Cause" of death (5.1.282, 316). Oroonoko kills the governor and himself, the long delay a result not of constraint, but of lack of determination. This resolution again removed the act of violence from British hands.

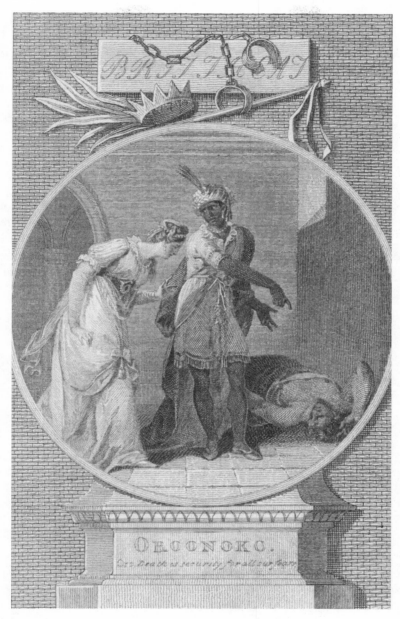

Figure 2.3. A. E. Smith sculp. (after W. Hamilton), *Oroonoko. Oro. Death is security for all our fears* (November 12, 1791). © V&A Images/Victoria and Albert Museum, London.

The theatrical performance of this story stressed problems with white masculinity, instead of the conflict of liberty and empire that animated Behn's novella. In the comic subplot, the "booby" son of an overbearing mother (to whom he is unnaturally sexually attracted) also rebels, but his brief rejection of marriage ends in his acceptance of it. His end contrasts Oroonoko's in that he "helps" himself by accepting submission. This critique of white masculinity intensified the broader parody of fears of slave resistance. Through the fluidity of notions of bondage, the play mocked Caribbean fears of uprising by reducing the threat of African resistance; advanced the idea that transforming men, including male African slaves, into "Husbands and Fathers" domesticated them (an implicit approach to colonization, but not desired in white men); and criticized unmarried, overpowerful white women as subversive to the natural sociosexual order. As Blanford remarks to another benevolent planter as they try and fail to save Oroonoko: "'Tis *Oroonoko's* Cause, / A Lover's Cause, a wretched Woman's Cause / That will become your Intercession" (5.2.13–14). Southerne mobilized associations of black slaves with feminine connotations of the bondage of love, weakening the original critique of tyranny.

In Southerne's version, Imoinda's death brings closure to a vision of miscegenation that cannot be realized:

> O! That we could incorporate, be one,
> One body, as we have been long one mind.
> That blended so, we might together mix,
> And losing thus our beings to the world,
> Be only found to one another's joys. (ln 120)[38]

The death of the racially transformed Imoinda concentrates a commentary more clearly attached to Oroonoko's rebellion in Behn's novella: enacted amid dwindling numbers of white men, Imoinda's death absolved the audience of fully facing the potential for racial transformation by removing the threat of miscegenation. It also ended the union of a "white slave" (an indentured servant) and an African slave that troubled West Indian planters. In a play performed in Britain, where growing concerns about the local black presence increasingly lay with mixed racial sexual encounters, the location of that threat in the coupling of a white Imoinda and black Oroonoko, instead of a warrior African prince and a vicious white planter, pandered to anxieties about the domestic consequences of empire. One of the several prints produced of Southerne's

play, *Mr. Savigny in the Character of Oroonoko*, even visually drew attention to the fact that Oroonoko was played by a white Englishman in blackface, forcing viewers not to suspend their disbelief (and perhaps also punning on the appended line from the play: "I'll turn my Face away, and do it so") (Figure 2.4).

The repeated narration of the rebel slave's death echoed other colonial fantasies that imagined the worst in order to control the ends of empire. Projecting discourses of liberty onto resistance occurred particularly in political tracts that discussed the eventual separation of the colonies. Metropolitan Britons had imagined colonial separation as an inevitable product of their unequal relationship to the metropole long before the American Revolution, partly because the history of Greek and Roman imperialism suggested that eventual outcome.[39] Political thinkers, such as James Harrington in his 1656 *The Commonwealth of Oceana*, thought about the colonies in developmental terms: "For the colonys [sic] in the Indies, they are yet babes that cannot live without sucking the breasts of their mother citys [sic], but such as I mistake if when they com [sic] of age they do not wean themselves; which causes me to wonder at princes that delight to be exhausted in that way."[40] Imagining the ends of empire in colonial revolt also reflected recognition of the incommensurability of empire and liberty (which Harrington tried to solve by envisioning a maritime republic, rather than territorial expansion). Dwelling on this potential future shaped interpretations of colonial resistance while also mitigating fears, clearly articulated during the American Revolution, that Britain would "vanquish" itself through colonization. During the seventeenth and eighteenth centuries, preserving colonial "Dependencies" occupied British writers and colonial officials, though their repeated articulation of an inevitable break constituted "an unintended invitation to rebellion."[41]

Whether Africans found any inspiration in metropolitan narratives of slave resistance is equally unclear (Londoners were careful to record the appropriately sentimental response to Southerne's play garnered from the elite African, William Ansah Sessarakoo, who had suffered an experience similar to Oroonoko's except that he survived).[42] But such explanations of potential colonial unrest shared similarities with those of imagined or actual slave resistance. Both, for instance, often focused on the subordinate's ingratitude. Both also reflected fears of the collapse of imperial hierarchies. It proved more difficult, however, to imagine slave resistance in

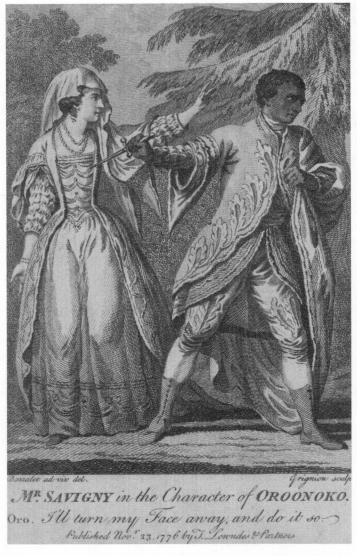

Figure 2.4. Barralet del., Grignion sculpt., *Mr. Savigny in the Character of Oroonoko* (November 23, 1776). Harry Ransom Humanities Research Center, The University of Texas at Austin.

straightforward terms of natural desires for freedom. Explaining African resistance by pointing to individual tyranny (such as the slave trader and deputy governor in Behn's *Oroonoko*) or a peevish temper (such as Morat's) delimited its implications for understandings of British oversight.[43] But, at the same time, appropriating slave resistance to critique domestic or colonial authority structures forced the attribution of ideas about tyranny and freedom to black bondage. This projection of natural desires for freedom onto the African slave or servant erupted in weird ways through discourses of masculinity, which are particularly apparent in revenge tragedies that centralized the enraging effects of impotency. Over the course of the eighteenth century, slave resistance, metropolitan fantasies about rebellious blacks, and African writers such as Cugoano invested the black male with a language of liberty. In the late seventeenth century, however, that process was only beginning, and such identifications with enslaved revolt or, to put it differently, such integrations of Africans into British discussions about freedom maintained distance by controlling the meanings of resistance.

Britain's turn to African slavery as the primary labor force for colonial plantations coincided with efforts to resolve perceived conflicts between the establishment of an empire and the retention of ideals of liberty. Harrington's *Oceana* argued for a maritime republic because, following Cicero, he believed it better to undertake "the patronage than the empire of the world": "This is a commonwealth of the fabric that hath an open ear, and a public concernment. She is not made for herself only, but given as a magistrate of God unto mankind, for the vindication of common right and the law of nature." The invitation to Jamaica that Harrington's critics extended to him suggests that some Britons realized the nature of Caribbean colonization made such imperial utopias impossible. In some respects, Behn's exploration of Surinam society provided the dystopian colonial society that worried, implicitly or explicitly, political writers about empire.[44] Slave resistance offered a site where the viability of certain ideas about empire could be measured against the fictional or quasi-fictional narration of social practice. The threat posed by the rebel slave was both to the immediate social hierarchy and to broader conceptions of imperial rule; negotiating this potential end of empire allowed Britons at home to work through questions about new relationships with black Africans.

Distance from the New World prevented African resistance from having the same legal and institutional consequences in Britain as it had in the Caribbean, but these print and song invocations of African revolt suggest that Britons did not entirely believe their own myths of imperial benevolence and that deep resistance to racial integration undermined them. By imagining the ends of empire in violence, metropolitan literary and theatrical performances worked through racial and social changes, imminent and imagined, resulting from these new relationships. They explored various causes and explanations for resistance and tested the inversion or potential subversion of assumed hierarchies. That prince Oroonoko's agency declined during the eighteenth century suggests that rising reliance on African slavery and growing numbers of blacks in Britain intensified fears of miscegenation. Narrating the black rebel's death resolved these tensions without creating a resolution, enabling Britons to create structures of meaning in which to understand incidents of resistance but preventing full rationalization of the conflict.

Perhaps the most important function of these stories was to model responses to resistance that preserved the witnessing role of the audience. Absolved of culpability in the violent ends of empire, death itself became that "common revenger of all injuries."[45] Just as Behn's Oroonoko berated Christians' ability to avoid responsibility for their actions because judgment was experienced postmortem, African death allowed audiences of Southerne's play, listeners to "A Lamentable Ballad of the Tragical end," and readers of Behn's novella to invest distance from the violence of empire with moral significance. As one of the planters in Southerne's play remarks: "We are not guilty of your injuries, / No way consenting to 'em, but abhor, / Abominate, and loath this Cruelty."[46]

Cugoano's reimagining of Britain's relationship to West African societies engaged precisely the problem of incorporation that had occupied metropolitan Britons during the preceding century. As Caribbean planters had to learn to become slaveholders, Britons at home also had to learn to become imperialists. This teleology in African death reflected an inability to imagine the African as a member of society and the fear that African slavery exposed illegitimate power structures. Cugoano's vision of living partnership offered an alternative path: he resolved this conflict by universalizing natural liberty and retaining the patron role that Harrington had advocated and that Behn, perhaps parodically, modeled in her narrator. To circumvent the endpoint on which these popular stories dwelled, Cugoano forced Britons to imagine a heterogeneous universal

community but lessened the potential for the racial other to replace the self: Africans would stay in Africa, a different formulation of how geographical distance could facilitate productive contact. By the time Cugoano offered this solution, however, such problems with the logic of imagined contact had deeply shaped British culture.

3

ACCIDENTAL MONSTROSITIES

> I often imagined that I'm suspended in air, motionless, while
> the Earth turns under me for 24 hours . . . I see passing under
> my gaze all the different faces: white, black, tawny, and olive
> complexions . . . I see first with hats, then turbans; woolly
> heads, then shaved heads; here cities with towers of porce-
> lain; there great countries with nothing but huts; here vast
> seas, there frightful deserts; in all, the infinite variety that ex-
> ists on the face of the Earth.
>
> —M. de Fontenelle, *A Discovery of New Worlds* (1688),
> trans. Aphra Behn

Oroonoko was the product of a metropolitan society that was changing rapidly in response to continental wars and the establishment of colonies abroad. The consumer revolution that transformed Britain's port cities in the early eighteenth century had already given rise to coffeehouses and other new spaces of consumption.[1] Some coffeehouses were named Jamaica, Barbados, Carolina, Turk's-Head, or Black Boy, incorporating the peripheries within London. Brutal Caribbean slave colonies became shops in which Britons congregated to consume the products of slave labor and trade, and to purchase slaves, plots of New World land, and tickets for lotteries. At these renditions of colonial outposts, Londoners could become "Adventurers" for a sixpence.[2]

Coming to terms with human variety and new interracial relationships, however, took much longer than the formation of Caribbean slave societies. Although the Black Legend (the popular mythology that developed in the sixteenth century about Spanish violence and oppression in the New World) provided British authors and artists with a convenient foil to their own imperial ventures, assimilation proved largely a fantasy in the seventeenth-century empire. Virginia and Massachusetts Bay turned to policies of alienation with regard to dwindling native populations, and

conversion rarely translated into freedom for rising numbers of imported African slaves. In Britain, Britons remained wedded to the fanciful "dreams of liberation" first articulated by Francis Drake and the Hakluyt brothers in part because they experienced Native American and African resistance through print and plays, where it could be romanticized and thus anesthetized.[3] Reluctance to recognize chattel slavery under British law and a popular belief that baptism conferred freedom also worked to hide the narrowing opportunities for manumission in colonial plantation societies. Evolving imperial sensibilities developed from these cultural encounters that took place primarily in Britain rather than in distant lands.

Even from a distance, though, the incorporation of blacks into an imagined Anglo-Christian community caused problems. Roy Porter suggested that late seventeenth- and early eighteenth-century England witnessed a period of "enlightened universalism," when new emphasis on reason encouraged a certain "tolerance" of cultural and physical difference. Roxann Wheeler has also reconstructed the variegated explanations for skin color circulating in Britain, arguing for the fluidity of notions of racial difference and for other markers of human difference (religion, clothing, etc.) being as important as skin color until the third quarter of the eighteenth century.[4] But the creative silencing of racial difference in British discussions of the origins of blackness and the meanings of black conversion suggest that the language of cultural relativism masked deep resistance to—or an inability to imagine—a racially plural Protestant community.

Scholars have examined philosophical and aesthetic treatises that raised questions about the origins and aesthetic value of blackness, but we know far less about the transmission and reinterpretation of these ideas by literate, but less learned Britons. This chapter takes a close look at a popular debate in a late seventeenth-century London journal in order to understand how some Britons thought and argued about human variety. In 1691, the *Athenian Mercury,* the first highly successful London periodical, found its primary audience in the coffeehouses that were named after American homes of African slaves. Over the course of the journal's seven-year run, readers questioned the editors about the origins of blackness and the implications of human diversity.[5] This discussion reveals the limits of cultural relativism among a seventeenth-century populace that prefigured tensions in eighteenth-century arguments about the nature of beauty. Some Britons, it turned out, remained better at keeping novel Atlantic bodies contained within curiosity cabinets, cultural spaces where diversity could be displayed but remain segregated from society. One so-

lution generated by this debate, which proved long lasting, was to imagine that blackness was an "accidental monstrosity," one that could be corrected through salvation. Blackness complicated visions of assimilation, but visions of assimilation also disrupted constructions of an essentialist notion of racial difference.

The Curiosity Cabinet

For the Whig editors of the *Athenian Mercury,* "Curiosity" was just "a part of nature." They intended to satisfy the curious by answering questions about sex, courtship, nature, religion, politics, trade, fashion, and the fantastical.[6] Twice a week, Londoners found a new double-sided folio half-sheet in local coffeehouses, free for the reading. For a penny, they could also buy a copy from John Dunton's bookshop in the Poultry or from female street hawkers known as Dunton's "Mercury Women." Coffeehouse proprietors acquired copies of the bound volumes of issues that appeared every few months under the title *The Athenian gazette, or Casuistical mercury: resolving all the most nice and curious questions proposed by the ingenious of either sex.* Total readership grew to the thousands as the journal reached provincial markets. Editions were available well into the eighteenth century for patrons to buy or peruse, and the editors alleged that they were read aloud in coffeehouses. Subscription rates remained consistently high through coffeehouse readings. The young Jonathan Swift contributed a panegyric to the journal, though he rescinded his support when the editors were outed as nonconformists. Meanwhile, from her provincial home, Elizabeth Singer Rowe contributed numerous poems as the "Pindarick Lady." The journal was a significant forum for female authorship. Rival publications, in particular Tom Brown's more orthodox *London Mercury* (later *Lacedemonian*), only encouraged the journal's popularity. It became the best-known and longest-lasting journal of its kind until *The Tatler* appeared.[7]

The "Athenian Society" was a pseudonym for four editors: John Dunton, a bookseller and publisher; Richard Sault, a mathematician and hack writer; Samuel Wesley, an Anglican clergyman and father of the abolitionists John and Charles Wesley; and John Norris, a neo-Platonist. Their journal issues contained anywhere from two to twenty questions, which they claimed to have received from men and women through the penny post to Will's Coffee House in Covent Garden. The editors took advantage of this new postal service, which moved letters and packages

about the City of London and its environs for a penny fee. Popular satirist Tom Brown parodied the journal's patronage of the general citizen, claiming that these "unknown, nameless Undertakers . . . pretend to answer all Queries which are sent them from all Degrees and Qualities; from the Prince to the peasant; but particularly such as are sent by the Fair Sex; for whom they have a most profound Veneration; that is, from the Lady in her cock'd Commode, to the Oyster-wench in her lawful Occupation at the Tavern-Door."[8] The *Athenian Mercury* offered a forum in which servants and gentlemen, women and politicians could ask questions in print; it belonged to the protobourgeois space of coffeehouses and it capitalized on the lure of curiosities to draw a mixed audience. The first issue announced that the journal intended to expand popular knowledge of science and other subjects, as well as to amuse and engage the curiosity of readers. The editors urged coffeehouse owners to buy the *Athenian Mercury* because the promise of the latest issues would attract customers.[9]

The *Athenian Mercury*'s agenda reflected the rise of a popular collecting culture in late seventeenth-century England, which had critical consequences for new understandings of human variety and for how Britons located themselves within this expanded world. In the sixteenth and seventeenth centuries, natural philosophers and other members of the elite began to collect objects from around the globe. These curiosity cabinets, which became the core collections of eighteenth-century museums, included select examples of exotic material culture (such as Afro-Portuguese ivories) and exotic plants or animals (such as tobacco). As Augustine Birrell wrote in the nineteenth century, "All sorts of curiousities [*sic*] found their way [to the Bodleian]—crocodiles, whales, mummies and black negro boys in spirits. The Ashmolean now holds most of them; the negro boy has been conveniently lost."[10] By the Restoration, as Behn's reference in *Oroonoko* to the king's "prized" antiquaries makes clear, these collections remained primarily elite property (Figure 3.1). Yet the rapid growth of print and rising numbers of small-scale collectors gave a broader public greater access to New World curiosities and to the contact zones that these objects created. By the 1690s, some coffeehouses were offering cabinets of curiosity among their attractions. James Salter's (Don Saltero's) in Chelsea specialized in curiosity cabinets: their fame would entice the young Benjamin Franklin to visit in his first trip to London. Apothecary John Conyers, James Petiver, and other middling Britons also advertised their own curiosity cabinets for public viewing.[11]

L' ANATOMIE ET L' HISTOIRE NATURELLE.

Figure 3.1. A curiosity cabinet with putti engaged in various activities. At left, two putti dissecting a large bat lying on a table, and two others examining a deformed fetus floating in a jar. At right, two putti playing with a spider. Cabinet with jars of pickled animals behind them; finished state of illustration to Fontenelle's *Oeuvres diverses* (La Haye: Gosse & Neaulme, 1728–1729). 1729, Etching and engraving. © The Trustees of the British Museum. All rights reserved.

The *Athenian Mercury* advertised a range of collectables for sale, including "Indian goods," travelogues, tapestries, "Indian figures," and general "curiosities."[12] And its eclectic compilation of artificial and natural curiosities was itself a figurative form of the curiosity cabinet. The leap from physical collections of rarities to literary miscellanea was not new. Miscellanea books, such as Donald Lupton's *Emblems of Rarities* (1636), promised readers variety, arguing that "the inward faculties" of the soul delighted "almost as much in changing varieties, as in their beings." John White promised a "rich Cabinet of varieties; if there be any thing therein contained that may yield you profit, solace of the mind, recreation of the spirits, or content, I shall think my labour well bestowed, and be glad; If it be otherwise, I shall be sorry that I have nothing therein to please your mind, intreating [*sic*] you to shut down the lid again."[13] By using a question-and-answer format, the *Athenian Mercury* innovated upon this literary form, relegating the selection of what was a wonder to the reading or lis-

tening public. John Dunton, a noted "lover of travels" who defined "Athenianism" as the love of novelty, emptied out the "closets of the curious" onto the pages of his widely read London journal.[14]

While attending to other questions about marriage or love, the *Athenian Mercury* also offered an attractive mix of information about foreign customs and British activities abroad, including descriptions of African customs, Turkish seraglios, and New England missions. Over a third of the journal's issues comprised sundry questions about Turkey, Africa, Native America, and other parts of the globe, as well as questions about skin color, slavery, or the saving of heathen souls. The question-answer format tended to democratize the content of individual queries: definitions of love, friendship, skin color, or political oppression were given equal space and front-page exposure. Although some issues were entirely devoted to the soul, the conversion of African slaves, or some other particular subject, most offered a relatively random selection of topics.[15] In so doing, the *Athenian Mercury* echoed the rather chaotic organization of curios in seventeenth-century cabinets. Interspersed between queries about the nature of the soul, the qualities and generation of light and color, the necessity of corporeal bondage to salvation, and the morality of one Christian selling another were questions about the origins of black skin, the righteousness of African slavery, and the role of English plantations as outposts of civilization in a heathen and savage world.

Of interest here are two "curios": black skin and souls. Long before the antislavery debates, Britons asked whether black bodies would rise to heaven in the form they existed or why God had created such a variety of skin color after his image. Despite abolitionists' later emphasis on denials of African humanity, Restoration and early Georgian responses to blackness focused more on the significance of human variety than on a question of whether Africans were human. In response to these concerns, the *Athenian Mercury* editors subjected the skin and soul of blacks to the light of their reason, producing a rather unsystematic but not internally inconsistent attempt to interpret human diversity. The Athenian Society's conflicted urge to eradicate and celebrate natural diversity inflected its portrayal of blacks: though the editors promulgated the idea that men could not know God's intent in his creation of various skin tones, they nevertheless circulated an understanding of blackness as an accidental monstrosity, a defect that would be corrected upon salvation. This belief shaped long-term discussions about beauty and human variety in Britain.

Skin

Seventeenth-century Britons' curiosity about human variety led to a proliferation of theories about the origins and nature of blackness. These theories originally came primarily from the scientific community, travelers, and the Anglican Church.[16] By the 1690s, the origin of human variety had become a popular debate. Despite the *Athenian Mercury*'s elaborate constructions of the origins of blackness, readers never completely accepted the editors' explanations. In 1691, for example, they were asked why "some men are black, some tawny, and some white in the same Climate, as in India." Skin color carried no moral implications for the editors in the context of this question. Readers encountered a short overview of the "Diversity of Opinion" on the subject: some, the editors said, have believed that Cain's mark was black, and "so by new Marriages and Intermixtures, the World might be diversly [*sic*] coloured." Others thought that Lot's daughters fled from Sodom with an impression of its smoke and flames in their minds; when they subsequently raped their father because they believed they were the only people left in the world, they fixed "a similitude of Colour upon Conception by the power of their imaginary faculty." The third opinion, based on classical notions of complexion, stated that nearness to the sun determined skin color, as the Portuguese were darker than the English.[17] But the editors admitted that these opinions were not yet truths. Before advancing their own hypothesis, they related the story of Mr. Briggins, captain of a privateer.[18] On an "Island of Blacks near Bantam," the captain and his party had been taken to the king's palace after they finished trading. The king inquired about the novelties they had encountered and then described a "Rarity" at his court, "a white Child born of two of his Subject Blacks, [though] neither of 'em [had] seen a white Man or Woman in all their Lives." After the captain inspected this rarity for himself, he concluded that "in its skin (not its Physiognomy) [the child] resembled a fair English Child." What the captain made of this East Indian novelty is unknown, because the editors extrapolated from this example their own interpretation of the origins of racial diversity: " 'tis more than barely probable that the first change of Colours in Persons came from such an Instance as this," they remarked. "News or sight" of a novelty would "form an Idea in others," which would be transmitted through procreation as a physical attribute of the offspring.[19]

The editors cited other examples of the powerful influence of the imagination on women and animals, including how Jacob's Rod caused his

flocks to bring forth only speckled progeny. This notion of impression, they argued, was the "same and more, than a fair Picture would have on a Woman in the same case," though they admitted that God's supernatural influence had something to do with the specific impression made by the Rod. The mother's soul (her mind), and the ideas therein, was imprinted on the child's body when the actions of the soul influenced the fetus through the umbilical cord. The editors concluded that "a Colour being once changed, it naturally follows that Intermarriages, Transplantations, and Conmixtures of such Persons must produce a variety of Colours," adding the caveat that the sun's proximity also contributed a "great Cause."[20]

The journal reiterated an ancient theory of fetal formation that had been propagated by Hippocrates, Galen, Plato, St. Augustine, and many other classical and Christian authors. Fetal impression remained the most popular explanation of monstrous births into the 1720s. References to Jacob's Rod and the influence of "Fair Pictures" were common. A 1708 poem on how to have "handsome children," for instance, suggested that "a fair Picture, and a beauteous Face, / By Fancy's mighty Pow'r, refine the Race."[21] Explaining blackness by fetal impression rendered it relative to other "deformities" also thought to result from this process. Although some readers thought that semen transmitted "natural defects" to progeny, the *Athenian Mercury* repeatedly accounted for them by the fixation of an impression on the maternal mind. These defects, they argued, are "monstrous, and as such unnatural." The editors, however, asserted that blackness, lameness, stuttering, and blindness were "Accidental," rather than essential, "Defects."[22] The *Athenian Mercury* responded to numerous questions about the transfer of marks onto a fetus; this conception of blackness—the impression onto a fetus of an idea in the pregnant mother's mind—was the editors' most frequent explanation of the origin of skin color.

When Robert Boyle argued in 1664 that blackness resided in the upper layer of the skin and not in a general disposition determined by environment and physiognomy, he opened the way for further considerations of exactly why that thin surface layer might produce the color that Britons perceived as black.[23] Although the *Athenian Mercury* did not embrace Hobbesian materialism or Lockean sensationalism to construct an origin of skin color in the faculties of sight, they did claim, as Thomas Hobbes and John Locke did, that color was a secondary rather than a primary quality. To a question about the physical properties of color, the editors similarly replied that color was an accident and could not be independent

of substance.[24] Blackness, as an "Idea," was produced by light rays and the presence or absence of absorbing pores:

> Colour in general, We presume, consists in these two things, a certain Disposition of the Parts of the Matter to be seen, and the Medium thro' which it is seen: By the first we mean, for instance, that a Cole has millions of little Pores when view'd by a Microscope which imbibe the light, and being not able to make that Reflection that a closer Body can, gives that *Idea which we call Blackness.* White is always found in a Body which has an Infinite Number of Asperous little pointed Particles of Matter, which by their Aptitude to give a great confus'd reflected Light, and thereby affords us that Colour which is call'd by that Name.[25]

The editors never connected this interpretation of the "Idea" of "Blackness" to blackness in skin, but their engagement with these new ideas suggests that while the origins of blackness might lie with the mother's imaginative faculties, its essential nature might ultimately reside in the structure of the skin and the particular way in which that object formed an image in the viewer's mind. Although the editors and readers did not relinquish Galenic constructions of a porous body or humoral interpretations of the origin of blackness, such curiosity in color production suggests a continuing interest in new theories. Blackness thus came to readers as a curio packaged with a range of rational explanation, from contemporary and ancient theories about fetal impression to new notions of the generation of color.[26]

Lot's daughters, scorched skin, maternal impressions, materialism, sensationalism: these explanations of blackness circulated in the seventeenth and eighteenth centuries in various combinations precisely because none of them satisfied curiosity. The repetition of questions about skin color in the *Athenian Mercury* suggests that the journal's answers did not persuade readers. Later issues continued to stress the inadequacy of knowledge on the subject and repeat its "Accidental" nature. But the editors occasionally strayed from their quest for rationality, exposing in those moments the strain in their celebration of variety. One querist wondered whether Adam and Eve were "single persons, and if Blackness be natural to the Ethiopian, and whiteness to the Europian [*sic*]; how can they derive their Original from one single person?" The editors replied:

> Blackness and whiteness are not natural to any people whatever, 'tis the effect of the Climate, English people that go near the Line

shall in two or three Generations, tho they marry only with English, become Tawny and Black; the same is observed of all animals, our English Bull-dogs will in two or three Generations degenerate into a Cowardly mean spirited Cur beyond Sex, as is very well known to all Travellers.

In the implicit equation of the "Cowardly mean spirited Cur" with the corrupted English traveler, the editors voiced a common belief that bodies and morals degenerated as they neared the equator and that "Tawny and Black" skin colors embodied this degeneracy.[27] Given that they attributed blackness to Egyptians, Americans, Ethiopians, Negroes, Indians, Portuguese, and Englishmen who had lived in the tropics, the equation of blackness with degeneracy was not a specific reference to Africans.[28] Indeed, the tale of the white child spontaneously generated by two black parents was set in an island near Java. Such malleability of blackness made Britons uncertain and explains why the editors' enlightened universalism was at times delimited by a belief that the white Protestant (on English soil) represented the chosen likeness of God.

Soul

Accidental monstrosity was a logical conclusion for believers in monogenesis who thought that whiteness was the norm and that rationalism was the highest expression of faith, differentiating the Christian from the pagan philosopher. The editors generally refused to link skin color to Christian semiotics that linked blackness with evil. This position reflected their desire to construct blackness as an accidental defect that occurred through the same mechanisms as other defects. Their intention was undoubtedly to counter writers who wished to make blackness "connate," or innate and immutable. In the *Athenian Mercury,* the black body fell subject to the same process of restoration upon salvation as other physical and nonessential "defects."[29] To reconcile skin color with biblical teachings was to reconcile all perceived imperfections with a perfect heavenly state and maintain the homogeneity of God's plan. Just as the difference between male and female souls was accidental and would be eliminated upon resurrection, so too would the difference between black and white people be removed on the last day.[30]

Accidental imperfections of skin were linked to the perfectibility of the soul and the unifying capacity of resurrection. From abstract considerations

of the nature of the soul, its essence and salvation, the editors moved to answer questions about the souls of black people and whether they would be saved. Their consideration of black converts to Protestantism reveals tensions between discourses of otherness and universalism, between godly ideals made after the image of a white body and relative notions of beauty. In 1691, the editors responded to the question of "whether all Souls are alike" by asserting that all human souls were equally excellent and differentiated from beasts by their rationality. They defined a soul as "an Immaterial Substance made after the Image of GOD, which together with a rightly Organiz'd Body, makes a Man." Disparities between human souls were accidental, but allowed men with "fitter organs" to have more knowledge, an "accidental perfection." Allusions to a gradation of men, however, yielded in the final line of the answer to a reaffirmation of the equality of male souls, from the fool to Solomon, from Aristotle to Peter and Paul.[31]

Yet when the editors answered whether "Negroes shall rise so at the last Day," they responded by asking one in response: "The Pinch of the Question" was "whether White or Black is the better Colour?" The editors offered a comparative explanation:

> For the Negroes won't be persuaded but their Jett is finer and more beautiful than our Alabaster. –If we Paint the Devil black, they are even with us, for they Paint him white, and no doubt on't are as much in the right on't as we, none amongst them who are legitimate being born white, but such as are a kind of Leprous Persons.

Africans, they noted, also boasted of Severus, Emperor of Rome, and saints, fathers, and innumerable martyrs who were "of that colour.[32] Another reader asked whether they thought the color of Ethiopians and other men would change at the Resurrection. The editors repeated that "If their Black-Colour be a Deformity now, they will doubtless then be cur'd of it, rising perfect men, as they wou'd if Lame or Monstrous. But that's a Question hardly yet well decided, for they think us as much deform'd as we do them." Over its seven-year run, the *Athenian Mercury* continued to promote the idea that beauty consisted of "that which pleaseth us."[33]

Such relativism enabled the editors (and the many journalists, travelers, artists, and politicians who repeated this aphorism) to elide the question of what constituted "perfect Men."[34] To a querist who wondered whether beauty was real or imaginary, the editors answered both, a dualism that rationalized variety while maintaining the white Protestant to be divine perfection. "Custom and Opinion," they said, determined standards

of beauty, but it was difficult to know whose standards were right: "He that abuses the Negro for his flat Nose and thick Lips; or the Negro who abuses him for his thin Lips and high Nose?"; "One who is born white among the Blacks, being as great a Monster as a Black among those that are white, and the Abyssines wou'd perswade us that Adam and Eve were Blacks, and that the Queen of Sheba was of that Colour they make almost an Article of their Creed." But the journal did not leave the question here, as it had in earlier queries on the subject. It argued that exceptions did not spoil a rule and that just because some nations failed to appreciate natural law did not mean that there was not "a best somewhere, White is lovely and Black horrid, one resembling the light the other darkness." Facing a question they could not answer, the editors resorted to a binary opposition of black and white, which Kim F. Hall refers to as the originary language of racial difference. Black was the color of night, of things "frightful, dark, and horrid." White, "refreshing and lovely," was the color of day and light. The laws of Nature determined which was "best." While blackness appeared horrid in response to a philosophical question about the reality of beauty, a question that the editors insisted was undecided and relative, they clung to its accidental nature: blackness, they continued, was an "accidental Imperfection (the Cause whereof see before)" and an African would slough off his blackness in the "darkness of the Grave, exchanging it for a brighter and a better at his return agen [sic] into the World."[35] The notion that black people would shed their blackness in their ascent into heaven implied a conception of color being a superficial quality located in a part of the body that could be sloughed off, detached, or restored to its original whiteness.

In the late seventeenth century, Britons followed their Elizabethan ancestors in seeking an answer to the problems of racial difference in the mutability of skin color.[36] But if Renaissance writers used biblical proverbs about the whitewashing of black skin to convey man's subordination to the power of nature, later writers were more hopeful that they could, in fact, achieve the impossible. In response to a question about breaking habits, the *Athenian Mercury,* for instance, related a version of Jeremiah 13:23, "Can the Leopard change his Spots, and the Blackamore his Skin, then may ye also do good that are accustomed to do evil." In contrast to Elizabethan dramatists who used the phrase, "to wash an Ethiop white," to signal the impossibility of transformation, the *Athenian Mercury* argued that their readers should be wary of such extremes, because they simply warned that change was difficult. Growing confidence

in an ability not only to assimilate the racial other but also to control nature made Britons, at least temporarily, more optimistic about the mutability of skin color. The logic of the "accident" was that it was ephemeral and potentially fixable through "fancy" and the power of "Fair Pictures" to "refine the Race."[37] If imperial portraits emphasized the gift of civilization as they depicted black servants in livery living with wealthy Britons, this popular journal emphasized to a broader public the potential for that association to remove blackness.

The accidental nature of blackness became in the context of souls a detachable component, a secondary quality that did not threaten conceptions of white Protestant bodies as perfect men. Understanding skin color as a superficial, physical attribute unrelated to the soul's quality or nature was an important move toward unhinging it from Christian semiotics. London engraver William Hogarth took this superficiality and made it the basis for an aesthetic centered on pleasurable variety a few decades later, but the *Athenian Mercury*'s editors, alongside other authors and artists who touched on beauty's relativity, presented it as a case of the jury still being out: that they could not know which was better did not mean that there was not a best.

Although Wesley answered most questions about religious issues, the different answers to the resurrection of black bodies, standards of beauty, and origins of skin color may reflect different authorship. They also indicate conjecture: this conversation about black skin and soul exemplifies the uncertainty with which Britons faced their growing knowledge of human diversity. Rationalizing blackness produced a form of monstrosity mostly unhinged from Christian semiotics but embedded in conceptions of the unity of God. The journal made human difference fit with a common heaven by rendering blackness an accidental imperfection to be corrected, if not in this world, then upon salvation. However relative beauty may have been, relativity did not generate a vision of a heterogeneous likeness of God in this journal or in the many eighteenth-century publications that reiterated its ideas. To do so would have meant allowing for the possibility that religions were also divinely encoded variations and that one was no closer to truth than another. The journal's grappling with variety replicated the late seventeenth-century curiosity cabinet in which variety was meant to inspire wonder and wonder to lead to a reaffirmation of God, but rationalist interpretations of variety did not inevitably generate acceptance of it. Over the course of seven years, the editors responded to a number of questions about color and conversion,

heathenism and barbarity that challenged their scriptural and scientific interpretations of the causes of human variation.

These debates continued in part because colonists and travelers repeatedly questioned the editors' explanations of blackness, forcing them to confront firsthand experience in the remote parts of the world. One such reader disputed the editors' assertion that African blackness was a product of climate and that Europeans who had left for the tropics would acquire the "same Tincture" in a few generations. "All which," said the reader, "is a mistake to my own certain Knowledge." He or she then refuted the editors' reliance on maternal impressions: "if accidentally some small change be in such persons as are daily exposed to the Sun, as we see in our own Climate, yet shall not that be conveyed to their Children." For these reasons, the reader was inclined to the "opinion of Dr. Heylin, who ascribes the Blackness of the Negroes to the curse upon the posterity of Cham. Pray your second thoughts on this matter?" The editors responded that the origin of blackness was "accounted a great secret in nature, which the wisest can but guess at." It may be, they conceded, that Ovid's fanciful explanation of blackness in the mythology of Phaeton was as near truth as any other: "Men say the Ethiopians then grew swart, / Their blood exboiled to the outward part." The Ethiopians simply lived too close to the sun. Even if the editors were mistaken (and they invited readers to set them straight), they argued that the reader's solution was wrong. Ham's curse, they argued, was a "pretty notion," helped by the fact that "Cham" meant "Heat," yet "all this is knockt" by the fact that Asia "was peopled by the posterity of Cham, who yet are only Tawny, not black, and that even those of his undoubted posterity in Africa it self, are of no other colour."[38]

The editors' reference to Asia introduced a contemporaneous argument that the postdiluvian world had been first populated from the East as sailors moved from one visible point of land to the next. Evidence for the Eastern origin of mankind lay in the "authentick" Chinese records "from a very few Years after the universal Deluge." The editors interpreted the first Chinese monarch to be Noah, claiming that the Chinese acknowledged him to be "the first King and Father of their Nation after the great Deluge." The similarities they drew between the two men began with the idea that the monarch, like Noah, had taught his people to abstain from consuming animal blood. But they quickly gestured toward much greater confluence by disappearing the parallels into the infinity of "other passages too long to be insisted upon."[39] In answer to how America, so remote from Europe,

came to be populated without a compass, they noted that there was no reason that islands had to exist before the Flood and that perhaps an isthmus existed, a land "Bridge" large enough for passage, or else other animals had floated over on large icebergs. Citing Sir Walter Raleigh, the *Athenian Mercury* located the biblical birthplace of mankind in Assyria, in an island called "Eden," wherein the four rivers including the Ethiopian "Gibon" converged.[40] Given the editors' assumption of Adam and Eve's whiteness, the peoples of Asia, if they were Ham's descendants, could not in their formulation of an eastward human migration be black. They had perhaps read Anglican clergyman and missionary Morgan Godwyn's assertion that the Canaanites had ended up in Asia and extended his rebuttal of Peter Heylyn's interpretation of Ham's curse.[41]

The *Athenian Mercury* circulated a black body that appeared in imminent transformation into whiteness upon resurrection. As Wheeler has argued, the journal assumed "an original whiteness from which all populations degenerated" and thereby "neatly reconciles English chauvinism with the sense of common human origins."[42] But it also offered a future of whiteness in the accidental nature of blackness. Blackness remained distanced, attached to and somehow tinged by its origins in English structures of barbarism and heathenism. An occasional, imagined African voice reminded readers of beauty's relativity by claiming jet to be more beautiful than alabaster. But the English Protestant nation remained white in counterpoint to the degrees of tawniness found in the rest of the world. Relative notions of beauty existed alongside (and in conflict with) the need to believe in an Original whiteness. Assertions of relativity may have posed as considerations of "the black viewpoint," but they did not necessarily embrace it.[43]

The *Athenian Mercury* made rare reference to the Africans (not to mention Native Americans or South Asians) who had come to live in local households and none at all to those who worked or were sold in the coffeehouses where its latest issues were often read. Some of these racial others did convert to Protestantism, experiencing baptism in local parishes. During the Restoration, discussions about the meaning of blackness were divorced from those about domestic forms of slavery, but the questions raised about skin color reflected the difficulties of conversion, which was and remained one of the primary explanations for imperial power. What clearly emerges from the journal's seven-year run is that these sorts of questions about salvation, the origins and transmission of blackness, and the relativity of beauty found a reading public of a new scale in the 1690s. Uncertainty about the implications of human difference for

a single line of biblical descent suggests concerns about the validity of theories of monogenesis. To counter such radical insinuations, these editors clung to maternal impression and the sun, and they left unresolved the tension between their outward stance of relativism and their inward idealization of themselves. This tension meant that black skin and the soul of the black body continued to be curiosities.

Although the Athenian Society's version of enlightened universalism showed significant strains when it came to God's chosen likeness, it also led it to dispel some fantastical ideas about blackness and Africans. In most cases, the editors countered these ideas implicitly, which meant that a reader had to be aware of other conceptions of blackness in circulation at the same time. The mark of Cain, for instance, was repeatedly described not as blackness, but as the impression left upon a murderer's "spirits." Similarly, at the end of the first volume, the editors answered a question about how monkeys first came into the world. Their response made no parallels between apes and Africans. "That they are not produced," they argued:

> as some would perswade us, from any Heterogeneous or unnatural Mixtures, is plain from this unanswerable Reason; Nothing so produced ever generates any further, as we see in Mules and other Monsters, which are meer individuals, the Providence of God preserving all things in that natural order in which he made them, and making it impossible to introduce any new Species into his Creation, though those Species numerously and beautifully varied; fixing besides a general Inclination in all Creatures to their own kind, though of never so seeming different a make, as in Mastives, Lap Dogs, Gray-Hounds, &c.[44]

Perhaps those who "would perswade us" referred to travelers who intimated sexual relations between Africans and apes—we do not know. In rejecting some ideas about blackness and Africans as fantastical, the journal followed in the footsteps of Godwyn's *Negro & Indian's Advocate,* which also refuted the idea that Cain's mark or Ham's curse legitimated slavery, proved in a carefully laid argument that blacks were men, not beasts, argued that they were not the produce of unnatural intercourse with apes, and asserted that their bodies were the works of God, that they were "Rational Beings," and so on.[45]

The *Athenian Mercury*'s account of a Southwark Fair curio exemplified how such rationalism constrained encounters that might have generated

moral readings of skin color or simple equations of blackness and monstrosity. Exotic bodies from the colonial world had been included in European displays of the monstrous since the sixteenth century.[46] Yet the reception of such bodies did not always work neatly to embody ideas about racial difference. The editors answered a question that read, "In the Year 1685, there was shewn in Southwark-Fair a black Negro Man, having a Child growing out betwixt his Breasts, with all the parts of a Man, except the Head: Query, What might cause such a Birth, and how did it receive its Nourishment?" The preternatural monstrosity of this particular curio did not prove to be blackness, however much the inquiring reader might have thought the descriptor "black Negro" important. Instead, the editors likened the creation to the workmanship of a tapestry being made by two workers: the faster one used up the materials before the "slothful" worker could finish, leaving him "constrained to leave his business imperfect; and fasten it to the other as well as he can." For "another Instance much like this," the editors noted, "See Vol. 1, N.29, Q4," where a similar tale of two joined white bodies could be found. The journal left the monstrous a category of strangeness, but not of ridicule or danger. A logical cause to the Southwark Fair monster was intended to instruct the populace, helping to dispel an age of fanaticism and atheism with a rationalist faith that saw the light of reason as the light of God. Literature on oddities and cabinets of wonders catered to a market in the weird and wonderful that persisted throughout the early modern period, but the *Athenian Mercury*'s debates about the nature of skin and soul also suggest that rather than simply try to categorize novelties as signs of the Other, Britons attempted to fit black bodies into a conception of themselves.[47] Accidental monstrosity constituted the awkward product of trying both to collapse and not collapse a distant space into the Isles.

Contact with African, Native American, Chinese, and Islamic societies encouraged radical revisions of the terms and methodology of knowledge in Britain. Growing awareness of variety in the broader maritime world generated new and revitalized old constructions of human diversity. Lotte Mulligan argues that the so-called scientific revolution was less abrupt than previously thought, that structures of thought inherited from Aristotle or Plato continued to inform the practices of science.[48] But the convergence of factors—the rapid expansion of knowledge about foreign worlds, the concomitant challenge that these new ideas posed to the established church, the developments in science and foundation of the

Royal Society, and the growth of popular interest in curiosities and collecting of things novel and strange—shaped the construction of foreign peoples as well as their imagined place within God's creation. The Anglican Church appropriated the language of natural philosophy in its attempt to thwart an insurgence of what it called "atheism" and to counter, on the other hand, an excess of what it deemed dangerous "enthusiasm." New forms of rhetoric—testimony, evidence, documentation, and witnesses—became part of an apparatus of "Reason" that opposed the "immediate" knowledge of Catholic infallibility or "enthusiastic" religions such as Quakerism.[49]

For a sector of society, the appeal of curiosity cabinets lay with this new system of classifying the world. In the seventeenth century, curiosity cabinets performed a critical function in organizing elite English (and European) interest in foreign peoples. By the 1690s, new critical epistemologies emerging out of the scientific revolution began to influence these cabinets. The *Athenian Mercury*, for instance, gave a positive review of John Conyers's curiosity cabinet; from their own perusal of this cabinet and from conferring with "Persons of Judgment," the editors said, they decided that Conyers "hath not only new methodized the things that he then had, but also made very considerable additions to them, so that the whole may appear New even to those who have heretofore seen his Musaeum."[50] Adding new novelties and subjecting the collection to new methods of categorization was an ongoing process, as the *Athenian Mercury* discussions about the origin and transmission of blackness make clear. The editors participated in this trend toward rationalism: the empirical probability they espoused reflected broadly on the Restoration's departure from earlier Aristotelian conceptions of knowledge and truth that represented a "newly focussed constellation of ideas about the nature of evidence, symptomology, prognosis, and inference." The editors culled instances from travelogues and colonial reports (often received through John Dunton's personal connections to New English ministers) to answer questions about biblical truth.[51]

Thus, on the one hand, the *Athenian Mercury* demonstrates how foreign nations and exotic lands were used to confirm divine narratives, as well as how this process pushed those narratives in new directions. The editors drew on travel knowledge to answer specific questions about snippets of Christian theology, making this journal one medium through which such knowledge was made available to people who may not have had access to the original texts. Coffeehouse patrons and subscribers could

read or hear the journal and learn information about a variety of peoples; and they would be told how this information confirmed or contested biblical or other knowledge. These dissenting editors tried to make new knowledge fit what they already believed, but it inevitably altered their beliefs and standards of authority. When readers questioned the truth of biblical tales about the apple or the serpent of Eden, the editors turned to similar beliefs in foreign societies, pointing to the presence of such serpents in Madagascar where English ships traded or the existence of an "apple of Paradice" in India and Arabia. They argued for the existence of witchcraft by reminding readers that its effects were known in all four quarters of the globe.[52] On the other hand, when new knowledge contested deeply held beliefs, the editors tended to bend the evidence to fit their frameworks or to explain discrepancies through differences in bodies politic.[53] Foreign societies and their customs became fodder for thought, sources for comparison and greater understanding of the Protestant self, while simultaneously these foreign societies were absorbed into an evolving Anglo-Christian historical narrative. Language evolved as well, when, for example, Turkishness became a euphemism for Tory, absolutism, sexual corruption, or the sins of luxury. On the most general level, this form of integration was how imperialism transformed British culture.

This dialectical, interpretive process altered cultural frameworks and produced specific representations and understandings of foreign societies and peoples. Cultural relativism failed to solve the problem of blackness, but the journal did not erect a foundation of essential difference upon which a category of race could be built. Instead, this literary curiosity cabinet incorporated the black body through its fragmentation. The skin and soul of black bodies, African customs, Turkish mannerisms, and "black" Indians' stoicism—these subjects were treated separately in often utterly unrelated and incoherent fashions. Such simultaneous familiarity with the part and unfamiliarity with the whole directly related to the nascent organization of these bodies within a structured narrative of Protestant conversion that nevertheless continued to promulgate their exoticism. The act of collecting dislocated the body from the customs and cultures that contextualized and humanized it. Just as early images of Native Americans telescoped their bodies only to remove their geographical and societal context, the editors and readers contemplated the blackness of some bodies in a laboratory of their own "Reason" without extended reference to the societies or lands from which they had originated.[54]

The journal thus maintained a figurative curiosity cabinet around blacks with whom only some readers may have had contact, distancing while incorporating them into an English polity as a site where a rational Anglicanism could be articulated. The *Athenian Mercury* debates reveal the tensions raised by the recognition of human difference within a Christian framework of monogenesis; they suggest the inability to extend the boundaries of the Protestant community to include foreigners who had become subjects abroad and, to a lesser degree, at home. Various African countries, Turkey, and other parts of the foreign world were defined in relative and, as such, tolerant terms only when they were considered as separate subjects; different conceptions of beauty, depictions of the devil, religious practices, and social customs could be contemplated only while these foreign societies remained foreign. Keeping societies separate and that middle ground, the colonial plantation, largely invisible sustained the *Athenian Mercury*'s rationalist, relative stance toward understanding other peoples. In this chaotic literary curiosity cabinet, divisions between things were as important as the relations between them.

Selling interpretations of curiosities marked a significant departure from the *Transactions* of the Royal Society, which stressed the collection and detailed description of new objects over their elucidation.[55] The *Athenian Mercury*'s editors, by contrast, donned the role of interpreter for the public, packaging their curios with rationalist, relativist interpretations of them. Before the Reformation of Manners movement inspired Joseph Addison and Richard Steele to produce the *Tatler* and the *Spectator*, John Dunton and the Athenian Society argued for the utilitarian value of their journal, which would disseminate in plain style the technical discoveries of science, dissenting theology (though this was not at first admitted), advice about love and marriage, and any other subject that should take the fancy of their readers. Following in the footsteps of Francis Bacon and others who stressed the public value of education, knowledge was construed as a source of self-improvement, learning a means to liberate the mind. The journal's stated purpose was to rid its readers of the "superstition" and "ignorance" that kept them in "Slavery."[56]

Knowledge, however, was also a source of anxiety.[57] By the journal's own logic, new knowledge and new curiosities could have monstrous or improving effects, depending on how they were encountered. The search for knowledge, as the preface to the first volume stated, would lead to "hell itself" if it meant advancement. The *Athenian Mercury,* alongside

John Toland and Mary Astell, supported women's desire for education but nevertheless followed Boyle in believing that men of "fitter organs" had better understanding. Boyle's circle believed that "only the fortunate enlightened (and therefore Christian) philosopher would be vouchsafed the instrument with which to unlock the cabinet of nature."[58] Fear that misinterpretations of new knowledge would lead to enthusiasm, factionalism, and disorder helped to elevate those with "Right Reason." Part of the *Athenian Mercury*'s strategy for making its advice agreeable was its conscious inclusion of curiosities, but by interpreting them it also sought to control the thinking space they created or the impression they made on readers' minds. As they bent that knowledge to fit cultural preconceptions of a common, white origin of mankind, they resisted destabilizing understandings of the self. That they resorted to imagining the skinning of the black body upon its resurrection reveals the violent tension created by their desire to hold onto different cultural standards for beauty while at the same time insisting on a universal past. Continuing belief in monogenesis meant that growing awareness of human diversity challenged beliefs that the British Protestant was nearest to God. Rationalizing beauty as the product of custom or opinion merely delayed answering the question of what was best. That some Britons began, as early as the 1690s, to wonder about the possibilities of polygenesis highlights the sizeable stakes involved in the acceptance or rejection of variety.

In the early seventeenth century, Samuel Purchas, echoing Peter Martyr, had suggested that human variety was part of a divine plan. Later artists, notably William Hogarth, would translate this conception of human diversity into a tenuous acceptance of black people into the London populace. Other authors and artists could not, however, celebrate variety so unreservedly. Georgian art treatises and, later, antislavery writings would repeat the *Athenian Mercury*'s brand of cultural relativism and perpetuate similar tensions that resulted from the desire to erase difference while simultaneously embracing natural variety. Even though these relativists generally agreed that man could not know the purpose of God's montage, accepting that other societies held other ideals of physical beauty did not entail accepting racial plurality. Improving knowledge about the effects of tropical sun on white skin challenged climatological conceptions of skin color as well as ancient theories of maternal impression, destabilizing the elision that relative notions of beauty allowed; as these challenges to older ideas about difference became increasingly popular toward the end of the eighteenth century, notions of polygenesis took

hold. Over the course of the century, there would be those who simply accepted the idea that blackness was "horrid" or turned to models of human speciation that denied a common origin to mankind.

The slave trade, however, ruptured the division that sustained the *Athenian Mercury*'s relativist stance toward foreign peoples. Boundaries that were necessary to maintain rational inquiry broke down when the souls of black slaves were translocated into English spheres of faith. The *Athenian Mercury* tried to solve this problem by turning a religious question about the chosen people of God into an aesthetic question about the beauty of black skin. Sloughing off black skin in the ascent to heaven collapsed variety into heavenly unity, providing a temporary solution to the problem of imagining a racially plural Protestant community. But the extension of the Protestant covenant abroad complicated the careful reconciliation of God's variety and the notion of being Chosen upon which hinged the veracity of Protestantism over Islam and Catholicism. The presence of exotic others within the Protestant covenant raised impossible questions about what constituted the true likeness of God. For if the divine narrative led, in the end, to the eradication of heathenism and thus to the incorporation of nonwhite peoples into the Christian brotherhood, it forced Britons to consider the fact that variety was not eradicated along with conversion. This journal's construction of the black body in terms of skin and soul attempted to reconcile the irreconcilable, to make the unity of God fit the disunity of his creations. Later journalists continued to articulate British rationalism through an enlightened appreciation of black skin, but they began to suggest that this beauty signified the benevolent treatment of black slaves on British plantations—figuratively, in the polishing of jet.

4

There are . . . Ways of receiving Ideas into the Mind, besides
the Sense of Seeing. There are Millions of Persons in England
who never saw Rome, and yet I presume but very few of 'em
who han't some Idea thereof, and that in some part true, or
conformable to the Object (tho not adequate and perfect)
which they might receive by the sense of Hearing or Reading.

—*Athenian Oracle* (1706)

It is the late 1730s. In his London workshop, engraver Charles Mosley
makes a series of prints representing heats in a "European Race." The first
appeared in 1737, "humbly inscribed to ye Politicians of Great Britain,
France, Spain, Rusia Turky, Germany, Italy Holland and Corsica" (Figure
4.1). It depicts a race for a crown on a seashore, with an accompanying,
explanatory passage from Ecclesiastes 9:11: "I returned and saw under the
Sun, that the race is not to the Swift nor the Battle to the Strong, neither yet
Bread to the Wise, nor yet Riches to men of understanding, nor yet favour
to men of Skill but time and chance Happeneth to them all." The umpires
personify the continents. Europe reaches out to the oncoming competitors.
Asia is half-asleep. America and Africa are sleeping. As the biblical quota-
tion suggests, fortune rather than strength or wealth will decide this com-
petition. France is winning with the help of the Stuart Pretender, while
Prime Minister Walpole's concessions are preventing Britain from finishing
first. In the second heat, published in 1738 and dedicated to all the "Politi-
cians of the Universe," France continues to pull ahead toward the prize. A
fight has broken out among the continents: Europe grabs Asia by the col-
lar, waking up Africa in the process, though America remains asleep.[1]

Britons had been justifying the Protestant Reformation for some time
through military and naval conflicts, but these Continental contests had,
by the late seventeenth century, become entangled in the pursuit of em-

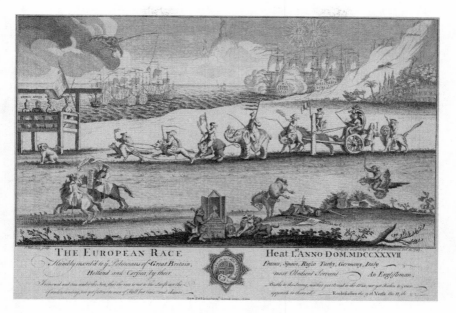

Figure 4.1. Charles Mosley, *The European Race Heat 1st Anno Dom MDCCXXXVII* (London, October 10, 1737). © The Trustees of the British Museum. All rights reserved.

pires. The race for empire fed broader anti-Catholic sentiments that fostered a deepening sense of nationalism during the Georgian era. If the New World received more attention from the British public than did contemporary struggles in Europe, it was in part because the theater of Continental rivalries had acquired a significant new stage abroad.[2] As trade cards, maps, and other forms of print associated the black body with the products and profits of empire, ongoing wars with Catholic powers inspired literary works, such as Alexander Pope's *Windsor Forest* (1712), that glorified maritime trade as a means to elicit the deference of the known world to the British crown. Almost continuous war with France and the Netherlands over the slave trade or with France and Spain over religion and colonial territories meant that urban centers, especially London, were flooded with propaganda that denigrated European countries for oppressing domestic and New World subjects. The British appeared, by implicit and explicit contrast, enlightened and civilized—at least to themselves (and when they were not contemplating slave resistance on

their own plantations). Journalists, merchants, fiction writers, and ministers promoted the civilizing effects of new commerce, supporting a perception of empire as a reflection of British virtue.[3]

Questions about the morality of slavery and the significance of human diversity continued to disrupt this imperial vision. By the early eighteenth century, the percentage of New World territories that relied on steady importation of newly enslaved Africans expanded considerably, benefiting British slave traders who also acquired the right to supply the Spanish colonies. Growing demand for slave labor and commodified captives intensified demographic concerns about maintaining imperial control. Because slavery was omnipresent in the early modern world, more attention has been paid to how Britons justified appropriating Native American lands than to how they justified such visible exploitation of human labor, especially in the Restoration and early Georgian eras.[4] But journals, sermons, and fictional tales published between 1680 and the 1750s suggest growing slave populations generated critical popular debate.[5] Justifications for New World *dominium* included an increasingly transatlantic conversation about the right to enslave, the reason for enslavement, and the master's duty to the enslaved. Slave resistance meant that these articulations of Britons' imperial presence never stabilized and, over the course of the first half of the eighteenth century, a notion of Africans' natural right to resist emerged alongside questions of whether skin color was being used to justify oppression. These debates reveal how the colonial plantation became a site of debate about British virtue, linking the retention of a balance of power in Europe to the luster of black skin.

Caring for Souls and Lives

Restoration journals primarily responded to concerns about the slave trade's legitimacy and English degeneracy in the New World rather than slave resistance. Moral questions about selling Africans or keeping them in plantation bondage did not require these journalists to confront the problems of incorporating racial others into Protestant communities. The *Athenian Mercury,* for instance, staged a second debate (separate from the one about human diversity) about slaving that interpreted the trade in human cargo as a means to conversion and thus as an important form of Protestant-Catholic conflict. The conversation focused largely on an abstract master-slave relationship, mobilizing very little knowledge of colonial societies. While the editors drew on New England missionary

reports, they did not directly include slaveholding colonists in their discussions of mastery. Such internal dialogues would, as the century progressed, become increasingly transatlantic as colonial planters, especially in the Caribbean, and slave rebellions forced metropolitan Britons to revisit over and over again the meaning of slavery and slaving.

The *Athenian Mercury* depicted the slave trade and slavery as a process of acquiring new souls to further the Protestant interest, a potential that could only be fulfilled if planters attended to their duties as masters. Its discussion of colonial slavery ignored skin tone, but the logic of the envisioned master-slave relationship paralleled that of the divine correction of black skin. As the acquisition of heathen souls came to signify a broader challenge to Catholicism, the conversion of the African slave became embedded in broader discussions of British virtue. Late in 1691, for instance, the *Athenian Mercury* argued that it was "undoubtedly Lawful to Deal and Traffick with 'em ["Negroes"]; for how should we else convert 'em?" However hard they worked on plantations, "tis the greatest *Kindness* we can do 'em, since otherwise they must either be *Killed or Eaten,* or both, by their barbarous conquering Enemy—Besides, it might be a means to *save* their *Souls* as well as *Lives,* were that care taken of 'em that ought to be." The editors held common assumptions about the value of trade and the nature of life in West African coastal societies and colonial plantations. They expressed one of the most popular ideologies of the late Stuart and Georgian eras: saving African "*Souls* as well as *Lives*" by English "care" and "*Kindness.*"[6]

This London journal presented the slave trade as a beneficial and virtuous relationship with Africans that preserved rather than destroyed them. Conversion and care—read, enslavement—saved those Africans from dying or living out a future of barbarism and paganism. European travelers to Africa and North America often expressed horror at mutilations of the non-European body—whether by ritual scarification, sacrifice, cannibalism, or female circumcision.[7] They offered readers both vicarious encounters with exotic violence and horrified perspectives on it. In these tales, individual Africans or Native Americans were often left uncertainly implicated. The *Athenian Mercury*'s description of Africans being "*Killed or Eaten,* or both, by their barbarous conquering Enemy" falls within this tradition of mystifying exotic violence: "they" have been denied security and peace by "those" Africans who ate them instead of tending to their souls. Although cannibalism could at times imply a lack of rights in European eyes and thus legitimate slavery, in Restoration

journals the central motif was the act of salvation from this presumably depraved state.[8]

Only by redirecting those doomed Africans into a legitimate trade would they survive victimization by the "Enemy," the unidentified "barbarous" conqueror who probably also sold them to European merchants.[9] Because the voracious conqueror remained vague, the imagery of monstrous consumption was projected into an infinite future: there is no end, in this incidence, to the mangling and eating of the African body by other Africans. The martial and volatile societies on the western coasts of Africa made an unspoken contrast to the salvation, care, and kindness of some geographically unarticulated English presence. Applying to an extreme the notion that commerce extended civilization, the editors argued that the heathen African was saved through the experience of being commodified. This conception of the duties of a Christian to "care" for infantilized victims of barbarity had long been a European justification for *dominium* in the New World.[10] It produced a vision of the slave trade that masked its violence, rendering the very moment in which Africans became currency, exchangeable for objects on both sides of the Atlantic, the point at which salvation became possible—for both the African and the Briton.

Although the *Athenian Mercury* situated itself within the trend toward rationalism in the late seventeenth century, it still supported what Linda Colley has called "an apocalyptic interpretation of history in which Britain reincarnated Israel and its opponents were represented as Satan's accomplices." The editors insisted that William III's attempts to liberate Europe from Catholic oppression would bring even greater glory than Caesar's conquests, which had "ravish'd the Empire of the World."[11] An English summary of a 1689 French publication argued that "France has kept the Court of Rome as it were in Slavery; and that he [Louis XIV] does not stand to complain, as if the Pope did him wrong, not to become his Vassal." This "conduct," the editors urged, ought to waken the "Princes of Europe." England was "ready to act against [France], and . . . to deliver Europe from a slavery that she is begun to fall into." War and expansion, colonization and slaving were part of the process by which the "bonds" of Protestants would be broken, the "hostile Tyranny" of Catholicism brought down and replaced with Protestant "paternal Rule."[12] English benevolence thus offered slavery to benighted Africans while saving Europeans from the same fate.

The roots of this notion of benevolence lay again in the earliest Atlantic encounters, in the formation of English imperial identities from the materials provided by the Black Legend. Britons juxtaposed Spanish vio-

lence and greed to their more benign and altruistic ventures. They envisioned amoral and anti-Christian Spanish raids supplanted by Protestant settlements of English colonists who sought salvation in the New World and for New World inhabitants. Enslavement proved a powerful metaphor for the ascendancy of Catholicism both at home and abroad, and Britons responded by depicting their own involvement in African slavery as a process of liberating those who lived in "Bondage to Sin and Satan."[13] Yet journalists had to remind readers continually that the duties of such mastery included conversion and the placement of Africans in a happier state of life.

Certain biblical passages invested this imperial vision with urgency. Citing Matthew 28:19–20, the *Athenian Mercury* argued that Scripture ordained the preaching of the gospel: "Go and Disciple all Nations, baptizing 'em, &c. teaching them to observe all things, and lo I am with you even unto the End of the World."[14] A number of Britons asked whether colonists ought to be required to baptize slaves. In 1694, one reader of the *Athenian Mercury*, perhaps in reaction to Barbadian planters who resisted African conversion, wished to know whether "those Merchants and Planters in the West Indies, as well as all other parts of the World, that buy Negroes or other Heathen Servants or Slaves, are not indispensably bound to bring such Servants to be Baptized, as well as Abraham was to Circumcise his Stranger Servants?" If Abraham, the editors asked rhetorically, had to circumcise the members of his household, including those who "were bought with mony [sic] of the stranger," should not Christians "by Parity of Reason . . . do the like by their slaves and servants?" Such biblical interpretations of imperial mastery invested it with significance in terms of Britons' rejection of Catholicism, even if the scriptural passages were the same that Catholics used to support their own claims to New World *dominium*.[15]

The *Athenian Mercury*'s discussion of imperial mastery, however, gave it a Protestant twist by integrating the conversion of racial others into sectarian debates and using it to argue for Protestant unification. It interpreted, for instance, a master's duty to enslaved African children in terms of broader debates about infant baptism. The dissenting editors used the example of African and Native American children to argue against Quakers and Antinomians who had refused the practice. They believed that the "vertues" of Christ's death ought to be offered to all who wanted to wash away "their original pravity." Drawing both on local authorities and on the exoticism of the African soul, the editors informed readers

that "a great Man of our church" believed that "a Negro's child ought to be baptiz'd, as well as any others." As Christ had said: "To all that were a far off, as well as to believers and their children." The universalism of infant baptism proved its veracity:

> we find it not only in the Churches of Europe, but also that 'tis the Uniform Practice from the first Plantation of Christian Churches, and of such Colonies of the same Mother Church, as had Correspondence by their Bishops or Presbyters; and such as were of Original Plantations, or betwixt which 'tis more than probably there was no Communication, by reason of the vast distance and want of Intercourse betwixt the Countreys where they lived, as the Abassin Church in the further Æthiopia, and the Indian Church in Conlan and Crangonar, and about Maliapar, planted by St. Thomas.

In the furthest outposts of Christian missionary work, inborn knowledge of God was found among the youngest of children. The editors culled examples from John Eliot's *Tears of Repentance* (1653), an account of northeastern native American conversion, to argue that all children had potential if not actual faith. All infants, they argued, who were "born in Abraham's house, or bought with mony of the stranger, or Barbarian (who often sold their own children then, as they do now) if they [had] then . . . the seal of the Covenant, how have they since forfeited it?"[16] Such focus on the duty to bring enslaved or foreign children into the Anglican faith reflected the central tenet of baptism in Christ's covenant, the editors' desire to heal rifts within the Protestant church, and their notion of the slave trade as a process of conversion. By embodying Abraham, the father of the Jewish nation, the English proselytizer furthered a divine mandate and unified Protestants through an expansionist ideology.

This conversation highlighted the biblical underpinnings of some visions of empire. Baptism of Africans, Native Americans, and Turks occurred, in the *Athenian Mercury* and other journals, within a broader mercantilist vision of spiritual resources. Protestant success would, in this particular vision, delimit Catholic, especially Jesuit, expansion. In a world in which victory indicated divine favor, the impulse to baptize had much to do with proving Protestantism to be the true faith. If "any such care" were to be taken, the editors warned, "it must either be by the Papists or us."[17] Although most English colonists invested little energy in conversion and some actively prevented it, Britons at home fantasized about this imperial outcome and its importance for their race for religious and political

preeminence in Europe. The Church of England also tried, after the Restoration, to insist that planters convert their slaves.[18] Journals such as the *Athenian Mercury* were acutely conscious that this fantasy was in jeopardy. The consequences of appearance (which mattered more than reality) had already been clarified by the Anglican missionary Morgan Godwyn: people made conversion of foreigners "an Essential Mark of the Catholic Church, and from thence would prove their Religion true, and ours, at the same time, false." Failure to convert heathens provided "sufficient grounds to unchurch us, and to determine us no Christian Nation."[19] Empire, in this iteration, was a race to claim heathen souls, the success of which would determine the outcome of the Reformation.

Although some blacks were baptized in Britain and the colonies, from the *Athenian Mercury*'s perspective, Protestants and Catholics were equal failures in this project because of a general corruption of Christian values. On the one hand, the editors thought, European wars sapped energy that could have been expended abroad. On the other hand, all the "voyages, expeditions, or embassies" designed to "promote, or plant the Christian faith among the Heathens" would "puzzle a good Historian." Catholics had made but one convert, they mocked, because their predilection for the "rich and fertile parts of the earth" had prevented any further success. Protestants, meanwhile, had "found time and means to correspond even with the remotest parts of the earth, where wealth or profit call'd us, nay sometimes where only revenge." "Tis in vain," lamented the editors to a reader who wondered why so little care had been taken to convert pagans and Turks. How can we "talk of Converting Turks and Pagans, while we, who call our selves Christians, are worse than Pagans and Turks, both in our selves, and to one another." The "Immoralities" that "reign[ed]" in England, they argued, rendered proper "care" of heathens "ineffectual." Atheism had spread through Christendom, "or what's as near as men can possibly go for their own Consciences." It did not surprise them that a witty man had inquired why a London gentleman had baptized "his Black" and "spoyl'd a Good Heathen—since even the Light of Nature teaches, to abhor the Manners of too many Christians." They blamed such problems on greedy masters who "for fear of loosing their bodies" would "venture their Souls."[20] Such failures to convert and care for pagan Africans directly undermined the journalists' justification for the slave trade; they would eventually require Britons to conjure new answers to the persistent question of why they involved themselves in the slave trade, especially as colonists blamed metropolitan Britons for failing to give

financial support to conversion efforts and as Africans rejected this vision of benevolent rule.

Making Care the Measure of Britons

During the Restoration, improving this situation—the spread of immorality in Christendom—meant exhorting masters to fulfill their imperial role. A master who valued the body over the soul stood charged with heathenism and lost his distinction from his slave: "Talk to a Planter of the Soul of a Negro, and he'll be apt to tell ye (or at least his actions speak it loudly) that the Body of one of 'em may be worth twenty Pounds, but the Souls of an hundred of 'em would not yield him one Farthing." Perhaps worst of all, the actions of these masters intimated that Christianity rendered men worse than if they had remained heathen. The *Athenian Mercury* pointed to perverse tempers among the planters, the suitability of some more for "Slaves than Freedom," or a lack of education that meant they were only Christians in name.[21] Going forth and baptizing, by contrast, improved the Protestant master, elevating him as he elevated his slaves. This moral discourse bound together the converter and converts as the slave's spiritual well-being became proof of the master's Christian virtue.

Attributing moral degeneracy to colonists insulated those at home from the effects of conquest and confirmed beliefs, which had helped to justify conquest, that people living closer to the tropics lacked refinement. Many authors commented on colonial corruption and rejected metropolitan complicity by turning to climatological explanations for behavior: "We are only charged with the Neglect," Godwyn remarked; "I shall not add the opposing of it; that being the Crime of such degenerated English, who with that air, have imbibed the Barbarity and Heathenism of the Countries they live in: And with whom, through the want of Discipline, Christianity doth seem to be wholly lost, and nothing but Infidelity to have come in its place."[22] He echoed early reports from Caribbean settlements that stressed the "atheistical" brutishness of planters who were in need of "Reformation." Throughout the eighteenth century, popular tales, journals, and travelogues disparaged planters, drawing both on the notion that "the sort of people," as Lord Willoughby had put it, who generally constituted the front wave of settlement were not "civilly bred" and on the idea that tropical climates encouraged immorality. A 1725 pamphlet reported that "many English" in "our Western Plantations" had, rather

than gain converts, "degenerated into Heathen, being Members of no Church, without Morals, without Faith, without Baptism."[23]

Such repudiation of colonial settlements extended, however, only so far. It was meant to push colonists to fulfill moral duties, to uphold this specific imperial fantasy—it did not pose a challenge to slavery, though latent within it was one. For the *Athenian Mercury,* the problem was the belief that slaves ought to be freed upon conversion. This focus on baptism may have reflected the legal fuzziness of slave status in Britain, which made the question of conversion more critical to defining their subordination than in colonial settings that had clearer slave laws. Some evidence suggests that blacks in Britain deliberately sought out baptism in the belief that they would then be set free. And despite colonial laws, many planters also remained uncertain about the implications of conversion.[24] The *Athenian Mercury*, however, argued that no biblical precedent suggested that this should be so: nowhere did St. Paul "once tell his Master 'tis his Duty to set him Free, all he desires is, he'd again receive and forgive him; nay, he tells [his] Servants, 'tis their Duty, in whatever state they are call'd, therein to abide." And besides, the editors concluded, reiterating and subtly altering their original justification for the slave trade to include a more permanent sense of status:

> some Persons, nay, Nations seem to be born for Slaves; particularly many of the Barbarians in Africa, who have been such almost from the beginning of the World, and who are in a much better condition of Life, when Slaves among us, then when at Liberty at Home, to cut Throats and Eat one another, especially when by the Slavery of their Bodies, they are brought to a capacity of freeing their Souls from a much more unsupportable Bondage.

Invoking Aristotle's doctrine of natural slavery to reassure imagined (and real) slaveholding or slaving readers, the editors claimed that Africans had been barbarians from time immemorial. Christian duty extended only so far as to place them in a "better condition of Life." Bondage of the body still constituted a means to liberate the soul. The *Athenian Mercury* tentatively encouraged a law or custom that would enable African slaves to gain freedom only if it encouraged them to convert.[25]

Without the concurrent transformation of civic status with conversion, incorporation of African Protestants lay only in the ecclesiastical domain and, ultimately, in an ascent to a common heaven; it lay in an imagined future, one that for the *Athenian Mercury* also involved the removal

of blackness. This characterization of the master-slave relationship as fulfilling scriptural duty suggests why the plantation was spatially and formally absent in Restoration discussions of conversion except as a place of moral depravity (in the context of exhorting planters to fulfill their duties). The question of slavery's legitimacy was asked and answered within a set of assumptions about how the Protestant covenant extended to the planting of colonies abroad. "For how should we else convert 'em?" situated slavery squarely within a European market of heathen souls. The editors, fighting to challenge growing "atheism" and religious relativism, knew that successful participation in this market had political and civic ramifications for Britons. In part, this conception of the slave trade as redemption and the plantation as God's work drew from the portrayal of the New World as a biblical wilderness and paradise that held out "extraordinary temptation, obligation, and promise."[26] It also exposed fears of the moral reverberations of the pursuit of empire for those at home. But this conception of enslavement integrated Africans into British culture as signifiers that connected domestic virtue to imperial presence, a moral resource defined by mercantilist visions of the fixed quantity of souls. These imagined relationships circumvented the racial consequences of contact by retaining an imperial hierarchy that inscribed social and cultural distance from the converts.

Sixteenth- and seventeenth-century missionary expeditions had provided the groundwork for such extensions of the Protestant covenant. Godwyn's publications in the early 1680s, for instance, portrayed the New World duties of Englishmen as a typological fulfillment of the Scriptures: "And since that our Blessed Lord commanded his Apostles, St. Mat. 28. to go and make Disciples of ALL the Heathen, why may it not be alike lawful for me, with the great Apostle, Heb. 2.8. to both argue and conclude, In that he said All, he had excepted none?"[27] Godwyn connected the successful reformation of planters' manners directly to the success of the "Protestant Interest" in thwarting "Popery," since when "those Myriads of People" became Christian, they would become "a Strength and Defence to our Religion (in this time of its distress)." For Godwyn, to fail in this project would be to risk God's apocalyptic wrath. As religious societies formed in London to advance the gospel abroad, ministers overseas and at home gloried in the idea that "GOD hath given [them] an extraordinary Authority over [their] Slaves;—a Power, which (except in Life or Limb) hath very few Limitations."[28] But they made clear to metropolitan and colonial congregations that duty required attendance to

the spiritual deliverance of slaves. The Society for the Propagation of the Gospel, which organized in 1701, argued for conversion on the basis of familial obligations, but continued to give the act of conversion urgency by infusing it with anti-Catholic consequences. In 1750, Thomas Bacon, an Anglican minister and slaveholder who preached on Maryland's eastern shore, published four sermons in London on "the great and indispensible duty of all Christian masters and mistresses to bring up their Negro slaves in the knowledge and fear of God." "Christian charity," Bacon argued, required each slaveholder to "labour for the Good of their souls . . . as they are a Part of our Families and Substance, and absolutely under our Power and Direction." The "peculiar Favour of Providence" had given slaves to the British for their "Benefit," and they could not do without them. Yet God had, "by fixing their Lot among us," intended to secure "the better Provision for their souls." Another sermon published in Newcastle exhorted that it was "now the birthright of Englishmen, to carry, not only Good Manners, but the purest Light of the Gospel, where Barbarism and Ignorance totally prevailed." These discussions of mastery reconciled politico-ecclesiastical conceptions of authority with evolving notions of commercial virtue. They reflect the integration of this vision of empire into the Briton's "birthright."[29]

The emblematic value of the African body for this narrative of imperialism derived from its economic value to European empires: as a common denominator of Atlantic imperialism, the black slave was invested with symbolic potential to characterize imperial rule. Godwyn, for instance, visualized his utopian imperial project in a broadside called *The Revival* (1682), which described an illustration that was to be included in the *Negro & Indian's Advocate*.[30] The projected image stressed complicity in the abuse of slaves abroad. In his imagination, the right quarter represented the call to spread the gospel to "all sorts of People thro-out the World": it contained St. Peter delivering the Oracle, "God is no respecter of Persons, but in every Nation, &c.," and beneath him "Veritas Christiana: or this, Nothing common, &c." In the left quarter, St. Philip baptized the Ethiopian Eunuch, representing the biblical passages that proved God's plan (as communicated in Acts) included the specific conversion of "Blacks or Negro's." Beneath St. Peter, the New England motto, "Come over and help us" (Acts 16:9), would be placed above (and fulfilled by) a group of New England ministers instructing natives who stand above the inscription, "The Shame of Others." On the other side, Catholic missionaries preaching to African, Asian, and American subjects would remind

Protestant viewers of their struggle: Catholics would stand beneath "(to those that shall less value their Conversions and Labours therein)" and above "The Reproach of the Protestants." An overseer occupied the lowest rung in this visual hierarchy, "whipping and most unmercifully tormenting a poor Negro-Slave under his Governance, for no other Crime, but for having been that day (Sunday) baptized." The colonist would say, with a willow rod in one hand: "Ye Dog, as were baptized in the Morning with Water, so in the Afternoon ye shall be baptized in blood." Godwyn described the abused black body as though it were the body of Christ: "The Negro tyed by both his Wrists up to a Rafter or Beam; deep marks of each Stroak appearing upon his Flesh, and drops of Blood in abundance issuing or starting out of his Body, stript quite naked; he withal expressing his pathetical Expostulation, How long, Lord God!" Beside his description of this emotive figure, Godwyn footnoted the complicity of the English public: only "a few were concerned in this horrid Fact, yet our whole Nation are guilty by conniving at, or not protesting against their Impiety in the suppression of Christianity." The point of this illustration—to curry the moral outrage and reformation of his audience—was encapsulated in three final biblical epigraphs: "If by any means I may provoke to Emulation, &c. . . . Peradventure he sleepeth, and must be awaked. Be not ashamed to confess wherein thou hast transgressed, and resist not the Truth." This hierarchical representation of the spiritual colonial world placed the English colonist on the bottom, using the enslaved and tortured African body as an emblem of the unfulfilled project of conversion and the battle against worldly sin.

This moral vision of empire brought the metropolitan reader, planter, and slave into an unstable triangular relationship. The black body and soul literally became a text with which metropolitan Britons articulated ideologies of mastery, tying domestic morality (and especially its reformation) to the proper treatment of African slaves.[31] Othering planters by reproving their behavior created space for the slave to be the victim and at times to become the spokesperson for metropolitan morality. Planters, according to the *Athenian Mercury,* flatly discouraged their slaves from attending church, even though many of the "wretches, as we have been inform'd, earnestly desire it."[32] The heathen became the victim in a story that was primarily about European virtue. Such fetishism of marks on the black body and enslaved Africans' "pathetical Expostulation" proved central to mainstream antislavery rhetoric as "How long, Lord God!" morphed into "Am I Not a Man and a Brother?" and as Godwyn's projected image

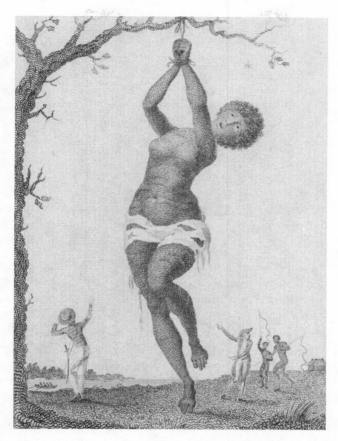

Figure 4.2. William Blake, *Flagellation of a Female Samboe Slave* (London, 1794). © V&A Images/Victoria and Albert Museum, London.

became manifest in other artists' works, perhaps most famously William Blake's depiction of the flagellation of an African woman enslaved in Surinam (Figure 4.2). Threats of cannibalism that had legitimated the slave trade shifted to threats of planter mutilation, and thus the reformation of manners at home was tied to the proper treatment of slaves abroad. Care and conversion remained central to this imagined relationship, but the African cannibal was replaced by the degenerate planter, embedding the black slave ever more critically in conceptions of British virtue articulated in relation to other European empires.

From Souls to Skin: Redefining Care

The emergence of the plantation in ideologies of empire mapped growing reliance on African bondage for imperial success. Each passing year increased Britons' dependency on the trade that transformed Africans into "black gold." By the 1730s, Britain had become the leading slaving nation in Europe. The use of African labor gained support as the coupled growth of slaving and slavery brought an unprecedented period of expansion to most of plantation America from 1713 until after the Seven Years' War.[33] Despite Barbados's exceptional early success, metropolitan writers did not fully recognize that plantation trade could rival the wealth produced from Spanish mines until the 1720s and 1730s. Merchants stressed the value of the African trade to the rest of the trade cycle. In 1729, colonial agent Joshua Gee remarked,

> OUR trade with Africa is very profitable to the Nation in general; it has this Advantage, that it carries no Money out, and not only supplies our Plantations with Servants, but brings in a great Deal of Bullion for those that are sold to the Spanish West-Indies . . . The supplying [of] our Plantations with Negroes is of that extraordinary Advantage to us, that the Planting Sugar and Tobacco, and carrying on Trade there could not be supported without [t]hem; which Plantations, as I have elsewhere observed, are the great Causes of the Increase of the Riches of the Kingdom.[34]

Even after the trade in such so-called servants came under fire from antislavery activists, Britons argued that it was the "principle and foundation for all the rest, the main spring of the machine, which sets every wheel in motion."[35] James Wallace's *History of Liverpool* (1795) recounted that "almost every man in Liverpool is a merchant, and he who cannot send a bale, will send a bandbox." "The attractive African meteor" had "dazzled" everyone: "many of the small vessels that import about an hundred slaves, are fitted out by attornies, drapers, ropers, grocers, tallow-chandlers, barbers, taylors, &c." Colonial slave populations increased at an even faster rate than staple production: the 60,000 enslaved Africans living in 1690s North America quintupled by 1750, while Caribbean colonies housed about nine Africans to every one Briton by the 1730s.[36] The value of Africa, once primarily measured in its gold, ebony, and ivory, was reconstituted in terms of the wealth produced by black labor in New World colonies.

Slave revolts forced Britons at home to confront the exploitative rela-
tionships that engendered this wealth as they unsettled the mythology of
black domestic servitude that worked to refashion plantation labor, met-
ropolitan romanticism of enslaved resistance, and initial ideologies of
conversion and care. Although some scholars have pointed out the origins
of abolitionist discourse in early eighteenth-century transatlantic conver-
sations about the practice of slavery, the importance of slave resistance in
forcing the ideological extension of Calvinist discourses of resistance to
include African slaves has not received enough attention.[37] Extending the
right to resist intensified debates over the meaning of blackness, as metro-
politan critics and colonial planters invested the luster of black skin with
signification of the oppression or benevolence of British rule.

In the 1730s and 1740s, metropolitan journalists and some West In-
dian planters argued about the practice of slavery through the voices of
two quasi-fictional Africans: a maroon leader, Moses Bon Sáam, and a free
black Christian, John Talbot Campo-bell. These dialogues mobilized an
established ventriloquist tradition that used foreign perspectives to inter-
rogate the self. For the *Athenian Mercury,* the "Good Heathen" exposed
Christian corruption; for the playwright James Miller, the "poor untutor'd
Savage" scoffed, "Civiliz'd ha! who are they." Miller announced that au-
diences would find in this savage a clothed Body but "naked" Mind, a
man who spoke the "Truth" of nature and was "A Glass too true, in which
we all may see, / Not what we are, but what we ought to be."[38] Postcolo-
nial readings that stress the definition of the self in opposition to an
Other miss this dimension of the Atlantic frontier in Britain, in which the
heathen became a reflection of what Britons "ought to be." Metropolitan
Britons began to see themselves through the gaze of those they oppressed,
creating space for uncertainties about imperial practices to manifest
themselves in fantasies about these relationships and to be intensified or
activated by instances of slave resistance.

From the earliest decades of the British slave trade, as artists appro-
priated the black servant's gaze to reflect on the virtue or vice of specific
forms of mastery, authors borrowed the enslaved voice to articulate a
standard of mastery, a practice that derived from the rhetorical device of
reversing the savage and civilized. Such interrogations typically sought to
rationalize hierarchy by rationalizing racial difference, leading to some
of the same difficulties that confronted the *Athenian Mercury* editors in
their celebration of variety. But, over the course of the eighteenth century,
the rising popularity of captivity narratives, including those of African

and Indian bondage, and the developing fashion for pathos suggests a particular desire to dwell on both enslaved experiences and African or Native American perceptions of Britons. Pamphleteers, poets, and journalists imagined the individual slave appealing directly to metropolitan sentiment. Several epistles from Yarico, the Native American or African lover of a greedy British merchant, lamented her enslavement. A 1736 version berated the British merchant for his empty Christianity, portraying Yarico "tenderly" pleading "the Negro's cause" while the reader "melts in soft compassion at her woes." The pathetic savage—and his or her contradiction of the typology of barbarians—had earlier roots in the Renaissance, when even Caliban spoke some of the most eloquent lines in Shakespeare's *The Tempest*. But the softening character reflected the developing construction of British imperial benevolence in terms of the empathetic experience of suffering.[39] Slave rebellions, however, ensured that the location of that suffering increasingly shifted from the voracious cannibalism of unknown West Africans westward to colonial settlements, especially Caribbean plantations, and to the persistent problem of what constituted care.

The *Prompter* introduced the "Old Free Negro" Moses Bon Sáam in January 1735, in response to West Indian slave rebellions and the formation of an autonomous Jamaican maroon community. Bon Sáam most likely embodied a combination of domestic ideas about rebellious slaves and reports of the Jamaican maroon leader Cudjoe. Given that two London playwrights, Aaron Hill and William Popple, edited this journal, ennobled and rebellious fictional slaves, such as Oroonoko, probably provided a model for Bon Sáam: like Oroonoko, he proved more interested in secular liberty than Christian salvation. But the *Prompter* also informed readers that their information about Bon Sáam's speech arrived with an "Eminent Merchant" from a Caribbean island.[40] Bon Sáam was the imagined leader of the Jamaican Leeward maroon community, whose ascendancy and formal recognition by white Jamaicans was mapped in a series of reports to the *Gentleman's Magazine* in the 1730s. The Leeward maroons, centered at Cudjoe's Town in the cockpit region of western Jamaica, established an autocratic government reminiscent of the Asante polity on the Gold Coast. Jamaican planters finally acknowledged their power after losing a war that ended in 1739. Cudjoe's Treaty acknowledged the maroons' autonomy while requiring them to return fugitive slaves.[41] Bon Sáam was probably based on Cudjoe (the *Gentleman's Magazine* reported that the maroons had elected a "king"), providing an instance long before the abolitionist movement in the 1770s and 1780s in which

we can clearly track African influence on metropolitan understandings of slavery, racial difference, and imperialism. That Britons imagined Cudjoe through such powerful and classicized black characters as the West African prince Oroonoko shaped how they interpreted and explained his act of grand marronage.

"Dear Fellows in Arms and Brothers in Adversity!" began Moses Bon Sáam to his followers. He lamented that he could not find happiness in freedom: he had gained "Ease" by defending his master, but he found no "Blessing" in such freedom, "tormented" as he was by slaves' "Groans, because no longer a Partaker" in their "Misery." Freedom had awakened pity, whereas slavery had accustomed him to suffering: "I have, since, been taught your Wretchedness, by Sixteen Years of Liberty: By Sixteen Years, not spent in Ease, and Luxury, like the Lives of our Oppressors; but in long, laborious Diligence in Pursuit of their Arts, and Capacity." He had discovered that only "Education, and Accident, not Difference of Genius," caused the "provoking Superiority, that bids the Pride, of a White Man, despise and trample on, a Black one."[42] Acquiring those accidental effects himself, Bon Sáam had learned that blackness was the sole reason for enslavement. The question had come down to whether Britons could justify the slave trade and slavery without rejecting the divinity of variety.

Bon Sáam did not make it easy for his "maroon" audience: he echoed in dramatic form the conclusion about blackness that some Britons reached through rationalism: "WHAT Preference, in the Name of that mysterious GOD, whom These insulters of Our Colour pretend to worship, and confide in, what wild imaginary Superiority of Dignity, has Their pale, sickly, Whiteness to boast of, when compar'd with our Majestic Glossiness!" "If there is Merit," Bon Sáam continued, "in Delicacy, we have Skins, as soft as their Velvets; If, in Manliness, consider your Shape, your Strength, and your Movement! Are they not, All, Easier, firmer, and more graceful!—Let a White Man expose his feeble Face to the Winds." His "majestic glossiness" invoked the stoicism attributed to Africans and Native Americans, literally embodying resistance in the luster of his skin. The white man, he thought, could not bear such suffering: "Tho' terrible and haughty, to his Slaves," he would lose his "Fierceness" in the smallest struggle against the elements.[43] Liberty had taught Bon Sáam slavery's horrors: adding education to rage created the potent rebel leader of this quasi-fictional text.

Bon Sáam encouraged his fellow maroons to study classical arts of war, reflecting the association of savagery and chaos (as opposed to civility

and order) that had shaped the earliest European representations of native societies in the Americas. The "whole Advantage," Bon Sáam asked, "of these proud Spoilers of the Work of GOD, who dare make Beasts of human Forms as noble, and more manly, than their own, in what, consists it, but superior Happiness?—They are not wiser by Nature, but more exercis'd in Art, than We are." Whites, he pointed out, could raise armies because, like the classical Romans, they had rules and modes of war, as well as more discipline; his maroon followers, on the other hand, were resolved but not dependent, and so fell apart and lost their "Firmness." To prevent such emasculating descent into chaos, Bon Sáam advised his followers to wait patiently and "be thought weak" until the foundations of their resistance were "secur'd" and "deepen'd."[44]

Aside from labeling planters "proud Spoilers of the Work of GOD," Bon Sáam's speech did little to advance the cause of conversion. His inattention to the state of enslaved souls and his belief in the necessity of a leader to unify and direct resistance echoed Southerne's characterization of Oroonoko's fictional slave rebellion. His attribution of resistance to black male "Rage," indeed to hypermasculine blackness, also fit theatrical and literary understandings of revolt. But in the fear of education lay a new racial consciousness in constructions of imperial hierarchies. Planter immorality entered into the discussion in terms of their daring willingness to "make Beasts of human Forms." Threatened again with the indefensible belief in the superiority of whiteness, accepting the beauty of black skin became an index of British imperial virtue, while bondage became a site of debate about the meanings of human diversity. If in Restoration journals, discussions of human variety and practices of colonial slavery remained separate issues, by the early decades of the eighteenth century they had become linked. Bon Sáam denigrated planters who disparaged children of God on the basis of skin color, whipping them not only with their implements of torture but with their words.

Bon Sáam drew inspiration from two historical examples of slave resistance, which had been invoked repeatedly in Calvinist discourses of the right to resist: first, his namesake, Moses, who delivered his people, "a Nation, chosen, and belov'd, by GOD," from a slavery no different from their own; and second, the Dutch, who had once been "a Kind of White Slaves," but had thrown off their bondage a hundred years before. In the 1730s and 1740s, both metropolitan and Caribbean Britons reacted to Bon Sáam's speech in the *Prompter* as if it were a straightforward defense of slave resistance, sparking a lively transatlantic conversation.

That the speech elicited such a backlash highlights the planter audience to such metropolitan depictions, as well as its radicalism—especially considering how deeply qualified Bon Sáam's incitement to rebellion was. He did not seek to eradicate the slave system, but to retreat to the island's center, containing his rebellion within its forests. He instructed his followers to "study to support our new Liberty, [rather] than revenge our past Slavery," inspiring them with the example of the Dutch: "assure yourselves that the Proudest of your Enemies will embrace you, in spite of your Colour, when they foresee Destruction in your Anger; but Ease, and Security, in your Friendship."[45] His vision of the maroon community mobilized classical notions of virtue; rather than overthrow their neighbors' slave system, they would work the land. Power, not revenge, would ensure friendly relations with former masters.

Bon Sáam also did not challenge the bondage of already enslaved Africans, but rather the legitimacy of binding subsequent generations. He countered Aristotelian notions of natural slavery and the common-law notion that Africans had been slaves since time immemorial by pointing out that Moses's descendants had forefathers who were slaves. He principally, however, sought to invoke a sentimental reaction in his audience by invoking parental despair: "Why rejoic'd we, at their Birth . . . since we intend them but for Anguish, and Agony?" Such emotive identification with enslaved parents, however, was limited by the slip from a tragic into a satirical tone: "Happier Parents bequeathe Money, and Vanity, and Indolence, to their Offspring.—Alas!—These are Legacies, for FREEMEN!—We have Nothing but Shame, to bestow on our Posterity." Criticisms of British parenting were popular in Georgian London. The Exclusion Crisis and Glorious Revolution had instigated debates about parental transmission of sin, while many Britons perceived the uncertainties of paper wealth, speculation, and national debt as enslaving not only themselves, but also their children.[46] Rising concern for orphans and changing parent-child relationships may also have encouraged the location of pathos in the slave's unborn child. Shifting, however, from the enslaved African parent's plight to Britons' inability to bring up their children with good manners devalued freedom only to stress again the complex ideational association between domestic virtue and the treatment of slaves abroad.

Finally, Bon Sáam's speech also appeared beneath an epigraph, ostensibly from Horace, that warned, "This is a BLACK!—Beware of him, good Countrymen." The Prompter told readers that the speech was a warning against educating slaves, which masters only did, they thought, "with a

View to the Profit." Fear of uncontrolled knowledge reflected the destabilization of social hierarchies in Georgian Britain and the desire to maintain boundaries between Britain and the external world. Some, such as Thomas Hobbes, had explained the English Civil War by pointing to young men who found rebellious principles in classical texts.[47] To educate the slave was to provide similar inspiration, supplying both historical figures of resistance and the language of liberty that pervaded British political discourse. Thus, when the *Prompter* explained the inevitability of unrest, it voiced another important and problematic consequence to ideologies of mastery: African slaves' incorporation into an Anglo-Christian community was predicated on their being in the process of acculturation, but the process of acculturation trained Africans in British notions of liberty.

The *Prompter* intended to encourage colonists and metropolitan Britons to expand white plantation labor by exporting more metropolitan poor. That they elicited support for this approach to colonization by emphasizing the threat posed by a black leader such as Bon Sáam reflected the literary and theatrical success of such characters in Britain and the fact that such threats were much more real to colonists than they were to those at home. As long as freedom remained in an imagined future or an autonomous black republic relegated to the colonial peripheries, Britons could romanticize the rebel slave without having to imagine African freedom within British boundaries. The *Prompter* could use the African rebel to criticize British morality in the same breath that it reemphasized racial boundaries.

The preface attached to Bon Sáam's speech compared British condemnation of slave rebellion to the hypocrisy of Greek and Roman historians who "abound with Instances of This immoral Narrowness of Heart, mistaken, for a Publick Virtue, and disguised under the Appearance of Humanity." Wherever the Greeks and Romans had made "Inroads upon Countries, [which] had the Misfortune to border on their Provinces, They slide, insensibly, over Murders, and Robbery, and sanctify their own Butcheries, with the finer Name and Pretence of Civilizing Barbarians, and Reducing Savage Nations under the Protection of their Empire." Yet, the preface continued, when these "Barbarians" returned the favor and invaded them, those same ancient orators condemned the "Perfidy, As if Actions, which, on their Side, were Valour, Justice, and Humanity, had chang'd Colour, with their Change of Party, and become, when put in Practice against Themselves, Violation, Cruelty, and Rapine!" The *Prompter* accused Britons of similar hypocrisy.

Reading *The British Empire in America* had "thrown" the editors "into this Track of thinking," as they encountered "a Succession of these low, unjust, and indeed Dishonest, Reflections, occasioned by a Desperate Attempt of some unhappy Negro Wretches, about thirty Years ago, to throw off the Yoke of their never-ending Slavery, in one of our Plantations, by a Rash, and unsuccessful Rebellion." The *Prompter* argued that the author (presumably John Oldmixon) would have been smart to restrict his criticism of the Barbadian slave rebellion to its imprudence. To condemn it as a moral outrage, to call it "perfidious, and UNGRATEFUL Villainy," was to deny that "there could be any natural Injustice, in the Endeavours of a wretched Race, to deliver themselves and their Latest Posterity, from a Condition, to which Death is a thousand Times more preferable." Such criticisms also overlooked, in their opinion, the fact that Britons' ancestors had delivered themselves from a similar state of slavery by murdering "Thousands of their Oppressors, in cold Blood, and in one single Night."[48]

The *Prompter* naturalized enslaved African resistance by comparing it to British and classical precedents but did not directly claim that the practice of bondage was wrong, morally or otherwise. Instead, it simply cautioned colonists against increasing the numbers of "their Black Inmates, from Africa." Such precautions would, in their view, prevent the death of the masters, whose limited numbers offered no protection in a war that would be waged between "Luxury" and "Misery." Planters would be better off, Popple and Hill argued, heeding Sir Josiah Child's 1668 treatise, which argued that colonization relieved poverty at home and did not, as some Britons thought, deplete populations necessary to sustain Britain's economy.[49] Transplanting more of the British poor would relieve an unwanted burden and ensure the "Safety" of the American colonies "by an Effectual Balance against Negro Rebellions."

Popple and Hill thus situated Moses Bon Sáam's speech in an ambiguous light: on the one hand, they argued that slave revolt was understandable and consistent with what Britons had done. But, on the other hand, their solution was not to extend formal rights to Africans in Caribbean colonies, just imaginative rights to imagined slave rebels who were to be replaced by white labor. This rebel leader reminded Britons of their own past, but also of the imprudence of following examples that cannot be successfully imitated. Hence the *Prompter*'s criticism of Oldmixon's characterization of the Barbados rebellion: imprudent act, certainly, but describing it with moral outrage would be hypocritical.

Responses to Bon Sáam's speech interpreted it as a defense of slave resistance, perhaps because of the growing campaign to encourage planters to ameliorate slavery by treating bondsmen more humanely.[50] These concerns reflected Britons' uncertainty about engaging in a slave system first founded by "Slavish" Continental neighbors and the representation of their own claims to liberty sitting uncomfortably with the practices of slavery abroad. These tensions could not be denied, as at home, by not defining the status of blacks. For decades, authors displaced anxiety about the slave trade onto colonial planters who failed to measure up to their imperial roles. Perhaps inevitably, colonists and those with West Indian interests eventually contested metropolitan depictions of planter cruelty. Differentiation of Atlantic interests grew from these negotiations of anxieties about the practice of slavery, which often involved debates about the meaning of blackness.

Over the course of its publication, the *Gentleman's Magazine* ran a series of letters debating planterhood that began with a reprinting of Bon Sáam's speech. Two of these responses took the form of a fictional speech, one from "Caribéus," the "Chief of the Whites," and the other from John Talbot Campo-bell, a "free Christian Negro" from Jamaica who rejected the maroon community. These speeches demonstrate the formulation of pro–West Indian arguments from metropolitan discussions of the meanings of mastery: the colonists, as with their slaves, were ready to use their "own Arts" against those at home. In 1735, the *Gentleman's Magazine* received an anonymous letter including Caribéus's speech from someone who wished to see "Justice to our Fellow-Subjects of the Colonies, falsely accused of Cruelty and Oppression by the *Prompter*." The author assumed that Bon Sáam justified the maroon rebellion, "under Pretence of favouring Liberty." He charged Popple and Hill with treason, because the king had just sent reinforcements to help suppress the rebellion. But the author's main concern was to disavow the "common Mistake" that "those Negroes are under the most miserable Slavery." Slave abuse was not in the master's interest: Africans were "happier" in plantations than in Africa, "much happier than the Bulk of Mankind; nay, than the poor labourers of England." Appealing "to all Gentlemen" who had resided in the colonies for any length of time, he urged them to say whether the white inhabitants were not the "most generous, humane, hospitable People in the World, and whether the following Speech of Caribéus, Chief of the Whites, or that of Moses Bon Sàam, Chief of the Blacks, be founded in Truth, and Fact."[51]

Caribéus's speech located tyranny in the former slave rather than the master, accusing Bon Sáam of ingratitude for his "kind Manumission" and of despotism over the maroons. Rejecting the idea that Bon Sáam embodied Moses, Caribéus identified him with Satan, "endeavouring by subtil Arts, and feigned Grievances, to withdraw that unthinking Multitude from honest Industry, to a Life of Indolence and Rapine." This "imposter," he argued, sought to make himself "a Mountain Tyrant; and rule his Fellows with the iron Rod of his despotic Will." He asked, invoking the slave trade as a means to African salvation: "To whom are you indebted for this Blessing?—To the honest Merchant, that first redeemed you from native Slavery to savage Tyrants of your own Complexion, and planted you here in easy Servitude." He further pointed out that enslaved children were brought up at their masters' great expense, "a Purchase of their Labour." Bon Sáam, he declared, was the wolf among flocks of sheep.[52]

Once he recast Bon Sáam as a seditious tyrant, Caribéus turned the language of paternalistic care back toward the larger population of rebel slaves. Here, in "Ease" and "Plenty," Caribéus argued, "Free from the corroding Cares of Life," slaves became "Happy enough to attract the Wishes of glittering Courtiers, moving in Orbs Superior; but absolutely depending on the Frowns and Smiles of an Imperial Minion," meaning a British colonist. Their children were "safer" beneath him than "even the rich Miser's Heir, lest a Prey to Fraud, Injustice, and perfidious Guardians!" When questions arose over the institution of slavery in the 1750s, both the group of absentee planters who lobbied Parliament for West Indian interests and mainland planters, such as William Byrd II, argued that they served God if even a few Africans from the "savage and barbarous Guinea" entered into a "better Knowledge of their Duty to God and man." The slave trade, Henry Laurens remarked, was the "Gates of Mercy to Mankind."[53] Caribéus pandered to metropolitan fantasies about imperial mastery, employing the language of generosity and care to disprove suggestions of oppression and to assert his own colonial authority. Yet he, like Bon Sáam, also shifted the debate from the care of souls to the care of the black body.

Caribéus's moral outrage reflected the importance of gratitude in metropolitan notions of patronage, imperial or domestic. The language of debt and gratitude underpinned informal restructuring of social hierarchies based on the new importance of national and local trade within the state: it was an expression of deference that sustained the impression of reciprocity while reinforcing hierarchies that had been destabilized by the

rise of the merchant class. If charity had come to be considered the greatest virtue, many Britons considered ingratitude to be one of the worst sins. Criminals, for instance, were considered "strangers to Reformation by Gratitude."[54] When Caribéus demanded that the rebelling slaves owed a debt of gratitude for the "paternal fondness" with which they had been treated, he evoked the image of the fortunate slave that was by then a staple of metropolitan literary culture—and of planters' representations of themselves.[55] By ungratefully denying the connection between the physical form of their bodies and the life of "ease" and "plenty" that they enjoyed, the Jamaican maroons violated, in Caribéus's eyes, the codes of behavior that signified to Britons the capacity to participate in civilized or polite society.

If Bon Sáam made respect for blackness a sign of white morality, the "Chief of the Whites" responded by asking the rebels: "Yet ye complain ungrateful! But ill-suiting such Complaints, your proud Leader boasts your Strength, Activity, velvet Skins, and glossy Countenance . . . Are these the natural Effects of bloody Whips and Hardship, or of Ease, Exercise and Plenty?" Their "deluding Chief" vaunted his "sooty Visage," but "thus may the gloom of night compare to chearful [sic] Day; or Guilt atrocious vie with snow-white innocence!" The resort to an originary language of racial difference was mitigated again through a reiteration of the accidental nature of blackness, shifting attention to its lack of reflection of an interior moral state: lest his readers think that he attributed too much significance to skin color, Caribéus insisted that real "Merit" consisted "not in the Complexion's dye," but took "its rise much deeper, from the low Recesses of the Heart. When that is fortified by strict Integrity, and warmed with the Love of Virtue and Benevolence, it dignifies the Man with real Merit."[56] Ironically, both planter and fictional rebel slave denied the relevance of skin color as a marker of an internal moral state, but each appropriated "glossy" blackness as a sign that confirmed his own agenda. For Bon Sáam, it signified his resistance against wrongful denigration. For Caribéus, it signified the ease of enslaved life beneath British rule.[57] The contested symbolism of "glossy" black bodies in narratives of imperial mastery reflected how aesthetic valuations, also expressed through the domestic slave market for dark black Africans, made British domination of them problematic.

British authors repeatedly returned to the idea that they should have encouraged white immigration to the colonies. In January and March 1737, reports of an Antiguan slave conspiracy reached London, and the specter

of Moses Bon Sáam rose again. The *Gentleman's Magazine* summarized a letter that asked whether "selling the prime Conspirators, to the Spanish Mines, wou'd not have secur'd the Whites, as well, as to put so many to Death for a Crime, which (if we may guess by what has lately come from the Press) will be deem'd a Pitch of Virtue by not a few in our Mother Nation. (See the Speech of Moses Bon Saam, a Negro, Vol. V, p 21.)." The letter argued, once again, that unrest resulted from importing too many African captives into the West Indies. If Stuart-era colonization patterns had continued, the writer observed, the islands would have been filled with white labor. He blamed the post–Glorious Revolution government for lying to the public, telling them that further immigration would drain needed people from the Isles when really it aimed to capture a share of the Dutch slave trade.[58] At first, the author admitted, planters enjoyed the cheaper source of labor. But when the islands began to "swarm" with blacks, they tried too late to regulate the trade: "You see then who let in this Inundation of Blacks on the Sugar Islands. The Planters have neither Ships to send, nor Commodities to purchase them, but it was the whole Body of Merchants in England that brought them over."[59] The following April, a similar letter printed in the *Gentleman's Magazine* suggested that Britain could only try to protect white colonists from slaves' "Machinations and Insurrections." Failure to protect these interests, the author argued, would mean that France would become "for ever sole Mistress of the Foreign Sugar Trade."[60] Metropolitan reverberations of slave resistance, as well as the threat of French and Spanish military attacks on colonial settlements, created persistent concern for West Indian stability. Journalists reproved the crown for denying the colonies adequate protection, while admitting that some Britons at home wished the West Indies would sink to the "bottom of the seas."[61]

Georgian Britons connected the stability of their imperial possessions with the balance of European power. Reports of unrest in Jamaica, Antigua, South Carolina, and in areas near St. Augustine reached London in the 1730s and 1740s and continued to disrupt metropolitan fantasies about African and Native American gratitude. The founding of Georgia in the 1730s as an extension of charity projects at home also aimed to provide Britons with narratives of happy and healthy colonists who need not turn to slavery.[62] By the 1750s and 1760s, that plan too had failed. Reliance on African slavery was hard to dispute, making calls such as the *Prompter's* for a turn to white labor impractical and forcing Britons to negotiate the racial logic of their empire.

Doing so produced the language of abolition by naturalizing slave resistance, mobilizing comparative focus on white laborers, and linking oppression to racial prejudice. If the plantation was largely absent from Restoration periodicals, later journalists offered Britons (and colonists abroad who subscribed to these journals) detailed information about what went on in the colonies. Expanding knowledge of major resistance movements and the threat posed by an autonomous black community in the heart of Jamaica destabilized metropolitan understandings of the colonial project. But long practice with controlling the meanings of resistance by inhabiting rebel African perspectives allowed journalists to accommodate, to an extent, these new ideological challenges. As Popple and Hill coped with the threat of a Jamaican African rebel by romanticizing him, pro–West Indian writers responded by constructing alternative histories of the slave trade that emphasized Britain's role in creating the Caribbean's heavily black societies. This debate over the causes of unrest prefigured the differentiation of imperial interests that fueled the abolitionist movement a few decades later; pro- and antislavery sentiment evolved within transatlantic dialogues and from a dialectic between ideologies of mastery and colonial slavery as it was mediated through print. By the 1730s and 1740s, planter immorality no longer posed the only problem. If baptism did not confer freedom, by 1746 the African slave had acquired a "relish of a right to liberty" under British rule.[63] Whether blackness was an excuse to oppress and degrade a lucrative labor force became a central question in discussions about the slave trade and slavery.

In 1740, Mercator Honestus addressed the "Gentleman Merchants in the Guinea Trade," especially those from Bristol and Liverpool, on the question of slavery's legitimacy once again. He asserted that "all Mankind are brought into the World with a natural Right to Liberty, and that a Man cannot forfeit his Right to Liberty, but by attempting to take away the Property of another unjustly, in which I include his Life, Liberty, and other Valuables; and that a Parent's meriting a Loss of Liberty, is no Reason why the Child, the Descendant from that Parent, shall lose its Liberty." He denied the arguments that had legitimated slavery for the *Athenian Mercury*: "is it not in vain to urge the Sentiments of those from whom they buy them, or to assert that they would destroy, or eat them? For I don't doubt the Blacks are more civilized than they are generally represented, and it is very certain, that with some Pains they might become much more so." Such native African innocence had been corrupted by

their translocation into societies that had "less Virtue and pure Religion than their own."[64]

In a scathing response, the Leeward Island minister Robert Robertson insisted that "every Allegation" of Honestus's letter that had "any Merit, had been answered above 5 years before; but since he was ignorant of it then, it may be better (as he well observes) both for the Publick and himself, that he shou'd be rightly inform'd." We know little about Robertson's life, other than that he was rector of Saint John's Church in Nevis for some years and that he owned slaves. The "Answer" to which he referred was his own fictional speech of John Talbot Campo-bell, which had been published with a copy of Moses Bon Sáam's speech in 1736.[65] Robertson had responded to the maroon leader through a free black Christian who remained loyal to the slave system and the Jamaican planters: Campo-bell asked "his countrymen in The Mountains of Jamaica" to return to their masters and give up the "black Creole tyrants," those "Monsters in Wickedness, Devils incarnate" who had led them astray.[66]

Robertson's Campo-bell embodied the civilized slave who had been educated and favored by his master, precisely the fiction that underlay the liveried black servants in British portraiture. He attributed his enslavement to wars between Congo and Angola, and reminded his brethren that had they not been "banish'd," they would have been killed or retained in perpetual slavery in Africa. He recognized that he "was born a Slave, as all [his] Forefathers were time out of mind."[67] A planter who liked his face bought him and his family. Campo-bell received the name John; Talbot, his mistress's maiden name, was added when he was baptized. Perhaps Robertson intended to connect this figure, who accompanied his young master to England, to the Yorke-Talbot opinion in 1729, which stated that neither baptism nor residence in England conferred freedom upon slaves. John Talbot became John Talbot "Campo-bell" when the Bishop of London confirmed him: a "Person of Quality then present (by whose Means I have receiv'd many Favours since) wondring and pleas'd to see one of our Colour at Confirmation" gave him the "honour" of adding "Campo-bell."[68] Robertson rooted this image of the fortunate slave in a West Indian planter's care, which left room for him to cast the guilt, if guilt there was, onto other slave trade participants.

Wrapped into this fortunate slave's appeal to the maroons was a sophisticated argument in favor of the West Indian interest.[69] The epigraphs to Campo-bell's speech immediately announced Robertson's reversal of the terms of the debate: first, he argued that it was the British at home who

were hypocritical, citing Aristotle's warning that "it is ridiculous for a man to reproach others for what he does or would do himself, or to encourage others to do what he does not or would not do himself." Robertson rejected the idea that the guilt for the slave trade resided with planters and charged the metropolitan press with "fitting whatever falls into their Clutches to their own Taste and Notions": if planters were to be blamed, he argued, it was only after the "African gentry" who had first sold their "countrymen," the Guinea merchants "(sent from Europe under the Protection of the Nations to which they belong)" who conveyed them to the sugar islands, and the "good People of England, who protect and encourage the Trade, because all the Gain, both of it and the Sugar Trade, always centers among themselves." Such sentiments would echo in other colonial commentaries on how Britons at home positioned themselves in relationship to the slave trade.[70]

Robertson agreed with the 1737 Antiguan letter that the option of peopling Jamaica with whites had long since disappeared, not only because white laborers would not come but also because France would never stop importing African captives into its plantation colonies. Campo-bell also undercut the vision of the maroons as potential friends of the whites: "Friendship! Alas! That anything is called Rational shou'd so prostitute thy sacred Name!" From his perspective, none of the maroons had "any thing of Good-Nature or Humanity." Not only did they practice cruelties upon each other and their own children, but they would also, given the chance, "cut all [the whites'] throats with one Knife." Robertson countered the romantic image of the potent black leader with the cold point that the savage would murder them if he had the opportunity.[71]

African rage, argued Campo-bell, never reached Britons at home who had a "Hand" in their bondage. Instead, white Jamaicans who had little influence over the current expansion of the slave trade suffered. Many planters, he noted, were so disaffected that they wished no more slaves would be brought from Africa; they fantasized "that all the Slaves in the British Sugar Colonies were in Africa again . . . and that their Mother-Country would either send them Hands from herself to carry on the Sugar Manufacture, or put them in some other Way of Living that cou'd be carried on without Negroe-Slaves." For the slaves "were brought hither in so provoking and uncouth a Manner, and are so perverse and provoking . . . as to tire the Spirits, and break the Hearts of all" who dealt with them. For Robertson, the idea that Bon Sáam embodied the spirit of the biblical Moses was preposterous, for African slaves had arrived

naked and already enslaved, while Joseph had led his people with their possessions into Egypt under the impression that they were being given land. Campo-bell counseled the maroons to submit "forewith to the white People here. They are Englishmen, and Cruelty is no Part of their Character; I dare promise, your Lives under them will be safer, easier, and happier than ever they can be in these Mountains."[72] Campo-bell felt personally affronted by the rebels, for his own manumission had placed him on a par with whites as a freeholder of a small estate that included a few African slaves.

The second epigraph to Campo-bell's speech returned the moral assessment of slavery to metropolitan authors: "That which I see not, teach thou me: If I have done Iniquity, I will do no more (Job 34:32)." Campo-bell traced contemporary concerns with liberty and slavery back to Bishop Sanderson's 7th Sermon (1638); he had acknowledged, as did other royalists, that slavery was wrong. But when the trade began in earnest, Campo-bell said pointedly, the bishops avoided talking about it. After the Glorious Revolution, the "Republican" ascendancy brought about the latest fashion for natural rights: "nothing was to be heard every where but Liberty, the Law of Nature, the natural Rights of Mankind, whereof Liberty is one, which ('tis said) they might be robbed of, but could never forfeit, and the like; and the bringing any of the Human Race into Slavery was pronounc'd execrable." Robertson's 1741 letter to the *Gentleman's Magazine* extended this argument, remarking that some Britons believed that those who enjoyed liberty "shou'd spare for no Cost to procure the same, as far as possible, for the rest of Mankind every where." Yet just when Robertson appeared to switch sides, he observed that despite the need for a legal and moral investigation into slavery, Britons continued to think about how to gain the most from it. Only a few claimed the practice of slavery to be inconsistent with Christianity. Such hypocrisy was particularly apparent in England, where "Liberty is the Cry Morning, Noon, and Night" and where nothing was more common than to "brand the Subjects of Spain, France, Denmark, and other Countries with the opprobrious Name of Slaves." If Britons at home thought that slavery was wrong, Campo-bell argued, then why did they "join with countries that they call slavish and tyrannical in making slaves?"[73] Profit, of course.

Robertson closed his account with an argument that reinforced the connection between British freedom and African slavery by shifting from the acquisition of souls to the maintenance of Europe's balance of power. Abandoning West Indian sugar interests would allow other nations whose

"Consciences" were not "so strait-lac'd" to gain the entire trade. And that would mean the destruction of "that general Balance of Trade (and, by Consequence, of Power) which wise Men think ought to be maintain'd in the World."[74] Campo-bell left his brethren (the Jamaican maroons who disappeared from the discussion) with the choice between becoming slaves to Catholic countries by losing the balance of trade or awaiting divine judgment and maintaining the African trade. Either way, he remarked, the decision belonged to the metropole. Campo-bell presciently invited a "masterly" writer to compose "A Treatise proving the Absolute Unlawfulness of the Slave-Trade; both on the Coast of Guinea, and in all its subsequent Stages." Such consideration would answer Bon Sáam's complaints and, by extension, those of all other Britons who declaimed against the trade for fashion's sake, while enjoying the system's fruits. If there was "Iniquity" in the slave trade, he said, God "may inspire a certain People in Europe (whose Strength at Sea is great, and may be made almost what they please) to take the whole upon themselves, and put a Stop to it with their Shipping at the Fountain-Head."[75]

Robertson's response also attempted to recast the debate over blackness by centralizing the economic underpinnings of the slave system, shifting the explication for racial slavery from a religious to a political imperative. God's fairness, Campo-bell argued, was ensured as "He is no Respecter of Person, but regards the Negroes as much as he does these English, or any white Men whatever; for we with our black Skins are the Work of his Hands as well as the best of them, and he careth for us all alike." Robertson responded to the insinuation that planters insulted blackness by arguing that skin color was irrelevant to the trade. "Possibly you may be tempted," Campo-bell said, "to think, that they mean none but Themselves, and the other Whites, shou'd be free, and that of all our Colour are born to be Slaves. I assure you, they have no such meaning." If Bon Sáam could advance an economic argument in favor of ending the trade, no doubt Britons would send them back to Africa. Yet this was a fate, Campo-bell reminded the maroons, that would lead to death at the hands of those African rulers who had been the "first Authors" of their bondage. Robertson's 1741 letter imagined a world without the slave trade: "What then? our Governors in Africa must devise some other Way to employ their Hands than by selling them abroad for Slaves; the Slave-Merchants of Europe will lose a very gainful Trade, and be forced to look out for some other, or to rest content with that of Gold Dust, Elephants Teeth, &c." Britain, Robertson thought, could survive the end of the slave trade

better than European countries and, if it did pursue that "Path to Glory," it would "become Arbiters of the Affairs (not of one Quarter only, but) of the greater Part of our habitable Globe."[76] Returning to a trade in raw materials would become one of the most important arguments favoring the end of the slave trade during the latter part of the century.

The fictional slave who spoke for a West Indian interest exposed Moses Bon Sáam's metropolitan roots. The minister capitalized on growing emphasis on eyewitness authority in Britain, decrying the "long Standing Humour in England, of judging . . . the Proprietors of the Negroes in our Sugar Islands" without producing "so much as one single open Evidence to support their Sentence."[77] Robertson insisted that his concerns went beyond defending Caribbean planters: he feared the "strange Neglect in England, in all Attempts towards coming to the right Knowledge of the State of the Negro-Slaves in our Sugar-Colonies." Metropolitan observers "proceeded as if either they cared not to know, or knew well enough already, what are the Hinderances [sic] of their Conversion, and the certain Ways of removing them." Indeed, one poisonous side effect of Britons' refusal to face their responsibilities for slavery was that those best equipped to tell them of the state of the slaves were slighted and ignored. Despite this burden for "the many lives" that the slave trade had destroyed and the "little Care" taken for its victims' "souls," Britons still—in Robertson's view—hypocritically censured the planters. He pleaded with his "Countrymen at Home" not to "shake off this stupendous Load of Guilt" by throwing "it upon the White People of these Colonies; we have, all of us, more than enough to answer for otherwise."[78]

By blaming planters, Robertson suggested, metropolitan Britons hindered the "care" that they pretended to model and advocate. In his 1727 letter to the Lord Bishop of London, Robertson had accused Britons of failing to provide the necessary religious infrastructure to fulfill their expectations for conversion. A few ministers intoned planter damnation and then considered their work done. Such a zealot, Robertson continued, would then often write to a friend in England, "who may toss it round in Discourse almost every where, till it works its Way through the Press into the World, and has the luck to pass there unquestion'd for above (it may be) half a Century."[79] If growing numbers of slaves engendered histories of imperial unrest that located the source of trouble in planter greed, merchant greed, metropolitan greed, or a misconception of the effects of emigration on the metropole, for Robertson the numbers also betrayed the impracticality of conversion. For some 200,000 enslaved

Africans, he noted, only a handful of ministers had arrived to tend to their souls.

This protracted debate highlights the importance of the image of care in British notions of imperial mastery and colonial slavery's potential threat to this vision. If Godwyn had specified, and anesthetized, metropolitan complicity in the trade by characterizing it as a problem of neglect, Robertson made such neglect the greatest source of guilt. The effectiveness of Robertson's arguments might be gleaned from the fact that the *Gentleman's Magazine* editor invited him to send further accounts "of our Affairs in the West Indies" directly to him.[80] Indeed, Robertson advanced in the 1730s and 1740s much of the content of abolitionist and proslavery critiques that circulated in 1770s and 1780s Britain. As Christopher Leslie Brown argues, the continuity of these ideas makes it more important to understand what impelled Britons to act in the 1780s, when such arguments for the immorality of slaving had not generated more than a transatlantic battle of letters in previous decades.[81] But lumping everything preceding the abolitionist movement into a block of "antislavery sentiment" elides the subtle changes in these arguments and how they were driven by specific acts of African resistance. The extension of the right to resist (in theory) to Africans and the question of whether British planters were making beasts of human forms reflected how master-slave negotiations in colonial plantation societies reverberated into the Isles.

Ever since Restoration authors, such as the *Athenian Mercury* editors, linked the veracity of Protestantism to the plantation project, the body of the African slave abroad became central to British perceptions of their imperial role. Civilizing slaves meant different things for different Britons: some focused on the inculcation of industry; others described the refinement of manners or even of color. Imperial authority was constructed on a heathen landscape as Britons reproduced a culturally elevated vantage point while forever approaching and transforming the dependent imagined societies that existed beyond their sight. This act of distancing was a tautological construction that depended upon the internal logic of the projected British relationship to an African coast. The object of this imperial gaze was constructed and unstable, while the gaze itself was a form of domination and control. The anonymous slave remained both heathen and convert, distanced from participation in British affairs through perpetual servitude but allowed, through the sloughing off of black skin, a place in a Protestant heaven. The assumption of barbarity

predetermined the nature of British interaction: it was an "undoubtedly Lawful" transaction predicated on the conversion and salvation of the bodies being traded—or the continuing displacement of the horrors of slavery onto planters who were commonly perceived to be rich rivals and outsiders.[82] While Britons refused to clarify the status of African servants at home, so too did they refuse responsibility for the status of slaves abroad.

Ideologies of *dominium* that rested on scriptural precedents for conversion, on the Christian imperative to spread the gospel to all ends of the earth, and on the growing social importance of charity movements were destabilized by a natural rights discourse made fashionable, as Robertson argued, by the Glorious Revolution. Although some Britons continued to argue that corporeal bondage was necessary to spiritual salvation, these debates reveal continuing instabilities in imperial narratives: by slaving, did Britons make themselves no better than their slavish continental neighbors? Were they targeting those of darker complexions for a life of bondage when the diversity of skin color, as journalists argued, was part of the divine plan? Efforts to make slavery legitimate connected the uplifting of the heathen to the prevention of British degeneracy. Economic arguments about the necessity of diverting into British colonies African captives who would otherwise end up in Catholic ones had religious support in the idea that conversion wrought improvement in the converter: African enslavement would embolden and strengthen Protestantism not only by adding souls, but by deepening faith. Although beyond the scope of this book, the emergence of a reformation of manners movement in the late seventeenth and early eighteenth centuries, the founding of Georgia as an experimental nonslave society in the plantation south in the 1730s, and the growing cultural emphasis on humanitarian acts seems directly responsive to accumulating incidents of slave revolt and the internal, though increasingly transatlantic, conversation about the ethics of slavery. The question was one of where the guilt lay, as Robertson grasped and used to defend himself.

Journalists, ministers, and other spokespersons involved in the construction of Britain as an imperial center attempted to present Britain (and centrally England) as a place to turn for models of mastery. But that move only worked as long as those useful scapegoats, African cannibals and colonial planters, failed to challenge these representations of them. Robertson responded to Bon Sáam's accusation that planters violated the natural rights of mankind by using a language of economic interest, which rested

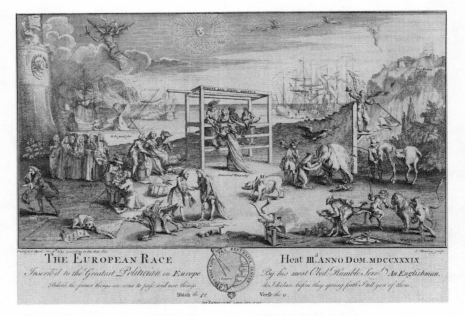

Figure 4.3. Charles Mosley, *The European Race Heat 3rd Anno Dom MDCCXXXIX* (London, April 9, 1739). © The Trustees of the British Museum. All rights reserved.

the "Balance of Power" on the "Balance of Trade" and largely ignored the acquisition of souls. He left metropolitan readers with a continuing conundrum: the practice of colonial slavery maintained liberty at home, but it made a mockery of their pretensions to virtue. African slaves were never uncontested symbols of commercial virtue. For some, these indices of wealth represented the bondage to luxury and vice that continued to threaten British liberty.[83] For the time being, however, the desire to maintain the balance of power in Europe overwhelmed uncertainty about the slave trade. It is not surprising that after the Treaty of Paris in 1763 formalized Britain's ascendancy as the leading imperial power in Europe, such arguments for the balance of trade became less powerful in discussions of slavery.

In the first half of the eighteenth century, however, that imperial outcome was far from certain. Mosley's depiction of the European race ended in 1739 with France as the winner (Figure 4.3). Europe provides the laurel wreath; Asia gives a scimitar; Africa offers ivory; America bestows

gold. Beneath France's feet is the frightful announcement of "Universal Monarchy." Meanwhile, Britannia appears depressed, "buffeted by a Spaniard, and cajoled by a Frenchman, who are picking her pockets."[84] A detail of the judges' stand reveals Mosley's perception of the intimate relationship between Africa and America, as Africa pulls its ivory horn from America's cornucopia. This tumultuous "Universe" represented the international scene of the late 1730s, encouraging Britons to advocate for a more active imperial presence: according to Mosley and other critics of Walpole's government, only by galvanizing war would the balance of power shift toward Britain and universal monarchy in Europe be averted. By the fourth heat, produced in 1740, war had been declared, reviving Britannia's aspirations to maritime supremacy.[85]

The entanglement of power in Europe with access to the combined riches of Africa and America delayed serious consideration of ending the slave trade but also shaped popular understandings of the importance of black slaves to imperial success. Journalists, ministers, and fiction writers mapped the intersections of colonial and metropolitan markets for African slaves in their debates over the meaning of blackness. From this metropolitan perspective, the racialization of the slave trade occurred in the attempt to reject its racial logic in the midst of the failure of ideologies of conversion. But other conversations in graphic art also centralized the encounter with blackness in constructions of British imperialism and made a mockery of such resistance.

PLEASURABLE ENCOUNTERS

Bacchus' black servant, negro fine.

—Charles Lamb, referring to his pipe (ca. 1805)

Sometime during the 1750s or 1760s, London grocer George Farr solicited an engraver to produce an advertisement for his tobacco (Figure 5.1). Farr was in the grocery business during the middle decades of the eighteenth century, but exactly when this advertisement was commissioned and who produced it are unknown, as it is unsigned and undated.[1] Although the details of the advertisement's production remain obscure, the imagery that Farr used to tempt customers is striking for its effacement of the real origins of tobacco sold in eighteenth-century Britain. Above the happy little pun, "The Finest Tobacco by Farr," the engraver depicted a black prince or king sporting a Native American headdress and sitting on a throne. The royal black male takes up almost the entire advertisement, replacing the white colonial planter in his mediation between the hogsheads of new tobacco and the ships that have arrived to transport them elsewhere. The thousands of African slaves who worked tobacco fields in Virginia, Maryland, and other British colonies do not appear; the cherubic child who brings him a tobacco plant is the only other figure associated with the crop. This advertisement connected tobacco with the black male, yet spectacularly failed to acknowledge the existence of the colonial plantation. Instead it envisioned the tobacco trade as an exchange with a black prince or king: a vision perhaps naive, perhaps consciously effacing the brutal realities of tobacco production, perhaps subtly subversive of plantation power relations, and certainly silent about the role of African women in the cultivation of British tobacco.

The imagined origins of tobacco in shop advertisements illuminate the intersection of race, consumption, and male homosociality in late seventeenth- and eighteenth-century Britain.[2] Tobacco has long been considered

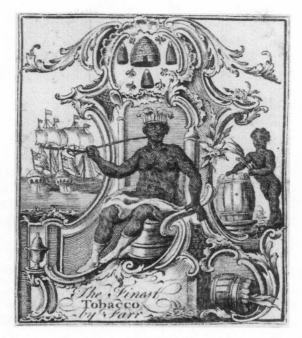

Figure 5.1. "The Finest Tobacco by Farr" (London, ca. 1750–1770), in Heal Collection, 117.48, Prints and Drawings Department, British Museum, London.

an important factor shaping the development of New World settlements and colonial practices of slavery, but we have only begun to analyze the ways in which tobacco, sugar, and other Atlantic and Eastern goods engendered new forms of sociability and new spaces of consumption in Britain. There is still a limited understanding of the cultural meanings that Britons attached to exotic drugs and how those meanings shaped and were shaped by notions of race, conceptions of slavery, and ideologies of empire.[3]

Farr's advertisement is one of hundreds of Restoration and Georgian tobacco advertisements that survive primarily in the collections of the British Museum and the New York Public Library. Their wide range of imagery, including patriotic emblems, Masonic symbols of brotherly love, Scottish Highlanders, the Royal Exchange, and city views, reflect tobacco's diverse associations. Most advertisements offered remarkably heterogeneous fantasies about the source of tobacco, from black royals, to images of trade with or domination over black figures, to scenes of interracial

147

camaraderie (Figures 5.2–5.13). Similar advertisements produced for shops in Bristol, Newcastle, Kent, and other provincial areas suggest the widespread appeal of these scenes of tobacco's origins.[4]

These cheap advertisements were in high circulation in a broad range of society. Surviving sources have not shed direct light on the artists' intentions, the shopkeepers' goals, or the smokers' interpretations, but we know that black bodies were being produced as advertisements for colonial goods. The minimal attention given to these advertisements has focused on the hybrid Native American–African ethnicity of the black figures that populate them and not on the imagined relationships between British smokers and black tobacco producers.[5] The often congenial and always gratifying relationships that these images depict suggest that we should reconsider the moment in which Britons began to associate New World goods with the labors of black slaves and Georgian British perceptions of heathenism.

Scholars of the abolitionist movement argue that Britons did not connect slave labor to the goods produced from it until the 1760s. That early grocers did not choose to advertise other wares, notably sugar and coffee, as consistently with black figures suggests these conclusions may yet hold true for such colonial products, but numerous eighteenth-century prints depicted black servants bringing tea, coffee, and chocolate to their white masters, and some shopkeepers chose signs that included black boys and sugar loaves.[6] Tobacconists, in contrast, frequently enticed customers by capitalizing on the crop's association with exotic peoples. Although abolitionists demonized the consumption of products produced by slaves in new ways, they were not the first to recognize the connection of these goods to black producers. Tobacconists offered customers a variety of imagined encounters—from eroticized representations of British dominion over blacks to provocative images of homosocial relationships with black smokers—that resist any straightforward inscription of the unequal and repressive relationship between colonized and colonizers. The advertisements presented here display the range of racial encounters with which shopkeepers tempted their customers. Unpacking these images and their imagined relationships between British and black smokers requires reconstructing the genre of tobacco advertisements in Britain, including the emergence of tobacco shops and commercial advertisements, the iconographic traditions with which the engravers worked, and the cultural meanings of tobacco that the tobacconists and engravers manipulated to sell their product. Such an analysis reveals that tobacconists promoted the

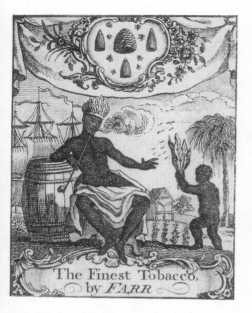

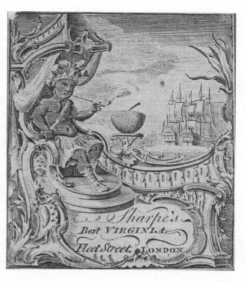

Figure 5.2. "The Finest Tobacco, by Farr" (London, ca. 1750–1770), in Heal Collection, 117.49.

Figure 5.3. "Sharpe's Best Virginia, Fleet Street, London," in Heal Collection, 117.145.

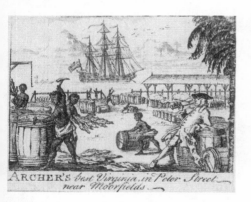

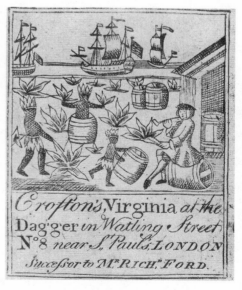

Figure 5.4. "Archer's best Virginia, in Peter Street, near Moorfields," in Heal Collection, 117.4.

Figure 5.5. "Crofton's, Virginia at the Dagger in Watling Street No 8 near St. Paul's, London Successor to Mr. Richd Ford," in Heal Collection, 117.32.

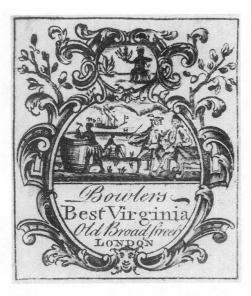

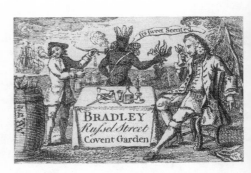

Figure 5.7. "Bradley Russel Street Covent Garden," in Heal Collection, 117.15.

Figure 5.6. "Bowlers Best Virginia Old Broadstreet London," in Heal Collection, 117.14.

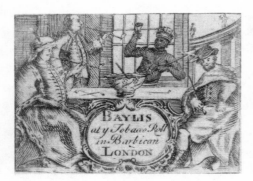

Figure 5.8. "Baylis at y Tobacco Roll in Barbican London" (ca. 1720). © City of London, London Metropolitan Archives.

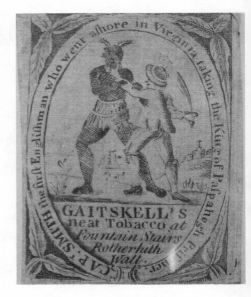

Figure 5.9. "Gaitskell's neat Tobacco at Fountain Stairs Rotherhith Wall." © City of London, London Metropolitan Archives.

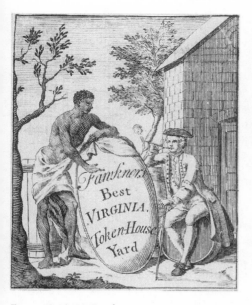

Figure 5.10. "Fawkners Best Virginia, Token-House Yard," in Heal Collection, 117.50.

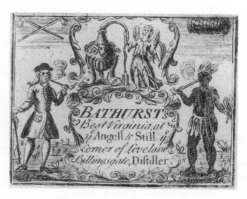

Figure 5.11. "Bathurst's Best Virginia, at ye Angell & Still ye Corner of Lovelane Billingsgate, Distiller," in Heal Collection, 117.6.

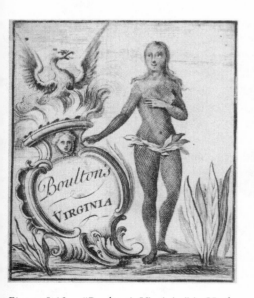

Figure 5.12. "Boulton's Virginia," in Heal Collection, 117.12.

Figure 5.13. "Chance's Best Virginia, Fetter Lane, London," in Heal Collection, 117.22.

experience of this originally Native American drug as a vicarious and often illicit encounter with New World heathenism. Perhaps more than any other imagery in Georgian Britain, these advertisements reveal how imagining relationships to black slaves worked to collapse the space between metropole and colony in ways mediated by domestic experiences of the products of slave labor.

Marketing the Heathen Weed

Tobacco shops appeared in London as early as 1605. By the late seventeenth century, they had popped up in neighborhoods across the metropolis. Virginia's sweet-scented tobacco captured the English market by the end of the Stuart era, while supplemental supplies came from the East, the British Caribbean, and South America. From 1736 to 1746, 6 million pounds of tobacco were sold in England for domestic consumption. Tobacco remained the second most important colonial crop (after sugar) to Britain's economy throughout the eighteenth century. In 1765, Robert Rogers remarked, "the annual revenue arising to the crown from tobacco only, is very considerable; and several hundred thousands are employed in, and supported by, raising and manufacturing it." Several hundred thousand African slaves worked in colonial tobacco fields: slaving boomed after 1713 when the Treaty of Utrecht granted Britain broad trading rights with Spanish colonies. At the same time, plantation agriculture took off on the mainland as planters reorganized their plantations around slavery. Throughout the eighteenth century, ships brought loads of tobacco into London and hogsheads were disbursed to various shops through the Royal Exchange. We know little about what went on inside tobacco shops, though parodies of "Clowdie Tobacco-shops" indicate that consumption occurred on the premises. Tobacco shops forged a crucial link between the production and consumption of tobacco, connecting metropolitan consumers of American goods to an English, and then British, empire.[7]

Although English colonies began to produce tobacco for European markets quite early in the seventeenth century, it took at least half a century for plantations to emerge in London tobacco imagery. The earliest tobacco literature borrowed representations from Continental iconography, which illustrated *Nicotiana*'s association with sociability by depicting a group of white men sitting at a table with their pipes, pots, and glasses or emblematized its derivation from New World societies with inert black Indians, antecedents to the modern Indian figures that still stand

sentry at tobacco shops today. Single broadsheets, such as "The Armes of the Tobachonists" (1630), were among the first forms of tobacco imagery in London that responded to these Continental borrowings; they focused primarily on the social disruption caused by the spread of smoking (Figure 5.14). This early street ballad described the selling and smoking of tobacco as an illicit and sensual experience, assigning the tobacconists' arms to the "Herraldry from hell." A commoner shown "*reuerst proper improperly*" stands, according to the explanatory poem, for men who "doate to much vpon this heathen weed" in "hells blacke pit, Whereas the Diuells in smoake and darknes sit." The poem also offered a common myth of tobacco's origins: "The Moores head shewes, that cursed Pagans did, Devise this stinke, long time from Christians hid." In the last quarter of the seventeenth century, tobacco advertisements acquired images of plantations and exotic trade, yet the sensual encounter with the "stinke" of "cursed Pagans" remained central to the attraction and repulsion toward this particular drug.[8]

By the late Stuart era, shopkeepers responded to the spread of print and increase in literacy rates by changing the strategies that they used to advertise their goods. Tobacconists and other traders began commissioning local artisans to engrave or etch trade cards, billheads, and tobacco papers. Trade cards tended to be smaller than tobacco papers and were distributed on the street, door to door, or at sales. Tobacco papers bear smaller engravings with larger borders and were used to wrap parcels of tobacco, the stains of which often still remain. Shopkeepers furnished these papers along with billheads (receipts) to remind customers of the shop and its location. Trade cards and tobacco papers included the shop sign, usually set off in a cartouche or medallion. By the seventeenth and eighteenth centuries, many of these shop signs included racial imagery (see, e.g., Plate 1). As place markers, these signs migrated onto trade cards and tobacco papers, but they did not necessarily have an intended connection to the advertised goods because new shop owners often retained the sign previously associated with the shop. Tobacco papers, generally in contrast to trade cards, included imagery specifically related to the product in addition to the shop sign. Whereas George Farr's trade card illustrated only his shop sign, "the Beehive and Three Sugar Loaves," his tobacco papers featured racial imagery with the traditional shop symbols displayed at the top (Figure 5.15; Figures 5.1, 5.2).[9]

Georgian tobacco papers reflect three main marketing strategies: first, they stressed the quality of the product (the "best" or "finest"). Second,

Figure 5.14. "The Armes of the Tobachonists" (London, 1630). © The British Library Board.

Figure 5.15. "George Farr Grocer . . ." (1753), trade card, in Heal Collection, 68.99.

they emphasized direct access to the source of tobacco. The titles of the tobacco papers, such as "Sharpe's Best Virginia," often employed Virginia as a metonym for tobacco (Figure 5.3). The associated images of New World people and colonial plantations in "Archer's best Virginia" and other advertisements effectively implicated Londoners in the pleasures and responsibilities of owning not only the scenes but also the people depicted (Figure 5.4). Most advertisements reinforced this claim by superimposing the shop sign onto their New World scenes or, alternatively, in the case of Farr's tobacco papers, by juxtaposing the shop sign with the black prince (see Figures 5.1, 5.2, 5.15). Third, some of these advertisements included visual puns and puzzles, which undoubtedly encouraged consumers to spend time looking at them. In "Archer's best Virginia," for instance, inscriptions of "PE" and "ER" in patches of grass in the center foreground prompted the viewer to go searching for the missing "T" to complete "Peter" for Peter Street (the shop's location); a black laborer in the center background uses the "T" to bang shut a hogshead (see Figure 5.4).[10] The writing of Peter Street into the plantation landscape marginalized the colonist and reduced the distance to the plantation. Because shops printed such advertisements on tobacco packaging, colonial images, themselves amalgamations of different exotic regions and British desires for dominion, figuratively formed part of the experience of smoking. The use of place markers, as in "Archer's best Virginia" and Farr's shop sign, brought the tobacco shop to Virginia and imported the best of Virginia into the metropole.

Tobacconists banked on the appeal of exoticism when they used images of New World peoples and colonial plantations in their advertisements. In so doing, they drew on iconographic traditions dating back to the late medieval and Renaissance eras. Although the primary source for these black bodies was probably the shop sign, since tobacco advertisements were largely an extension of this popular imagery, engravers also inherited hybrid Native American–African figures from maps, travelogues, plays, and other colonial imagery in Georgian Britain. Roxann Wheeler has offered several reasons why Native American and African bodies could be interchanged, including the generic use of the term "black" to describe both groups, the generic use of the term "Indian" to describe any so-called savage, and the fact that both Africans and Indians were enslaved.[11] The tobacco prints' hybrid figures also specifically reflect the association of Africans and Native Americans with the tobacco trade and with smoking.

What do these advertisements say about how Britons imagined their relationship to the producers of this drug? A definite chronology to the advertisements might reveal something about metropolitan consciousness of the expansion of slavery, but ordering them is difficult because most have no engraved dates. Engraving styles suggest that the advertisements range from the 1700s to the 1780s. Some of the simple rectangular cartouches are from the late seventeenth century. Even without a definite chronology, these advertisements furnish invaluable insights into the imagery of tobacco's origins with which tobacconists tempted potential customers. Like modern American advertisements that stress, for instance, bread's origin in wholesome Midwestern wheat fields, Restoration and Georgian advertisements pictured tobacco coming from imagined Virginias where black royalty, black tradesmen, fellow black smokers, or relaxed black laborers appeared to live. All these images suggest a complex interaction among ideologies of empire, the social experience of smoking, and the cultural meanings of tobacco.

Encounters with Heathenism

Tobacco's mixed reception in Britain reflected a society trying to come to grips with a foreign drug that, along with other colonial goods, had transformed urban life. Some believed that consumption was virtuous and patriotic because it kept the trade system afloat; others argued that consumption subverted morality, that sensual gratification signified sin. From King James I's 1604 attempt to ban tobacco through the late eighteenth century, historians, travelers, traders, satirists, and poets debated smoking's virtues and vices.[12] Tobacconists pandered to and parodied both sides by locating the origins of tobacco with scenes of British domination over the New World on the one hand, while stressing British smokers' affiliation with heathen tobacco producers on the other. These imagined encounters reflect the multiple forms of desire elicited by this mildly transgressive drug.

"Gaitskell's neat Tobacco" is a striking example of a tobacco paper that located the source of tobacco in English domination. The inscription around the cartouche identifies the image: "Capt Smith the first Englishman who went ashore in Virginia taking the King of Paspahegh Prisoner" (Figure 5.9). Gaitskell's engraver simply adapted Robert Vaughan's engraving of Smith's capture of the King of Paspahegh, which accompanied an edition of Smith's *Generall Historie of Virginia, New-England, and the Summer*

Figure 5.16. C: *Smith takes the King of Paspahegh prisoner, Ao 1609*, detail from Robert Vaughan's map in John Smith, *The Generall Historie of Virginia, New-England, and the Summer Isles: With the names of the Adventurers, Planters, and Governours from their first beginning An: 1584. to this present 1626* (London, 1627), 84. This item is reproduced by permission of The Huntington Library, San Marino, California.

Isles (Figure 5.16). Vaughan's image, in turn, was a reworking of Theodore de Bry's "A weroan or great Lorde of Virginia," which was based on John White's sixteenth-century studies of Roanoke Indians. "Gaitskell's neat Tobacco" particularly demonstrates how engravers borrowed and altered earlier iconographies of the colonial Chesapeake when reimagining this region as the origin of this exotic plant.

Gaitskell's engraver made a number of suggestive changes to this staple image of imperialism. Vaughan's empty landscape in the upper right background, beneath a scene depicting Smith's capture by the "Pamaunkee" Indians, has been replaced with a depiction of a mission. Tobacconists rarely used Christian imagery in their advertisements, but this mission most likely alluded to the commonly articulated notion that British colonization was a means to the salvation of African and Native American souls. Another substitution associated this religious undertaking with trade: a ship has appeared between the Indian king's legs. There are other, subtle changes: Smith's hand, once grasping a lock of the king's hair, now clinches his throat, and the king looks outward at the viewer instead of upward, seemingly toward another Smith engaged in slaying native Algonquians. Perhaps the greatest alteration is in the form of the Indian king's body. His muscular Indian frame has been exchanged for a heavyset black body dressed in a skirt of leaves or feathers. The two prominent feathers in his headdress have sagged and now look hornlike. Horns might have invoked demonic associations with the savage and connect to the Christian mission. Alternatively, Winthrop D. Jordan has shown how written accounts emasculated Native American males as they declared English dominion. These horns may also intimate the emasculation of the cuckold's horns and thus help to characterize Smith's act of domination. The engraver also altered Smith's dress so that he resembles a common Georgian Briton rather than an early seventeenth-century English conquistador. Gaitskell's engraver transformed an Indian lord into an amalgamated African–Native American figure in the process of locating the source of Gaitskell's tobacco in Britain's Protestant and commercial conquest of the New World.[13]

Literary representations of English dominion over black tobacco producers emerged by 1659, as part of a broader effort to promote colonization by linking it to an anti-Catholic agenda. Tales about tobacco's origins and how Englishmen had procured the plant became entwined with these ideological explanations for slave labor. *Panacea* (a tale that Britons "persistently" told themselves) relayed that the English had outwitted the Devil, the Spanish, and the French, recruiting heathen tobacco producers by introducing them to the true form of Christianity. In 1714, the year in which the end of the War of Spanish Succession lessened the threat of Franco-Spanish alliance, tobacco merchants issued a broadside that insisted tobacco exportation, the branch of trade that made England "formidable abroad," depended on sustaining the "Sale and Consumption of our Plantation Tobacco." Tobacco sales, several authors argued, kept tobacco

production going, plantations expanding, and Britain busy conquering France. Christopher Smart defended the public utility of smoking by having the pipe itself speak in 1752. A personified "black Tobacco-Pipe" responded to a "Bag-wig" who called it odious:

> Know, puppy, I'm an English pipe,
> Deem'd worthy of each Briton's gripe,
> Who, with my cloud-compelling aid,
> Help our plantations and our trade.

Metropolitan folklore about tobacco promoted colonial plantations, trade, and domestic consumption as part of the larger battle with European rivals for trade profits.[14] "Gaitskell's neat Tobacco" visually translated the conquest of a trade good into the conquest of a black man as it offered this imperial scene to entice and amuse customers.

Gaitskell invited London smokers to connect the pleasures of his product to mainstream beliefs about the religious and commercial virtues of colonization. Yet even this relatively straightforward marketing ploy contained potentially parodic elements, especially when considered within the context of Londoners' discussions about tobacco's effects on masculinity. No doubt it would be anachronistic to interpret Gaitskell's tobacco paper as an Englishman's wishful answer to the question of whether size matters, but the challenge that the diminutive Smith faces in overcoming his much larger enemy introduces comic elements into this colonization narrative that could either aggrandize his heroism or raise humorous questions about the success of this famously short and self-admiring man's attempts at conquest. Britons widely perceived tobacco to be a necessary stimulant for soldiers, but authors made fun of the "smoakie gallant" whose armory and artillery consisted of tobacco paraphernalia. In 1699, William King's mock-heroic poem *The Furmetary* remarked,

> 'Tis break of Day, thy sooty Broth prepare
> And all thy other Liquors for a War,
> Rouse up *Tobacco,* whose delicious sight,
> Illuminated round with Beams of Light,
> To my Impatient Mind will Cause Delight

King proceeded to send the weed to conquer other "Nostrils."[15] The frequency with which authors burlesqued the conquests of smoky gallants suggests that the relationship of tobacco smoking to authority lent itself to satire.

Physical contrasts also complicate the racial hierarchy in "Fawkners Best Virginia," though in this case the disparity produces more erotic than comic undertones (Figure 5.10). The Briton dominates the black man in certain respects: his full dress highlights the black man's partial nudity and evokes a comparison of civility and savagery.[16] The Briton also sits looking out of the image, whereas the black man stands, looking at him. Yet the structure of the gazes that lead us to the Briton is again complicated by the black man's dominant physical presence. The intentionality of his gaze and the suggestive placement of his loincloth, along with his height and strength, endow the black man with more influence than one might expect in an image of imperial hierarchy. His sexualized, classicized body suggests that the pleasures of tobacco, beyond smoking the product itself, had something to do with imagining this exotic black figure in one's company. The brand of tobacco that the white man presumably smokes is represented as almost an extension of the black man's body as his loincloth drapes over and connects him to Fawkners's shop sign.

Fawkners certainly sought to sell his product by constructing a particular experience of Virginia as one in which his shop, as represented by the sign, served as a medium through which the British smoker and the virile, black male were brought together. Perhaps this advertisement implied that the "heauenly dreames" experienced by some British smokers included a fantasy about the black male producer; perhaps by purchasing Fawkners tobacco, it suggested, one also bought a seductive vision of imperial authority figured in terms of the availability of this powerful black male body. "Gaitskell's neat Tobacco" and "Fawkners Best Virginia" are two of the most striking advertisements that enticed potential customers with fantasies about domination, yet even these examples contain contrasts between European and heathen masculinity that unsettle their depiction of British authority.[17]

These instabilities derive from the silencing of slavery itself, and the subsequent construction of authority from cultural perceptions of the tobacco trade, including the experience of nicotine. Only a few written accounts of tobacco hinted at the physical domination of Africans and Native Americans in British plantations. A 1716 poem linked Bacchus's discovery of tobacco to his ability to subdue the Indians:

Unknown, Tobacco, useless, grac'd the field;
till Bacchus, first, its ample leaf reveal'd:
when, by its strength refresht, the fainting God

subdu'd the Indians, and its virtue show'd.
By Bacchus taught, the wondring world grows wise;
and all mankind the usefull herbage prize.

Tobacco's utility lay in its ability to rouse fortitude, to stimulate the stamina needed to subdue the Indians through Bacchanalian conversion.[18] Descriptions of British domination over black tobacco producers, however, remained relatively rare; far more common were accounts and images that depicted the source of tobacco in transatlantic trade.

"Bathurst's Best Virginia" and "Bradley" located tobacco's origins with images of fraternal trade rather than outright conquest, though these advertisements also projected a complex combination of British authority over and identification with black tobacco producers (Figures 5.7, 5.11). "Bathurst's Best Virginia" assigned the pleasure of smoking to an idea of colonialism as trade. A Briton and a black man stand looking at each other from either side of the cartouche. Above the Briton are crossed tobacco pipes (the crossed pipes were most likely the arms assigned to all tobacco traders, including Bathurst); over the black man is a raw tobacco roll. The two different emblems suggest the Briton's involvement in consumption and the black Virginian's in production, yet the men smoke identical pipes. Most of these advertisements depicted galleons in the background, a conversation between a Briton and a black person, or a direct image of trade. Tobacconists marketed the experience of this drug as an interracial, transatlantic encounter individually experienced but, as "Bathurst's Best Virginia" suggests, mutually enjoyed.[19]

If the projection of a black man who physically dominates the white smoker complicates images of conquest, scenes of trade also contain more traditional connotations of hierarchy. "Bradley" offers a picture of the moment of exchange that suggests the persistence of inequality (Figure 5.7). Tobacco brings heathen and Briton to a table set up rather incongruously in a plantation landscape. The black man with a crown of feathers is perhaps the designated head of the laborers who are represented in the background directly beneath the proffered tobacco plant. The smaller white man may represent an overseer or simply a consumer, effeminate in comparison to the black producer, who is in turn dominated by the merchant or planter. The ships in the background suggest that this exchange is based upon trade, as does the elite Briton's inspection of the wares and the black man's assertion that his crop is indeed "sweet Scented." The inspection of wares, an accepted consumer ritual, was as natural to trading negotiations as

smoking with the trading partner. Yet playing judge to the products of slave labor or overseeing production were roles that also stood in for political dominion in eighteenth-century tracts. Many Britons presented themselves as merchants rather than conquistadors, benevolent God-fearing people like Robinson Crusoe whose only desire was to profit from mutual trade. As Joseph Addison observed in 1716, "it is our Business to extend to the utmost our Trade and Navigation. By this means, we reap the Advantages of Conquest, without Violence or Injustice; we not only strengthen ourselves, but gain the Wealth of our Neighbours in an honest Way; and, without any Act of Hostility, lay the several Nations, of the World under a kind of Contribution." In "Bradley," the imperial exchange is unequal. Oversight and inspection imply hierarchy in tension with the affinity projected by their shared appreciation of tobacco. "Crofton's Virginia," "Bowlers Best Virginia," and other tobacco papers also portray a black man asking for a white man to approve his crop or an overseer or planter smoking while slaves labor in his field (Figures 5.5, 5.6).[20] These images of tobacco plantations and trade managed to display a sense of reciprocity and a hierarchy of Britons over black tobacco producers.

Most tobacconists depicted the subordination of these African–Native American people as arising from a desire to trade or consume tobacco and not as direct enslavement. In the absence of shackles, whips, or collars, these black figures often appear to be voluntarily trading with Britons in a product they both appreciate. Mutual interest in tobacco and trade supplies an alternative explanation for British acquisition of this crop; British authority in the presence of conviviality makes the production of tobacco appear consensual. This relationship, devoid of outright British aggression, fits with the trading relationship set forth by economic tracts and dramatic plays. As George Lillo's extremely popular play, *The London Merchant*, put it: "by Love and Friendship . . . [we] teach them the Advantages of honest Traffick—by taking from them, with their own Consent, their useless Superfluities." Enticing smokers to identify with the merchant or planter who shares a pipe with an exotic native invites vicarious participation in contact with and authority over this producer of tobacco, a figure whose own sovereignty over the tobacco fields maintains the illusion that these figures are trading partners rather than forced laborers. Tobacconists may have deliberately distorted the facts when they offered these benign visions of imperialism; they may have critiqued the brutal realities of colonial tobacco production; or they may simply have absorbed the commonly articulated idea that British colonies, in contrast to those of the French and

Spanish, extended the benefits of trade and civilization to "reap the Advantages of Conquest, without Violence or Injustice."[21]

With the exception of Gaitskell, tobacconists rarely used symbolism of religious conversion, even though conversion remained one of the most powerful explanations for British authority over Africans and Native Americans in the Georgian era. The failure of efforts to proselytize began to undermine this particular argument for colonization, but it was never fully overturned. Most tobacco papers lack conversion iconography despite popular imperial propaganda that explained England's domination of the tobacco trade by its introduction of heathens to the "true" form of Christianity. It seems unlikely that the candle in "Bradley" carries its traditional symbolism of salvation unless it alludes, tongue-in-cheek, to the "supernaturall reuelations" that some Britons had when they smoked (Figure 5.7). In fact, a few advertisements contain visual jokes that may have parodied the salvation that smokers claimed to experience. "Boulton's Virginia," for example, offers up for sale an image of a woman whose facial features and long hair draw clearly on British conceptions of Native American bodies (Figure 5.12). By pointing toward the bust on the cartouche, she draws attention to its eyes, which glance sideways, directly at the thin cluster of leaves that conceals her genitalia. She partially covers her bare breasts, a gesture that derives from classical and Christian representations of temperance or chastity. The phoenix atop the cartouche associates the experience of this Native American woman with salvation. In "Crofton's Virginia" and "R. Mascall's Best Virginia" (ca. 1700), the engravers parodied old Christian iconography of Noah emerging from the ark, which prefigured the resurrection of Christ (and thus the salvation of man), by comically placing a plantation slave in a hogshead in exactly the same pose (Figure 5.5). What salvation tobacconists alluded to seems to be primarily about smoking and not, unless satirically, about the conversions that imperialism was supposed to bring about for African and Native American slaves. These advertisements instead highlighted the shared experience among heathen and British smokers of the more secular pleasures of tobacco.[22]

The tension in these images arises from the erasure of slavery itself. Circulating images of colonial tobacco production along with tobacco would have reinforced imperial relationships by marking the metropole as the "*destination* of rural production," yet the fanciful explanations of Britain's acquisition of this product—from conquest to fraternal trade to happy little plantation scenes—only underscore the degree to which en-

gravers willfully or ignorantly reconstructed the origins of tobacco. Tobacconists may have expected their customers to think arrogantly that black tobacco producers would naturally "bend before" them, as Alexander Pope envisioned Native Americans bowing to the glory of London. But the smoker's partnership with the heathen, especially in advertising that centralized trade, interferes with the visual establishment of authority. Communal smoking does not fill the void but complicates it. Although the printing of "black Virginians" on tobacco papers reflects British smokers' engagement with empire, that engagement also extended the London smoking fraternity to include black heathens. The interracial sociability depicted in "Baylis" and other advertisements with similar scenes is an important precedent for claims that became increasingly powerful in the second half of the century for the brotherhood of all people regardless of skin color (Figure 5.8).[23] These early images of fraternity rooted the affiliation of white and black smokers in their shared and mildly transgressive indulgence in this American drug.

Written accounts about tobacco sometimes displaced the physical domination of Africans and Native Americans in British tobacco plantations onto a different conception of bondage. Travelers and colonial historians also used the drug's sensuality to elide British agency in the subordination of New World peoples. Some Britons believed Native Americans and Africans were obsessed with the plant and, paradoxically, dependent on the British to provide it. Robert Beverley, the first creole historian of Virginia, noted that Native Americans had grown dependent "chiefly upon the *English*" for the weed. In 1750, Thomas Short expressed the addicting effect of this drug as a factor in enslavement: "Multitudes have sold one another into perpetual Slavery for a Trifle of it [tobacco]; and these not only Strangers or Captives, but their own Countrymen, yea their own Relations; Princes have not only sold their Subjects, but Prisoners unjustly accused of Crimes; and Masters for it and Spirits, dispose of their Servants and Slaves." Tobacco, as a demonic fume, was said to be the god of Native Americans, an idea that Olaudah Equiano transferred to Africans when he described a pipe-smoking god worshipped in his (at least literary) Igbo homeland. According to these tracts, addiction to the heathen weed shackled blacks to tobacco fields. The comforting idea that enslavement arose from something other than British aggression may have been a variant of the frequently articulated idea that Africans were already slaves in their own countries before being brought under British supervision. The notion that tobacco enslaved black heathens derived

from conventional descriptions of exotic pagan societies that revolved around sensual pleasures and from the common rhetorical use of enslavement to express the passions' claim on the body. The problem, however, was that consuming tobacco, as Short noted, also enslaved the British.[24]

Tobacco's association with heathenism and sensual pleasure made British consumption of it problematic. Originally described as the preferred drug among Native Americans, tobacco had long been associated with magic, visions, witchcraft, shrines, and evil spirits, all sources of power tapped by exotic healers. The perception of Indian sorcerers and witches using tobacco to foretell the future and become intoxicated and wild was well entrenched. Reports of smoking in Eastern and African societies reinforced these associations. English travelers publicized the controversy over tobacco in the Ottoman Empire, highlighting rich, sultry women who spent their days sitting on cushions, smoking pipes. Writers implicitly or explicitly connected indulgences in tobacco to the paganism or devil worshipping of exotic smokers as well as to the sensuality of the Turkish seraglio or African court. James I's pointed query continued to worry many Britons well into the eighteenth century:

> What honour or policie can mooue vs to imitate the barbarous and beastly maners of the wilde, godlesse, and slauish Indians, especially in so vile and stinking a custome? . . . Why doe we not as well imitate them in walking naked as they doe? in preferring glasses, feathers, and such toyes, to golde and precious stones, as they do? Yea why do we not denie God and adore the Deuill as they doe?[25]

British fears about tobacco stemmed from the belief that it was heathenish and that it seemed to induce states similar to those described in the exotic smoker; at the same time, many of the effects of nicotine—trances, sleeplessness, euphoria—fit those ascribed to demonic possession in folklore. Some believed that it had been brought by the devil, and some called it the witch, though others considered it a divine, holy, sacred, or sovereign herb. Most writers assumed these mental states to be inspired by something other than the Christian God. In 1623, John Taylor ruefully remarked that "mischiefe or mischances seldome come alone, and it is a doubtful question, whether the deuill brought Tobacco into England in a Coach, or else brought a Coach in a fogge or mist of Tobacco." More than a century later, a 1733 satirical poem similarly railed against the "Fiends and Devils" and the "Dæmon" of tobacco smoking while blessing "untainted Air" for "Deliverance."[26]

Tobacco's demonic connotations did not mean that the "foreign Weed" was shunned, especially after the profits of the tobacco trade won converts among those who initially believed that the crop turned gold into smoke. Probably the most enduring belief about tobacco was its value as a prophylactic. The uses of the "Indian weed" in quack medicines multiplied as it became a cure-all for hunger, stomach trouble, headaches, and other ailments. Doctors cataloged and advertised its health benefits, and many recommended daily use to sustain life. During the crisis over the 1733 Excise Bill, oppositional tracts argued that tobacco was not a luxury but rather a necessary staple among the poor. Even Crusoe managed to salvage tobacco from his wrecked ship. Richard Steele, a devoted smoker, sang the "Virtues of the Health-Restoring Plant," a gift of "Cures" as numerous as the maladies contained in Pandora's Box. Many considered the plant "Divine," as it gave "ease, To all our Pain and Miseries."[27]

Tobacconists conflated ideas about contact with New World peoples with the deeply desired and slightly transgressive pleasures of an American drug. Despite, or perhaps because of, growing fears of tobacco and its addictiveness, by far the most consistent theme in these images is pleasure: the upward gaze of the black men in "Chance's Best Virginia," the relaxed slaves of plantation scenes, and the joy of the black and white smokers in "Bathurst's Best Virginia" (Figures 5.11, 5.13). In "Bradley," the black man tempts the Briton with his tobacco's sweet scent; in "Bowlers Best Virginia," the squat black sitting on a hogshead is a black version of the emblem of Bacchus found in a late eighteenth- or early nineteenth-century child's broadsheet (Figures 5.6, 5.7, 5.17). Poetry describing tobacco's "earthly pleasure" was popular in London, with many poems appearing in several editions. On the flipside of the witchcraft coin was the "belching" god Bacchus.

Steele's poem, which praised the curative properties of tobacco, also celebrated it as "Bacchus his Herb." In 1736, A Pipe of Tobacco cried, "Happy Mortal! he who knows / Pleasure which a Pipe bestows." Most London smokers found the practice to be relaxing and meditative.[28] Common enjoyment of the sensuality of smoking draws the Briton and the black man together in these images. The sources of enjoyment lay in varied cultural associations with tobacco—its health benefits, links to witchcraft, and sensuality—as well as its seminal role in socializing and its value to trade and empire. Part of its appeal was the imagination of contact with black heathens and their incorporation into the metropolitan smoking scene.

Figure 5.17. "Bacchus," detail from child's broadsheet. Sold wholesale by Lumsden and son, Glasgow. © V&A Images/Victoria and Albert Museum, London.

When engravers imported New World people into the conventions of sensuality that had governed early seventeenth-century tobacco imagery, they invited British smokers to compare their own indulgences in tobacco with those of cursed pagans. Some Britons found this comparison deeply troubling: authors derided Englishmen for smoking "like Moores," called smoking a conversation with an "Indian whore," or compared the smoker's skin color to the black man's. Yet tobacconists made a particular contribution to the debate over tobacco by using the illicit aspects of tobacco consumption to draw customers. For metropolitan Britons well acquainted with the extensive popular debate over tobacco's vices and virtues, the table in "Bradley," with candle, pipe, bottle, and glass, may well have been in a London tavern; the relaxed and sensual elite white male may be a colonial counterpart to the smokers that satirist Ned Ward parodied for sitting about "puffing" in their nightgowns (Figure 5.7). Richard Lee's shop card depicted a version of William Hogarth's *Midnight Modern Conversation* that played on the association of white smokers and black bodies (Figure 5.18). Hogarth's prints were well known for depicting artwork above the heads of Londoners, whose behaviors were often subversively characterized by the art's content. In this image, which several tobacconists borrowed or adapted for their shops, a painting of a black

168

Figure 5.18. William Hogarth invt., *Richard Lee at ye Golden Tobacco Roll in Panton Street near Leicester Fields* (ca. 1720–1765), in Heal Collection, 117.108.

boy on the back wall hangs above a group of rowdy white men who are smoking and drinking around a table. These associations of the British smoker with the black Indian or African hint at the pleasures and anxieties involved in contemplating themselves alongside feathered, seminude black men sharing the experience of a plant thought to be both demonic and divine.[29]

Some tobacconists made light of this affiliation by making it explicit. If "Bradley" took a British smoker to a Virginia tobacco field, "Baylis" transported the black Virginian to a London table (Figures 5.7, 5.8). The engraver may have drawn upon earlier satirical depictions of Atlantic figures in tavern crowds. In 1631, for instance, Richard Brathwaite joked about ballad mongers and their song makers: "Now you shall see them . . . droppe into some blinde Ale-house, where these two naked Virginians

will call for a great potte, a toast [a woman], and a pipe." The knowledge that foreigners attached meanings of friendship to tobacco probably encouraged the extension of brotherhood to encompass the black smoker. According to M. Corneille le Bruyn, when Turks "[pay] Visits one to another, immediately Tobacco and Coffee is brought forth, and afterwards they Smoke and discourse the Point very Gravely, without rising from their Divans, unless it be for their Necessities." Similarly, the Native American peace pipe became a symbol of friendship, akin to the British "Flag of friendship." Even simple tobacco papers such as "Chance's Best Virginia" depicted two slaves smoking together, one on either side of the cartouche (Figure 5.13). Although as mirror images the two men serve to balance the arms, they also suggest that smoking was a communal, male activity. Sarah Greenland's advertisement for her tobacco pipes showed two white, feathered figures on either side of a banner inscribed, "Let Brotherly love Continue."[30] "Bathurst's Best Virginia" and other advertisements balanced the arms with a black man and a Briton, suggesting that smoking with natives, an accepted ritual of colonial negotiations, emblematized British trade (Figure 5.11).

These images of genial relations with black Virginians as well as the comical male physiques lessened the threat of paganism in ways appropriate to mock-heroic conquest. Engravers had imported a reassuring but worrying image of heathen addiction to corporeal (and thus sinful) pleasures. Representations of black bondage to tobacco helped to displace British imperial aggression yet also expressed an implied fear of Britons' own bondage to sensual pleasures. Numerous poets and pamphleteers bemoaned Britons' enslavement to the pipe. As Short remarked, "the greatest Inconvenience arising from habitual Smoking is, that the Herb is of such an infatuating Nature, that those accustomed to it cannot leave it off without the greatest Mortification, and a kind of Violence or Force done to their Inclination." Tobacconists and tobacco promoters responded by emphasizing tobacco's benefits to individual health and collective imperial interests: advertisements displayed patriotic banners announcing that tobacco was "Pro Patria"; they associated tobacco plants with Britannia, the English lion, and knights holding shields inscribed "omnes vinco," or "I conquer everyone." "Edward's Best Virginia," for instance, depicted a feathered white figure on horseback, with his lance pointing down toward a fleur-de-lis. A banner inscribed "For Our Country" appears alongside Britannia and the English lion.[31] Tobacconists suggested that blacks and whites enjoyed the pleasures of tobacco, but, for the British male,

smoking was also a conscious investment in the public utility of the to-
bacco trade, whereas such sensual pleasures bound blacks to the New
World plantation with its promise of civilizing improvement or at least a
continual supply of the weed.

Viewed within the context of British discussions about tobacco, these
advertisements incorporated black smokers and Britons' own illicit attrac-
tion to heathen sensuality into multiple patriotic and parodic narratives
about Britain's largely harmonious relationship to its imperial subjects.
These imagined relationships made light of Britain's anti-Catholic war by
turning it into a deployment of heathens under the British Protestant ban-
ner that recalled the popular themes of *Panacea*. One wonders what witty,
racially conscious, and often patriotic black Londoner Ignatius Sancho
had in mind when he commissioned two advertisements in 1779 for the
tobacco that he sold in his Westminster grocery. One used black cherubs to
stress the sensual pleasures of his Trinidadian brand. The other, titled "The
Wish," depicted a white man holding hands with a Native American–
African figure standing on a fleur-de-lis (Figures 5.19, 5.20).

Refashioning Contact

The tobacco papers' plantation scenes reflect the rising importance of
what Karen O'Brien calls the "imperial georgic," a mode that offered "a
model of social self-understanding which allowed them [British readers]
to comprehend the country and the city as separate yet integrated
spheres of activity within an expanding British Empire." O'Brien sug-
gests that slavery could not be "digested" by georgic poetry because it
ruptured the association between productive labor and civic virtue that
was characteristic of this literary mode.[32] These tobacco papers effected
a similar erasure of the brutal relationships between British colonists
and black slaves by offering a range of ways in which smokers could
fantasize about the origins of this foreign weed that had brought to-
bacco shops, smoking clubs, and smoking inns to urban life, whether in
conquest of black men, trade with black royals, or the convivial experi-
ence of smoking with black heathens. Though occasionally depicting
blacks laboring in plantation fields, tobacco papers maintained the rela-
tionship between virtue and labor by constructing the subordination of
black Virginians largely in terms of their mutual interest in the produc-
tion and trade of tobacco. Silencing slavery generated alternate visions of
virtuous contact and authority, which also created space for potentially

Figure 5.19. "Sancho's best Trinidado" (London, 1779), in Banks Collection, 117.150–1, Prints and Drawings Department, British Museum, London.

Figure 5.20. "No 19 Sancho's Best Trinidado Charles Street, Westminster, The Wish," in Banks Collection, 117.150.

subversive forms of identification and interaction with these imagined black smokers.

These fantasies circulated in coffeehouses, tobacco shops, and taverns, which were already renowned for various forms of illicit consumption. The pleasure of tobacco was tied to British conquest. It was also frequently equated with the pleasures of a woman and associated with the conviviality of a coffeehouse culture centered on male homosociality. Tobacco brotherhoods developed in the seventeenth century as a branch of a distinctly male subculture in English inns. Foreign visitors and domestic graphic artists recorded the maleness of smoking crowds. A few tobacconists directly represented imperial relationships, depicting a group of white, male smokers sitting at a table as black men pour them drinks or labor in a tobacco field in the background. Many more images blurred the lines between white and black smokers. As tobacconists suggested that white and black smokers shared these indulgences, they parodied common fears that contact with heathens would cause British degeneration. On the one hand, the engravers, like many professional painters, conflated classical, Turkish, African, and Native American imagery to create rather generic black figures that were sold to Londoners as Virginians or colonial producers and used to promote tobacco consumption. On the other hand, the blackness of these generic bodies may have had more to do with notions of tobacco's effects than any intrinsic quality of the bodies themselves. Other than the reality that British slaves were typically black, there was a good reason for the tobacco producer to be black. Thomas Nash, one of the earliest writers on tobacco, happily asserted that it was a "divine drugge" and pointed out that the blackness of the prince of darkness's face was likely because "you haue been a great . . . Tobacco-taker in your youth, which causeth it to come so to passe: but Dame Nature your nurse was partly in fault, else she might haue remedied it . . . The deuill [is] a great Tobacca taker." A 1733 satirical poem insinuated that the filthiness of the smoker's face reflected what had happened to black Indians: "One known to you will this Assertion back, / That Fiends and Devils smoak'd the Indians black." Earlier, James Duport related that tobacco "seems black in the pipe / But stains the white." Limited bathing probably meant that this relation was true. Other pamphlets included a line from Ovid that described how the raven was not white because his malicious activities had blackened him. Meanwhile, antismoking pamphlets debased smokers by calling them "chimny-sweepers."[33] Tobacco could turn anyone black: the devil, Native Americans, Africans, even Britons.

Georgian tobacco papers generally emphasized the Briton's affiliation with the black male to a greater degree than did high art that incorporated black subjects. Rather than portraying relations with blacks in terms of their submissive gratitude as portraits and tracts on the slave trade often did, they depicted relations as arising largely from a shared delight in the pleasures of this plant. The overwhelming presence of white and black men in these images suggests that experiences of smoking were rooted in the homosocial bonds that were central to colonialism and the formation of the early modern coffeehouse, smoking club, and tobacco shop. Visual and literary images of British imperialism, as well as eyewitness accounts, figured the pursuit of empire as a masculine endeavor centered on the exploitation of a New World that was often rendered female in allegories and descriptive prose. Wheeler has suggested that the "enterprising male figure" was the "dominant preoccupation" of the 1720s and 1730s: "European and African men engaged in trade emerge more fully than their female counterparts in early representations of imperial contact and in conceptions of human difference."[34] Tobacconists made an intriguing contribution to this conversation: imagining black heathens indulging in *Nicotiana* allowed Britons to create fantasies about their domination over and their fraternity with black men, a homosocial narrative of empire that arose from a sense of shared pleasure in a drug that (along with sugar) had enabled Britons to challenge Iberian and Dutch control over Atlantic commerce.

These advertisements also reflect how participants in the developing subcultures of tobacco shops and coffeehouses could understand their movement away from familial, domestic spaces in terms of their contribution to a nationalistic, masculine, and imperial enterprise. James I's attempt to ban tobacco in the early seventeenth century utterly failed, yet fears of tobacco's ability to disrupt social bonds and familial life persisted. Some Londoners criticized smokers for exchanging their familial hearths for tobacco clubs where prostitution and other forms of deviant social behavior were reputed to be the norm. Numerous tracts represented smoking as an alternate form of sexual gratification. Some authors burlesqued tobacco by showing how it led men to fulfill desires for foreign drugs instead of for their wives. Others allied tobacco with freedom from the domestic realm while equating the coffeehouse with the "Citizens Academy." An advice pamphlet to newly married husbands encouraged them to resume the "Pipe and wonted Freedom" and consider exchanging an unsatisfactory wife at Bristol for "two hogsheads of Best Virginia to-

bacco." In response to women who blamed coffee, tobacco, and other drugs for distracting, bankrupting, and emasculating their husbands, *The Mens Answer* tied participation in the social life of coffeehouses to a satirical vision of the imperial enterprise: "so many of the little Houses, with the Turkish Woman straddling on their Signs, are but Emblems of what is to be done within for your Conveniences, meer Nursuries to promote the petulant Trade, and breed up a stock of hopeful Plants for future service of the Republique, in the most thriving Mysteries of Debauchery."[35]

Empire, colonial drugs, and exotic bodies figuratively lured men to tobacco shops and coffeehouses. In effect the wrapping of these prints around imported tobacco conferred a body to the weed. Smokers consumed the "Indian whore," "King of Trinidado," or "the strange Indian": personifications of tobacco that Britons took from the Indian's devil. Such personifications perhaps explain why Charles Lamb referred to his pipe as "Bacchus' black servant, negro fine."[36] Tobacco leaves, often satirically substituted in these advertisements for the traditional Native American feathers, created these imagined encounters, which were transformed into commodities in and of themselves.

The development of colonial plantation agriculture fueled a consumer revolution in Britain, which entangled consumers in the imperial project. Tobacco shops, like coffeehouses, lay at the center of a cosmopolitan culture increasingly shaped by Britain's place at the peripheries of the Atlantic world. At their simplest, Georgian tobacco papers, which were part of the mundane experience of urban life, offered smokers visual aids to imagine themselves as colonists or merchants without ever leaving a chair. Yet the debates about tobacco suggest that smoking elicited anxieties about British degeneration because it evoked fears of the sins of luxury and concerns about the consequences of contact with heathens.

Instead of responding to doubts about tobacco consumption by erecting essentialist notions of racial difference or by simply ignoring its heathen associations, tobacconists used a variety of marketing tactics that combined the polyvalent meanings of tobacco, empire, and homosociality. Advertisements depicted tobacco's pleasures as at once the idea of contact with and authority over black tobacco producers, the fantasy of extending the British smoking fraternity to include exotic black friends, and the transgression of consuming a potentially demonic plant and entering into homosocial communities. In so doing, the designers of tobacco

papers drew on an established relationship of the black body to British imperialism and cultural perceptions of the racial other as a figure of deviance. By associating tobacco with patriotic visions of empire, these images echoed other forms of promotional literature on colonialism, but they made a particular contribution by linking the physical euphoria of nicotine to the pleasures of these imperial myths.

Engravers appropriated a representation of deviant social behavior in the black heathen to legitimate deviant behaviors among British smokers themselves; use of the royal black male in the tobacco papers promoted and sanctioned tobacco consumption as well as the consumer's entry into illicit relations with black heathens. Whether willful or ignorant reconstructions of British authority, these images were part of the construction of myths about Britain's greater imperial benevolence and at times even insinuated a partnership between the Briton and "black Virginian" that furthered Britain's political challenge to France. Baylis and other tobacconists offered carnivalesque images of black and white smokers coming together to delight in tobacco, constructing a myth of interracial sociability that encoded the plant's symbolic significance in some Atlantic interactions as a medium for establishing fraternal relationships.[37]

Although tobacconists portrayed the pleasures of their product in terms of the power differential between Britons and black Virginians, their advertisements stressed the encounter itself, meaning that the pleasures of *Nicotiana* remained associated with heathen behavior despite its value to trade and empire. This innovative iconography supported conventional views of colonial benevolence, but it also created space for imagining a fraternal relationship between colonial oppressors and their victims. The tension implicit between these different messages became explicit later in the eighteenth century, when the image of the benevolent British colonial became a staple of proslavery ideology while interracial fraternity, however imperfect and hierarchical it remained, became central to antislavery thought. Meanwhile, these advertisements show that categories of belonging and exclusion could be mediated in ways that unmoored the binary opposition of black and white and the association of that opposition with vice and virtue from lines of self and other.

Tobacconists enticed smokers by breaking down rather than reifying the distance between Britain and the colonies, even as the fanciful representations of British relationships to black producers inscribed the very real distance between them. In these tobacco prints, engaging with blackness became a lighthearted, often late-night encounter, a pleasurable experience

largely unrelated to ideas of eternal damnation, which has been cast in a mock-heroic discourse of consumption and a parody of the sinful pleasures that some Britons attributed to tobacco. Tobacconists, especially those who used explicit acts of domination in their advertisements, believed that they could draw customers by associating their product with the racial boundaries and imperial hierarchies that sustained imperialism. But as the engravers centralized the Atlantic encounter to the experience of this plant, they created images that integrated the metropole and colony in ways that pushed local imaginations of interracial contact toward a recognition of Britons' affiliation with black heathens and perhaps even recognition, albeit satirical, of the heathen in themselves.

I mean the setting forth, in the strongest colors, the surprising alterations objects seemingly undergo through the prepossessions and prejudices contracted by the mind.—Fallacies, strongly to be guarded against by such as would learn to see objects truly!

—William Hogarth, *The Analysis of Beauty* (1753)

A few decades before the painter sketched his Black Boy shop sign, William Hogarth fashioned his own interpretation of a "Black-Boy" for one of his "modern moral progresses," *A Harlot's Progress* (1732). The six engravings narrated a young woman's arrival in London, descent into prostitution, and death. In *Harlot 2,* she appears as mistress of a Jewish merchant, tipping over the tea table to distract him while her lover sneaks out the door (Figure 6.1). A monkey and a black slave, symbols of her "High Keeping," attend them in an ornate parlor. Although no less a product of fantasy than the shop sign, *Harlot 2* turned inward, parodying elite women's desire for child slaves by depicting a nonelite mistress playing at the high life.[1]

Hogarth's "Black-Boy" disrupts his intended symbolic role not only by providing a comic commentary on the debacle, but also by being a child, one who immediately repudiates his involvement in the destruction. His right hand gestures toward the harlot, betraying her as the source of chaos and dissociating him from the collected objects that have caused the Jew's downfall. Dramatists who staged this story expanded upon that repudiating gesture to explain how the Jew discovers his mistress's rebellion (in the print it is unclear how he learns of her transgression). *The Jew Decoy'd* (1735), for instance, cast the black boy as a bystander who accidentally betrays the harlot by revealing whose snuffbox remained forgotten, lying in the bed. *Harlot 2* did not provide such narrative speci-

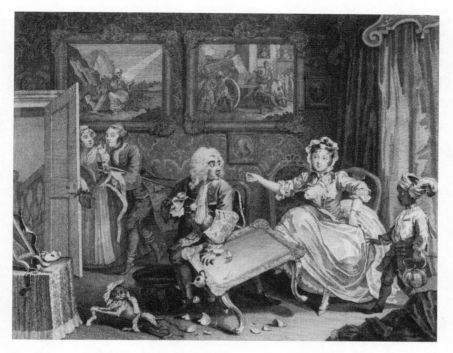

Figure 6.1. William Hogarth, *A Harlot's Progress,* plate 2 (London, 1732). © The Trustees of the British Museum. All rights reserved.

ficity to the child's role in this scene, but the iconographic subversion of the ostensive gesture did similar work. As the black servant dissociates himself from the falling items, he breaks the emblematic status that his body inherited as the bearer of these trade products, distancing himself from the scene of sexual deviance.[2] He becomes simply a child, but one who sees and comprehends the situation before him.

After setting up shop in London around 1720, Hogarth produced some of the most popular and influential pictures in Georgian Britain. His prints, which were often based on local events and people, decorated boudoirs, taverns, coffeehouses, inns, and other private and public spaces. Crowds perused his latest satires in print sellers' shop windows: some guffawed, others chuckled, and a few became incensed at the latest exposition of what a Quaker fan described as the "Licentiousness, Vice, Hypocrisy, Faction, & Apostacy" of the town.[3] Numerous legal and illegal copies of his works extended the reach of his social commentaries in and

beyond the British Isles. This circulation, along with the fact that Hogarth depicted black characters more often and in more contexts than any other contemporary artist, makes his graphic prints a central archive of popular midcentury engagement with black servitude, racial difference, and the domestic consequences of imperialism.

The question, for this book, is not what Hogarth thought of the slave trade or black slavery (which has preoccupied scholars interested in his black characters), but how he construed the symbolic and social significance of black servants in London society.[4] His criticism of the sensibilities of aspiring men and women who sought black servants for opulent display was one of several ways in which he engaged with the integration of blacks as slaves and as individuals into British society. If elsewhere in visual culture black servants remained static emblems for imperial wealth or domestic refinement, Hogarth located them in the kinetic energy of this city. He constructed the black person's individuality and agency against a society that primarily circulated black figures as reflections of preconceived visions of imperial mastery, but that had also begun to incorporate blacks into scenes of metropolitan life.

His prints consequentially became a primary medium through which Britons rooted the meanings of racial slavery in local contexts that challenged aristocratic notions of imperial mastery, a process that produced a new vision of the black servant as part of the motley London scene. Two developments in his works reformulated local meanings of blackness and slavery: his sustained association of black servitude with a moral corruption that he figured in terms of white British slavery and his related ability to portray people of color as independent personalities who participated in urban life outside the bounds of their serving roles. His gloss on the black presence resonated so deeply with his audience that his characters became an iconographic tradition, critically shaping and intensifying popular consciousness of London's limited but growing racial diversity.

Objects of Delusion

Hogarth's satire of the meanings that Britons attached to black servants was an aspect of his broader social commentary on the delusions that Londoners fell into as they pursued status and other material and fantastical desires. His attack on the myths of mastery was a criticism of elite social practices (including the display of black servants), which other authors and artists had characterized as the cultivation of virtue. His prints recon-

structed these practices by situating black servants in the social and cultural life of local taverns, boudoirs, parlors, prisons, streets, and fairs, mobilizing and then subverting their imagined symbolism. By depicting black servants with emotions and behaviors similar to (and sometimes as corrupt as) those of their white masters or mistresses, Hogarth questioned their ability to draw attention to and positively characterize a central white subject or a local store. Rather than being scripted, interchangeable, supporting characters in a narrative of British virtue and power, Hogarth's blacks acted as independent agents who belonged to (and often did not reflect well upon) the motley London world in which they worked and lived. This iconoclastic move, which questioned precisely the kinds of visual imperial hierarchies that portraitists promoted, disrupted the exoticism of blackness.

Hogarth's ability to make this iconoclastic move was, I will argue, a reflection of his anatomical studies, which convinced him that the variety of skin tones covered a universally ugly interior. This vision of the black body, as a variant of a common human type, did not necessarily entail an acceptance of racial pluralism (indeed, Hogarth's commentary potentially strengthened negative associations with blackness), but it produced new space for the black servant to become naturalized and humanized relative to other representations.

For those unfamiliar with Hogarth studies, a brief word about my interpretive approach to his prints may be appreciated. Early modern and modern critics have developed a sophisticated understanding of his visual construction of meaning through emblems, visual puns, proverbial knowledge, and other visual and literary modes of expression. His prints suggest certain interpretations through the addition of a piece of paper in a pocket, an animal motif, or an exotic servant. This method of reading his visual works (made explicit by his inclusion of text both beneath the prints and in them, and recognized by contemporaries) was based on the relationship between emblems and bodies, art paintings and their owners, servants and masters, or animal and human expression.[5] His connections between disparate things, such as a basket of kittens and a pregnant wife (*The Distressed Poet*), emphasized the metonymic nature of knowledge and reflect his engagement with contemporary discussions about judgment. Hogarth brought this mode of interpretation to the viewer's awareness by employing meandering lines of sight, odd juxtapositions, and multiple layers of bodies and objects. This deeply self-conscious construction of his graphic pictures had critical ramifications for how he

manipulated the meanings of black servants to comment on local London behaviors.

Hogarth began using black slaves to expose delusions of power early in his career. *Sancho's Feast* (ca. 1730) depicted Sancho, Don Quixote's sidekick, imagining himself king, yet he is starving to death as servants bring and then remove food before he can consume it (Figure 6.2).[6] The view into the court is as off-center as Sancho's self-conceptions; its revolving movement takes us from the departing boy back over his right shoulder to the arrival of an identical servant (in reverse view) who places another plate upon the table, and through him to the crowd extending from left to right and ending, as in *Harlot 2,* in the astonished gaze of a black slave. From the edge of the print, the black man, dressed as a page with a slave collar and pearl earrings, appears struck by Sancho's predicament. His presence contributes to the visual legitimacy and symbolic creation of the fictional court, but Hogarth's satirical inversion of the Italianate tradition of the black page brings into relief the dependence of such authority on subjects' collusion. The black man, his dress, and his collar contribute trappings of aristocracy, yet the king's starvation and his mockery of it undermine his courtly symbolism. He is an object practiced upon by overly optimistic desires: as an apparatus of Sancho's delusion, he represents and (through his laughter) subverts the meanings that elite and aspiring Britons associated with a black slave's presence.

Hogarth achieved this commentary on the delusions of power not by denigrating kingship directly, but by having the slave *make himself* unavailable for the king's self-fashioning. His immediate (rather than symbolic) and transgressive (rather than reaffirming) presence materializes through his affinity to the other lower-class characters beside him. Framed by a stage curtain and echoed in the three musicians in the balcony, the trio is critical to the court's theatricality. The black man's wide-eyed, open-mouthed expression portrays a slightly vacant delight in the king's troubles; his mocking gaze performs the normative function of the low. By being both symbolic of the court and an agent in its deconstruction, the black page makes his own critique of the role that he has been given. His carnivalesque laughter destabilizes Sancho's self-fashioning because it explodes the character he is meant to play. Hogarth thus invested the means to iconoclasm in the icon itself. As Henry Fielding remarked about Hogarth, "It hath been thought a vast commendation of a painter, to say that his figures seem to breathe; but surely it is a much greater and nobler applause, that they appear to think."[7]

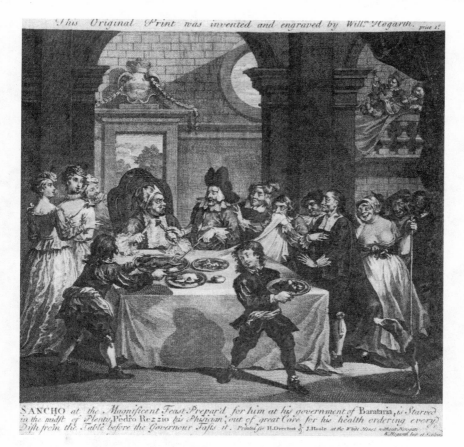

This Original Print was invented and engraved by Will.ᵐ Hogarth. price 1ˢ

SANCHO at the Magnificent Feast Prepar'd for him at his government of Barataria, is Starved in the midst of Plenty, Pedro Rezzio his Phisician out of great Care for his health ordering every Dish from the Table before the Governour Tasts it. Printed for H.Overton & J.Hoole at the White Horse without Newgate.

Figure 6.2. William Hogarth, *Sancho's Feast* (London, ca. 1730). © The Trustees of the British Museum. All rights reserved.

Given that Hogarth sketched "out on the spot any remarkable face which particularly struck him," it seems likely that his black characters were portraits. At least one case supports this inference: the black woman in the tavern scene of *A Rake's Progress* was based on Black Betty, who worked in Tom King's coffee shop, the site of *A Rake's Progress III*, and appeared in other prints (see Plate 13).[8] In this sense, his new iconography of local, interracial relationships and his naturalized and humanized black characters marked the presence of blacks in Britain and their integration into the ranks of the servant class. But his use of the black servant to

183

comment on the delusions of white Britons reflected also on their incorporation into social and material displays of mastery. As an increasingly modish form of luxury in port cities, black servitude could signify (for good or for ill) broader social changes. And to an artist familiar with both European art traditions and popular imagery, the black body also offered a rich repository of meanings that could be exploited in myriad ways to characterize metropolitan behaviors.[9] Hogarth's often-subtle parody of black servants' conventional iconographic position as minor characters that set off the main subject exposed the contingency of their social meanings, disrupting the "prepossessions and prejudices contracted by the mind" that caused objects (such as slaves) to undergo "surprising alterations."[10] He maintained their role as ostensive gestures, but reworked their symbolism by drawing upon lust, bondage, sin, and other negative ideas that Britons also attached to black skin. What black servants pointed out about white Britons was no longer so flattering—and, as importantly, what Britons wished them to mean was exposed as fantasy.

Hogarth's depictions of social displays of black servants engaged a variety of forms of delusion (such as vanity, hypocrisy, tyranny, or licentiousness) and a variety of consequences (such as death, dishonor, dependency, or sterility). All, however, suggested that these displays indexed slavish behavior—redeploying blackness and slavery to reveal how Britons had become, through their blind acquisition of corrupting objects, slaves to fashion and opinion. The roots of this burlesque of elite slave ownership lay in a parody of the trope of the liveried black servant. Hogarth's *Taste in High Life* (1746) made that target particularly clear (Figure 6.3). Mary Edwards, Hogarth's patron, solicited the original painting (1742) after being mocked by her friends for her old-fashioned dress. *Taste in High Life* made fun of modish French fashions in return. It expressed the whites' sensibility through their over-attention to the objects that surround them: a baby squirrel on a cushion suggests fragility; the hoop skirts portrayed in a picture on the wall emphasize the acceptance of constriction and containment in the name of fashion. Hogarth equated the small black child with the tiny teacup, placing them within an aesthetic of miniaturization that his contemporaries associated with women.[11] These collected objects helped to construct (and for Hogarth, mock) aristocratic high life (note the pun in the child's elevation), just as they had in *Harlot* 2.

Hogarth especially targeted black servants' associations with white women, drawing on literary satires of their social value within displays of female beauty and virtue (*The Character of the Town Misse* instructed

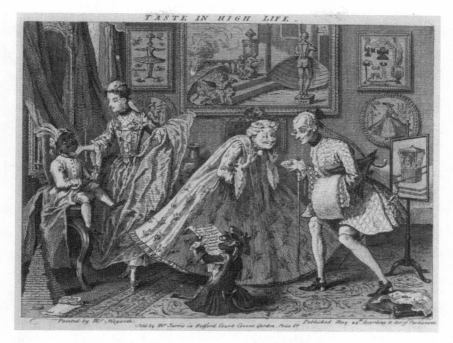

Figure 6.3. William Hogarth, *Taste in High Life* (1746). © The Trustees of the British Museum. All rights reserved.

women to acquire a "Blackmoor" and a lapdog if they wished to be "Fair and Sweet"). I have argued elsewhere that Hogarth linked this social practice, which literary critics have termed "petting," to a corruption of maternity. Metropolitan emphasis on child slavery allowed particular issues around sexuality, racial purity, and the reproduction of the nation to be formulated through these displays of mastery—for Hogarth, the question was one of unnatural versus natural procreation, and the displacement of maternal affection onto exotica that by becoming substitutes for progeny constrained more natural expressions of care.[12]

In *Taste in High Life*, Hogarth made this critique of female consumption through a parody of the iconography of elite portraiture, mobilizing and then subverting the black servant's expression and symbolism of adoration. The mistress–black servant relationship in this print especially resembles Godfrey Kneller's painting of, perhaps, Mary Davis (see Figure 1.5).[13] Both artists portrayed the elevated position of black slaves in elite

185

circles. Kneller's portrait places the boy atop a plinth, drawing attention to the shared position of slaves and art as objects collected for their ability to bring prestige. Hogarth drew the black boy sitting atop a table, turning his elevation into a comic commentary on the length of his coattail. The child's elevation speaks not to his cultural elevation from perceived West African barbarity, but to the elevation of black servants in the semiotics of fashion.

Both women gesture toward the child's chin. Leo Steinberg argues that the chin-chuck was "a visual text with both carnal and mystical connotation. Passing between Christ and the Virgin, the gesture becomes an all-purpose sign for the love bond between Christ and Mary-Ecclesia, between Christ and the soul, the Logos and human nature." He suggests that by the eighteenth century this gesture became secularized and began to disappear from images of heterosexual union and Christian love. The secular chin-chuck functioned as a mildly condescending gesture that established hierarchy but also affection. Hogarth's motif conveys the secular love that this mistress (mis)places on her exotic attendant. If we read the gesture within its lingering spiritual connotations, it also comments—in a parody of the Madonna—on the substitution of this child for Christ or, more generally, the mistress's physical progeny. Hogarth made a similar move in *Harlot* 2 when he juxtaposed the Ark of the Covenant (depicted in a painting on the back wall) with the tea set, parodying the investment of spiritual signification in fashionable objects, the modish form of idolatry.[14]

Hogarth repeatedly located the source of this moral corruption in Londoners' obsession with corrupting forms of consumption: gin, black slaves, monkeys, squirrels, castrati, or hoop skirts delude his female characters, and these fashionable "substitutes / For children" appear to lead to sterility, declining matrimony, prostitution, white orphans, disease, and death.[15] In its direct parody of practices of portraiture, *Taste in High Life* rendered black servants equivalent to the copies of masterpieces that, in Hogarth's *Analysis of Beauty,* corrupted taste and reflected the self-obsession of consumers of fashionable art. This print characterized the mistress-servant relationship not as an expression of maternal power and beauty, but narcissistic love. As satirist Tom Brown remarked, women who sought such fashionable attendants admired "nothing but themselves."[16] The black child responds to the chin-chuck in a self-affirming way, becoming a fetish that highlights the mistress's corrupted desire for this response from her objects, whether squirrel or slave.

Even if Hogarth did not specifically respond to Kneller's work, he appropriated the black gaze from portraiture only to turn the child's adora-

tion into a reflection of the mistress's affectation. His contribution to the display of black servants was thus satiric and subversive of the civility, politeness, and Christian virtue that elite mistresses hoped to convey. Scholars have usually seen Hogarth's blacks as representing the exotic and thus as equivalent to the colonial imports that slave labor provided. I am suggesting here that Hogarth played with their connotations as exotic objects to turn aristocratic displays of black servants into a burlesque of social virtue.[17] He maintained the mirror and the inscription of distance: the child slave remains a bearer or onlooker who characterizes British mastery. But he changed a sign of wealth and virtuous power into one analogous to the constraint/containment of a hoop skirt, refashioning the trope of the anglicized black slave as an empty icon of sociosexual corruption. The woman's sight of herself in the slave became a reflection of her own bondage to fashion, a corruption of "taste" in this "high life" that is also responsible for the conspicuous absence of her own progeny. Hogarth did not directly speak to the morality of the slave trade, but he participated in a growing midcentury concern that slaves did not reflect well upon Britons at home and that ideologies of "care" that sanctioned slavery were corrupt.[18]

Such concerns with the corruption of taste and the objects of delusion reflected the larger eighteenth-century project of social improvement, which sought in the first half of the century to control unsettling social change unleashed by the expansion of trade and the rise of the fiscal-military state. Attempts to control consumption generally focused on women, so it is difficult to know whether the emphasis on female relationships with black servants (in portraiture and graphic art) recorded social practice or cultural associations. But the entanglement, in this Atlantic frontier, of black servitude in discourses of fashion highlights how this contact zone of Atlantic slavery was formulated and contested in aristocratic and often female domestic spaces and terms. Hogarth's images of black children, for instance, spoke to new object-subject relationships emerging with the consumer revolution and to the fear that these new relationships interfered with more "natural" forms of social and cultural procreation.[19] For Hogarth, the effects of such conspicuous consumption on the health of society were profound. When he invited his readers to "see with [their] own eyes," when he discursively constructed a public that was "classless because all of its members have equal status as witnesses," he sought to democratize sight and, in so doing, to free his contemporaries from blindly accepting customs and fashions that limited their natural freedom and expression.[20]

Enslaving Fashions

"Shacklings are repugnant to nature," Hogarth wrote in his famous (some would say infamous) treatise on aesthetics, *The Analysis of Beauty* (1753). He referred to local practices of using "steel-collars" and other "iron-machines" to teach children proper posture or, specifically, to cure the bashfulness that led them to drop their heads. For Hogarth, such unnatural bondage of the body encapsulated how fashions disfigured an innate freedom and the varied expressions of character that followed from it. His aversion to "Shacklings" flowed from his general preoccupation with captivity, which contributed to discussions about fashion's effects on the social body. Antifashion discourse in eighteenth-century Britain was also an anti-absolutist discourse, invoking an image of fashion as an arbitrary tyrant that enslaved its victims. Unlike some of his contemporaries, Hogarth's concern lay more with this constriction than with the immorality of consumption per se.[21] Once decoupled from myths of mastery, the black page (often bound in his own fashionable "steel-collar") carried negative connotations of slavery and blackness into Hogarth's commentaries that emphasized the tragic consequences of white Britons' bondage to fashion and opinion.

A Harlot's Progress, for instance, mapped in each plate the deepening disaster of this young woman's decision to come to London. Her unruliness in *Harlot* 2 was set in the context of *Harlot* 1, where a bawd preys upon her naïveté as a new arrival in London to sell her body to an infamous London rapist. Her cousins have not come to meet her. A well-known reverend remains blind to her predicament, having eyes only for his letter of preferment. Ronald Paulson has written extensively about plate 2 as a critique of the wrathful nature of the Old Testament God through its evocation of sympathy with Uzzah, who is depicted in a painting on the wall (the unfortunate man who tried to catch the falling Ark and was smitten unto death), its association of the Jew with deist critiques of Old Testament justice, and its resulting moral question of whether the harlot's punishments fit her crime (she will be cast out by the Jew, turn prostitute, be incarcerated in Bridewell, and die of venereal disease in subsequent plates).[22] The entrance of the child slave in plate 2 plays an important function in connecting and explicating the two central characters' delusions of power in terms of their own forms of enslavement and moral corruption.

The antics of this couple (the Jew's acquisition of a mistress and other emblems of wealth to fashion himself into a gentleman and the harlot's

cuckolding of the Jew) turned the black servant and kettle into a bur-
lesque of elite social practices (see Figure 6.1). This modern moral prog-
ress invested an imperial display with a critique of local aspirations and
sensibilities. As the tea party devolves into a scene of sexual deviance,
tropes of civility metamorphose into tropes of prostitution: the courtly
figure of the liveried black servant who was an emblem of luxury and
bore other emblems of luxury (in this case, the kettle) transformed into
an implement of prostitution carrying another implement of prostitution
(compare to Figure 1.6). Though Hogarth's story derived from reports of
local prostitute Kate Hackabout, *Harlot* 2 was, in many respects, a visual
rendition of the anonymous literary satire *Character of a Town Misse:*
both followed the life of the "strumpet" or modern "town misse" who
"exposes her own Flesh for . . . Sale by the *Stone*" and uses the "necessary
Implements," "the Blackmoor" and dog, or here monkey (though some
dramatic versions of this series replaced the monkey with a dog), to further
her ends. The scene of cuckolding activates the kettle's colloquial (and
negative) associations, becoming an emblem for the sticky situation in the
parlor, as in Samuel Richardson's *Pamela,* "He has made a fine Kettle
on't—han't he!" This connotation complemented one common view of
the tea table as "the mother of scandal, or the nurse of ridicule," which fit
the obvious suggestion of hot water. The kettle could have also alluded to
a joke about skin color (see, e.g., Thomas Otway's *Caius Marius:* "I'm an
honest, black, tauny, Kettle-fac'd Fellow"). Late Stuart and Georgian lit-
erary satires used the kettle as an emblem of female sexuality (according
to the *Dictionary of Sexual Language and Imagery,* it was a euphemism
for the vagina). Several satires featured men advertising their services for
stopping up kettle holes. Graphic artists also used the kettle in scenes of
prostitution: Louis Philippe Boitard, an admirer of Hogarth who occa-
sionally pirated his prints, engraved *The Sailor's Revenge, or The Strand
in an Uproar* (1749) with a kettle among the objects that a harlot's maid
spirits away from the destruction of a brothel (Figure 6.4). The woman
clutches the prominent kettle, whispering to the whore, "Tis well Mis-
tress we've saved our Dun." Boitard satirized the kettle as debt collector
or "Dun"; it is an implement of prostitution in this print.[23] The kettle
was an object of elite sociability, but it was also acquiring less polite
associations with women and sex in Georgian London. Hogarth would
have been aware of those colloquial connotations, especially as he sent
the kettle into a scene of sexual transgression. His iconoclasm of the trope
of the liveried black page worked in part by having his mistress and master

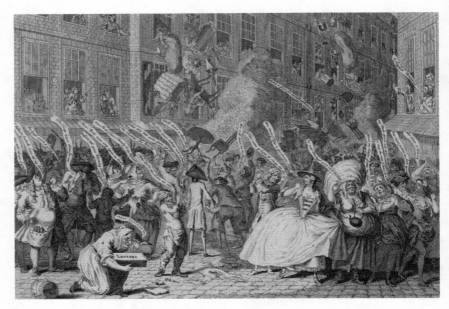

Figure 6.4. Louis Philippe Boitard, *The Sailor's Revenge, or The Strand in an Uproar* (London, 1749). © The Trustees of the British Museum. All rights reserved.

imagine that they possessed an object that conveyed their beauty and power, even as their behaviors made a travesty of that symbolism.

The engraver George Vertue observed that Hogarth's harlot "captivated the Minds of most People . . . of all ranks & conditions from the greatest Quality to the meanest." Male dramatists of *A Harlot's Progress* emphasized an imagined female audience to this print, stressing its critique of women who became the playthings of men: as John Breval announced in 1733, "Females! the wily Harlot's Net beware, / Pleasing's the Lure, but fatal is the snare."[24] The tragedy of the harlot's actions (her cuckolding of the Jew) is brought into relief through her formal relationship to the child slave: *Harlot* 2 associated the slave with the harlot by position, both literally in their location in the print and figuratively as the Jew's possessions. His Turkish attire made the allusion to bondage specific, suggesting a comparison of the boudoir to a seraglio and more generally to the luxury and sexual degeneracy that Britons associated with the Orient. In relation to the Jew's mistress, the Turkish slave specifically invoked a form of despotism signified by the Grand Turk's keeping of

190

women. By the late seventeenth century, the seraglio had emerged as a British metonym for male lust and political despotism. The editors of the *Athenian Mercury,* for instance, described a man who had taken two wives as a "Great Turk of a Husband" who kept a "Seraglio of Women"; they suggested to the second wife that she consider her "bondage" forsworn and herself free to marry again.[25] Bringing the idea of prostitution and slavery into this London parlor illuminated the closed-in walls and the harlot's dwindling freedom. The black slave with his kettle foreshadowed her descent into prostitution and incarceration in plates 3 and 4, a role formally reinforced by the fact that a reading of the print from left to right ends in his backward gaze upon the scene. Disrupting the meaning of the black servant disrupted the harlot's delusion of power, replacing it with a view into the particular, local, and morally ambiguous consequences of her actions. Slavery, tyranny, and trade were already figuratively present in *A Harlot's Progress* without the addition of a black slave; his presence reinforced and manifested these themes.

The Turkish slave was a complex symbol that allowed viewers to think through and compare the Jew's and harlot's delusions of power. For many dramatists, this Turkish trope provided context for the repetitive association of Moll with tyrannical men throughout the series, raising questions about where responsibility for her fall lay; a poignant narrative about the abuses of power accompanies the antics of this harlot, one of the "Ladies of Pleasure . . . alias *unfortunate Women,*" as Cibber described them. Not all viewers of Hogarth's prints, however, emphasized this view of Moll's decline: for Breval, for instance, the Turkish slave conveyed the "*Insolence of* Prostitutes *in* Keeping" that "*Exceeds the haughtiest* Sultan *of the East,*" a gender reversal that engaged Hogarth's lingering question about whether the aspiring Jew or the cuckolding mistress were at fault, but placed the blame on the harlot's own usurpation of power. As he poetically translated the harlot's power, "How Fops and Beaux her easy Dupes are made" and "While *Beaux* by Thousands own themselves your Slaves."[26]

This burlesque of aristocratic virtue thus also ridiculed the Jew's pretensions to gentleman status by revealing his own enslavement by his objects of wealth (including the harlot). Some Britons saw the pursuit of fashion as rendering men susceptible to slavery because they abandoned "the simplicity and customs that alone" prevented such degeneration into a "passive" acceptance of "obedience." The comic mimesis of surprised expressions in *Harlot* 2 renders equivalent (and interchangeable) the monkey, slave, and Jew. Paulson suggests that the monkey verbalizes the phrase

"made a monkey of": in emblem books and other satires, monkeys or apes symbolized foolish affectation, deceit, and hypocrisy. The triad of reactions also implies that the Jew has been made a slave of his possessions. Substitution of black slaves for male masters had occurred within literary satires of courtship (as well as within portraiture of elite women in which the black servant inhabited the biblical position of Eliezer). Tom Brown's collected works, for instance, included a translation of a Frenchman's letter to his mistress, titled "Upon sending her a Black, and a Monkey." "Africk, to oblige you," he wrote, "has exhausted herself, and sends you two of the oddest Creatures she produces . . . Both of them are in Perfection; the Black is the saddest Dog of all Blacks, and the Monkey, the most malicious Devil of all Monkeys." "I am extreamly glad," he says, "that you will always have a Slave in your Presence, to represent me: He is not more yours, than I am." The "Black" is his "Representative," a body intended to remind her of him and also to stand in his place, expressing his sentiments and replicating his flaws. *Harlot 2*'s satirical mimesis also mobilized the servant's connotations of slavery, but targeted the Jew's delusions of power rather than his bondage to love. He sees himself in the mirroring figure of the slave, but does not yet realize that he has also been made a monkey of (a cuckolded fool, a hypocrite). Cibber's *Harlot's Progress* staged this scene with the harlot reveling in her "Charming happy Life" outside marriage in which the Jew "rifles" her while she "rifle[s] his Purse," forcing the "fond Hypocrite" to give her money while she makes such "Fools of Mankind."[27] Hogarth's critique of keeping mistresses echoed contemporary writings that linked this practice to the degradation of marriage, but emphasized how such practices led to the destruction of male honor—to a slavish emasculation.

As Hogarth subverted the black servant's ostensive gesture, one final reconfiguration of meaning occurred. His blackness, rather than signifying wealth, became a sign of sin. In the 1690s, the *Athenian Mercury* responded to a question about whether plays were lawful by reminding its audience that the first "Intention of them was to display Vice and Virtue in their proper Colours." Vice was "black and deformed"; virtue was given the "most pleasing form." In *Harlot 2*, the page's blackness (through its association with fashion and prostitution) highlighted the couple's participation in vice, but it also deepened the symbolism of hypocrisy. The boy's blackness, in relation to the kettle that he carries and the pot that falls off the table, verbalizes the proverb of the pot calling the kettle black. Chinaware (and the breaking of it) was a metaphor for female sexuality that Pope famously used in *The Rape of the Lock,* but the tea

set is also intimately linked to the Jew, because Hogarth satirized the Jew's location of his honor in a harlot's fidelity. The teacup is the most conspicuous item of the tea set associated with him, but the black-handled teapot, positioned effeminately between his legs, also falls just beyond his reach. "The pot calling the kettle black" indicated then, as it does today, the hypocrisy of admonishing others for shortcomings that one shares, reinforcing the symbolism of hypocrisy also introduced by the monkey. Shifting the emphasis in this scene to the Jew centralizes him as an aggressor, bringing the rapist from plate 1 out of the shadows and foreshadowing the punishment of the harlot in subsequent plates by yet other male authority figures. The allusion to this proverb highlights the hypocrisy of the Jew's pretense to Christianity and his (related) failure to see his own faults in keeping a mistress.[28]

In this proverb, blackness is a mediating term that unites the pot and kettle while being wrongly used to discriminate between them. By relating the child through his expression to the Jew and bringing him into positional and metaphorical relationship to the harlot, Hogarth used blackness as a mediating term between them. It is crucial that he left the decision of who is to blame to the viewer, because doing so causes any interrogation of the origins of such blackness to be not in the slave but in his signification— the vice, slavery, fashion, Turkishness, commoditized sexuality, and childish naïveté that characterize the parlor scene. The slave child, caught in arrested movement from right to left, functions like the Old Testament paintings on the wall, lending to both central characters his symbolism. He becomes, like Sancho's black page, an agent in the deconstruction of myths of mastery, both by dissociating himself from the scene of destruction and by continuing to function as an ostensive gesture when no longer signifying mastery. The baseness of this relationship corrupted the moral value of the liveried black servant, liberating his free-floating significations of blackness and slavery to refashion those who sought his attendance.

Hogarth's inclusion of a black, pregnant woman in *Harlot* 4 extended the progress of slavery and prostitution in the series, deepening the association of black bodies with sexual deviance and physical confinement (Figure 6.5). This displaced commentary (literally displaced, in the distance of the black woman from Moll in the Bridewell prison cell) also replicated the structural position of blacks in portraits and other visual media as ostensive gestures: this still figure is barely visible in the shadows, an obscure allusion to slavery, sexual deviance, and perhaps transportation that contextualizes Moll's incarceration. In contrast to Hogarth's "Black-Boy,"

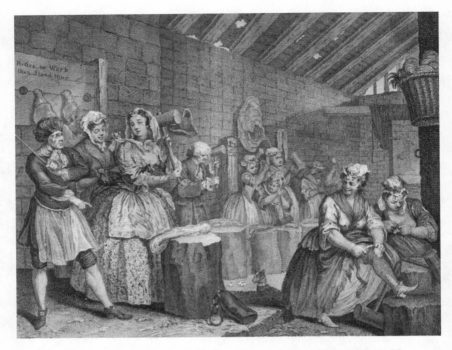

Figure 6.5. William Hogarth, *A Harlot's Progress,* plate 4 (London, 1732).
© The Trustees of the British Museum. All rights reserved.

this character did not become a staple of British visual culture—indeed no copier directly interpreted the black woman's presence. Some turned her white, perhaps suggesting some confusion and discomfort with this character. Colored versions of the print, following Hogarth's original painting, accentuated her blackness, losing the subtle shadow of deviant sexuality in his print but clarifying the multiracial nature of Bridewell's female populations in mid-eighteenth-century London. In this case, Hogarth disrupted the symbolism of black servitude more abstractly, gesturing toward the subversive (and nearly invisible) presence of black prostitutes in London. Early eighteenth-century references to black harlots are rare, but they were included in Jack Harris's midcentury lists of more high-class prostitutes, and Hogarth included black women in two other scenes that engaged questions of sexual deviance (see, e.g., Plate 13).[29] In *Harlot* 4, the emphasis on prostitution was offset by the lecherous male who appears here as the prison warden (he is explicitly sexually abusive in some dramatic ver-

194

sions), again locating the question of blame somewhere between prostitution and tyranny.[30]

Mobilizing and then subverting the signification of an object was Hogarth's principal method of iconoclasm. From a postmodern perspective, his exposure of the "Licentiousness, Vice, Hypocrisy, Faction, & Apostacy" of the town was merely another construction of meaning; for Hogarth, it was intended to help Londoners to see for themselves how objects acquired meaning through the social behaviors of those who possessed them. In that visual move, he stripped black servants of their affirming symbolism and activated negative, colloquial associations in their stead. Instead of displaying aristocratic virtue or emerging ideas about commercial refinement, *A Harlot's Progress*'s black characters united discourses of slavery and prostitution with the keeping of women, the male sexual predator, and the absent figure of the church.[31] They belonged to a semiotics of vanity, tyranny, and sexual deviance that explained the harlot's death.

All of Hogarth's prints with black characters staged this complex iconoclastic revision of the meanings of mastery. In *Marriage À-la-mode*, plate 4 (1745), a print based on *Taste in High Life*, he also pointed out the sociosexual vice of white women who slavishly sought fashionable black servants. The story began in an elegant house, where Earl Squander arranged his son's marriage to the daughter of a wealthy but stingy merchant. It ended in the son's murder and the daughter's suicide. As a 1746 verse explanation succinctly put it: "Two shackled Slaves in one Abode / And this is Marriage A-la-Mode." Plate 4 shows the countess and her friends in her boudoir, acting out a baroque parody of the classical and biblical paintings of rape and incest that hang above them (Figure 6.6). The lawyer Silvertongue (her future lover) invites her to a masquerade, pointing to the one depicted on the screen. A coral draped over the back of her chair indicates that she is a mother. Other than the black boy sitting on the floor, however, no child appears. As Nichols remarked, "The child's coral, hanging from the back of the chair she sits in, serves to shew that she was already a mother; a circumstance that renders her conduct still more unpardonable. Some of her new-made purchases, exposed on the floor, bear witness to the warmth of her inclinations." The black child, one of the purchases on the floor, has stopped unpacking a collection of curiosities bought at auction to point salaciously at the (cuckolding) horns of the figurine of Actaeon, enacting the absence of innocuous play in the boudoir. As an anonymous interpreter of this plate narrated it:

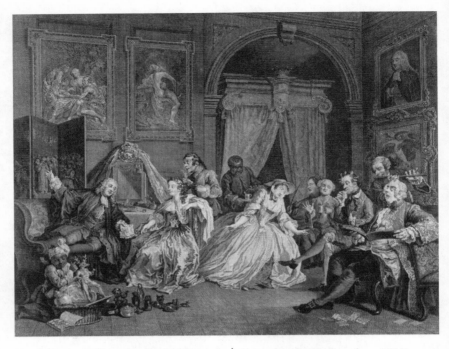

Figure 6.6. William Hogarth, *Marriage À-la-mode,* plate 4 (London, 1745).
© The Trustees of the British Museum. All rights reserved.

> The crafty Black (who on the Floor,
> Lies turning Toys and Trinkets o'er,
> Which she had purchass'd [*sic*] from the Stock,
> Of that fam'd Auctioneer Don C—k)
> Seeing the Way the Game is plaid,
> Picks out an Emblem aptly made,
> To suit his Lord; Acteon's Head:
> And grinning as in's Hand 'tis borne,
> He slyly points towards the Horn.

The child is a figure produced by his corrupted and local environment, commenting on and contributing to the vice of the boudoir. He belongs to a category of fashion including the Italian castrato and the pictures on the wall, yet he also occupies the domestic space of progeny.[32] As in *Taste in High Life,* the black child connects fashionable art collecting to the

corruption of female virtue, especially in terms of maternity; as in *Harlot 2*, the countess's delusions also lead her into adultery.

If the projection of the liveried black servant onto Atlantic networks of wealth production silenced plantation labor by replacing it with the labor of domestic servitude, the work of black servants in Hogarth's prints deepened that act of surrogation (his was not an abolitionist critique that tied these forms of consumption to the abuse of slaves abroad). He ridiculed the value of black labor: the black child in *Marriage* 4 literalizes this sociocultural work, as he unpacks more curiosities, turning the domestic landscape into a profusion of grotesque ornaments. The painting over the child's head, which depicts the rape of Lot by his daughters, racialized this burlesque of elite female virtue. The Restoration and early Georgian eras witnessed a flurry of interest in theories about skin color, but the confusion of classical, scientific, biblical, and fanciful explanations of the variety of skin tones had not been clarified by Hogarth's lifetime. His brief description of the origins of skin color in his *Analysis of Beauty* contributed to this debate from an anatomist's perspective, but his prints suggest that he was well aware of other interpretations. He and his coffeehouse audience had access, for instance, to the *Athenian Mercury*'s restatement of the idea that blackness derived from Lot's copulation with his daughters: blackness originated, in this explanation, when the daughters transferred their sight of Sodom's smoke and darkness to their progeny. Hogarth's painting of Lot highlighted the generation of blackness in deviant sexual behavior, denaturalizing the child's blackness as his color becomes a literal or emblematic sign of the countess's engagement with the Sodom of the boudoir (and suggestively, perhaps, the black male servant).[33] The black child is not just conscious of the transgressive encounters that he witnesses; he actively contributes to their unfolding.

Hogarth did not condemn the slave trade's immorality: he should not be classified as an abolitionist.[34] He was, however, an important precursor to this movement. His visualization of the relationship between consumption and bondage registered how imperialism formed a periphery to developing antislavery thought in Britain, supplying symbolic forms of slavery that could be used to think about bondage at home. Hogarth's primary concern was the harmful effects that he perceived in his fellow Londoners' desire for foreign goods (including slaves). His depictions of black slaves contributed to an eighteenth-century discussion that connected desire for foreign luxuries to growing limitations on British liberty. Hogarth set up a fluid dialogue between forms of moral and physical enslavement

that allowed him to use black slaves to comment upon the corruption of his fellow Londoners, both black and white. A few decades later, abolitionists would take an importantly different tack by formulating a broader moral argument against African slavery and demonizing the consumption of its products, but Hogarth's images, drawn before Atlantic slavery came to be widely perceived as an exceptional phenomenon, lay the groundwork for this development by associating the possession of black slaves, and the work that they did for Britons at home, with local forms of sociosexual vice.

Learning to "See Objects Truly"

The "prejudices" of those, Hogarth argued in 1753, who lost "sight of nature" and took "things upon trust," "blindly descend[ed]" into the "coal pit of connoisseurship." That "coal pit" was fashion, the customs and opinions (or metonymic associations) to which a child had been inured. Hogarth offered his particular nostrum for these "Fallacies," calling on Londoners to free themselves, teaching them to exchange gullibility for an informed awareness of human nature that would allow them to judge what was real. His prints encouraged viewers to experience the idea of knowledge that he put forward in *The Analysis of Beauty,* a way of seeing "with [your] own eyes" to recognize the synthetic nature of associations and thus the contingency of meaning. Such contingency, as Richard Kroll observes, was an important feature of Augustan texts, which "habitually reveal and examine the terms under which they construct themselves." It was also, as John Bender points out, a technique of realism that insisted the audience "witness the commonplace in a certain particular way . . . bring[ing] the everyday world to consciousness, reframing it and calling attention to its visual oddities—a step necessary to ethical awareness yet prior to it."[35]

Coming to terms with new forms of consumption involved debates over the meanings of objects on display. As money and commodities circulate through his prints, affectation, disease, and death afflict Hogarth's characters. His revision of the desire for slaves as the blind consumption of slavery added to apprehensions that owning slaves corrupted masters and to less prominent fears that masters corrupted their slaves. These concerns, which would also become popular abolitionist arguments, had focused on planters abroad. Hogarth domesticated the problem of slavery in his specific critique of London fashions as he self-consciously drew

on the meanings of blackness and slavery to construct local narratives. No longer were planters the only British supplicants to the "great Idol, the GOD OF GAIN."[36]

Hogarth's iconoclastic depiction of black servants contributed to his larger effort to encourage "reflexivity and self-contemplation," which were "basic to the kind of moral consciousness [he] and his contemporaries sought."[37] As increasingly desirable and accessible objects, Hogarth's black slaves commented on the spread of elite social practices (it was a harlot, rather than an elite woman, who was being served by the page), which produced imitations that cheapened the servants' value as indexes of upper-class morality by exposing that display of morality to be a masquerade. His prints thus radically departed from earlier print satires that employed the black page as a straightforward sign of status and from portraits that conceived the civilizing of the black heathen as aristocratic work. Hogarth's trope of the anglicized black signified instead the pagan art object Christianized and idolized.

This parody of elite social practices was effective because he depicted black servants in situations like and unlike those in which spectators would have seen them. *Harlot* 2 replaced the genteel lady with a harlot; *Taste in High Life* associated the collecting of black children with artifice. These graphic commentaries resembled the deliberately partial examples that Hogarth provided in his *Analysis of Beauty* to direct readers' imaginations. This corrective use of the partial type suggests that his burlesque of contemporary relationships with black slaves functioned like an antimasque, the point of which was that "the personage to whom the masque is presented will be embarrassed by its contents and reform his behaviour in line with the moral in the resolution of the masque." A Quaker farmer compared the restorative capacity of Hogarth's prints to his own treatment of cattle with wormwood.[38]

Commentaries that directly connected his prints to particular elite women and the more general absorption of the black servant as a figure of satire registered the effectiveness of his parody. Hogarth's eighteenth-century biographers interpreted *Taste in High Life* as a satire of noble women who tried to display their virtue by educating black children, one of the common justifications for bringing Africans to Britain. As John Nichols disparaged: "Her familiarity with the black boy alludes to a similar weakness in a noble duchess who educated two brats of the same colour. One of them afterwards robbed her, and the other was guilty of some offence equally unpardonable." A manuscript gloss to the third edition of

Nichols's biography in the British Library marks the "noble duchess" as the Duchess of Montagu, perhaps the same who employed the black Londoner and writer Ignatius Sancho.[39] In this cynical and racialized critique of elite women's behavior, Hogarth's print became a framework in which to think about the entanglement of black servants in domestic discourses of fashion.

Few of these kinds of explicit applications survive, but as versions of Hogarth's blacks became general satirical weapons against the follies of white Londoners, the broader resonance of his work became apparent. Hogarth's black boy with a kettle in particular stuck with viewers: when Garrick acted Othello, a commentator remarked that his "appearance in that tramontane dress made us rather expect to see a tea-kettle in his hand, than to the hear the thundering speeches Shakspeare has thrown into that character, come out of his mouth."[40] This burlesque of aristocratic virtue turned the ostensive gesture into a repudiating gesture—a source of critique rather than confirmation. The threat of British slavery (inscribed here as bondage to foreign fashions—a variation on the balance-of-power argument) was still tied to black slavery; freedom, however, was not to be achieved through the further acquisition of slaves, but rather by seeing them truly.

Black Londoners

Hogarth, however, also did something more that would have critical ramifications for metropolitan perspectives on race, slavery, and empire. His characterization of white Londoners through cultural meanings of blackness and slavery generated a moral and physical equivalency that enabled his black characters to become individualized and humanized in their relationships with white Britons. Breaking the affirming mirror allowed his black characters to become particularized representations, expressing emotions that derived from Hogarth's characterization of their position within a scene. Their ambivalent position as onlookers and participants, actors and audience highlighted the spectator's participation in the creation of meaning. Hogarth, in novel ways, naturalized and humanized the black character.

The frequency with which blacks appeared in Hogarth's works was singular, but the attention to racial diversity in social spaces outside of elite homes was not. Over the course of the eighteenth century, artists increasingly incorporated blacks into the metropolitan social scene. This

critical shift, which accompanied rising numbers of blacks in mid-eighteenth-century London and other port cities, signaled a significant change in the site of imagined British encounters. Chapter 1 discussed this development in relation to depictions of master-servant relationships in public spaces, but amid these representations of high society were images of blacks participating in the festivities of the urban lower class. John Collett, a follower of Hogarth, produced paintings that integrated them into local life: his *May Morning* (1760), for instance, depicted a black male servant among a group of servants celebrating May Day. Other paintings and graphic prints depicted blacks at work and play in Britain: a black violinist performed at a country dance; a black man danced with a cook or maid; a black servant pulled a coffeepot out of a fireplace in a coffeehouse; a black pageboy let in a visitor at a surgeon's house; a black man solicited sex from a prostitute at a sailor's wedding (Figure 6.7; see Figure 1.7).[41] Hogarth intensified this growing consciousness of racial diversity in London, shaped it by providing an iconography with which to make sense of it, and captured the activities of blacks in ways that asked subtle questions about their presence.

Freed from the script, Hogarth's blacks staged a far greater array of responses to white Britons than the ones that affirmed myths of virtue. If we stand back from his prints and look for the simplest role of his black characters, the answer never requires turning to meanings of blackness or slavery in Georgian London. Viewers can experience the prints through the sensations offered by the black characters: betrayal and surprise in *Harlot 2*, idle obscurity and pregnancy in *Harlot 4*, mockery in *Sancho's Feast*, the "pet" in *Taste in High Life*, lust in *Noon*, shock or, if we include the chimney sweeps, disparagement in *Election: Chairing the Member*, enjoyment in *A Rake's Progress III*. Reading such commentaries as, for example, a response to the destruction of a Jew's honor is a moral reading that requires the viewer's assent to the validity of metonymic and metaphorical associations. This proposition might make a reader of this book wonder why we have spent time explicating the valences of meaning that Hogarth's black characters added to his prints if in the end what is singular about them is their detachment from these meanings. But that is precisely what was novel about Hogarth's blacks. The disruption of myths of mastery allowed blackness and slavery to become free-floating signifiers that encompassed both white and black Britons, a detachment of inherited symbolism that produced a representation of a black Londoner through the subversion of the exoticism of blackness. As in *Sancho's*

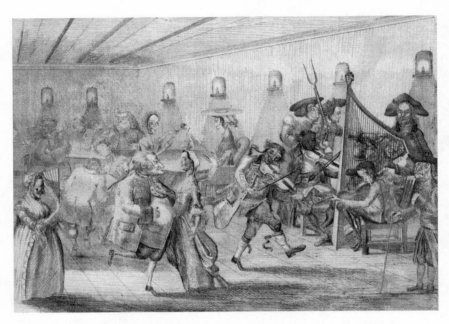

Figure 6.7. Thomas Worlidge, a satirical print depicting an entertainment in a hall (London, ca. 1720–1766). © The Trustees of the British Museum.

Feast and *Harlot* 2, the means to that detachment lay in the icon itself, perhaps reflecting Hogarth's consciousness of the variety of positions and relationships that actual black Londoners held within his city.

His black characters are individuals, different from each other, but not radically separate in their emotional responses from other Londoners in his prints. Contrasting his black footman in *Marriage* 4 to Tom Brown's earlier representation of an "American" makes the novelty of this situation clear (Figure 6.8; see Figure 6.6). Brown's frontispiece, which decorated multiple editions of his collected works, depicted a shaded man in feathers standing in a pulpit-shaped balcony, hiding his eyes in revulsion at the debauched behavior of Londoners who carouse in the street below. The illustration referred to Brown's *Amusements Serious and Comical, Calculated for the Meridian of London,* in which he entertained himself with the thought of bringing an Indian to town. "London is a world by itself," he observed; "we daily discover in it more new countries and surprising singularities than in all the universe besides." Among the populace

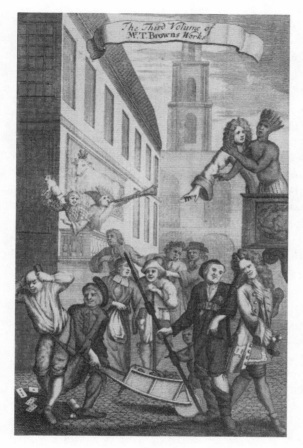

Figure 6.8. Thomas Brown, *The Works of Mr. Thomas Brown, Serious, Moral, and Comical,* 2nd ed. (London, 1708–1709), vol. 3, frontispiece. This item is reproduced by permission of The Huntington Library, San Marino, California.

there were "so many nations differing in manners, customs, and religions, that the inhabitants themselves don't know a quarter of 'em." "Imagine," Brown rhapsodized, "what an Indian would think of such a motley herd of people, and what a diverting amusement it would be to him to examine with a traveller's eye all the remarkable things of this mighty city." What a great deal of "variety" and perhaps "diversion" "this stranger" would furnish with "his odd and fantastical ideas." Brown's imagined encounter with the man he variously deemed an "American," "a stranger," "a friend,"

and "a savage" drew from seventeenth-century natural philosophy: the shaded man's affronted, externalized gaze derived from notions of the noble savage as a foil in a narrative that traced European history as a corruption from some more pristine past. Reversing the savage and civilized informed critical views into British (and European) manners and customs. For some it facilitated serious philosophical inquiry; for Brown, Aphra Behn, and others, questioning the civility of European mores through the exotic gaze also furnished diversion and variety.[42]

Scholars have relied on the idea that Hogarth believed in cultural relativism to interpret the black presence in his graphic works. But his depiction of local interracial relationships departed from such representations of black or shaded people, who remained divorced from the society in which they were being analyzed and discussed. *Marriage* 4 also portrayed an exotic man reacting to a scene of debauchery, but the black footman offers an almost scornful leer that implicates him in the activities of those he serves.[43] The viewer is also invited to look through his gaze, in this case to experience his voyeuristic pleasure and thus to be mildly repulsed by the gaze itself. The repulsion that Hogarth invited his viewers to feel in the black footman's expression is the repulsion he wished them to feel more broadly in the boudoir's sexual deviance; he chose a person whose gaze was used by other artists and authors as a flattering lens onto the white British subject, but whose body also carried connotations of licentiousness. Bindman suggests that the black footman is "in awe" of his betters, an "innocent 'savage'" confronted by those who "merely enact the superficial signs of civilization." But the black footman's rapture is not really different from Ms. Lane's equally misplaced adoration of the castrato. A verse explanation of this character remarked: "Grinning, behind attends a Black, / Holding the Dish at Madam's Back; / And feasting his enraptur'd Ears, / Thinks it the Music of the Spheres."[44] The footman is not exterior to this scene; he does not occupy the role attributed to the savage in Brown's illustration, for instance. To the remote degree that he invokes some imagined Africa or New World, he does so only to collapse the boundaries between Britain and Atlantic societies. Beneath Hogarth's myriad appropriations of the black body to comment on both white and black Londoners lay an underlying principle of similarity and an underlying moral equivalency. That equivalency created space for new forms of cross-racial identification and new desires for racial differentiation, but a fundamentally local experience of racial plurality was now at stake.

Understanding why this iconographic shift was possible requires look-
ing more closely at Hogarth's *Analysis of Beauty*. When Dabydeen wrote
the first extended analysis of Hogarth's blacks three decades ago, he
thought that they fit conceptions of the savage as a foil to European deg-
radation because he misread a reference to Africans in Hogarth's *Analysis*.
The passage in question (which was excised for publication but remains
extant in manuscript) reassessed arguments for the relative nature of
beauty. Hogarth cited the "instance" often given in support of "moral
beauty," the standard tale of the "Nigro [*sic*] who finds great beauty in the
black Females of his own country" and finds "such deformity in the eu-
ropean [*sic*] Beauty as we see in theirs." His aim in reiterating this apho-
rism, however, was not to agree with it. Although he granted that notions
of beauty differed because of custom and habit (as a child brought up in
a "coal Pit" would "disrelish" daylight), these different notions of beauty
were, for him, "prejudices" that reflected the loss of a proper "sight of
nature." Hogarth's passage that included what Dabydeen called "the
black viewpoint" in fact rejected the idea that beauty was relative.[45]

The rejection of relativity, however, did not lead Hogarth, as it led
others, to argue in any extended way that white bodies represented the
beautiful. Rather than assert (as the Earl of Shaftesbury, David Hume,
and many others did) that people with more refined judgment ought to
decide what was beautiful, Hogarth suggested that beauty could be un-
derstood by studying its common "Principles" and "Causes" rather than
its effects. He followed Francis Hutcheson in arguing that the question
ought to be what physical causes generated the "Sensation" of beauty
rather than what standards should be used to measure beauty. To do so,
he drew on Lockean sensationalism to render desire a function of indi-
vidual sight, a perception that nevertheless followed fundamental laws.
With his famous "Line of Beauty," he argued that the perception of beauty
resulted from a predictable anatomical reaction to an object with serpen-
tine lines. He found those serpentine lines in the "particular, imperfect
products of nature" rather than in classical ideals of beauty.[46]

Belonging to that "alternative tradition of thought in eighteenth-
century Britain" represented most clearly by Bernard Mandeville, Hogarth
argued that aesthetic judgments were too often specious and should be
rooted in the success with which an object imitated nature honestly—with
all its flaws intact. He chose to use live models at his Academy in St. Martin's
Lane in explicit reaction against painters who modeled bodies after broken
classical statues or copies of originals long since lost to the ravages of time.

Those who sought such models, he thought, cultivated "prejudices." Hogarth preferred natural variety, which he saw not only as a source of visual pleasure but also as a more compelling moral order. "Curiosity," he said, is "implanted in all our minds." His "wanton" line of beauty sparred with the rigidity and order of the classical aesthetic, liberating variety as the undulating lines of surface that please and divert the eye, seduce the mind, and elicit pursuit or "chase." Although some contemporaries claimed that Hogarth had merely copied his line of beauty from other art theorists, many were pleased with the attempt to correct "that worthless crew professing Vertu & connoisseurship."[47] That attempt produced a novel, though still problematic, integration of people with differently colored skin.

Hogarth rejected relative notions of beauty by constructing human diversity as the superficial variety of skin tones that covered a universally ugly interior. Turning to a literally underlying structure of beauty, the serpentine lines of bones and muscles, he relegated skin color firmly to the realm of secondary qualities as he universalized the common physiological structure of mankind: his anatomical dissection of skin color defined blackness as one of several "different colour'd juices" that filled a "cutis" "composed of tender threads like network." These juices came in white, yellow, brownish yellow, ruddy brown, green yellow, dark brown, and black. Such "variety of complexions," Hogarth argued, reflected Nature's concealment of a universally ugly interior: "It is well known, the fair young girl, the brown old man, and the negro; nay, all mankind, have the same appearance, and are alike disagreeable to the eye, when the upper skin is taken away." "Nature," Hogarth said, "contrived a transparent skin" to "conceal" such a "disagreeable" object. His anatomical vision of the black body, perhaps a reflection of the growing general interest in anatomy in midcentury London, was a variant of a common human type. This is why, I believe, he paid attention to the multitonal qualities of black skin and delighted in chiaroscuro. Variations of skin tone contributed to his concept of beauty as "a composed intricacy of form, which leads the eye, and through the eye the mind, a kind of chase." Color or variety of shading offered a source of visual pleasure, of seduction and *Varietas*. Infinite variety in Hogarth's aesthetics was an essential feature of the beauty and bounty of nature, anticipating William Blake's conception of the variegated likeness of God. For Brown, the novel gaze of an outsider provided "variety"; for Hogarth, variety consisted in "that infinite variety of human forms which always distinguishes the hand of nature from the limited and insufficient one of art."[48]

Hogarth arrived at an understanding of natural variety that lacked the tensions seen in contemporary attempts to fit the disunity of creation into a belief in divine unity. His emphasis on the individual (and the individual as a source of variety) enabled his varied and particularized representations of racial difference. His aesthetic had a social corollary in novelty and individualism, forces that countered the aristocratic hegemony that he, and Mandeville before him, decried for its self-flattering equation of elite social practices with virtue. All forms of oppression, including affectation, suppressed natural variety. Against the universalism to which elite art aspired, Hogarth's graphic works portrayed a London overflowing with bodies from the grotesque to the classically beautiful, where passions and appetites were laid bare. He provided, as Mandeville wished an artist would, a universalism rooted in an attention to variety and to the complex relationships between character and form. This theory of aesthetics enabled his integration of blacks into London society because it challenged the exoticism of blackness and thus the viability of the black body as a site for imagined encounters with the external world.

In Hogarth's London, blacks participate in the same desires, affectations, and delusions for which they are also emblems. In their particularized, humanized forms and pursuits of pleasure, they are not exotic; they are just like their fellow Londoners. His biological model of racial difference did not produce a rigid concept of human difference, complicating the trajectory of cultural fluidity to biological fixity of intellectual constructions of race that has been widely accepted.[49] Working from an anatomical equivalence of basic human structure, Hogarth's theory of beauty suggests that his black characters provided a source of visual pleasure by adding variation to the landscape. He could randomly people his prints with black characters and exploit their symbolic resonances to add or reinforce meanings in his narratives. Such a conception of variety challenged racial and imperial sensibilities that located the black body outside of British society and that allowed blackness to signify virtue only in its relationship to the white body (whether through relativism, the sloughing off of its skin, its metonymy for British labors abroad, or its general exoticism). When Hogarth formulated an "aesthetic of sensation and pleasure as opposed to moral beauty," he generated a conception of the black body that could be unmoored from its location in British structures of the monstrous, even if he used (and often deepened) its signification of liminality in his baroque parody of British behavior.[50] This perception of human variation enabled him to envision blacks within London, expressing

emotions that differed from one another, but not in kind from those of other Londoners. He collapsed the boundaries of the savage and civilized to articulate a truly universal, and universally Fallen, image of mankind. The result was that Hogarth portrayed blacks as independent characters, unsettling the hierarchy of Britain over the empire that many wished to keep intact.

Hogarth's only graphic series that included a black man interacting with Londoners outside the confines of servitude suggests that he intended to provoke his audience with this view of human sameness. *The Four Times of the Day* (1738) presented a series of impressions of London at various times of day, from winter to fall.[51] In *Morning*, a white man fondles a white market woman. In *Noon*, a black footman stands at the edge of the print, fondling a white milkmaid (Figure 6.9). In the chilly morning the woman veered away; by noon the maid leans toward her black lover. The contents of her pie pour into the broken plate belonging to a young boy who wails. Hogarth played with the common association of noon with sexual vigor and black bodies with the sun.[52] This couple also repeated the iconography of the satyr and nymph in the dark-skinned lover pursuing a milky-white woman. Across the lane divided by a gutter, a French Huguenot family walks gaily down the street, incarcerated in layers of stiff clothing. Above them hangs a shop sign of the "Good Woman," a headless hoopskirt. The "Good Woman" sign may have belonged (ironically perhaps) to the shop of a colorman (a vendor of paints)— perhaps that of Joseph Pitcher, who had a shop near St. Giles Church (depicted in the background) in 1764.[53]

The kissing women, a trope of French fashion, are contrasted to the earthy lovers. Hogarth juxtaposed two different forms of consumption—of things versus sexual appetite—and located them both in Hog Lane. His first satirical print, *The South Sea Scheme*, had offered similar variations on lust from that of the flesh to that of "Monys magick power."[54] Both forms of consumption juxtapose the plain-clothed churchgoers in the background, yet the question of whether the French couple has just come from the service entangles the two worlds. *Noon* echoed Tom Brown's similar description of the confusion of the spiritual and profane: "passing from the spiritual bawdy-houses [Quaker Meeting-Houses], betrayed by the hypocritical sign of a coffee-house we fell into a carnal one." Hogarth depicted different versions of constraint: sexual appetite on the left is linked to the wailing child and a tight corner, a commentary again on children and physical confinement that had animated his previous depictions of blacks in London.

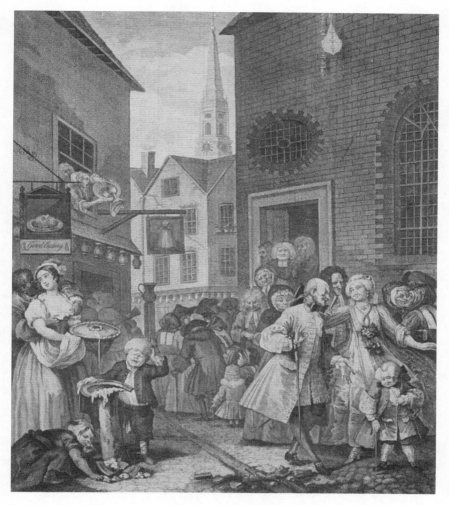

Figure 6.9. William Hogarth, *The Four Times of the Day: Noon* (London, 1738). © The Trustees of the British Museum. All rights reserved.

On the right, a different form of confinement appears in the sublimated bondage of fashion. Both sides are unproductive. On the right, there are kissing ladies (those "old toothless French beldams"), on the left titillation, intimated in the spilling pie as the loss of milk or semen. *Noon*'s complex sense of nature as sensate and unrefined—as expelling and releasing— is baser, but not free: we are still left with the closed-off space and the

209

concentration on poverty in the hungry child scavenging food from the broken plate.

One of Hogarth's eighteenth-century biographers noted that the "Crying Boy in Noon" was a quotation of Nicholas Poussin's *Rape of the Sabines* (1633–1634), which Hogarth saw at Mr. Hoare's at Stourhead. Poussin's image of Livy's tale about the founding of Rome centralized the moment in which the Romans, lacking women for their new settlement, decided to abduct the Sabine women.[55] *Noon* deployed this image of transgressive sexuality on the left to comment on the Huguenot couple that may have just come from the service at L'Eglise des Grecs, a Huguenot meetinghouse. The enclosure of the two sewer lines separates the bottom left corner from the rest of the print, giving the foursome an emblematic quality that encourages the left-to-right reading common to Hogarth's prints. The print highlighted how blacks and Huguenots occupied similar positions in relation to the Protestant British viewer. Journalists argued that the British had liberated both of them: the Huguenot from Catholic enslavement, the black African from a cannibalistic society that would have "Killed or Eaten" them.[56] Their respective enclosures of fashion and space call into question their shared liberation, whether physical or spiritual. In place of being eaten, black men are associated with hungry children and rape; in place of the Eucharist, the Huguenots consume fashion.

Hogarth made the parallel between the black man and Huguenot woman explicit by adorning them with identical pearl earrings. This shared use of ornamentation worried some Britons. One woman asked the *Athenian Mercury* whether she should stop wearing earrings given that pagans wore them:

> I have worn Ear-rings several Years, but I begin now to think them unlawful, and dare not any longer wear them: For first, I find, that these and Idolatry go together, and are to be abandoned together, Gen.35.4. Again, I see them particularly spoken against, Isa.3.20. Also, I find that they are the Attire of Pagans and Infidels all the World over, and are inseparable from them. Lastly, they are now grown into an universal Vanity in this Nation, and should not those who are sober of our Sex be distinguished from others, by leaving off this common badge of Pride and Vanity? I desire your Direction and Advice as to this, and as soon as you can?

Another woman wrote that her minister had reproved her for wearing pearls and asked whether the editors also thought her sacrilegious. In

both cases, the editors supported ornamentation, but not ostentatious display. They admitted that "A Jew's Servant, who in kindness to the Family, desired to remain so for his Life, had his Ear publickly bored, and unquestionably the Master might cause a Ring to be hung therein, *Deut.* 15.17, as we do Collars about Negro's, to signifie whose Servant he was." But they dismissed the idea that such adornments only connoted servility and slavery. Other tracts, however, equated bodily adornment with religious hypocrisy.[57]

By comparing the black man and Huguenot woman, *Noon* tapped an anxiety about looking or behaving like the pagan other. In an effort to distinguish Christian from pagan consumption and trade, the adornment of black bodies came to signify in British texts the fetishistic, nonutilitarian trinket trade that Defoe disparaged in *Robinson Crusoe*. In Hogarth's print and female anxieties about jewelry, the trifle met the commodity, the idolater the Christian iconoclast, the fetish the symbol of wealth. If the *Athenian Mercury* compared the uses of pearls and decided that the practices differed, Hogarth made the comparison but left the viewer to decide. In the process, he may have drawn on Shakespeare's commentary in *Two Gentlemen of Verona*, where "Black men" were thought to be "pearls in beauteous ladies' eyes."[58]

Echoing *Harlot 2, Taste in High Life,* and *Marriage 4, Noon* tied fashion and the black presence to constraint; it explicated such moral corruption in terms of female behavior. In *Noon*, the bridge created by a dead cat more generally unites the two groups. The broken pieces of stone that lie about the cat's body may suggest that it has been murdered or thrown into the gutter, but it constructs the connection between these two groups out of rubble and morbidity. The dead cat is a curious motif—the cat often stood in for a woman in Hogarth's and other engravers' prints, and it is possible that he intended to link the consumption of fashion or miscegenation to the death of the female body. Some may also have seen this print as associating the presence of foreigners with diseases, a commentary evident in fears that the French deliberately weakened the British by acting as "pimps" and causing the spread of syphilis.

Yet Hogarth located the contentious intimacy on the left, where the foursome's physical closeness contrasts the space that separates the characters on the right. This structural tactic reflected his common representation of foreigners in isolation, but it threw into relief the black man's intimacy. The question of looking like the pagan other cuts across this image

of transgressive sexuality, invoking the contentiousness of miscegenation on the left to explore, once again, the corruption of fashions on the right. Hogarth, in other words, conflated the moral corruption of this fashionable family with the transgressive sexuality represented by the coupling of a black male and a white woman, leaving his viewers to decide the significance of this connection.

By collapsing the boundaries of self and other, Hogarth's graphic works departed from the tradition of print satire to which they also belonged. The "naturalization" of blacks, which with Hogarth became a conscious commentary on British society, evoked racist fears in other settings: a year after Hogarth's *A Harlot's Progress* appeared, T. Fox depicted a "Blackamoor" among a group of Europeans and poor waiting to be incorporated officially into Britain (Figure 6.10). The prospect elicited a disparaging caption:

> A Blackamoor peeps o'er the rest,
> And gains in hopes he shall be bless'd;
> with the rich Plenty of the Horn,
> As well as those in Britain born.
> I wish my Friend had haply thought
> To put in here a Hottentot;
> or a chimpanzee, meetly plac'd,
> Most aptly would the Piece have grac'd.

Hogarth's questions about the local consequences of racial diversity lacked the bluntness of Fox's mobilization of the Chain of Being, but they engaged similar anxieties. That popular prints would become a primary stage for the manifestation of such xenophobic fears is not surprising—as a cheap, quick form of social commentary, engravings, etchings, and other graphic works tended to express a variety of popular responses to local events and social practices.[59] Hogarth's prints centralized the recognition of the self in the other (in fact they pointed out how the self had been projected onto the other), destabilizing the racially encoded distance that, for many, prevented the empire from overrunning the center.

What Hogarth added to the iconography of interracial relationships was a self-consciousness of construction and an awareness of the multiracial and multiethnic character of his city. Unlike Georgian tobacco prints or Thomas Southerne's *Oroonoko,* most of his engravings situated blacks in London rather than projecting them abroad. If Brown por-

Figure 6.10. T. Fox, *The Dreadful Consequences of a General Naturalization, to the Natives of Great-Britain and Ireland*, detail (London, 1733). © The Trustees of the British Museum. All rights reserved.

trayed his feathered Indian looking down upon the motley London herd, placing him outside the "many nations differing in manners, customs, and religions" that had transformed the town into a cosmopolitan metropolis, Hogarth located the black gaze from within this motley group, emanating from individuals who belonged to a heterogeneous and corrupted society that also included Huguenots and Jews.[60]

Scholarly focus on concepts such as the Great Chain of Being, hierarchies that derived their philosophical base from Aristotelian notions of essence and the essential hierarchy of things, has neglected alternative philosophies. Freemasonry, deism, and the new epistemologies generated by the Scientific Revolution generated competing ideas about popularism and pluralism. Hogarth's links to these traditions have been well documented. His focus on individual response and character reflected incipiently democratic spaces, such as coffeehouses, that questioned rank and privilege and encouraged debate. Universalizing an ugly interior and locating beauty in

the variations of a superficial surface echoed the logic of his social commentary in which his characters were universally Fallen and yet delightfully entertaining in their individual expressions. This identification with the plights of his own characters not only made his commentary on British morality complex and his prints provocative, but also blurred the boundaries of self and other. He did not turn such Fallen Londoners into a public virtue; he was not Mandeville. But he did find aesthetic beauty in the variegated, if often tragic, experience of common desires.

Jonathan Swift, the Earl of Shaftesbury, and other writers offered a "humanistic commonplace" when they suggested that the articulation of the self involved embracing its multiplicities, or "becoming plural" as Shaftesbury termed it. But Shaftesbury's aim was "that uniformity of opinion which is necessary to hold us to one will," which spoke to larger social issues of religious and political dissent.[61] Hogarth's politico-aesthetic, in contrast, encouraged variation and individualism as a counterweight to what he perceived to be the enslaving rigidity of Shaftesburian aesthetics and social structures. In that celebration of the individual, we have the most important attributes of Hogarth's black characters: they are humanized and particularized in comparison to the idealized black bodies in portraits and the cartoonish bodies of emblems, and they have surfaced as participants in the motley world of London. In a distinct echo of Caliban's learning how to curse, Hogarth asked his audience to think about whether blacks were (like the harlot) self-interested products of their metropolitan environment. Placing *Noon*'s black footman at the edge of the print, capturing the slave in *Taste in High Life* in a chin-chuck, or dressing the black boy in *Harlot* 2 in theatrical Turkish attire drew attention to black servants' social marginalization in Britain and their enmeshment in corrupt social relations and collective fantasies. The distance of Britain to the New World or Africa became merely the inscription of social distance, largely in terms of social status.

Despite Hogarth's true-to-life details of place and peoples, Allan Ramsay and other contemporary critics noted that he portrayed types of characters rather than particular individuals in his satires. Various people in his graphic works resembled known people (and contemporaries expended great effort delineating who they were), but he also discovered a redundancy of matter in his daily observations of London, a grammar of form that enabled him to create characters familiar to all. That his black char-

acters resonated with his audience is apparent in how frequently they reappeared. In the 1730s, Cries of London playing cards (which depicted images of street life) reproduced *Southwark Fair*'s black trumpeter. Copies of *Harlot* 2 decorated fans, chinaware, and other material objects. Illegal and legal reproductions of *A Harlot's Progress, Times of the Day,* and other series included his black characters, often in cruder forms. Play-wrights and poets also translated his progresses into pantomimes, ballad operas, comedies of manners, and a broad variety of other literary and theatrical productions. Cibber's *Harlot's Progress* was especially success-ful, opening in 1733 at the pantomime house at Sadler's Wells, then appear-ing at Drury Lane multiple times, and at various fairs.[62]

Numerous authors and artists followed Hogarth's footsteps down London streets, expanding the troupe of local, black characters. But few subsequent engravers matched his skillful rendering of the individ-ual character. George Bickham's *The Rake's Rendez-vous* (ca. 1735), a spinoff from Hogarth's *A Rake's Progress III,* included a black maid, yet this extraordinarily stiff figure observes a couple kissing rather than being involved in the amorous tavern atmosphere (Figure 6.11; see Plate 13). Subsequent engravers and authors did not always bother them-selves with the nuances of Hogarth's commentary, but they did take with them a new consciousness of racial variety. Most simply imported his black Londoners into their own scenes of high and low life. In the late eighteenth century, Thomas Rowlandson, James Gillray, and other graphic artists borrowed the turbaned page from *Harlot* 2, sending him into other parlors and parodies of London taste; they lifted the lusty black footman from *Noon* and made him a pornographic subject or a character in satires of the servant class. These caricatures stripped Hog-arth's characters of their complex symbolism in ways oddly reminiscent of the African and Native American bodies that lost, on their way into metropolitan print, the cultural contexts that defined and individuated them.[63]

If the literary and artistic followers of Hogarth's works were less subtle in their engagement with the psychological and social conse-quences of slave ownership, they often adopted his use of the black body to throw white British bondage into relief. In so doing, they absorbed and broadened Hogarth's critique of British imperial mastery. Such cri-tiques would become increasingly important in late eighteenth-century political cartoons and in social prints that mocked fashionable white

Figure 6.11. George Bickham, *The Rake's Rendez-Vous; or the Midnight revels wherein are delineated the various humours of Tom King's Coffee House in Covent Garden* (London, ca. 1735–1740). © The Trustees of the British Museum. All rights reserved.

male masculinity through mimetic bodily forms of black (or blackened) male bodies. The 1773 *Miss MACARONI and her GALLANT at a Print Shop,* for instance, ridiculed the fashionable man by associating him with a portrait of a black boy who is probably a harlequin figure, though he lacks the colorful motley outfit (Figure 6.12). The text below explains that the "Macaroni and his Mistress here / At other Characters, in Picture, sneer," while they fail to see ("To the vain Couple is but little known") that they are equally ridiculed. The Macaroni points out a print of a woman with a fan similar to the one that his mistress carries, but behind his head hangs another picture of a black boy whose head tilt and arm position mimic his.[64] Such mockery of white men through their unwitting imitation of black males would become an important, racialized strand of satire in the latter part of the eighteenth century that encouraged xenophobia—even as the proliferation of black characters in graphic art integrated black men more broadly into views of Britain.

If, as Bender argues, Hogarth's prints reveal "a Hogarthian analytic in which both alignment and failure of alignment with the real are meaningful," his social change relied on this reflection and a return to nature for confirmation, taking a new consciousness of act and object as a new

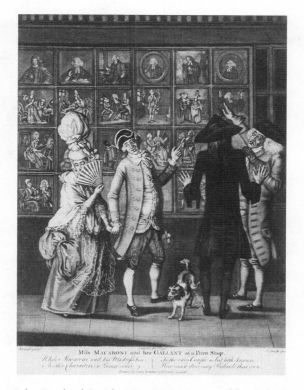

Figure 6.12. John Raphael Smith, *Miss MACARONI and her GALLANT at a Print Shop* (London, 1773). © The Trustees of the British Museum. All rights reserved.

text of interpretation.[65] Hogarth's graphic works reconsidered the black servant as a sign of exotica and virtue. Blackness offered a source of symbolism—of heat and energy, theatricality and adoration, Turkishness and slavery, trade goods and social corruption—but Hogarth drew attention to the fact that these meanings, like those attached to the other objects and subjects that he depicted, were given to blacks through their performance in society. His works disembodied the meanings of blackness as he displaced them onto his central white characters, creating a structure in which to understand an interior state of moral corruption, not in blacks per se but in London society.[66] The question in his prints with which subsequent Britons engaged was not how blackness originated, but rather what racial diversity in Britain meant. Few shared Hogarth's

delight in the varieties introduced through skin color or his willingness to emphasize black participation in common British activities and desires. The racially plural society left in Hogarth's wake began seriously to challenge metropolitan Britons, especially as the American Revolution threatened, from another direction, beliefs in imperial virtue.

BRITAIN'S REBEL SLAVES

Oh, man! man! how short is your foresight, how ineffectual
your prudence, while the very means you use are destructive
of your ends.

—Isaac Bickerstaff, *The Padlock: A Comic Opera* (1768)

In 1787, London engraver William Dent published *The Poor Blacks Going to Their Settlement* (Plate 15). At first glance, this print ridiculed the Sierra Leone expedition, the abolitionist effort to create a free black settlement in West Africa where former American and British slaves could be relocated. Closer inspection, however, reveals that the "poor blacks" going to their West African settlement were not black: the two men at the front of the procession are the white Lords Fox and North. Behind them trail a number of other prominent white politicians and members of the Prince Regent's household. These "black" Londoners reluctantly trudge toward the London club Brookes Rectifier of Spirits, where the prince's supporters congregated (and which is here depicted as a debtor's prison). This procession might have alluded to black Londoners who did not wish to be resettled, but it centrally portrays the political failures of George III's former ministry. Dent's print was a crude satire of the expulsion of the Fox-North coalition in the 1780s.

Londoners maligned the Fox-North coalition for its association with the loss of the North American mainland and, more generally, for its ineffective approach to empire. Dent capitalized on these sentiments by attributing the politicians' current misfortunes to various aspects of Britain's overseas ventures: a placard inscribed "Ruined by the American War" hangs from North's garter ribbon, while another strung about Fox's neck suggests that he has been hung by the ill-fated coalition for his India Bill, which sought to place East Indian affairs under crown, rather than company, control.[1] For late eighteenth-century satirists, what seemed

219

glorious, if worrying, expansion of the British empire into India, Canada, and the Caribbean following the Seven Years' War had rapidly devolved after the American Revolution into an unsettling, and often shameful, uncertainty. Their commentaries on this upheaval had profound implications for popular representations of race and slavery and their conceived relationship to empire.

Dent linked these imperial debacles to issues related to the growing black population in London. Behind Fox and North, Lord George Gordon, the instigator of the anti-Catholic Gordon Riots who also wrote against slavery and forced transportation to Botany Bay, holds a paper inscribed, "Defence of the Blacks by Lo[rd] G—— G——," and says, "By all the glories of mischief they have no right to send us to Africa." Gordon comforts "Man Friday," who is probably playwright Richard Sheridan, a supporter of Fox's opposition to the American war and a sympathizer with the Irish resistance. At the end of the line, Lord Chancellor Edward Thurlow, a prominent lawyer and politician who encouraged the continuation of coercive policies toward the colonies, urges forward Weltje, the Prince Regent's cook who had political aspirations. The train of "poor blacks" moves toward the prince, depicted as a hybrid Native American–African man who looks shocked to see them. A basket inscribed, "Pray Remember us Poor Blacks," hangs beside him. Dent's print conflated the expulsion of politicians and their imperial policies in America, Ireland, India, and Africa with the removal of the black poor from London.

This political cartoon contains a number of strands of racial iconography: Sheridan as Man Friday refers to Defoe's popular tale of Robinson Crusoe's slave, for instance, and the prince's Indian-African body derives from the racial iconography associated with tobacco shops and coffeehouses.[2] My concern, however, lies with the artistic, literary, and historical traditions that enabled Dent to perceive the black body as an appropriate analogy for the corrupt British politician. The most significant character for these purposes is actually Weltje, the prince's cook, who exclaims, "O! Oh!—bless your heart Massa Beetle-brow—if you no lick a poor neger man he'll pimp for you." Dent identified this political aspirant's poor command of English (Weltje was known for his "barbarous Anglo-Westphalian jargon") with the dialect of one of the most popular caricatures of the black slave in late eighteenth-century Britain—the figure of Mungo.[3]

The Mungo imagery offers a window into the changing meanings of black slaves in Britain during and after the American Revolution. He first

appeared as a character in Isaac Bickerstaff's 1768 opera *The Padlock*, where he offered witty, though acerbic, commentary on his enslavement. By 1769 and through the 1780s, Mungo reappeared in Opposition satires of George III's ministries. By the late 1770s to the mid-1780s, he emerged as the Mungo Macaroni and was identified with a black Londoner, Julius Soubise, who was famous for his extravagant tastes and participation in the amours of London's high life. In the late 1780s, Mungo became a stock sentimental character in literature advocating for the closure of the slave trade. As a character who oscillated between the comic and the tragic, Mungo embodied two major developments in imagined relationships between white Britons and black slaves: the sentimental image of the poor African that curried support for abolition, and the comic image of the black Londoner that expressed, for satirists such as Dent, political and social corruption in Britain. Both images, in different ways, indicate that some late eighteenth-century Britons saw in the rising numbers of black poor the decline of imperial authority. These two interrelated strands of iconography reveal that questions about imperial authority manifested themselves in an increasing discomfort with various forms of interracial intimacy, the corruption of the symbolism of the liveried black servant for narratives of British virtue, and the formulation, if unintentionally, of a working-class black Londoner. The late eighteenth-century black slave figured external and internal unrest as a single phenomenon. As colonial rebellion and social tensions at home compounded each other, Britons experienced their own subordination to the Atlantic world.

Bickerstaff's Mungo

In the last four decades of the eighteenth century, prints, plays, songs, portraits, paintings, and pamphlets including black servants or slaves proliferated. Satirists, confronted with the political turmoil of the later Georgian reigns, appropriated the Hogarthian tradition of using the black body to connote the slavery of their fellow Britons.[4] Painters found a market for portraits of well-known black Londoners. Playwrights gave black characters central roles. Conflict with mainland and West Indian colonies, antislavery agitation, Enlightenment debate, and increasing numbers of black people in Britain generated a mass of diverse representations.[5] The Mungo imagery provides a useful perspective on these developments because his character reappeared in multiple genres of representation over a contiguous time frame. The evolution of this character provides insight into how

Britons used the figure of the black slave to negotiate changing racial de-mographics in London and imperial upheaval.

The actor David Garrick put on Bickerstaff's comic opera at Drury Lane in 1768. *The Padlock* captivated London audiences and not long afterward captured the imaginations of people in Germany, Hungary, France, New York, Boston, and Philadelphia.[6] The opera's plot centered on the misfortunes of an overly protective lover whose attempts to safe-guard his honor lead to his undoing. The audience, however, mostly de-lighted in Mungo, the humorous black slave whose relationship with his master is provocatively tumultuous. That Mungo's disgruntlement owed a significant debt to Shakespeare's Caliban is without question, though in this opera tyranny is ascribed to a Spanish master, Don Diego. For my purposes, however, Bickerstaff's Mungo exemplifies how Britons inter-preted slave resistance through conventional understandings of lower-class discontent, producing a slave who challenged his master in indirect ways. Bickerstaff thus gave narrative form to the black servants who critiqued white mastery in Hogarth's prints.

The Padlock was an adaptation of Cervantes's famous "exemplary" story, "The Jealous Old Man from Extremadura." This story relates the misfortunes of Carrizales, an old white man whose paranoia about being cuckolded leads him to lock up his young white wife, Leonora, in his house and surround her with an old white maid, a black eunuch, and several white and black slaves.[7] His tyrannical efforts to fortify his honor excite the imagination of a young white scholar, Loaysa, who uses his musical talents to entice the eunuch (Luis) and maid into letting him into the house. Once Loaysa brings down this "fortress," he shortly conquers the ears and eyes of those inside. The sweets, clothes, and other innocent pleasures with which Carrizales had tried to distract Leonora cannot compete with the potentially dangerous pleasures roused by music. Cervantes's tale, how-ever, did not end with Old Testament justice. The exemplary moment occurs as his main characters overcome natural desires. Leonora resists the temptations of the young lover and breaks the stereotype of the weak-willed woman. Carrizales foregoes bloody retribution for forgive-ness, even though Leonora never manages to correct his belief that he has been cuckolded. As Carrizales accepts all blame, he internalizes the psy-chological portrait of the subordinate provided by Loaysa's refrain, "Un-less I guard myself, You will never restrain me." He dismantles his for-tress, frees his slaves, and releases Leonora from her marital obligations with the request that she marry Loaysa instead. When Carrizales dies the

following week, though, Leonora exchanges one life of confinement for another in a convent, presumably believing herself to be guilty of infidelity even though her transgressions never reached beyond "thought."[8]

Bickerstaff made several changes to the original story. Leonora and Don Diego (Carrizales) are not married, but rather are coming to the end of a three-month trial of living together. Diego's crucial absence, consequently, is occasioned by his departure to ask Leonora's parents to allow him to marry her. The comic opera also omits Leonora's concluding entrance into a convent, leaving the tale at the point at which the old man has given the young lovers leave to marry. Bickerstaff's overhaul of the plot is intriguing, but his changes to the black male character, the eunuch Luis, are more relevant. In his introduction to the opera, Bickerstaff claimed that "the characters are untouched from the inimitable pencil of the first designer; unless the dialogue with which the English writer supplies them has done them an injury."[9] The dialogue, in fact, transformed the Spanish Luis into a British Mungo.

Bickerstaff retained Cervantes's conflicted portrayal of the black eunuch's sexuality, but Mungo's dialogue connects the undertones of sex and violence in the story to a broader critique of the master-slave relationship. Both old men ruefully reflect that their precautions came to nothing, despite the fact that they had banished "all that had the shadow of man, or male kind" from Leonora's life.[10] Such effacement of the black slave's sexuality is directly contradicted, in Cervantes's tale, by Luis's restricted access to the house, which suggests that Carrizales still perceived him to be a potential threat. Bickerstaff achieved Mungo's ambiguous sexuality without making him a eunuch, constructing his potency through Diego's paranoia about him, his mockery of Diego's ability to consummate the future marriage, the old maid's perception of him as a sexual predator (and his comic dismissal of her as an object of sexual desire), and the erotic relationship between him and Leander, the musician. Bickerstaff's Mungo is more than a lover of music; in an echo of Hogarth's *Sancho's Feast*, his interest in his master's subversion critiques Diego's tyranny as it supplies the audience with the spectacle of a black slave helping, through his laughter, to bring down those in power:

Diego. Can you tell the truth?

Mungo. What you give me, Massa?

Diego. There's a pistreen for you; now tell me, do you know of any ill going on in my house?

223

> *Mungo.* Ah Massa, a damn deal.
>
> *Deigo.* How! That I'm a stranger to?
>
> *Mungo.* No, Massa, you lick me every day with your rattan: I'm sure, Massa, that's mischief enough for poor Neger man.
>
> *Diego.* So, so.
>
> *Mungo.* La, Massa, how could you have a heart to lick poor Neger man, as you lick me last Thursday?[11]

Bickerstaff's opera investigated how tyranny corrupted both perpetrator and subject. A tale of Eastern despotism characterizes the old man's despotism and provides context for Mungo's rebelliousness.[12] Leander flatters Mungo by calling him "Master," investing him with an authority equal to Diego's, and by singing a song that he had learned in Barbary when "a slave among the Moors." The song describes a "cruel and malicious Turk" responding to his "fair Christian slave named Jezábel" who rejects "his beastly desires." As the angry Turk draws his saber to decapitate her, the pair speak to each other, but what they say is obscure: "here's what he says to her *(sings and plays)*. Now you shall hear the slave's answer *(sings and plays again)*. Now you shall hear how the wicked Turk, being greatly enraged, is again to cut off the fair slave's head *(sings and plays again)*. Now you shall hear ——."[13] The caesuras invited readers (and presumably performers) to supply their own narratives of resistance and reprisal; this unarticulated conversation required the readers' own fantasies of subversion and retribution to provide an interpretive framework for the comic opera's moral messages.

Although the male master–female slave relationship obviously invokes Diego and Leonora, Leander also invites Mungo to see himself in Jezábel. The song follows a scene in which Mungo mourns his subjugation in an aria that became more famous than the opera itself:

> Dear heart, what a terrible life am I led,
> A dog has a better that's shelter'd and fed:
> Night and day 'tis de same,
> My pain is dere game;
> Me wish to de Lord me was dead.
> What e'er's to be done,
> Poor black must run;
> Mungo here, Mungo dere,
> Mungo every where;
> Above and below,

Sirrah come, Sirrah go,
Do so, and do so.
Oh! oh!
Me wish to de Lord me was dead.[14]

Leander's seduction of Mungo with a song about resistance to tyranny, which represents the rebel slave as a heroic moral exemplar, implicitly panders to Mungo's interpretation of his position. Yet Bickerstaff was writing a comic opera: the questionable motives of Mungo-Jezábel-Leonora complicate this potential critique of the master-slave relationship. The biblical Jezebel was the wicked wife of Ahab who seduced him into substituting fornication and the adoration of Baal for worship of the true God. The song's inversion of her character engages not only the ambiguities of Leonora's virtue but also the complex picture of Mungo's resistance, invoking the connection between bacchanalian desires and black slaves or servants in European art. The tension between the threat that the master perceives in Mungo and the comic outcome of the play criticizes tyranny by revealing the master's fear of his inability to control his household and by depicting a black slave facilitating his master's subversion through his indulgence of his and other servants' desires.

In the sense that Mungo's rebellion against Diego is not expressed through an attempt to rape Leonora, Mungo is not a Caliban. But his actions invoke a potentially transgressive picture of natural desire that asks similar questions about the nature of mastery. Diego takes a long time to realize what is happening when he walks into the scene of his cuckolding, despite the fact that Mungo laughs at him, telling him that the young lover is doing what he has not—having sex with Leonora. Deaf to Mungo's words but not to his sentiments, Diego interprets the drunken slave's late trip down into the wine cellar as a plot to murder his household:

Diego. Wretch do you know me?
Mungo. Know you—damn you.
Diego. Horrid creature! what makes you here at this time of night; is it with a design to surprize the innocents in their beds, and murder them sleeping?

Given what is transpiring at this moment in the opera, the idea that Mungo has been plotting to murder "the innocents" is farcical.[15] Diego's paranoid interpretation of Mungo's behavior picks up on the slave's disgruntlement, but misses the form that the slave's subversion took, substituting the image

of the violent black rebel feared by slave masters across the Atlantic. Diego had congratulated himself for closing up the house with an additional secret padlock, but the servants' discovery of it ensures their rejection of his authority. Once Mungo and the maid realize that he does not trust them, they abjure their responsibilities to him, allowing full reign to their fancy for a musical evening. Mungo merely laughs from the sidelines as the musician's intentions become clear, providing the couple with wine. Diego thus catches him in the act of enabling, but not effecting, the subversion of his honor. He mistakenly gives Mungo a direct role in his cuckolding when he accuses him of plotting murder. The opera's message was that authority exercised on the basis of distrust is inevitably going to fall. As Diego laments, "Oh, man! man! how short is your foresight, how ineffectual your prudence, while the very means you use are destructive of your ends."[16] *The Padlock* ascribed the image of the violent black servant to the mistaken impressions of a master who remains blind to how his tyranny causes his undoing.

Without more information about Bickerstaff himself, discerning whether this 1768 opera responded to specific slave rebellions or to representations of metropolitan tyranny following the 1765–1766 Stamp Act crisis is impossible. The portrayal of tyranny certainly fits both possibilities. Metropolitan Britons rarely expressed the same urgency about the maintenance of racial hierarchies that colored colonial discussions, nor did they turn to the kinds of legal codes that sought to mitigate the anxieties of colonial mastership through the brutal repression of slaves.[17] The black rebel's threat to the fabric of colonial society did not translate directly and thus could be comically dismissed, though the actual role of Mungo in this opera suggests other challenges being posed by the black presence in Britain. Diego recognizes Mungo's resistance but projects onto him an outsider's violence that overestimates the divisions between his servants. The integration of the black slave into the servant community leads to this master's downfall, even though the responsibilities for such subversion are located in the master himself. Bickerstaff's Mungo finds expression for his resistance, not through violence but through his common cause with other servants. In a society that did not house large slave populations, it was this movement—the absorption of blacks into the lower classes where they forged relationships with people potentially sympathetic to their position— that most threatened to undermine the distance required to maintain imperial mastery.

Mungo's subsequent textual life reflected his wide resonance in the late eighteenth-century Atlantic world. British artists and authors capi-

talized on his popularity, caricaturing a caricature as they appropriated different aspects of his persona for their own purposes.[18] He escaped Bickerstaff's opera as Butles Clowes and other engravers depicted him, as played in blackface by Charles Dibdin, in individual prints in 1768 and 1769.[19] Numerous other Britons adapted Mungo for political satires, songbooks, plays, and as the author of an eclectic collection of essays. From his initial role in an opera set in a Spaniard's house, Mungo came to represent the British slave and the black Londoner who resisted his subordinate position. Three particular developments are of interest: Mungo's reappearance in Opposition satires of George III's ministries, social satires, and abolitionist publications. These reincarnations of Mungo show how his character allowed Britons to think about their imperial role in an era of colonial rebellion and internal unrest.

Mungo's Corruptions

The end of the Seven Years' War in 1763 left Britons with a much larger imperial presence in North America, the Caribbean, and India, as well as a huge debt. Fears of having overstretched their ability to control this empire were mixed with the giddiness of success. The story of the following two decades is a familiar one: George III's government moved to institute greater administrative control over the colonies, enacting a series of colonial taxes. North American colonists, galvanized into action by merchants who often wanted nothing more than the continuation of the status quo, staged their resistance in a series of boycotts that targeted British goods. Britons at home rapidly forgot their initial support of colonial taxation when it undermined imperial stability.[20] Opposition to George III grew in Britain as the colonies rebelled; the popular press attacked the king and his ministers in myriad satires and newspaper articles.

Mungo proved useful in satirical commentaries on the state of affairs. During the 1760s and 1770s, Opposition satires drew on Mungo's vivid aria in their caricatures of the black slave as a figure running hither and thither for a demanding master.[21] These satires ignored the complexities of Bickerstaff's operatic portrait of the master-slave relationship, creating a sycophantic Mungo who became emblematic of political and social corruption. A 1772 print depicting Lord North robbing the Irish exchequer included a representation of Mungo, who comes from behind with his hand held out, saying, "Don't forget poor Mungo my good Ld. N—h" (Figure 7.1).[22] The Opposition Mungo was, in fact, Jeremiah Dyson,

Figure 7.1. Anon., *Hibernia in Distress* (1772), from the *London Magazine,* xli: 3. © The Trustees of the British Museum. All rights reserved.

the Member of Parliament for Weymouth, a Lord of Trade from 1764 to 1768, and a Lord of the Treasury from 1768 to 1774. He received a pension from the Irish establishment, which, though later revoked, left him with the reputation of being a sycophant. Dyson acquired the nickname of Mungo during a 1769 debate in the House of Commons, in which he vehemently opposed the political radical John Wilkes. His peers thought that he resembled Bickerstaff's character, "who," Horace Walpole remarked, "is described as employed by everybody in all odd jobs and servile offices."[23]

Graphic artists subsequently portrayed Jeremiah Dyson as a Mungo (or Mungo as a Dyson). Such desire to further personal interests embodied the broader political corruption that the Opposition perceived in George III's administration. Mungo-Dyson appears in these satires as a slave whose participation in the subversion of Wilkes, passage of the Stamp Act, and general ruination of Britain exposed his self-interested flattery and corruption of George III. In one satire, Mungo-Dyson tries to beat Britannia with a cricket bat. In another, Lord Bute and his circle are about to crash the ship *Britannia* onto the rocks on an American shore

because the Stamp Act is weighing them down. Mungo-Dyson cries, "Oh! Masters, Masters, what will you do for me your poor Mungo Now." A third satire depicted Dyson-Mungo helping to trample on petitions and state documents.[24] These prints built on the graphic tradition of using black slaves to comment upon the slavery of white Londoners, but whereas Hogarth and his copiers stressed the unwitting nature of that bondage, the Opposition satirists targeted politicians' voluntary acceptance of such a status. Other artists, such as William Blake, argued that any so-called restoration of British liberty merely continued unwitting slavery, characterizing revolution as restorative of old tyrannies.[25] But the Opposition especially criticized Dyson's submissiveness—and by extension that of other members of Lord North's ministry. *The State Hackney Coach* (1773), for instance, imagined the sleeping king being driven by the devil. Mungo-Dyson is one of the man-horses pulling the coach, a beastly role that conveys his voluntary submission "to the yoke of slavery, bridled, harnessed and obeying the lash."[26] George III's ministers, the Opposition argued in this and a dozen other well-circulated prints, donned the yoke to acquire preferment; their corruption inhered in their emasculating and dehumanizing choice to be slaves. Satirists such as Dent, who added a number of other local politicians to the black community, contributed to this graphic reduction of the multivalent meanings of blackness to a simple sign of servility (see Plate 15). That reduction reflected their own impotence in the face of a government notoriously deaf to popular sentiments and social unrest at home.[27]

The ridicule and degradation that these political satirists sought to impose through their application of blackness suggests deep concerns about race and its connection to political and social corruption. Dent's direct conflation of the black London poor and the Fox-North coalition evolved from earlier satires, such as Thomas Rowlandson's *Every Man Has His Hobby-Horse* (1784), which integrated Mungo into images of corrupt political patronage (Figure 7.2). Rowlandson depicted the Duchess of Devonshire carrying Fox on her back toward a building inscribed "Mungo's Hotel Dealer in British Spirits." The black host pours gin for the duchess as she exclaims, with a bag of money in her hand, "For the good of the Constitution give me a glass of Gin." In the background, less than reputable Londoners, equipped with tankards, dance around standards that proclaim their support of Fox. The implication of this transaction is that Fox has acquired votes, with the duchess's help, from the bottom rungs of British society. For Rowlandson, the politician's association

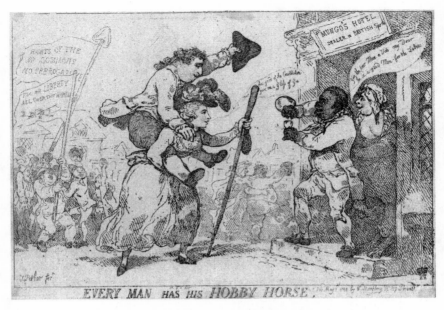

Figure 7.2. Thomas Rowlandson, *Every Man Has His Hobby Horse* (May 1, 1784). © The Trustees of the British Museum. All rights reserved.

with Mungo, the newest member of the unruly mob, symbolized traditional forms of political and social corruption.

Rowlandson's Mungo stands with a white prostitute intimately placed behind him in a reversal of Hogarth's *The Four Times of the Day: Noon* (see Figure 6.9). His character derived from social satires that incorporated Mungo into representations of "the extravagance, improvidence, dishonesty, and depravity of servants" in the 1770s and 1780s.[28] Prints satirizing life below and above stairs imagined his sexuality, from accounts of black footmen wooing white maids and cooks to those of black servants who appropriated elite codes of conduct in their pursuit of interracial relationships. In 1772, *High Life Below Stairs, or Mungo Addressing My Lady's Maid* envisioned Mungo seducing a white maid with caresses, wine, and Ovid's *Ars Amatoria* (Figure 7.3). The print transformed the subversive image of Bickerstaff's Mungo bringing wine to the young couple into the differently subversive image of his use of wine in his own courting: the Ovidian text reads, "For Wine inspires us and fires us with courage, love, and joy, etc." These social satires that depicted

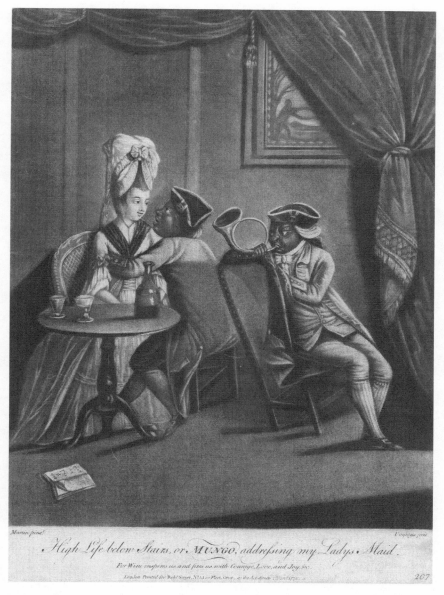

High Life below Stairs, or MUNGO, *addressing my Lady's Maid.*

For Wine chears us, and fires us with Courage, Love, and Joy &c.

London Printed for Rob.ᵗ Sayer, N°.53 in Fleet Street, as the Act directs 1.Jan.ʸ 1772.

207

Figure 7.3. William Humphrey (after Johan Fredrik Martin), *High Life Below Stairs, or Mungo Addressing My Lady's Maid* (London, January 1772). Lewis Walpole Library, Inv. 772.1.1.2.

servants aping their betters, engaging in amorous liaisons, or subverting the authority of their masters expressed class tensions by ridiculing the sociosexual desires of white and black servants.[29]

Identifying the reason for the proliferation of social prints preoccupied with black participation in London society is difficult, as engravers did not often leave descriptions of their work. Gretchen Gerzina argues that the movement of blacks into the lower class created tensions as "they began to consider themselves equal to white people of a similar class, and deserving of wages for their labour." The black poor fed middle-class anxieties about social order at a time when class antagonisms were at a peak. In the second half of the eighteenth century, the growing middle class generated a new demand for servants at the same time that the developing industrial sector opened opportunities for work outside the service sector. The social control thesis postulates that publicized crackdowns on crime, discussions of proper servant education, and charity movements were the activities of a middle class that sought to distinguish itself from its domestics in a world in which servants left at a whim, argued for tea and other traditionally elite goods as part of their service agreements, and generally exercised their power. The arrival of thousands of black Americans freed for their service to the British in the American war may have also exacerbated the deep humiliation afflicting Londoners in the wake of the American Revolution.[30] The concerns expressed in these satires, however, also reflected artistic conventions that these printmakers inherited from earlier representations of metropolitan race relationships. They developed from the use of the exotic other as a foil to the behavior of white Londoners, the increasingly common inclusion of blacks in local scenes, and the turn toward caricature that tended to create recognizable, yet not particularly admirable, types of humankind.

The static and idealistic representation of the black liveried servant gazing in admiration at a white master or mistress in British portraiture was a fiction that could only be sustained through the maintenance of an imagined distance between these exotic servants and the society in which they had come to live. Satirists extended Bickerstaff's acknowledgment of Mungo's integration into the servant class as they depicted their Mungos and other black characters consorting with white politicians, cooks, maids, and mistresses. Doing so undermined that imperial, racial, and social distance, reducing the viability of the elite black servant for narratives of virtue and creating a new iconography of race relations that grappled with the idea of a black Londoner. The signification of slavery

in these prints is difficult to discern: satires on black participants in London society differed little from satires of lower-class whites (and indeed, they are often ridiculed in the same print).

The majority of prints including black characters raised questions about their presence and particular social habits, yet in so doing they also provided evidence of the variety of spaces and roles that they occupied. Some Britons perceived such interracial relationships to be symbolic of broader social disorder, but only when these relationships moved beyond the boundaries of the lower classes did they become seriously, and idiosyncratically, contentious. One of the few representations of an identifiable black slave suggests the nature of these commentaries. Julius Soubise was the Duchess of Queensberry's black servant and protégé. A ship captain on his way to the West Indies noticed Soubise's charisma and decided to give him as a gift to the duchess. She educated and indulged him; his life embodied the preferential treatment that some black slaves experienced in Britain as subjects of an imperial mind-set that set out to prove Britons' ability to improve the African Other. Soubise became one of the most conspicuous fops in the city, a figure whose blackness endowed already troubling male pursuits of fashion with additional tensions. Whether *A Mungo Macaroni* (1772) caricatured Dyson or Soubise, or Dyson as Soubise remains uncertain (Figure 7.4).[31] This print belonged to a series of macaroni images that dwelled on aberrant male social conduct.[32] Casting a black slave as a macaroni turned a commentary on the slavishness of fashionable white men into one on the failures of British imperial mastery.

Some Londoners did not mind Soubise's foppishness: his amours ranged from the maids in his own household to elite women about the town (though he was also accused of rape). But another caricature of him went beyond cataloging fashionable male behavior. In 1773, William Austin engraved Soubise and his mistress in a fencing match (Figure 7.5). With the point of his foil touching her breast, Soubise exclaims a version of Mungo's lines, "Mungo here Mungo dere, Mungo Ev'rywhere, above, & below Hah! Vat your Gracy tink of me Now."[33] The Duke of Queensberry had made an unsuccessful attempt to reform Soubise's behavior the year before this print appeared, telling him, "You are now, by the kindness of your friends, in a situation much above what you had any pretensions to; but that should rather inspire you with modest gratitude than with foolish pride." Austin's print suggests that Soubise's relationship with the duchess remained one of the world turned upside-down, where he used his training not to express gratitude but to denigrate his mistress. This subversion

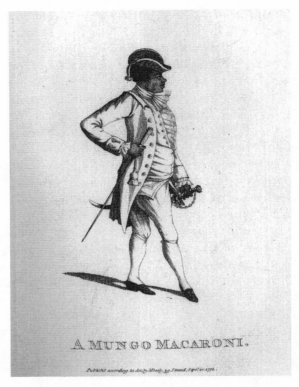

A MUNGO MACARONI.

Figure 7.4. Anon., *A Mungo Macaroni* (London, published by M. Darly, September 10, 1772). © The Trustees of the British Museum. All rights reserved.

of the idealized mistress-servant relationship, which as much ridiculed the duchess's failure to control her servant as it did Soubise's behavior, expressed anxieties about the proper hierarchy of white Britons over black slaves.[34] The duchess enters into this match by donning a face mask, a transient blackening of her face that literally shields her from the physical encounter and that can be, presumably, removed to restore her original self. Mungo-Soubise reflects the corruption of the master-servant relationship that was central to British fantasies about imperial virtue.

The movement of black Londoners into a generalized servant class did not prevent artists, especially those involved with the nationalist Royal Academy of Art, from continuing to invoke the white master–black servant relationship in portraits and other elite forms of racial imagery. Even

Figure 7.5. William Austin, [The Duchess of Queensberry and Soubise] (London, May 1, 1773). © The Trustees of the British Museum. All rights reserved.

after abolitionists questioned the virtues of such conquest, black bodies were still included in coats of arms. Thomas Gill's 1791 book ticket, for instance, displayed a royal black man wearing a collar that chained him to the coat of arms. Rising interest in India also gave rise to family and individual portraits that integrated more South Asian servants into the same ideological positions that African servants had formerly dominated. Meanwhile, Sir Joshua Reynolds, Johann Zoffany, and other artists continued to paint black servants or slaves in heroic portraits of British officers in the 1780s, reifying master-servant relationships in pictures of Britain's naval and military presence. The persistence of such imagery speaks to the cultural purchase that this imagined relationship with the black servant had in the construction of imperial identities.

Austin's print, however, echoed broader questions asked by black and white Britons about British mastery. In his posthumously published letters, the African Briton Ignatius Sancho questioned whether slaves were "fortunate" and "indebted" to "English commercial interests in West African

trade." George Colman's 1787 operatic version of *Oroonoko* openly satirized this well-established perception: "Why what return can the wench wish more than taking her from a wild, savage, people and providing for her here with reputable work, in a genteel, polished Christian country?"[35] The American Revolution and the abolitionist movement that occurred in its wake questioned the gentility and polish of this Christian country, and the responses to these developments proved as variegated as the initial debates over the meaning of blackness. Late eighteenth-century satirists used Mungo to ridicule Britons for their inappropriate familiarity with black servants and slaves. For Opposition satirists, this familiarity manifested itself as politicians assuming the sycophancy (and the blackness) attributed to slaves; for social satirists, this new intimacy led to interracial relationships or to the inversion of social and imperial hierarchies.

Dent's 1787 print of the Sierra Leone Expedition thus drew upon important visual and literary precedents when he created his Mungo-Weltje character for his disparaging scene (see Plate 15). He conflated one perception of the free black settlement (as removing a perceived source of disorder in London) with the expulsion of ministers whose corruption his print explicates as their participation in the destruction of the empire. Other engravers used black slaves to point out the hypocrisy of American claims to liberty, echoing Samuel Johnson's famous line, "How is it that we hear the loudest yelps for liberty among the drivers of negroes?" Another portrayed Britons as slaves to the "corrupting Ore" of America.[36] As the Native American figure, with some exceptions, came to represent white colonists, the black servant, whether white politician or actual black Londoner, came to embody British anxieties over the internal destabilization of empire.

By the 1790s, Mungo had evolved into a character resentful of hierarchies in general.[37] Late eighteenth-century commentators on the black presence in London echoed this visual and literary characterization, arguing that the "Sweets of Liberty and the Conversation with free Men and Christians" so enlarged "their Minds" that they soon made "such Comparisons of the different situations" in the West Indies and Britain. The magistrate Sir John Fielding believed that black slaves who had visited Britain returned to the plantations without the ignorance that made their bondage supportable, turning to "execute the blackest Conspiracies against their Governors and Masters." Echoing the burgeoning literature advocating limits on the education of white servants, Fielding argued that exposure to British education and notions of liberty was the root cause of West Indian rebellions.[38] Such late eighteenth-century commentaries

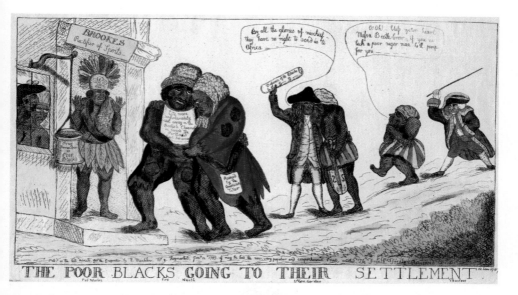

15. [William Dent], *The Poor Blacks Going to Their Settlement* (January 12, 1787). © The Trustees of the British Museum. All rights reserved.

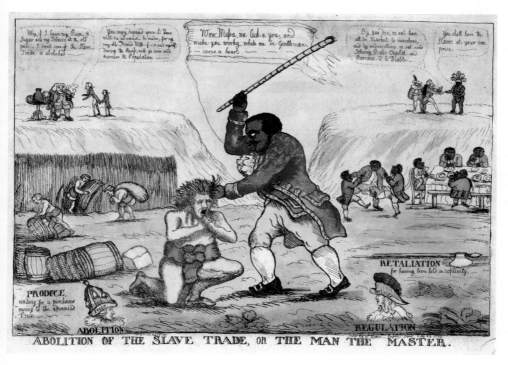

16. William Dent, *Abolition of the Slave Trade, or The Man the Master* (May 26, 1789). © The Trustees of the British Museum. All rights reserved.

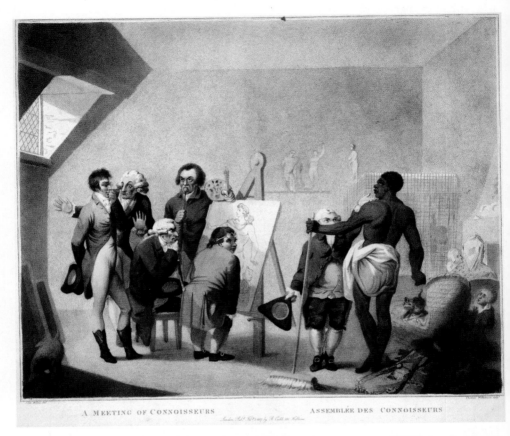

A MEETING OF CONNOISSEURS ASSEMBLÉE DES CONNOISSEURS

17. Thomas Williamson (after John Boyne), *A Meeting of Connoisseurs* (1807), hand-colored stipple etching.

brought earlier metropolitan interpretations of colonial slave rebellions home to Britain. The *Prompter*'s imagined Jamaican maroon, Moses Bon Sáam, had already established the connection between knowledge of liberty and disgruntlement with slavery some forty years before, a connection that only became exacerbated when large numbers of former slaves moved into the educational, intellectual, and cultural capital of the British Empire. The paranoia about blacks running amok in London echoed the paranoia of colonial slave masters about the potential threat of their male slaves. Satirists explained these overly forward black servants or slaves in terms of the corruption of British mastery; they preyed on fears of imperial decline and ignored the lessons learned by Bickerstaff's Don Diego as they found the source of the black rebel, not in British tyranny, but in the overindulgence of servants' desires.

The loss of the North American mainland did not, in the end, threaten Britain's economic health nearly so much as subsequent protracted wars on the Continent, but the ideological cost was severe. In 1778 the *Norfolk Chronicle* lamented: "What could be more flattering to an Englishman, in the utmost pride of his heart . . . than to see his country, the seat of such an empire, the mistress of such a world, how are all our well-founded expectations destroyed! Where are we now to seek our glorious dependencies?" British writers struggled to control the meanings of the revolution by internalizing its causes. William Mason argued that venturing across the Atlantic had caused Britain "herself to vanquish in America." *The Triumph of Liberty and Peace with America* (1782) insisted that "England can ne'er be conquer'd but at home . . . And if she falls, herself first gave the wound."[39] A 1782 print called the *Royal Hunt* depicted a Dutchman, Frenchman, Spaniard, and American causing the "Temple of Fame" or Britain's empire to crumble to the ground (Figure 7.6). Contemporary political prints portrayed Britain as the dismembered subject of war and disease. In Blake's *America,* George III in his various guises causes the disease and the plagues that recoil upon England, symbolizing the unforeseen consequences of his corrupt ministries.[40] From this perspective, the loss of the North American colonies was a grotesque projection of internal corruption.

Satirists attempted to delimit the effects of the American Revolution by interpreting political and social corruption through theatrical characters such as Mungo. His appropriation by multiple artists and authors suggests the growing importance of black slaves to popular conversations about political and social developments in Britain, especially because they could be used to connect internal and external unrest. But imagining black

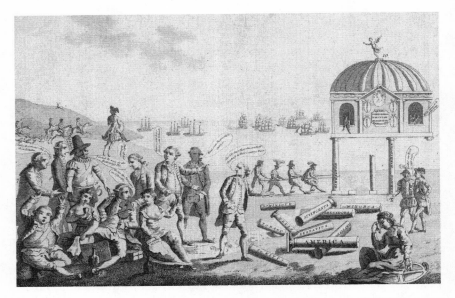

Figure 7.6. Anon., *The ROYAL HUNT, or a PROSPECT of the YEAR 1782* (February 16, 1782). © The Trustees of the British Museum. All rights reserved.

resistance in the midst of this "crisis of liberty" exploded the boundaries of these caricatures.[41] Laughing at a black male who embodied the impotence that many Britons seem to have felt was one way to try to come to terms with disorder both at home and abroad, but it was a short-term solution. Blacks occupied spaces and roles that did not fit with notions of imperial authority that relied on the distance of Britain to the New World; they had become in these satires local symbols of British corruption, figures needing to be either expelled or reformed.

Abolitionist Mungo

For some printmakers, the abolitionist movement was an extension of such corruption. Caricatures explained the motives of the leading abolitionist William Wilberforce by revealing him in bed with black prostitutes. These prints reemphasized the association of black female bodies with disorder that occurred in the earliest discussions of English imperial power.[42] Others, such as Dent's *Abolition of the Slave Trade, or The Man the Master*, blamed abolitionists' sexual predilections for turning the

world upside down (Plate 16). On the top left, George III sits smoking a pipe and drinking rum. He says to his ministers, "Why if I have my Rum & Sugar and my tobacco at the old price—I don't care if the slave trade is abolished." Pitt assures him, "You may depend upon it there will no advance be made, for my very able Friend Wilb[er]f[orc]e and myself, during the Recess, will go over and increase the Population." The effects of this decision appear across an Atlantic gulf. A larger-than-life Mungoesque black man dressed in aristocratic clothes beats a former white master who wears a loincloth: "Now Massa," the former slave says in an adaptation of Mungo's lines, "me lick a you, and make you worky while me be gentleman.—Curse a heart."[43] White slaves work the fields, while black masters dine and dance above an ax bearing the inscription "Retaliation for having been kept in captivity." Above the revelers, America tells France and Spain that British abolitionism will not stop its shipments of slaves. The print projected the same fears that enflamed writers in the 1730s and 1740s: France and Spain would not stop importing slaves and thus their products would undersell those produced in the British West Indies. The perceived attack on British sovereignty and prosperity was perhaps most succinct in *The Hibernian Attempt,* a print published four years earlier: a black slave wearing a feathered headdress, waving a striped flag, runs off with half of George III's crown.[44] Fears of such inverted hierarchies animated Austin's image of Mungo-Soubise's behavior toward his mistress.

These proslavery prints responded to Mungo's incorporation into abolitionist tracts in the late 1770s, where he also invoked political and social corruption, but in a context of reform. Bickerstaff's altered ending of Cervantes's story replaced Carrizales's decision to free his slaves with a cynical exchange between Mungo and Diego on the topic of emancipation. Mungo observes that Diego would give him nothing, to which his master replies, "Yes, bastinadoes for your drunkenness and infidelity." Mungo's unfulfilled emancipation led later authors to imagine an epilogue in which his plea for freedom was directed outward to the audience. Sentimental tracts in support of closing the slave trade integrated him into the long line of black slaves who used British notions of liberty to critique the practice of slavery, yet they did so to bring those arguments to a conclusion.[45]

Mungo's extended life in abolitionist tracts really began after Dyson left office in 1774 and after Granville Sharp made his famous legal case for the liberty of slaves on English soil. In 1787, the *Gentleman's Magazine* published an epilogue to the *Padlock,* supposedly written by a clergyman,

declaring that British audiences had laughed enough at Mungo, as even he could speak "some heartfelt truths." His oppression, Mungo argued, ought to elicit deeper feelings in that land of liberty than elsewhere. He asserted his common birth in freedom in a "globe" that "supports" all.

> Comes freedom then from colour? Blush with shame,
> And let strong Nature's crimson mark your blame.
> I speak to Britons—Britons, then, behold
> A man by Britons snar'd, and seiz'd, and sold.
> And yet no British statute damns the deed,
> Nor do the more than murderous villains bleed.
> O sons of freedom! equalize your laws,
> Be all consistent—plead the Negro's cause;
> That all the nations in your code may see,
> The British Negro, like the Briton free.
> But, should he supplicate your laws in vain,
> To break for ever this disgraceful chain,
> At least, let gentle usage so abate
> The galling terrors of its passing state,
> That he may share the great Creator's social plan;
> For though no Briton, Mungo is a man!

The following year, Sarah Trimmer's *Family Magazine* reprinted Mungo's epilogue in hope that it would inspire "proper reflections" in those "who are instrumental to the sufferings of the unhappy Africans."[46]

This epilogue limited the consequences of Mungo's emancipation: echoing the political prints of Dyson-Mungo that envisioned slavery as an emasculating condition, it centered on the restoration of Mungo's manhood. At the same time, the epilogue restored black masculinity outside of the national body, ensuring that British masculinity remained defined by the white male: Mungo will occupy space not as a "Briton," but as a "British Negro." Scholars of modern racisms have argued that the term "Negro," as opposed to "African" or "Ethiope," provided no history, no place, no location in time.[47] This framing of Mungo's emancipation, however, suggests that the term "British Negro" took on particular meanings of space and time in the context of the British empire: this "British Negro" was a reconciliation of new significations of slavery with entrenched racial hierarchies. Mungo is imagined not as a potential member of British society, but as a new black character that would no longer invoke British shame. Recognition of his manhood would allow

him to "share the great Creator's social plan" while emphasizing his difference from Britons. The epilogue reflects how some abolitionists co-opted the distress of slaves only to replace the amelioration of slaves' condition with the amelioration of their own.

The emergence of the pathetic slave as a central image in the abolitionist movement reflects both the embracement and denial of slavery as part of a broader attempt to regain control of the civic body and to restore former ideological structures that underpinned British imperial identities. Scholars, especially Marcus Wood, have drawn attention to the narcissism and even pornography of abolitionist images that wallowed in the persistence of inequality. The abolitionist Mungo spoke to the promise of a new association between Britons and Africans and also to the resistance to change. His relationship to his audience broadly echoed the abolitionist seal, "Am I Not a Man and a Brother," in that his plea shifted temporal understandings of British relationships with Africans toward an imagined future (Figure 7.7). The viewer of the seal or the reader of Mungo's epilogue became the subject of the slave's supplication. Individual response to his plea defined new forms of sensibility as it engaged a broader public in the reconstruction of imperial narratives. The characterization of that relationship barely altered earlier fantasies: authors had advocated the virtues of saving West Africans from cannibalistic societies, but images of black slaves in the company of British masters or in imagined colonial settings had placed that act of salvation/conquest in the past. These highly circulated reform images stressed the future of metropolitan engagement with Africans, helping to construct a foundation upon which antislavery activities in the Atlantic and subsequent intervention in West Africa could proceed.[48] Although invoking the friendship and common interests that underlay earlier images of interracial smoking fraternities, the slave's supplicating posture in the cameos, snuff boxes, bracelets, hair ornaments, and plates that spread throughout the Atlantic world rearticulated the objectification of black bodies in British culture.

Proslavery advocates focused their efforts on imagining for the public the monstrous societies that would result from abolition, in a sense marketing racism as they preyed upon local fears of miscegenation and loss of imperial control. Yet the power of the presumption of racial hierarchy lay in its ability to be appropriated for different purposes. The abolitionist movement responded to this crisis by adapting older iconographies of master-slave relationships to a new imperial order. Isaac Cruikshank's *God Save the King,* for instance, clung to the image of kneeling Africa to

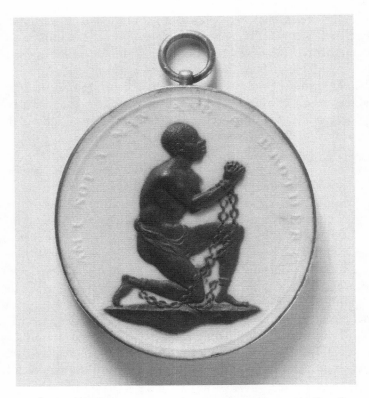

Figure 7.7. Josiah Wedgwood and Sons, *Am I Not a Man and a Brother* (ca. 1787), Medallion, English (Etruria, Staffordshire). © V&A Images/Victoria and Albert Museum, London.

reassert George III's imperial virility (Figure 7.8). As Vincent Carretta describes, "traditional emblems praising the king dominate" this "allegorical illustration of the national anthem . . . published in 1807 in part to celebrate abolition of the slave trade."[49] The traditional emblems include depictions of Africa, Asia, America, and Europe offering gifts to George III. The African kneels with an offer of ivory horns, a motif that had been prominently displayed on the lord mayor's coach for fifty years. Behind him, however, now stand two African boys, one of whom raises a banner inscribed, "Slave Trade Abolished." This image, as Carretta notes, is less than innovative, but the continuity of iconography was critical to how much abolitionist imagery worked. George III looks outward, upon the obeisance of the other quarters of the globe. His focus to his right

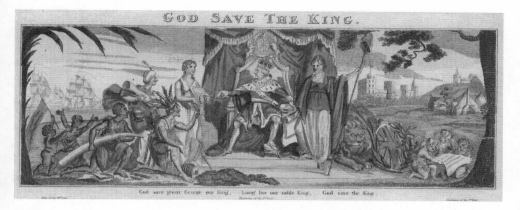

Figure 7.8. George Cruikshank, *God Save the King,* detail (1807). © The Trustees of the British Museum. All rights reserved.

sustains the scene behind his shoulder to his left. As ideologies of trade in raw materials supplant those in human beings, George III reappears as the figure lauded for his effective and controlled mediation of internal and external Britain. The iconography of imperial Britain has been altered by the addition of a banner celebrating the slave trade's closure, but the prosperity that had, in so many earlier images, derived from the obeisance of racial others had not changed.

The iconographic traditions with which abolitionist and proslavery advocates worked reached back into the seventeenth century. This supplicating pose derived from elite portraiture; it also echoed the spatial arrangements of allegorical images of the continents. The conservatism of abolitionist imagery highlights how the success of reform movements often depend on their ability to recycle powerful symbolic language to new ends. The novelty of Mungo's plea was that it involved more people in an old relationship with the black slave. The fates of the African and the Briton were still linked; these images reinforced the reliance of British identities on relationships with blacks. A critical shift in representation, however, took place as the black subordinate moved from commenting on a depicted British master to being the subject of any viewer, regardless of their social status. In part, what made this cultural shift possible was the expansion of the public in late eighteenth-century British art. As consumption of paintings and graphic prints grew, artists began to include different social classes in their images of public virtue. By erasing the specific master of a slave, abolitionists tapped into this trend, offering a

243

supplicating slave toward which any Briton could express his or her virtuous involvement in the Atlantic world.

The abolitionist movement, however, did not solve the problems of human diversity that had plagued British ideologies of assimilation since the first English ventures into the Atlantic. Writers continued to blame planters and merchants for failing to convert slaves; they wrote, again, of the natural liberty of mankind, the barbarity of tearing families apart, and the violence of subjecting individuals to a dehumanizing trade. Trimmer's *Family Magazine* rooted Mungo's sufferings in the tyranny of masters who failed to convert their slaves, keeping them in "worse than heathen ignorance." She and other authors rewrote the history of the slave trade by returning to travelogues, from which they reconstructed the original purity of African societies before European contact, and then demonized those, such as Hawkins, who had led England into slaving.[50] Slavery, implicitly, would not have been wrong if it had facilitated the care of souls. Such sentimental representations of slaves reconciled abolitionism with the failure of an imperial project and the birth of a new one. Abolitionist tracts created a history of barbarity in the imperial center as part of the construction of a history that was progressive in the dual sense that recognizing African humanity buttressed political arguments for ending the slave trade and that Britons had evolved from their ancestors. As the past became something to be overcome, the racial sensibilities that these authors projected onto the British past had to be lambasted and then corrected. Hawkins, whose violent acts in the sixteenth-century Atlantic did so much to engender the British Empire, was now a monstrosity, one often attributed to the failure of colonists to fulfill the imperial dream. Yet the hope that Britons could still imagine themselves as liberators of oppressed Africans lingered in the desire to liberate those they had made slaves.

Mungo imagery suggests some of the complexities of British responses to these arguments. A comparison of *Abolition of the Slave Trade, or The Man the Master* with the Quaker's abolitionist seal reveals that the specific racial hierarchy that this satirist inverted was the Quaker symbol of enlightenment and racially evangelical egalitarian thought (Figure 7.7, Plate 16). What becomes uncomfortably apparent in this contrast is how modern sensibilities, shaped by liberal humanism, supply an imagined benevolent individual as the intended recipient of the plea. Yet the inversion in *Abolition* disrupted that fantasy; the white slave's replication of the pose that the Quakers designed to be "expressive of an African in Chains in a Supplicating Posture" both degraded the pathos of the original black

slave and inserted a violent black male into the space of the unarticulated, but presumed humanitarian recipient of the plea. I find the racism of this image terrifying; it purported to be comic in the sense of carnival traditions where established hierarchies were transiently inverted, but it does none of the carnivalesque work to dispel the threat posed by the inversion. Instead it combined the recognition that violence could, in fact, be the response elicited by the supplicating posture with an iteration of the phantasm of the violent black male generated by the imperial process itself. Rather than attribute that phantasm to the imagination of a master who fails to recognize his own tyranny, as Bickerstaff's opera did, this print reanimated old planter paranoia and British class tensions in a context in which viewers were supposed to be at their most receptive to the needs of the slave. The projection of violence onto the black male, which Winthrop D. Jordan showed long ago to be a primary mechanism by which white men achieved colonial mastery, was here in the position of reviolating the supplicating male slave, a fact that the racial inversion masked. The print was not really about who was enslaved to whom; it was about white power and domination, critically exposing the black slave's vulnerability as it acknowledged that even the act of giving freedom was an act of mastery.

Placing abolition imagery in the broader context of discussions about race, slavery, and empire in Britain shows how abolitionists and proslavery advocates alike had to navigate and respond to popular understandings of the degradation of the master-slave relationship and growing concerns about black freedom in Britain. These print satires were hung on walls, stuck onto screens or furniture, circulated among friends, or viewed in shop windows, alehouses, coffeehouses, workshops, even on ships. Virtually any surface and any setting could become a stage for discussions of the latest governmental scandal, the consequences of the American Revolution, the motivations behind the abolitionist movement, or the follies and fashions of local Londoners. Growing consciousness of sociocultural change at a time when the empire seemed to be unraveling led artists and authors to connect the domestic black presence with misfortunes abroad. For proslavery artists, this connection led to the location of corruption in interracial intimacy itself. For abolitionists, it meant reestablishing the distance of the white Briton from the black body through the institution of a new form of benevolence centered on the restoration of the humanity, or indeed the manhood (discussions of the oppression of female slaves remained conspicuously rare) of African

slaves and white Britons. The meanings of Mungo in these reactionary images were always defined in relationship to the white British body. His freedom, as a result, remained in terms of the restoration of traditional racial hierarchies or the monstrosity of their inversion.

The profoundly slow and resistant ways in which societies change, even in moments when a new order is widely popular and supported by radically new forms of popular mobilization, reflects how different forces compete with each other. The American Revolution, while creating a moment in which notions of empire and nation were in flux, also destabilized the imperial ideologies that had allowed Britons to perceive their own virtues in the black presence in Britain itself, creating a context of fear that echoed in critical ways the situation of slave masters in the colonies. We have not paid enough attention to the reception of abolitionist images and their interaction with fracturing British myths of mastery. By the second half of the eighteenth century, the possibilities and problems raised by interracial relationships began to have as much to do with local perceptions of the blacks in Britain as with ideas about Britain's imperial presence.

Treating black slaves as a source of reformation or corruption helped white Britons cope with the internal transformation caused by their own integration into an Atlantic world. Having lost a part of America that had been the site of the encounters that many Britons had imagined over the course of the century, and fearful of the loss of the Caribbean, many Britons truly domesticated the racial other for the first time. The variety of spaces and roles in which Mungo appeared testifies not only to the complexities of British engagement with the master-slave relationship in an era when that relationship no longer held ideological certainty, but also to the nascent formulation, at least in graphic art, of a black man as a member of society, a black Londoner whose participation in domestic life mattered as much to the meaning of these images as his lingering symbolism of imperial mastery. The evolution of Bickerstaff's Mungo into later satirical and sentimental Mungos speaks broadly to the movement of blacks from the peripheries to the center of prints, paintings, poetry, and other media during the Revolutionary era. Blacks became subjects, rather than supporting characters, in domestic representations. This migration of the peripheries within, and the associated emergence of grotesque racial imagery in response to the imagination of Britain's own rebel slaves, reflects how Britons at home finally found themselves uncomfortably subject to the forces of the Atlantic world.

... the Understanding, like the Eye, whilst it makes us see and perceive all other Things, takes no notice of it self: And it requires Art and Pains to set it at a distance and make it its own Object.

—John Locke, *An Essay Concerning Human Understanding*

In November 1761, engraver John June published *A View of Cheapside, as it appeared on Lord Mayor's Day Last* (Figures C.1–C.4). Known for his humorous street scenes, June depicted the previous week's festivities surrounding the inauguration of a lord mayor of the City of London. The muddy street overflows with soldiers, women, men, pickpockets, prostitutes, and butchers. From the windows and balconies of abutting buildings, more respectable Britons watch at a safe distance the street spectacle below. A band of musicians marks the passage of the lord mayor's coach, the gilded innovation of designer Robert Taylor and coach maker Joseph Berry after a previous lord mayor had fallen off his horse during the long parade to Westminster.

This print captured the intensely local and urban politics of midcentury Georgian Britain, but closer inspection reveals more subtle evidence of the imperial context in which this jovial procession occurred. A hatter's store next to St. Mary-le-Bow displays a Black Boy and Hat shop sign, an unusual signboard for which Charles Catton I's circa 1747 watercolor sketch survives (Figure C.5). The back of the lord mayor's coach, painted perhaps by the Florentine artist G. B. Cipriani, leaves the crowd with an imaginative allegory of the city's relationship to the external world. Africa, represented by a mostly nude, kneeling black man, offers ivory tusks to the "Genius of the City," a white woman. Close behind stands America, a Native American (just visible in June's print) carrying a bow and arrows. The coach, now housed in the Museum of London,

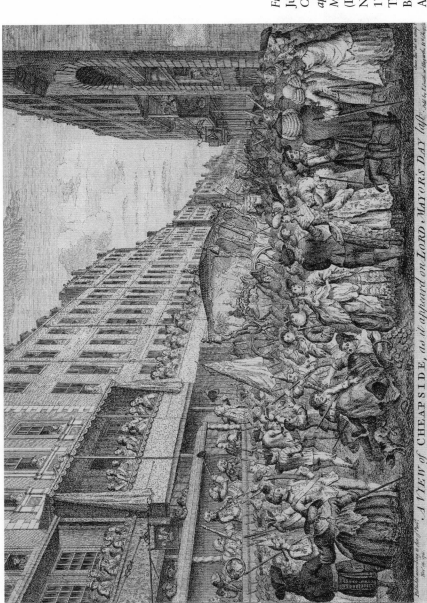

Figure C.1. John June, *A View of Cheapside, as it appeared on Lord Mayor's Day Last* (London, November 16, 1761). © The Trustees of the British Museum.

Figure C.4. Detail of black French horn player in June's *View of Cheapside.*

Figure C.3. Detail of the back of the lord mayor's coach in June's *View of Cheapside.*

Figure C.2. Detail of the shop sign in June's *View of Cheapside.*

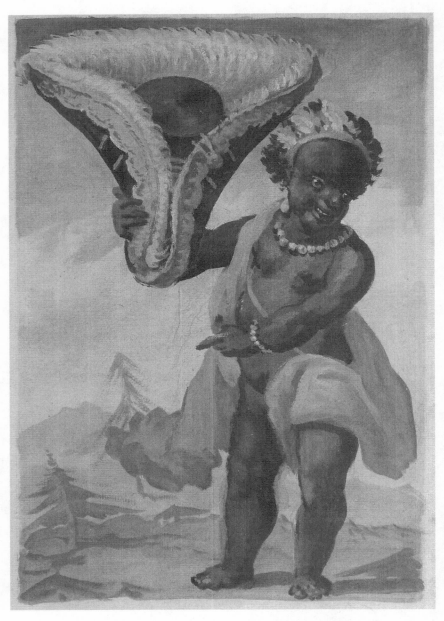

Figure C.5. Charles Catton I, attrib., *Sketch of Black Boy and Hat Shop Sign* (ca. 1747). © Private Collection.

brought an image of exotic patronage to bear on the urban scene in 1761, embedding the city in (and thus localizing) an allegorical hierarchy of the continents.[1] Among the musicians heralding its passage sits a black French horn player: his back is turned to the coach, instrument and adulation forgotten in his preference for a drink. Three different embodiments of blackness cut in a diagonal across June's London stage of popular politics: each was an urban, metropolitan fantasy, each a sign of the city's entanglement in Atlantic networks of trade and empire.

June's print appeared in the midst of a global war that would leave Britain the leading imperial power in Europe. Except in the military presence, these conflicts appear far removed from Cheapside revelers in 1761. But June's incorporation of blackness into this metropolitan landscape (which intersects and, as we will see, interprets the political scene) points to the profound consequences of the imperial turn for Britons at home. These signs of entanglement were, in their individual forms, complex products of Atlantic encounters. By placing them in conversation with each other, June not only turned the variegated expression of political participation into a heterogeneous experience of imperial relationships, but also produced, writ small, a history of Britons' subordination to the forces of exchange and encounter that shaped the Atlantic world.

Ostensive Gestures

The origins of this story lie in the appropriation of European models of interracial encounters and in the consequential assimilation of the black figure as an ostensive gesture. In metropolitan visual and print media, blacks were always pointing out something about Britons—helping them to understand their domestic landscape by locating a store in the global trades that sustained them, associating a London table with the exotic servitude that produced its foreign luxuries, or linking an elite or aspiring Briton to an imperial mastery that explained anew their wealth. Broad reproduction of the black body as an ostensive gesture gave it a free-floating signification, an eminently appropriable, characterizing role. Experience of this subordinating gesture became more important than the particular object or person being pointed at. An unfinished invitation or membership card printed for London mapmaker Robert Wilkinson in the early nineteenth century made that detachment clear (Figure C.6). Framing the blank shop or event description, the four continents bring their wares: "Africa" sits among an ivory horn, bag of gold, crocodile,

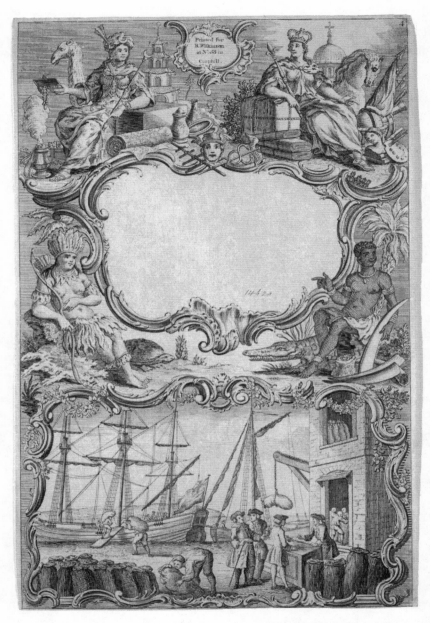

Figure C.6. *Figures Representing the Four Continents,* published by Robert Wilkinson, possibly an invitation or membership card (London, early nineteenth century). © V&A Images/Victoria and Albert Museum, London.

and palm tree and wears pearl earrings, bangles, and a swath of cloth. He points to the empty cartouche, which has yet to be filled with a description of the objects for sale. The cartouche features the head of Hermes, patron of commerce and generally of travelers, symbolism reinforced by the maritime scene of trade that underlies and supports the allegory.[2] The unfinished shop description highlights how the gesture itself had become a generalized framework. Any personified continent could have fulfilled this fantasy, but the engraver gave Africa a more active role in directing Britons' attention to the goods that have not yet materialized. His assured and assuring support sanctioned desire—the object of it was secondary. Even when Hogarthian characters, such as June's musician, populated graphic satires and plays with critiques of these fantasies, blacks were still pointing out Britons, if only to locate them in a less admirable light. Until the late eighteenth century, metropolitan Britons did not principally understand their relationship to Africans by defining themselves in opposition to them. Their entanglement in British identities occurred through the varied and at times conflicted ways in which Britons imagined these racial others seeing them.

This integration of the black body naturalized imperial hierarchies, but it also embedded and ensnared blacks in how Britons positioned themselves—both within Britain and within the Atlantic world. During the long eighteenth century, Britons at home tried in myriad ways to incorporate Africans into their society as much as they attempted to reproduce physical, social, and cultural distance from them. The fundamental need for these figures to say something about Britons inscribed how Africans had, through imperial expansion, become unequal members of a common imperial community. As blackness became a medium through which Britons imagined their connection to an expanded world that was not in fact under their control, however, an increasingly complex hall of mirrors deeply entangled those at home in the contact zone.

An Atlantic Frontier

One of the central insights of June's print was how these different though related articulations of Londoners' position within the Atlantic world could, by the 1760s, coexist on the same street. If the shop sign mobilized associations of black bodies with trade and the coach panel immortalized an imagined imperial hierarchy that legitimized that metonymy, the black French horn player refused his role in these fantasies, literally by

253

turning his back to the street and the coach and figuratively by becoming himself a consumer of goods. By illustrating the connection and conflict between these representational forms, June appropriated the black body (in its various iterations) to characterize the Cheapside procession.

As the shadowy figures of Britons' expectation and desire came into contact with a black Londoner, the street itself was illuminated as a similar space of negotiation. The street revelers also reject, through their carnivalesque involvement in theft, prostitution, and other activities, their symbolic role in the political inauguration. Writ in the deliberate conjunction of and conflict between these symbolic forms of blackness was the disorder of the street, which revealed a staged expression of political power to be an opportunistic moment for individual expression. *View of Cheapside* encoded the socially peripheral position of blacks in Britain in the subtle inclusion of racial imagery and the literal relegation of the black musician to the edge of the print. But it also revealed the symbolic centrality of blacks to constructions of metropolitan subjectivity by the 1760s. The social folly of June's Cheapside and its complex articulation of local political subjectivity emerge through the black musician's rejection of his expected, iconographic role in the mythological imperial hierarchies that created and contextualized his presence. Such appropriations highlight how contact with Atlantic peoples changed the thinking space even for those who never went abroad.

One might see June's diagonal as representing a progressive line extending backward from the vanishing point of the externalized racial other to the internalized black subject, and attribute that movement to the individualized behaviors of black Londoners. He appears to record a straightforward instance of interracial encounter—a black man interacting, and behaving, as a member of this motley London citizenry. But June also comically connected this musician to the static forms of urban racial imagery, drawing attention to his similar status as a representation. Although June may have met a black French horn player, it is equally likely that his encounter involved absorbing the symbolic, carnivalesque role that blacks had acquired through Hogarth's critique of London society. His print makes that continued representational status more apparent, as the racial iconography of heraldry was instantiated or enacted in the forgotten heraldry of the black musician.

The clash of the symbolic and social presence of blacks in June's Cheapside was thus not simply myth confronting reality (though that is how June construed the relationship between these representational forms). The black

musician was himself a fantasy of a black Londoner, a product of the black presence in Britain (in its real and virtual forms). Recognizing that June probably created this print before the inauguration actually happened (to maximize potential for sales) emphasizes how an event emerged not necessarily from its proximity, but through assessments of its meaning. That this printmaker did not have to witness the procession to engrave an immediately recognizable account of it—by mobilizing characters, social tensions, and material spaces familiar to his London audience—highlights how unnecessary the event was to its experience. The coach panel, shop sign, and black Londoner were materials with which June fashioned this encounter, exposing how the musician, while rejecting his emblematic status as bearer or embodiment of trade goods and supporting role in fantasies about imperial power, remained an ostensive gesture—pointing out the social follies of white Londoners by participating in them.

How much of the work of encounter lay in its imagination and reimagination is something that metropolitan Britons' peculiar position as both imperial center and Atlantic frontier made acutely visible. Atlantic historians have long debated the extent to which European encounters with West Africans and Native Americans outside of Europe constituted "dialogues of the deaf" or whether cultural miscommunication belied a fundamental understanding that extended past the boundaries of the trade transaction.[3] But the contact zone was never circumscribed by the moment of interaction: it was made and contested in individual and collective memory and fantasy as much as in social spaces. These modes of expression not only inscribed preexisting beliefs;[4] they also forged in the process of inscription new relationships with racial others that enabled new understandings of the foreign world and Britons' place within it. The act of imagining was a reflective and constructive process, whereby inherited knowledge was applied and reshaped by genres, audiences, and thematic contexts for which artists and authors fashioned their depictions. Such encounters altered the frameworks of British lives, even when they occurred in self-indulgent forms, testifying to the often unwitting ways in which searching beyond oneself yields both what is desired and a world that challenges not only those desires but the self that one had imagined.

June's print narrated the domestication of the black servant in his arrangement of these embodiments of blackness in the metropolitan landscape, a process that had more broadly transformed the black page in livery into a local Londoner. The black musician was both unimaginable

in terms of these static emblems of imperial hierarchies and entirely un-imaginable without them. His social presence, as June revealed, had been constructed out of his rejection of myths of mastery, a development that turned this London street into an Atlantic space of negotiation. Visual-ization of the coexistence of these representational forms, however, regis-tered the ongoing instability of this encounter, as imperial mythologies persisted in the material forms that artists and craftsmen had given them and as the physical or imagined presence of blacks remained a site for fantasy and visual play. This process of encounter did not stop with the Atlantic revolutions of the late eighteenth century or with the abolition of the slave trade.

Creative Silencing

Placed alongside the brutal expressions of racial violence memorialized in Barbadian or South Carolinian slave codes, the entanglement of black servants in metropolitan discourses of fashion or the fanciful notions of fraternal pipe smoking with black "Virginians" might appear ephemeral. But how metropolitan Britons imagined their relationship to African slaves had important consequences for continued reliance on them for imperial success. These imagined encounters both reinforced and disrupted imperial hierarchies, producing radically new forms of identification while also obscuring imperial violence.[5]

British colonists and antislavery advocates were not wrong when they accused those at home of shifting the burden of slaving, while enjoying the system's fruits. But accepting wholesale such notions of metropolitan igno-rance risks losing a considerable part of the picture. The "discovery" of African slavery in the second half of the eighteenth century was more than a polemical strategy—efforts to document the horrors of the middle pas-sage and abuses of African slaves did change how metropolitan Britons saw both the trade and slave labor—but it also provided metropolitan au-diences with the means to absolve themselves from participation in creat-ing the very structure of empire they were being mobilized to reject. Per-petuating the idea that abolitionists championed—that British soil did not support slavery—and that slavery's atrocities had been hidden until the late eighteenth century gave new charge to a witnessing role that had preserved a sense of distance from practices of chattel slavery for more than a cen-tury.[6] What abolitionists eclipsed in their chastising of metropolitan blind-ness was how the black presence in Britain (in its combined actual and

virtual forms) had elided imperial violence while producing its own forms of social and cultural conflict, which inscribed the geographical distance of Britain from the centers of slave labor. Britons were not blind to slavery; they were actively involved in imagining it into a system that confirmed preconceptions about their own role within the Atlantic world. That they failed in this project underlines the critical, destabilizing work of encounter, as slave resistance abroad and at home posed irresolvable challenges to the logic behind British fantasies of mastery and the free soil myth, and as the heterogeneity of popular fantasies about relationships with African slaves eroded, from multiple directions, fictions of racial hierarchy.

The arguments against slavery that abolitionists deployed had been formulated decades before a movement to end the slave trade emerged. One might ask, as Christopher L. Brown has recently done, what impelled Britons to act against slavery in the 1770s and 1780s. That question centralizes the challenge of the American Revolution to metropolitan ideas about empire and nation, emerging transatlantic networks of religious and secular activism, new forms of popular protest, and a group of white and black men and women who galvanized attention to the slave trade—all of which were important to effecting the sea change in British attitudes toward African bondage in the late eighteenth century.[7] Another approach to this conundrum, however, is to ask what made these arguments possible in the first place. This question turns the spotlight on reverberations of enslaved resistance in metropolitan society, transatlantic debates about the meanings of mastery and human variety, the disjunction between domestic and colonial forms of black servitude, and local experiences of interracial encounter (with an expanded notion of the term "encounter"). It includes the profound consequences of the Atlantic frontier in Britain, which enabled ideas about mastery to arise in the creative silencing of chattel slavery. Britons avoided confronting assumptions of white superiority in their fantasies about racial plurality and refashioned the labor of plantation slavery by dwelling on black domestic servitude. Fluid distinctions between free and enslaved, black and tawny, Native American and African permitted Britons to construct and maintain notions of a virtuous empire, even as this fluidity refracted Britain's peripheral geographic position to the socioeconomic processes underway abroad. The very heterogeneity of these imagined encounters intensified this collective engagement with slaving and chattel slavery.

This story emphasizes the radical potential of these multiple elisions as they circulated through popular media. The silencing of violence,

while reinforcing ideologies that portrayed slaving and slavery as extensions of care and salvation, also allowed Britons to work through new forms of interracial intimacy without fearing an immediate and untenable threat. Racially encoding geographic and cultural distance was key to this process; the prolonged exoticism of blackness in Britain, a function of its particular market for African labor, licensed sustained explorations of African slavery that were not possible in plantation settings. In the imagined fraternity of black "Virginians," the basic human sameness of Hogarth's black servants, the resistance to notions of polygenesis, or the intensely violent stories about the limits to enslavement, a vision of interracial relationships quite different from those in place emerged. That the arguments wielded by abolitionists in the late eighteenth century had been made decades earlier has focused attention on what made them act at the moment that they did, but it is also important to understand how the distance and distancing of African slaves shaped metropolitan Britons' understanding of their imperial role. Historicizing the slow erosion of notions of imperial mastery centralizes the consequences of repeated encounters with black slaves at home and abroad.

Rum, tobacco, sugar, and other colonial products changed how Britons related to each other and how they understood their connection to colonization; buying these products also meant buying into a variety of fantastical encounters with Atlantic peoples. Scholarly focus on the 1750–1850 period has obscured the origins of late eighteenth-century "humanitarian sensibilities" in earlier imperial formations. Britons had imagined their relationship to Africans in terms of their own benevolence from the earliest days of Atlantic exploration; the expansion of the slave trade and emergence of colonial slave societies over the next two centuries forced the rearticulation and elaboration of such ideas of mastery. Market culture was central to this process: preconceptions about imperialism and Atlantic peoples were mediated by the social and cultural values of colonial objects and black servants in Britain itself, simultaneously strengthening and subverting moral configurations of imperial engagement and the presumptions of racial hierarchy that underpinned them.[8]

What changed over the course of the eighteenth century (with the 1730s through the 1750s being critical decades of transition) was the sympathetic object of these master narratives—the exchange of African barbarism/heathenism for the enslaved condition—that reflected the erosion of the liveried black servant as a figure of virtue and the emergence of the

colonial plantation as a site of metropolitan morality. Elongating the chronological view on abolition raises questions about Thomas Haskell's argument that what was new in the late eighteenth century was the ability of individuals to connect their acts to remote consequences: the pursuit of empire and the expansive markets that it engendered created a popular imperial consciousness (an awareness of connection to a space "out there" that functioned to transform that space, and relationships with peoples within it, into an extension of the metropole), but it did so long before the end of the eighteenth century.[9] Apparently "new" ethical conventions hid how the "poor black" of the abolitionist movement substituted for the benighted African of earlier humanitarian justifications for the slave trade—a surrogation that reinforced myths of mastery predicated on maintaining the distance of the racial other even as it incorporated a new recognition of common humanity.

By the time Cugoano composed his thoughts on the "Evil and Wicked Traffic in Slavery and Commerce of the Human Species" in 1787, he could point to the theft of his natural-born liberty.[10] Understanding the ability of Britons to recognize the validity of this argument (and which arguments would be marshaled against it) requires a longer view of the negotiations between metropolitan authors and artists, colonial planters, and African slaves at home and abroad—and a critical awareness of the role of distance in shaping how resistance to slavery metamorphosed in Britain into a developing willingness to universalize rights to liberty. Contestations over the symbolic value of black servants mapped the expansion of black populations at home and abroad and the mediation of slave resistance through print and paint.

If the need to buttress social order led in British colonial societies to legal constructions of racial difference and in the United States to the exclusion of blacks from the body politic, in Britain growing intimacy with the social and racial consequences of imperialism intersected with the rise of capitalism and the ideological crisis caused by the American Revolution to yield legal bans on the slave trade. Taking up the cause of the enslaved situated Britons in familiar space. New fictions, new fantasies continued to embody British virtue in liberated Africans, distancing them by refusing full partnership in an imagined community and repeatedly locating Africans in African, not British, societies. Through this new and old imperial logic, Britons sustained a powerfully seductive relationship to an externalized Atlantic world, one that kept it at arm's length.

Becoming Racially Plural

Wondering what inspired the seven-year-old Catherine Rickler to stitch on her 1780 sampler the face and legs of a man and woman in bright white thread instead of leaving them the natural color of the woolen canvas may bring us closer to the cultural consequences of imperialism for metropolitan Britons than any abolitionist imagery.[11] Integrating metropolitan Britons into the contact zones of Atlantic slavery highlights the far-reaching social and cultural changes brought about by the objectification of African peoples. Stories of contact told through images, theater, songs, verse, newspapers, and many other forms of expression formulated a new awareness of human variety that became, in the late eighteenth century, a source of anxiety. Reorienting attention to Africans out in the empire and working to end the trade that had brought Africans to Britain alleviated some Britons' concerns about social and racial boundaries at home, but it did not fully displace them. Britons mobilized familiar cultural and social strategies to accommodate and control this new consciousness. The caricaturing process, for instance, that diminished the actual presence of enslaved or free blacks even as it popularized characters that were for all intents and purposes black Londoners, struggled to contain the threat some perceived in the rising numbers of blacks in Britain. Fears of miscegenation or xenophobic critiques of immigration existed alongside more sympathetic constructions of racial plurality, but all of these imagined encounters exposed how closing the slave trade could not reverse Britons' integration into the Atlantic world. A growing tide of cheap print that dwelled on individual black characters in a variety of domestic spaces and relationships recognized, often unwittingly, the social transformation that had already occurred.

Britons continued to fashion these relationships in self-affirming ways, dreaming up new encounters with supportive blacks even in the face of such radical resistance movements as the Haitian Revolution. In 1791, Macclesfield minister David Simpson described the dream of a beautiful, young woman whose husband had gone abroad to repair his fortune. She had been left in the care of a gentleman who tried to win her affections, forging a plan that Simpson believed would have "compromised her innocence, had not a dream alarmed and determined her to avoid the danger." In the dream, she was making her way to a strange house when a horse galloped toward her from a labyrinthine thicket. To avoid being trampled, she fled to the thorny hedge when, suddenly, a

"great black man, like a monstrous negro, burst from the hedge, and engaged the horse for some time, and at last slew him." The black man called to her and she trembled, more afraid of him than the horse. As she reluctantly approached him, he told her to look at the carcass, to see "who lies before you in the disguise of a horse." Ripping open its skin, he exposed her guardian lying inside. The black man then asked her to look at him and she "did so, and saw an angel, who instantly disappeared." Her fright awakened her at last. When she wrote to her guardian and told him of the dream, he was so shocked that he abandoned his plans and confessed. "Marvelous as this story appears," Simpson wrote to his Macclesfield audience, "it is nevertheless strictly true." Even in the year of the Haitian Revolution, an English woman (or a minister) could still dream about a "great black man, like a monstrous negro" coming to her aid.[12] Despite her fear of him, he played the role of a guardian angel, helping her to discover the Trojan horse in her life. Such imagined encounters continued to mediate new relationships brought into being by Britain's imperial turn, but the direction from this black man to look at him points to the reorientation of the imperial gaze.

For most of the century, blacks appeared in the wings or peripheries of images as minor characters that set off the imperial mastery of the white British subject and elevated Britons over their Continental neighbors. By the end of the century, blacks became central subjects of images and central to the desire to maintain imperial identities threatened by the American and Haitian Revolutions. This movement from the peripheries to the center mapped a critical integration of Britain into the Atlantic world. The inversion of the imperial gaze did not disentangle blacks from how Britons understood themselves (though it had that potential), but it did begin to undermine the viability of the black body as a site of encounter with the external world and to intensify domestic critiques of the domestic market for black labor.

Graphic satires continued in the nineteenth century to be a primary medium through which Britons negotiated the failures of imperial authority. In the year the slave trade was closed, John Boyne designed and Thomas Williamson engraved a print titled *A Meeting of Connoisseurs* (Plate 17). Kay Dian Kriz has drawn attention to how this print (and the watercolor on which it was based) drew on emerging discourses of physiognomy, which used the Greco-Roman form as its ideal, to critique white masculinity and reinforce assumptions of black inferiority.[13] It was also, however, a parody of ideologies of mastery as they were expressed in the

domestic market for black labor. Connoisseurs have come to this artist's studio to inspect his most recent picture, a large canvas depicting Apollo with a sheaf of arrows. The artist's impoverishment has forced him to employ this black man as his model, satirically inverting the association of the black body with displays of wealth.[14] While two connoisseurs compare the picture to the model, a third inspects the model himself, reaching up to move the black man's head. A series of physical contrasts eroticize the atmosphere. The alliteration of the model's black skin/white loincloth and the connoisseur's black breeches/white shirt sets off the model's nakedness. The black man's physique also throws into relief the short and rotund white male bodies, a disparity of stature repeated in the comparison of the model to the artist's likeness of him: the black man's negroid features and the substitution of a broom for Apollo's sheaf of arrows parodied his suitability as a model for this classical god. This male-male erotic space dominates the domestic space apparent in the right side of the print. The artist's son looks out from behind a cradle and his wife, holding her baby, has turned her back to the scene.

The combination of these gazes, to which the black man contributes a studied indifference, satirizes white masculinity by revealing homoerotic interest in the idealized black body. Aphra Behn's characterization of the aristocratic Oroonoko had similarly played with this classical ideal: "The most famous Statuary," she remarked, "cou'd not form the Figure of a Man more admirably turn'd from Head to Foot." In Behn's novella, however, the sense of rivalry over possession of Oroonoko was directly linked to and justified by the slave trade and by Oroonoko's elite status. Williamson's print, by contrast, turned the slave market into the artist's studio, a meeting of connoisseurs around a black servant who has jettisoned that role for this one.[15] By ridiculing the notion that the black man could be "refined into an ideal whiteness," this print staged a broader parody of ideologies of mastery, exposing (à la Hogarth) the domestic market for blacks as an art market and connecting such aesthetic interest in (and homoerotic desire for) the black body to moral and sexual corruption. This revelation was effected visually by stripping the black man of his livery, which lies in a pile on the floor, to reveal a partially nude black man wearing a loincloth. Ostensibly his undressing freed him to be more suitable as a model of Apollo, but what it revealed was a West Indian slave.[16] This parody of abolition echoed tobacco prints that capitalized on particularized desires for encounters with black bodies, but re-

lentlessly reversed the imperial gaze: instead of constructing white male identity through the black male gaze, Boyne's indifferent black model achieves a subjectivity denied to the white men. The imperial power traditionally communicated through white male relationships to black men was remembered in the bumbling inadequacy of those who engaged in the arts of connoisseurship. *Meeting of the Connoisseurs* suggested that such aesthetic interests had perverted and marginalized the domestic, heteronormative space.

If Boyne and Williamson focused on the removal of livery, other early nineteenth century satirists pondered the numbers of blacks dressed in British military uniforms, commenting on the incorporation of blacks into the body politic. The increasingly common inclusion of black military characters in graphic art from the 1790s through the 1820s, often in scenes where regiments had devolved into the pursuit of carnal pleasures, most likely reflected decisions to integrate blacks into British regiments, such as Lord Dunmore's proclamation offering freedom to any American slave who joined the British. More research is necessary to illuminate this iconographic and social development, but an initial survey of satiric prints from the early nineteenth century suggests that these figures became a site of anxiety about white masculinity. Thomas Rowlandson, in a few pornographic watercolors and in his more widely circulated etchings that included black characters, paid particular attention to the extracurricular activities of black soldiers and sailors, implicitly diminishing white male sexuality. In "The Dairy Maid's Delight," he offered an undoubtedly select audience an unambiguous image of desire: a white maid appears at her churn while having sex with a black soldier. This pornographic version of Hogarth's *Noon* reflected Rowlandson's interest in moments of life rather than complex moral commentaries, as well as his tendency to reveal undignified realities beneath dignified tropes.[17] The black lover comments on this white woman's desires as well as his integration into Britons' sexual fantasies, where he has replaced white male engagement with the white female body. Blackness represented one more form of transgressive desire in Rowlandson's erotica, which also canvassed Turks, Jews, misers, churchmen, academics, and several other stereotypes. *Kitchin Stuff,* Rowlandson's 1810 etching of a below-stairs scene, provided a softer exploration of interracial intimacy that dwelled on the domestic presence of the black sailor ("Black Jack" is inscribed on a pewter mug above him) (Figure C.7). Rowlandson's commentaries again linked anxieties about local forms of miscegenation, the diminishment of

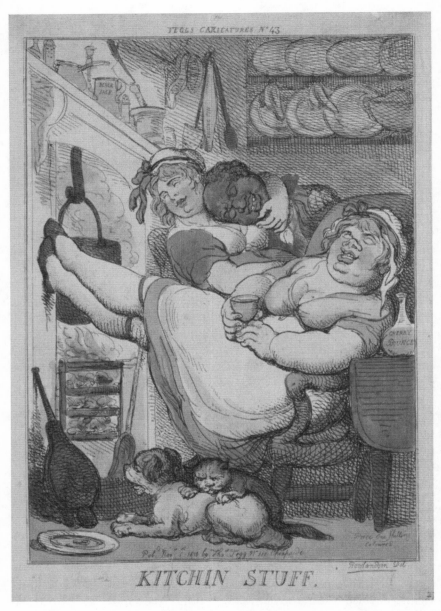

Figure C.7. Thomas Rowlandson, *Kitchin Stuff* (London, 1810), etching, hand colored. © V&A Images/Victoria and Albert Museum, London.

white masculinity, and the construction of black masculinity and subjectivity within the metropole. People of color remained a site where white Britons thought about themselves, but those envisioned social relations recognized a new participation of black men in local society.[18]

The dream of a Macclesfield woman in 1791 and the continued engagement with racial difference in social satires suggest that such fluid negotiations of the boundaries of self and other did not abruptly end in the Revolutionary era, even as Enlightenment sciences of the body naturalized racial hierarchies and paranoia about local racial diversity generated vitriolic caricatures of miscegenation.[19] These new biological explanations of racial difference are beyond the scope of this book, but their appeal reflected Britain's Atlantic Moment of racial consciousness. Rather than a transition from fluid to fixed notions of racial difference, what Britons experienced was an intensification of awareness of human diversity coupled with new and, in the late eighteenth century, uncontrolled anxieties about the meanings of that diversity. Abolitionist formulations of interracial fraternity in this context generated a satirical backlash that popularized racist fantasy, newly reinforced by appropriations (often misappropriations) of studies of physiognomy. Meanwhile, efforts to hold onto the exoticism of blackness occurred alongside new and sympathetic expressions of domestic interracial familiarity. Multiple strands of iconography, changing ideologies, new artistic styles, and new social realities of black life in Britain continued to allow heterogeneous experiences of empire, but a new black subjectivity complicated efforts to rearticulate imperial hierarchy.

The imperial mythology that developed in Britain reflected the social and cultural transformation of a society that was a periphery to a racially plural Atlantic world. The many discussions about the meanings of human diversity, the reasons for enslaved resistance, or the implications of dominion attempted to rationalize the signification of the colonial peripheries without and the Atlantic frontier emerging within. These imagined encounters, along with the voices of freed or enslaved Africans and white colonists, contributed to the radical decision to end the slave trade and produced a new, if still unclear, subjectivity of blacks in Britain. The few writings by black Britons in the late eighteenth century suggest their engagement with this emerging subjectivity. Watching the empire crumble from his London home in 1779, Ignatius Sancho concluded, "it's nothing to me—as I am only a lodger—and hardly that."[20] His brief invocation of an abject state did not prevent him from offering suggestions

about how to repay the national debt or cultivating connections to white and black Britons, and his posthumously published letters end with his African and British identities unresolved. Less than a decade later, Cugoano also struggled to negotiate his rejection of British slaving and his personal identification with Protestantism and other aspects of British culture. His imagined postabolition world included vague African populations as equal partners in a universal community, but offered Britons a new imperial role in their extension of civilization to receptive African peoples. Unspecified Africans were to belong to a universal community that incorporated the positive, in his view, aspects of British civilization, but they were not to be subordinate to an imperial center. This deliberately obtuse subject position resolved his own desires for and rejection of British Protestant culture, while simultaneously circumventing white Britons' anxieties about becoming racially plural. Sancho's and Cugoano's writings hint at the difficulties of imagining themselves into the forms of subjectivity available to them, as well as the kinds of accommodations that each made to gain a metropolitan audience; their complex articulations of British identity, as much as their articulations of African identity, reflect the deeply personal conflicts engendered by imperialism.

NOTES

ACKNOWLEDGMENTS

INDEX

AHR *American Historical Review*

BM British Museum, London, United Kingdom

CCHV Christ College Hogarth Volumes, Fitzwilliam Museum, Cambridge, United Kingdom

NPG National Portrait Gallery, London, United Kingdom

OBCR Old Bailey Online Court Record

V&A Victoria and Albert Museum, London, United Kingdom

WMQ *William and Mary Quarterly*

INTRODUCTION

1. Anon., *Design for a Black Boy Shop Sign* (ca. 1750), V&A Museum No. P.38 1986. For another shop sign sketch probably by the same artist, see the Conclusion. These watercolors come from a collection of signs that were originally bound together. They were likely the work of two or three artists, including Charles Catton I (1728–1798), who began his career as a coach-panel painter and painter of signboards, and most likely painted both the Black Boy and the Black Boy and Hat. I thank Celina Fox for her generosity in providing a reproduction of the Black Boy and Hat (see the Conclusion) and discussing the provenance of this collection with me. See Celina Fox, *Specimens of Genius Truly English: An Exhibition of Eighteenth-Century Designs for London Signboards from the Collection of the Late Lord Clark* (New York, 1984). For an extant Black Boy shop sign from Fleet Lane, see Kit Wedd, Lucy Peltz, and Catherine Ross, eds., *Creative Quarters: The Art World in London from 1700 to 2000* (London, 2001).

2. This book spans the period in which England unified with Scotland and officially became Britain, causing semantic difficulties when I refer to the entire period. I have opted, unsatisfactorily, to use Britain and the British when referring to this period, but readers should be aware of the anachronism.

3. I follow Kathleen Wilson's definition of imperialism as the "ideologies, values and practices supporting Britain's push for establishing and consolidating an

empire" being "historically embedded, an amalgam of practices, values and attitudes that bore cultural and political meanings and generated tropes of representation specific to the period." (Wilson, *The Sense of the People: Politics, Culture and Imperialism in England, 1715–1785* [Cambridge, Eng., 1995], 23). By popular I mean those forms of material culture owned, produced, traded, or seen by a variety of people. Cheap prints, for instance, have received little notice by historians, yet were consumed by people of every rank. My term "popular" should not be taken to mean exclusively constructions by and for the poor or for rural consumption. For an excellent study of late eighteenth-century cheap print, see Eliga H. Gould, *The Persistence of Empire: British Political Culture in the Age of the American Revolution* (Chapel Hill, N.C., 2000). For studies of the impact of the New World on elite European culture, see esp. John Brewer, *The Pleasures of the Imagination: English Culture in the Eighteenth Century* (London, 1997); Hugh Honour, *The New Golden Land: European Images of America from the Discoveries to the Present Time* (New York, 1975); Karen Kupperman, ed., *America in European Consciousness, 1493–1750* (Chapel Hill, N.C., 1995); Anthony Pagden, *European Encounters with the New World: From Renaissance to Romanticism* (New Haven, Conn., 1993); Anthony Grafton, *New Worlds, Ancient Texts: The Power of Tradition and the Shock of Discovery* (Cambridge, Mass., 1992); Pagden, *The Fall of Natural Man: The American Indian and the Origins of Comparative Ethnology* (Cambridge, Eng., 1982); T. F. Earle and K. J. P. Lowe, eds., *Black Africans in Renaissance Europe* (Cambridge, Eng., 2005); Simon Schama, *The Embarrassment of Riches: An Interpretation of Dutch Culture in the Golden Age* (New York, 1987).

4. For London, Liverpool, and Bristol as centers of the slave trade, see esp. Madge Dresser, *Slavery Obscured: The Social History of the Slave Trade in an English Provincial Port* (New York, 2001); James A. Rawley, *London, Metropolis of the Slave Trade* (Columbia, Miss., 2003); Ian Baucom, *Specters of the Atlantic: Finance Capital, Slavery, and the Philosophy of History* (Durham, N.C., 2005).

5. William Cobbett, *The Parliamentary History of England from the Earliest Period to 1803* (1816), 17:145, emphasis in original; Linda Colley, *Britons: Forging the Nation, 1707–1837* (New Haven, Conn., 1992), 101; Paul Langford, *A Polite and Commercial People: England 1727–1783* (Oxford, Eng., 1989).

6. *Athenian Mercury,* London, March 15, 1692; Thomas Brown, *Amusements Serious and Comical, Calculated for the Meridian of London,* 2nd ed. (London, 1702), 130–131. For other tall traveler tales, see Anon., *Cambridge jests or witty alarums for melancholy spirits* (London, 1745), 82–83, 86–87. See also Percy G. Adams, *Travelers and Travel Liars, 1660–1800* (Berkeley, Calif., 1962); Lauren Berlant, *The Queen of America Goes to Washington City: Essays on Sex and Citizenship* (Durham, N.C., 1997); Kim F. Hall, *Things of Darkness: Economies of Race and Gender in Early Modern England* (Ithaca, N.Y., 1995), chap. 1.

7. Lisa L. Moore, *Dangerous Intimacies: Toward a Sapphic History of the British Novel* (Durham, N.C., 1997), 15. For the breakdown of English insularity, see also Hall, *Things of Darkness,* introduction; Peter Fryer, *Staying Power: Black People in Britain since 1504* (Atlantic Highlands, N.J., 1984), 133; J. A. I. Champion, *The Pillars of Priestcraft Shaken: The Church of England and Its Enemies,*

1660–1730 (Cambridge, Eng., 1992); James Walvin, *Black and White: The Negro and English Society, 1555–1945* (London, 1973).

8. Imagination and fancy were interchangeable terms in early modern Britain.

9. See J. G. A. Pocock, "British History: A Plea for a New Subject," *The Journal of Modern History* 47.4 (December 1975): 601–621; Pocock, "The Limits and Divisions of British History: In Search of the Unknown Subject," *AHR* 87.2 (April 1982): 311–336; Pocock, "The New British History in Atlantic Perspective: An Antipodean Commentary," *AHR* 104.2 (April 1999): 490–500. For British rivalries with the Continent, see esp. Colley, *Britons;* Anthony Pagden, *Lords of All the World: Ideologies of Empire in Spain, Britain and France c. 1500–c. 1800* (New Haven, Conn., 1995); David Armitage, *The Ideological Origins of the British Empire* (Cambridge, Eng., 2000); Wilson, *Sense of the People,* esp. chap. 1; Felicity Nussbaum and Laura Brown, eds., *The New Eighteenth Century: Theory, Politics, English Literature* (New York, 1987); Gould, *Persistence of Empire;* Gould, "A Virtual Nation: Greater Britain and the Imperial Legacy of the American Revolution," *AHR* 104.2 (April 1999): 476–489. For Britain and the Ottoman Empire, see Linda Colley, *Captives: Britain, Empire, and the World, 1600–1850* (London, 2002). For the empire as a frontier of the nation, see esp. Kathleen Wilson, *The Island Race: Englishness, Empire, and Gender in the Eighteenth Century* (London, 2002), 17 and introduction; Wilson, ed., *A New Imperial History: Culture, Identity, and Modernity in Britain and the Empire, 1660–1840* (Cambridge, Eng., 2004).

10. Bernard Bailyn, *Atlantic History: Concept and Contours* (Cambridge, Mass., 2005); Wilson, *Island Race;* David Eltis, *The Rise of African Slavery in the Americas* (Cambridge, Eng., 2000); Armitage, *Ideological Origins;* Joseph R. Roach, *Cities of the Dead: Circum-Atlantic Performance* (New York, 1996); Jack P. Greene, *Interpreting Early America: Historiographical Essays* (Charlottesville, Va., 1996), chap. 3; Kupperman, *America in European Consciousness;* Jack P. Greene, *The Intellectual Construction of America: Exceptionalism and Identity from 1492 to 1800* (Chapel Hill, N.C., 1993); John K. Thornton, *Africa and Africans in the Making of the Atlantic World, 1400–1680* (Cambridge, Eng., 1992); Mary Louise Pratt, *Imperial Eyes: Travel Writing and Transculturation* (London, 1992); Bernard Bailyn and Philip D. Morgan, eds., *Strangers within the Realm: Cultural Margins of the First British Empire* (Chapel Hill, N.C., 1991); Robin Blackburn, *The Overthrow of Colonial Slavery, 1776–1848* (London, 1988).

11. Pratt defined the contact zone as the "social spaces where highly disparate cultures meet, clash, and grapple with each other, often in highly asymmetrical relations of domination and subordination—like colonialism, slavery, or their aftermaths." Pratt, *Imperial Eyes,* 4. New imperial history has successfully challenged the notion that the lives of ordinary Britons were not affected by the imperial project. See esp. Wilson, *Island Race,* introduction; Wilson, *Sense of the People;* Gould, *Persistence of Empire;* Alden T. Vaughan, *Transatlantic Encounters: American Indians in Britain, 1500–1776* (Cambridge, Eng., 2006); Troy O. Bickham, *Savages within the Empire: Representations of American Indians in Eighteenth-Century Britain* (Oxford, Eng., 2005); Roxann Wheeler, *The Complexion of Race: Categories of Difference in Eighteenth-Century British Culture* (Philadelphia, 2000); Martin Daunton and Rick Halpern, eds., *Empire and Others: British Encounters*

with Indigenous Peoples, 1600–1850 (Philadelphia, 1999); Felicity A. Nussbaum, *Torrid Zones: Maternity, Sexuality, and Empire in Eighteenth-Century English Narratives* (Baltimore, Md., 1995); Laura Brown, *Ends of Empire: Women and Ideology in Early Eighteenth-Century English Literature* (Ithaca, N.Y., 1993).

12. For this model of British colonial frontiers and Britain as a slave-owning society, see esp. Philip Morgan, "British Encounters with Africans and African-Americans, circa 1600–1780," in Bailyn and Morgan, *Strangers within the Realm,* 157–219. This model, conceived before the rise of new imperial history, does not account for how Britain was also an imperial center.

13. For the encounter within Atlantic studies, see, e.g., Wyatt MacGaffey, "Dialogues of the Deaf: Europeans on the Atlantic Coast of Africa," in Stuart B. Schwartz, ed., *Implicit Understandings: Observing, Reporting, and Reflecting on the Encounters between Europeans and Other Peoples in the Early Modern Era* (Cambridge, Eng., 1994), 249–267; Ned Blackhawk, *Violence over the Land: Indians and Empires in the Early American West* (Cambridge, Mass., 2006); Joyce Chaplin, *Subject Matter: Technology, the Body, and Science on the Anglo-American Frontier, 1500–1676* (Cambridge, Mass., 2001); Peter C. Mancall and James H. Merrell, eds., *American Encounters: Natives and Newcomers from European Contact to Indian Removal, 1500–1850* (New York, 2000); Pagden, *European Encounters;* James H. Merrell, *Into the American Woods: Negotiators on the Pennsylvania Frontier* (New York, 1999); Richard White, *The Middle Ground: Indians, Empires, and Republics in the Great Lakes Region, 1650–1815* (Cambridge, Eng., 1991).

14. Earl of Shaftesbury, cited in David Dabydeen, *Hogarth's Blacks: Images of Blacks in Eighteenth-Century English Art* (Athens, Ga., 1987), 72; Benedict Anderson, *Imagined Communities: Reflections on the Origin and Spread of Nationalism* (London, 1983).

15. An initial exploration of Bristol imagery can be found in Dresser, *Slavery Obscured,* chap. 2.

16. The privatization of the British slave trade in 1698 and the acquisition of the Spanish *asiento* in 1713 cemented Britain's emergence as the leading slave-trading nation in Europe.

17. For servitude in Britain, see Carolyn Steedman, *Labours Lost: Domestic Service and the Making of Modern England* (Cambridge, Eng., 2009); Bridget Hill, *Servants: English Domestics in the Eighteenth Century* (Oxford, Eng., 1996); J. J. Hecht, *Continental and Colonial Servants in Eighteenth-Century England* (Northampton, Mass., 1954).

18. For social histories of blacks in Britain and studies of the importance of Africa to British identities, see Kathleen Chater, *Untold Histories: Black People in England and Wales during the Period of the British Slave Trade, c. 1660–1807* (Manchester, Eng., 2009); Susan Dwyer Amussen, *Caribbean Exchanges: Slavery and the Transformation of English Society, 1640–1700* (Chapel Hill, N.C., 2007); Vincent Carretta, *Equiano, the African: Biography of a Self-Made Man* (Athens, Ga., 2005); Baucom, *Specters of the Atlantic;* Dresser, *Slavery Obscured;* Norma Myers, *Reconstructing the Black Past: Blacks in Britain, 1780–1830* (London, 1996); Gretchen Gerzina, *Black London: Life before Emancipation* (New Brunswick,

N.J., 1995); James Walvin, *Black Ivory: A History of British Slavery* (London, 1993); Philip Morgan, "British Encounters," in Bailyn and Morgan, *Strangers within the Realm;* Fryer, *Staying Power;* Anthony Barker, *The African Link: British Attitudes to the Negro in the Era of the Atlantic Slave Trade, 1550–1807* (London, 1978); David Brion Davis, *The Problem of Slavery in the Age of Revolution, 1770–1823* (Ithaca, N.Y., 1975); Walvin, *Black and White;* Winthrop D. Jordan, *White over Black: American Attitudes toward the Negro, 1550–1812* (Chapel Hill, N.C., 1968); Philip D. Curtin, *The Image of Africa: British Ideas and Action, 1780–1850* (Madison, Wisc., 1964); Folarin Shyllon, *Black Slaves in Britain* (London, 1974); Dilip Hiro, *Black British, White British* (New York, 1973); James Walvin, *The Black Presence: A Documentary History of the Negro in England, 1555–1860* (New York, 1972); Edward Scobie, *Black Britannia: A History of Blacks in Britain* (Chicago, 1972). For Africans in Europe, see also T. F. Earle and K. J. P. Lowe, eds., *Black Africans in Renaissance Europe* (Cambridge, Eng., 2005).

19. Kay Dian Kriz, *Slavery, Sugar, and the Culture of Refinement: Picturing the West Indies, 1700–1840* (New Haven, Conn., 2008); George Boulukos, *The Grateful Slave: The Emergence of Race in Eighteenth-Century British and American Culture* (Cambridge, Eng., 2008); Felicity Nussbaum, *The Limits of the Human: Fictions of Anomaly, Race, and Gender in the Long Eighteenth Century* (Cambridge, Eng., 2003); Geoff Quilley and Kay Dian Kriz, eds., *An Economy of Colour: Visual Culture and the Atlantic World, 1660–1830* (Manchester, Eng., 2003); Mary Floyd-Wilson, *English Ethnicity and Race in Early Modern Drama* (Cambridge, Eng., 2003); Wheeler, *The Complexion of Race;* Peter Erikson and Clark Hulse, eds., *Early Modern Visual Culture: Representation, Race, and Empire in Renaissance England* (Philadelphia, 2000); Srinivas Aravamudan, *Tropicopolitans: Colonialism and Agency, 1688–1804* (Durham, N.C., 1999); Beth Fowkes Tobin, *Picturing Imperial Power: Colonial Subjects in Eighteenth-Century British Painting* (Durham, N.C. 1999); Janet Todd, ed., *Aphra Behn Studies* (Cambridge, Eng., 1996); Hall, *Things of Darkness;* Margo Hendricks and Patricia A. Parker, eds., *Women, "Race," and Writing in the Early Modern Period* (London, 1994); Catherine Gallagher, *Nobody's Story: The Vanishing Acts of Women Writers in the Marketplace, 1670–1820* (Berkeley, Calif., 1994), chap. 2; Dabydeen, *Hogarth's Blacks.*

20. If we assume, for the sake of argument, that all blacks in the metropolis enumerated in the Somerset case were servants, then upwards of 15–20 percent of London's servant population was black by the 1770s. The servant population in 1777 was around 80,000. Although the estimate of 15000 blacks is most likely far too high, it records a sense of the impression of the local black population on, at least, some Londoners. See Hill, *Servants, 6.*

21. On the legal position of blacks, see Chater, *Untold Histories,* esp. part II; George van Cleve, "'Somerset's Case' and Its Antecedents in Imperial Perspective," *Law and History Review* 24.3 (Fall 2006): 601–645; Eliga H. Gould, "Zones of Law, Zones of Violence: The Legal Geography of the British Atlantic, Circa 1772," *WMQ* 60.3 (July 2003): 471–510; David Eltis, "Labour and Coercion in the English Atlantic World from the Seventeenth to the Early Twentieth Century," in Michael Twaddle, ed., *The Wages of Slavery: From Chattel Slavery to Wage Labour in Africa, the Caribbean, and England* (London, 1993), 207–226. For the free soil myth, see also Seymour

Drescher, *Capitalism and Antislavery: British Mobilization in Comparative Perspective* (New York, 1987). See also Sue Peabody, *There Are No Slaves in France: The Political Culture of Race and Slavery in the Ancien Régime* (New York, 1996).

22. The literature on abolitionism is vast, but little has been done to situate abolitionist imagery in the context of changing perceptions of blacks in Britain. See, for some of the most influential discussions, Christopher L. Brown, *Moral Capital: Foundations of British Abolitionism* (Chapel Hill, N.C., 2006); Marcus Wood, *Blind Memory: Visual Representations of Slavery in England and America, 1780–1865* (New York, 2000); Thomas Bender, ed., *The Antislavery Debate: Capitalism and Abolitionism as a Problem in Historical Interpretation* (Berkeley, Calif., 1992); David Eltis, *Economic Growth and the Ending of the Transatlantic Slave Trade* (New York, 1987); Drescher, *Capitalism and Antislavery*; David Eltis and James Walvin, eds., *The Abolition of the Atlantic Slave Trade: Origins and Effects in Europe, Africa, and the Americas* (Madison, Wisc., 1981); Davis, *The Problem of Slavery in the Age of Revolution*; Wylie Sypher, *Guinea's Captive Kings: British Anti-Slavery Literature of the XVIIIth Century* (Chapel Hill, N.C., 1942); Audrey A. Fisch, *American Slaves in Victorian England: Abolitionist Politics in Popular Literature and Culture* (Cambridge, Eng., 2000).

23. For musicians in army regiments, see Chater, *Untold Histories*, 237; J. D. Ellis, "Drummers for the Devil? The Black Soldiers of the 29th (Worcestershire) Regiment of Foot, 1759–1843," *Journal of the Society for Army Historical Research* 80.323 (Fall 2002): 186–202; Ellis, "Black Soldiers in British Army Regiments during the Early Nineteenth Century," *AAHGS News* (March/April 2001): 12–15. See also Walvin, *Black and White*, 60; Fryer, *Staying Power*, 79–88. For black seamen, see Emma Christopher, *Slave Ship Sailors and Their Captive Cargoes, 1730–1807* (New York, 2006); Peter Linebaugh and Marcus Rediker, *The Many-Headed Hydra: Sailors, Slaves, Commoners, and the Hidden History of the Revolutionary Atlantic* (Boston, 2000); W. Jeffrey Bolster, *Black Jacks: African American Seamen in the Age of Sail* (Cambridge, Mass., 1997); N. A. M. Rodger, *The Wooden World: An Anatomy of the Georgian Navy* (New York, 1986), 159–161. For servants, see Pamela Horn, *Flunkeys and Scullions: Life below Stairs in Georgian England* (Stroud, Eng., 2004).

24. For the Atlantic creole, see Jane G. Landers, *Atlantic Creoles in the Age of Revolutions* (Cambridge, Mass., 2010); Linda M. Heywood and John K. Thornton, *Central Africans, Atlantic Creoles, and the Foundation of the Americas, 1585–1660* (New York, 2007); Ira Berlin, "From Creole to African: Atlantic Creoles and the Origins of African-American Society in Mainland North America," *WMQ, 3rd Series* 53.2 (April 1996): 251–288. For the predominance of young black males in Britain, see Chater, *Untold Histories*, chap. 4.

25. Chater, *Untold Histories*, introduction; Eltis, *Rise of African Slavery*, 61–62, 79–80; Van Cleve, "'Somerset's Case,'" 604.

26. Van Cleve suggests that black bondage in Britain was not conceived as redemptive, but that overlooks the language of criminality and salvation in discussions of the African slave trade. See chapter 4. Van Cleve, "'Somerset's Case,'" 623.

27. For similar nomenclature problems in Renaissance England, see Hall, *Things of Darkness*, 6–9.

28. For the "situated multiplicity" of blackness in English texts, see Wheeler, *The Complexion of Race,* 45. For blackness and slavery in the colonies, see esp. Philip D. Morgan, "Virginia's Other Prototype: The Caribbean," in Peter C. Mancall, ed., *The Atlantic World and Virginia, 1550–1624* (Chapel Hill, N.C., 2007), 342–380; Jordan, *White over Black;* Edmund S. Morgan, *American Slavery, American Freedom: The Ordeal of Colonial Virginia* (New York, 1975).

29. Roger Chartier, *Cultural History: Between Practices and Representations,* trans. Lydia G. Cochrane (Ithaca, N.Y., 1988), 6. For speculation and imperial formation, see esp. Baucom, *Specters of the Atlantic.*

30. Peter Stallybrass and Allon White, *The Politics and Poetics of Transgression* (Ithaca, N.Y., 1986), 5.

31. Stephanie Smallwood, *Saltwater Slavery: A Middle Passage from Africa to American Diaspora* (Cambridge, Mass., 2007), 57; Robert W. Harms, *The Diligent: A Voyage through the Worlds of the Slave Trade* (New York, 2002), 147–148.

32. For opposition to slavery among the founders of comparative racial taxonomy, see David Bindman, *Ape to Apollo: Aesthetics and the Idea of Race in the 18th Century* (London, 2002), 12.

33. See for example, Kenneth L. Little, *Negroes in Britain: A Study of Racial Relations in English Society* (London, 1948); Davis, *The Problem of Slavery in the Age of Revolution;* Shyllon, *Black Slaves;* Hiro, *Black British;* Walvin, *The Black Presence;* Walvin, *Black and White;* Myers, *Reconstructing the Black Past.* For postcolonial studies, see Tobin, *Picturing Imperial Power,* chap. 1; Hall, *Things of Darkness.*

34. Fanon, "The Lived Experience of the Black," in Robert Bernasconi, ed., *Race* (Malden, Mass., 2001), 185.

35. For this iconography of America, see esp. Michael Gaudio, *Engraving the Savage: The New World and Techniques of Civilization* (Minneapolis, 2008), chap. 1.

36. Compare with Rebecca Zorach, *Blood, Milk, Ink, Gold: Abundance and Excess in the French Renaissance* (Chicago, 2005). For the body as a cultural construct, see Judith Butler, *Bodies That Matter: On the Discursive Limits of "Sex"* (New York, 1993); Eve Kosofsky Sedgwick, *Epistemology of the Closet* (Berkeley, Calif., 1990); Thomas Laqueur, *Making Sex: Body and Gender from the Greeks to Freud* (Cambridge, Mass., 1990).

37. For the limits of interpreting circulation, see Michel de Certeau, *The Practice of Everyday Life,* trans. Steven Rendall (Berkeley, Calif., 1984), xiii.

I. BLACK SERVITUDE AND
THE REFINEMENT OF BRITAIN

1. Thomas Wright, *Caricature History of the Georges; Or, Annals of the House of Hanover, compiled from squibs, broadsides, window pictures, lampoons, and pictorial caricatures of the time* (London, 1868), 9–10; Joyce Marlow, *The Life and Times of George I* (London, 1973), 69–71; Linda Colley, "The Apotheosis of George III: Loyalty, Royalty and the British Nation 1760–1820," *Past and Present* 102 (February 1984): 95; Hannah Smith, *Georgian Monarchy: Politics and Culture, 1714–1760* (Cambridge, Eng., 2006); Kathleen Wilson, *The Sense of the*

People: Politics, Culture, and Imperialism in England, 1715–1785 (Cambridge, Eng., 1995), 90–117; Maria Kroll, *Sophie: Electress of Hanover: A Personal Portrait* (London, 1973).

2. William Makepeace Thackeray, *The Works of William Makepeace Thackeray* (New York, 1898), 7:641 ("German negroes"). Studies of race relations characterize these two servants as black. Political histories note the Turkish members of George I's foreign household. See, e.g., Edward Scobie, *Black Britannia: A History of Blacks in Britain* (Chicago, 1972), 12; Marlow, *Life and Times*, 69–71. For the conflation of Turks and Africans, see Beth Fowkes Tobin, *Picturing Imperial Power: Colonial Subjects in Eighteenth-Century British Painting* (Durham, N.C., 1999), chap. 1.

3. For discussions of colonial slavery and debates about empire, see Christopher L. Brown, *Moral Capital: Foundations of British Abolitionism* (Chapel Hill, N.C., 1996); Brown, "Empire without Slaves: British Concepts of Emancipation in the Age of the American Revolution," *WMQ*, 3rd Series 56.2 (April 1999): 273–306; David Brion Davis, *The Problem of Slavery in the Age of Revolution, 1770–1823* (Ithaca, N.Y., 1975). For domestic slavery, see Kim F. Hall, *Things of Darkness: Economies of Race and Gender in Early Modern England* (Ithaca, N.Y., 1995); Susan Dwyer Amussen, *Caribbean Exchanges: Slavery and the Transformation of English Society, 1640–1700* (Chapel Hill, N.C., 2007); David Dabydeen, *Hogarth's Blacks: Images of Blacks in Eighteenth-Century English Art* (Athens, Ga., 1987); Srinivas Aravamudan, *Tropicopolitans: Colonialism and Agency, 1688–1804* (Durham, N.C., 1999); James Walvin, *Black and White: The Negro and English Society, 1555–1945* (London, 1973); Gretchen Gerzina, *Black London: Life before Emancipation* (New Brunswick, N.J., 1995); Peter Fryer, *Staying Power: Black People in Britain since 1504* (Atlantic Highlands, N.J., 1984); Anthony Barker, *The African Link: British Attitudes to the Negro in the Era of the Atlantic Slave Trade, 1550–1807* (London, 1978); Philip D. Morgan, "British Encounters with Africans and African-Americans, circa 1600–1780," in Bernard Bailyn and Philip D. Morgan, eds., *Strangers within the Realm: Cultural Margins of the First British Empire* (Chapel Hill, N.C., 1991), 157–220.

4. Anthony Pagden, *Lords of All the World: Ideologies of Empire in Spain, Britain and France c. 1500–c. 1800* (New Haven, Conn., 1995), 2 ("crucial display"); *The Craftsman,* quoted in Wilson, *Sense of the People,* 130 (see also 130–134); George Lillo, *The London Merchant, or the History of George Barnwell* (London, 1731); James Walvin, *The Black Presence: A Documentary History of the Negro in England, 1555–1860* (New York, 1972), 52; Linda Colley, *Britons: Forging the Nation, 1707–1837* (New Haven, Conn., 1992); Paul Langford, *A Polite and Commercial People: England 1727–1783* (Oxford, Eng., 1989); David Armitage, *The Ideological Origins of the British Empire* (Cambridge, Eng., 2000); Kathleen Wilson, "Empire of Virtue: The Imperial Project and Hanoverian Culture, c. 1720–1785," in Lawrence Stone, ed., *An Imperial State of War: Britain from 1689 to 1815* (London, 1994), 128–164; K. G. Davies, *The Royal African Company* (London, 1957), 331–332; Gee, quoted in Fryer, *Staying Power,* 27. Gee was a Pennsylvania agent.

5. For West African slave markets, see David Eltis, *The Rise of African Slavery in the Americas* (Cambridge, Eng., 2000); Robin Law, *The Slave Coast of West*

Africa, 1550–1750: The Impact of the Atlantic Slave Trade on an African Society (Oxford, Eng., 1991); Law, *Ouidah: The Social History of a West African Slaving "Port," 1727–1892* (Athens, Ohio, 2004); Law, *The English in West Africa, 1691–1699* (Oxford, Eng., 2006); Stephanie E. Smallwood, *Saltwater Slavery: A Middle Passage from Africa to American Diaspora* (Cambridge, Mass., 2007). More research needs to be done on the supply side of Barbados's shift to slavery. I am making a logical but unproven inference here about the disruption of Portuguese shipments.

6. *The Daily Courant*, March 25, 1707, No. 1595 ("dispose"); Postlethwayt, excerpted in Walvin, *Black Presence*, 52; Patrick Richardson, *Empire and Slavery* (New York, 1968), 26; Daniel A. Baugh, "Maritime Strength and Atlantic Commerce: The Uses of 'A Grand Marine Empire,'" in Stone, *An Imperial State at War*, 185–223; John Brewer and Roy Porter, eds., *Consumption and the World of Goods* (London, 1993); David Hancock, *Citizens of the World: London Merchants and the Integration of the British Atlantic Community, 1735–1785* (Cambridge, Eng., 1995); David Eltis and David Richardson, eds., *Extending the Frontiers: Essays on the New Transatlantic Slave Trade Database* (New Haven, Conn., 2008).

7. Anon., *The Character of a Town Misse* (London, 1675), 7 ("Blackmoor"); Z. C. Von Uffenbach, *Curious Travels in Belgium, Holland, and England* (written 1710–1711, pub. 1753), excerpted in Rick Allen, *The Moving Pageant: A Literary Sourcebook on London Street-Life, 1700–1914* (London, 1998), 38 ("such a quantity"); *Daily Journal*, April 5, 1723, cited in Dabydeen, *Hogarth's Blacks*, 17; Dunster, quoted in Wylie Sypher, *Guinea's Captive Kings: British Anti-Slavery Literature of the XVIIIth Century* (Chapel Hill, N.C., 1942), 3; Richard L. Bushman, *The Refinement of America: Persons, Houses, Cities* (New York, 1992); Carole Shammas, "The Housing Stock of the Early United States: Refinement Meets Migration," *WMQ*, 3rd Series 64.3 (July 2007): 549–590; Susan Dwyer Amussen, *Caribbean Exchanges*, esp. chap. 6.

8. Walvin, *Black and White*, 10 ("hallmark"). For British imitation of Catholic practices, see esp. John H. Elliott, *Empires of the Atlantic World: Britain and Spain in America 1492–1830* (New Haven, Conn., 2006); Anthony Pagden, "The Struggle for Legitimacy and the Image of Empire in the Atlantic to c. 1700," in Nicholas Canny, ed., *The Origins of Empire: British Overseas Enterprise to the Close of the Seventeenth Century* (Oxford, Eng., 1998), 34–54.

9. Philip D. Curtin, *The Rise and Fall of the Plantation Complex: Essays in Atlantic History*, 2nd ed. (Cambridge, Eng., 1998), 9. For gift exchange, see Linda Levy Peck, *Consuming Splendor: Society and Culture in Seventeenth-Century England* (Cambridge, Eng., 2005), chap. 1. For the Mediterranean as a training ground for British imperialism, see Alison Games, *The Web of Empire: English Cosmopolitans in an Age of Expansion, 1560–1660* (Oxford, Eng., 2008).

10. Stuart Hall, "Introduction," in Hall, ed., *Representation: Cultural Representations and Signifying Practices* (London, 1997), 2. Several scholars have discussed portraits of black slaves. See, e.g., Tobin, *Picturing Imperial Power*, chap. 1; Dabydeen, *Hogarth's Blacks;* Aravamudan, *Tropicopolitans;* Marcus Wood, *Slavery, Empathy, and Pornography* (Oxford, Eng., 2002); T. F. Earle and K. J. P. Lowe,

eds., *Black Africans in Renaissance Europe* (Cambridge, Eng., 2005); Hall, *Things of Darkness;* Amussen, *Caribbean Exchanges,* chap. 6.

11. See, e.g., [Simon Marmion Hours], Bruges, ca. 1480, fol. 97, National Art Library (Great Britain), Manuscript, MSL/1910/2386; Titian, *Diana and Actaeon* (1556–1559), National Galleries of Scotland, Edinburgh, NG 2839; Earle and Lowe, *Black Africans;* Jean Devisse and Michael Mollat, *From the Early Christian Era to the "Age of Discovery,"* pt. 2, *Africans in the Christian Ordinance of the World (Fourteenth to the Sixteenth Century),* trans. William Granger Ryan, vol. 2, *The Image of the Black in Western Art* (New York, 1979); Vittore Carpaccio, *Miracle of the Relic of the True Cross at the Rialto Bridge* (ca. 1494), Gallerie dell'Accademia, Venice; Paolo Caliari detto Veronese, *Convito in casa di Levi* (1573), Gallerie dell'Accademia, Venice.

12. Jeffrey Wortman, *Jacob Jordaens, A Baroque Master* (Washington, D.C., 1979), 23; Iain Pears, *The Discovery of Painting: The Growth of Interest in the Arts in England, 1680–1768* (New Haven, Conn., 1988); Louise Lippincott, *Selling Art in Georgian London: The Rise of Arthur Pond* (New Haven, Conn., 1983); D. G. C. Allan and John L. Abbott, eds., *The Virtuoso Tribe of Arts and Sciences: Studies in the Eighteenth-Century Work and Membership of the London Society of Arts* (Athens, Ga., 1992); Marcia Pointon, *Hanging the Head: Portraiture and Social Formation in Eighteenth-Century England* (New Haven, Conn., 1993); David Solkin, *Painting for Money: The Visual Arts and the Public Sphere in Eighteenth-Century England* (New Haven, Conn., 1993).

13. For African Balthazar, see, e.g., Conrad Wagner (illuminator), *Adoration of the Kings,* Leaf from the Giltlingen Missal (Augsburg, ca. 1485–1489), V&A Museum No. 274:2; Gerard David, *Adoration of the Magi* (tempera on canvas, ca. 1490), Galleria degli Uffizi, Florence; Hans Baldung Grien, *Three Kings Altarpiece* (oil on wood, 1507), Gemäldegalerie, Berlin, Germany; Andrea Mantegna, *Adoration of the Magi* (distemper on linen, 1495–1505), Getty Museum, Los Angeles, 85.PA.417; Hieronymus Bosch, *The Adoration of the Magi* (Netherlands, oil on panel, early sixteenth century), Philadelphia Museum of Art, Inv. 1321; Albrecht Durer (1471–1528), *Adoration of the Magi* (oil on panel, 1504), Galleria degli Uffizi, Florence; Master of 1518, *Adoration of the Magi* (Antwerp, oil on panel, 1505–1527), Fogg Museum, Harvard University, 1991.146; Assoc. of Hugo Van der Goes, *Adoration of the Magi* (n.d.), Victoria Art Gallery, Bath, England; Peter Paul Rubens, *Adoration of the Magi* (oil on canvas, 1626–1629), Musée Du Louvre, Paris. For Turkish Balthazar, see Rubens, *Adoration of the Magi* (oil on canvas, 1624), Koninklijk Museum voor Schone Kunsten, Antwerp, Belgium; Rubens, *Mulay Ahmad* (oil on panel, ca. 1609), Museum of Fine Arts, Boston, Accession No. 40.2; Julius S. Held, "Rubens' 'King of Tunis' and Vermeyen's Portrait of Mulay Ahmad," *Art Quarterly* (1940): 30–36; Peter C. Sutton, *Age of Rubens* (exh. cat. Museum of Fine Arts, Boston, 1994), 235, no. 9; C. J. Nieuwenhuys, *A Review of the Lives and Works of Some of the Most Eminent Painters* (London, 1834), 198, no. 47. See also Paul H. D. Kaplan, *The Rise of the Black Magus in Western Art* (Ann Arbor, Mich., 1985); Richard C. Trexler, *The Journey of the Magi: Meanings in History of a Christian Story* (Princeton, N.J., 1997). For the Tupi Magus, see Vasco Fernandes and Francisco Henriques (?), *The Adoration of the Magi* (oil

on panel, 1502–1506), Viseu, Museo de Grão Vasco, inv. 2145, reproduced in Annemarie Jordan, "Images of Empire: Slaves in the Lisbon Household and Court of Catherine of Austria," in Earle and Lowe, *Black Africans,* fig. 40 (see also pp. 162–165). For alabaster sculptures, see *Adoration of the Magi* (carved, painted and gilt alabaster, ca. 1450–1500), V&A Museum No. A.39-1946 and Museum No. A.26-1946.

14. Gude Suckale-Redlefsen, *The Black Saint Maurice* (Houston, 1987); Mattia Preti, *The Marriage at Cana* (oil on canvas, 1655–1660), NPG Inv. No. NG6372; Master of the Centenar (attrib.), Altarpiece of St. George (Valencia, Spain, ca. 1400–1425, painted), V&A Museum No. 1217-1864; Lucas Cranach the Younger, *Christ and the Woman Taken in Adultery* (oil on canvas, after 1532), The Hermitage, St. Petersburg, Russia; Paolo Veronese, *The Martyrdom of St. Justine* (ca. 1555), Galleria degli Uffizi, Florence; Matthias Grünewald, *The Meeting of St. Erasmus and St. Maurice* (ca. 1520–1524), Alte Pinakothek, Munich, Germany; Rubens, *The Feast of Herod* (ca. 1635–1640), Private Collection, U.S., reproduced in Anne-Marie Logan and Michiel C. Plomp, eds., *Peter Paul Rubens: The Drawings* (New York, 2005), no. 57; Anthony Van Dyck (attrib.), *The Finding of Moses,* Warburg Institute Collection of Photographs, London (reproduced in Dabydeen, *Hogarth's Blacks,* fig. 29b); William Hogarth, *Moses Brought to Pharoah's Daughter* (February 1752), reproduced in Ronald Paulson, *Hogarth's Graphic Works,* 3rd rev. ed. (London, 1989), pl. 193; Luca Giordano, *The Crucifixion of St. Peter* (seventeenth century), Galleria dell'Accademia, Venice (The Bridgeman Art Library, Image No. FTB 61421); Bonifacio de' Pitati, *The Parable of the Rich Man (Epulone) and the Beggar Lazarus,* Galleria dell'Accademia, Venice (Art Resource, Image No. ART123841); Paolo Veronese, *Martyrdom of St. Sebastien* (oil on canvas, 1565), San Sebastiano, Venice.

15. For black saints and martyrs, see, e.g., *Athenian Mercury,* London, May 23, 1691.

16. Luca Camberlano, *Allegorie des Continents et Armes d'un Cardinal* (1620), Windsor Castle Library, AC1.108; The Four Continents with Oval Landscape Cartouche and Horse, Lion, Leopard and Camel (textile, 1650–1700), Lady Lever Art Gallery, LL5219 (WHL4330); Paris and Pallas (Athene) with the Four Continents (textile, 1650–1700), Lady Lever Art Gallery, LL5260 (WHL3462); Oriental Figures, Beasts and Birds on a Black Background (textile, 1700–1735), Lady Lever Art Gallery, LL5429 (WHL2256), LL5430 (WHL2257), LL5446 (WHL2250). I thank Pauline Rushton at the Lady Lever Art Gallery for her help in locating these textiles. See also Joseph Burke and Colin Caldwell, *Hogarth: The Complete Engravings* (London, 1968), 5; The Circle of Knowledge (Board game, ca. 1845), V&A Museum No. CIRC.161-1969; Allegory of the Continents Trade Card, for H. Linwall, Tea Dealer, Grocer (n.d.), BM, Heal Collection, 68.182; *Figures Representing the Four Continents,* published by Robert Wilkinson, possibly an invitation or membership card (London, early nineteenth century), V&A Museum No. 14620; The Four Continents: Europe, Asia, Africa and America, Figures Set (Plymouth, Eng., hard-paste porcelain, 1768–1770), V&A Museum No. 3089-1901.

17. For European portraiture, see esp. Earle and Lowe, *Black Africans.* For examples of court imagery, see, e.g., Filipo Zaniberti (1585–1636), *The Banquet of*

Doge Giovanni I Comaro (oil on canvas, ca. 1625), Palazzo Ducale, Venice; and Antonio Domenico Gabbiani (1652–1726), *Three Musicians at the Court of Ferdinando de'Medici* (after 1687), Galleria Palatina, Palazzo Pitti, Florence (Art Resource Image No. ART158243). For Venetian influences more broadly, see also David Bindman, ed., *Black Gold: Representing Africans in the Age of the Enlightenment* (unpub. manuscript). I thank David Bindman for generously loaning his manuscript of the third volume of *The Image of the Black in Western Art*. For French paintings, see, e.g., Jean-Antoine Watteau, *Les Charmes de la Vie* (oil on canvas, ca. 1718–1719), Wallace Collection, London, Inv. No. P410; Pierre Aveline (after Jean-Antoine Watteau), *Les Charmes de la Vie* (1730), BM, Prints and Drawings Department, 2000,1126.26; Jean-Antoine Watteau, *The Music Party* (1733), Wallace Collection, London, Inv. No. P140; Jean-Marc Nattier, *Mademoiselle de Claremont as a Sultana* (1733), Wallace Collection, London, Inv. No. P456.

18. Norbert Schneider, *The Art of the Portrait: Masterpieces of European Portrait-Painting, 1420–1670* (Cologne, 1994), 12.

19. Because so many portraits are scattered through individual collections and smaller museums, attempting to quantify the number with black servants more precisely is problematic, especially as the circulation of prints produced from these images extended their reach.

20. Walvin, *Black and White,* 7; Hall, *Things of Darkness,* 211–212; Hugh Thomas, *The Slave Trade: The Story of the Atlantic Slave Trade 1440–1870* (New York, 1997); Davies, *Royal African Company.*

21. Titian's portrait of Alfonso d'Este has been lost. See Titian (after), *Alfonso d'Este, Duke of Ferrara* (oil on canvas, late sixteenth or early seventeenth century), Metropolitan Museum of Art 27.56; Herbert Cook, "The True Portrait of Laura de' Dianti by Titian," *Burlington Magazine for Connoisseurs* 7.30 (September 1905): 450; Elise Goodman, "Woman's Supremacy over Nature: Van Dyck's Portrait of Elena Grimaldi," *Artibus et Historiae* 15.30 (1994): 129–144. Impressions of Tompson's mezzotint, which appears to be a copy of Aegidius Sadeler II's early seventeenth-century engraving, are in the British Museum, Nos. 1874,0808.1307, 1877,1013.1035, 1902,1011.5314, 1902,1011.5315. Which Greville brother is featured is uncertain. For this painting, see George Vertue's Notebooks, 1734 and 1737, *Walpole Society* 24 (1936): 63. I thank Pamela Bromley at Warwick Castle for her assistance. Joseph Lee (after Van Dyck), *Lady Dorothy Percy (ca. 1598–1659), Wife of Robert Sidney, 2nd Earl of Leicester, with a Black Page,* enamel plaque (1623), NPG Picture Library, Box "Servants" (Sotheby's Lot 47. Portrait Miniatures, November 25, 1974).

22. Christopher Brown and Hans Vlieghe, eds., *Anthony Van Dyck, 1599–1641* (London, 1999), 19; see also Solkin, *Painting for Money,* 9.

23. For the initial colonial reading, see Dabydeen, *Hogarth's Blacks,* 30–31.

24. Van Dyck, *Marguerite of Lorraine, Duchess of Orléans* (ca. 1634), Galleria degli Uffizi, Florence, Italy. This portrait can be viewed online at the Bridgeman Art Library.

25. Robin Blake suggests that Henrietta's misfortune elicited the care that he gave the image, as well as the elevation that he granted her over her sister by presenting her with a page. Robin Blake, *Anthony Van Dyck: A Life, 1599–1641*

(Chicago, 2000), 292–293. For Van Dyck's companion portraits, see Brown and Vlieghe, *Anthony Van Dyck*, 160–163.

26. J. Douglas Stewart, *Sir Godfrey Kneller and the English Baroque Portrait* (Oxford, Eng., 1983), 14.

27. Studio of Sir Anthony Van Dyck, Portrait of a lady, full-length, in a white satin dress, a liveried page-boy holding a bowl of roses at her side, a draped pillar and landscape beyond (ca. 1640), sold Christie's, Old Master Pictures (Trance 6530) December 12, 2001, lot 17. See Erik Larsen, ed., *The Paintings of Anthony Van Dyck* (Freren, 1988), 2:502; Brown and Vlieghe, *Anthony Van Dyck*, 29.

28. Adriaen Hanneman, *Maria Henrietta Stuart, Wife of Prince William II of Orange (1631–1660),* Collection of Mauritshuis, The Hague; Sir Peter Lely, *Elizabeth Murray, Countess of Dysart, Duchess of Lauderdale* (ca. 1645–1650), Ham House, Surrey (Art Resource Image No. ART416853); Studio of Lely, *Lady Elizabeth Noel, 1st Countess of Gainsborough* (before 1680), NPG Picture Library (Bridgeman Art Library Image No. USB 132334); Godfrey Kneller, *Unknown Woman with Negro Page,* called Nell Gwynne (1680), NPG (on loan from Berkeley Castle). For Verney's portrait, see Amussen, *Caribbean Exchanges,* 191 and fig. 2. For other portraits of unidentified sitters or painters, see NPG Picture Library, Box "Servants" and Box "After Van Dyck."

29. See, e.g., Lely, *Lady Charlotte Fitzroy, Later Countess of Lichfield* (ca. 1672), NPG Picture Library (York Art Gallery), Box Lely Exhibition Cat. No. 1-69; Oliver Millar, *Sir Peter Lely, 1618–80* (London, 1978); Lely (after), *Portrait of George Monk, 1st Duke of Albermarle* (1608–1670), NPG Reference Neg. 36474.

30. For similar concerns, see Kim F. Hall, "Object into Object? Some Thoughts on the Presence of Black Women in Early Modern Culture," in Peter Erickson and Clark Hulse, *Early Modern Visual Culture: Representation, Race, and Empire in Renaissance England* (Philadelphia, 2000), 346. For "loneliness," see Dabydeen, *Hogarth's Blacks,* 32.

31. Cf. Charlotte Sussman, *Consuming Anxieties: Consumer Protest, Gender, and British Slavery, 1713–1833* (Stanford, Calif., 2000), 4. A precise chronological analysis has not been attempted because many extant portraits are anonymous and undated, and the sitters have not been identified.

32. Schneider, *Art of the Portrait;* Pointon, *Hanging the Head.*

33. Millar, *Sir Peter Lely,* foreword, 64; J. Chaloner Smith, *British Mezzotinto Portraits* (London, 1883), 2:463; William Faithorne Jr., *Elizabeth Cooper,* published by Edward Cooper, after Sir Peter Lely, mezzotint, late seventeenth century, NPG D1523.

34. Horace Walpole, *A Catalogue of Engravers, who have been born, or resided in England* (London, 1782), 127.

35. Hall, *Things of Darkness,* 242; Millar, *Sir Peter Lely,* 64. For abstract idealism rather than individualism in Renaissance portraits of women, see Elizabeth Cropper, "The Beauty of Woman: Problems in the Rhetoric of Renaissance Portraiture," in Margaret W. Ferguson, ed., *Rewriting the Renaissance: The Discourses of Sexual Difference in Early Modern Europe* (Chicago, 1986), 175–190. See also Anon., *Mrs. Edward Rudge with a Black Page* (late seventeenth century?), NPG Ref. Neg. 25463.

36. William Faithorne Jr., *Elizabeth Cooper,* published by Edward Cooper, after Sir Peter Lely, mezzotint, late seventeenth century, NPG D1523; Dunster, quoted in Sypher, *Guinea's Captive Kings,* 3.

37. Aravamudan notes that Charles II acquired a black boy for fifty pounds in 1682 and may have given him to Kéroualle. The Moroccan ambassador had presented another boy to the king in 1681. I agree with Aravamudan, however, that this portrait is of a young girl. Aravamudan, *Tropicopolitans,* 37.

38. This portrait was painted in France and only briefly resided in England in the 1680s, but the duchess was a prominent and problematic symbol of the English court; her fashions were influential. J. Delpech, *The Life and Times of the Duchess of Portsmouth,* trans. A. Lindsay (New York, 1953); S. Wynne, "The Mistresses of Charles II and Restoration Court Politics, 1660–1685" (PhD diss., Cambridge University, 1997). For interpretations of the consumption and display in this portrait and others, see Aravamudan, *Tropicopolitans,* 37; Hall, *Things of Darkness,* chap. 5; Amussen, *Caribbean Exchanges,* chap. 6; Tobin, *Picturing Imperial Power,* chap. 1.

39. For Madonna imagery, see Dabydeen, *Hogarth's Blacks,* 32; Sir Godfrey Kneller, Portrait perhaps of Mary Davis with page (oil on canvas, ca. 1685–1690), Audley End House and Gardens, England. For the duchess's dour gaze, see Amussen, *Caribbean Exchanges,* chap. 6.

40. Hall, *Things of Darkness,* 244. For an example of this type of portrait, see Adriaen Hanneman, *Maria Henrietta Stuart* (1631–1660), Collection of Mauritshuis, The Hague.

41. For women and slaves as property, see Hall, *Things of Darkness,* chap. 5.

42. Tom Brown, *The Works of Mr. Thomas Brown, Serious and Comical, In Prose and Verse,* 5th ed. (London, 1720), 329–330.

43. Peck, *Consuming Splendor,* chaps. 1–2 and pp. 215–222; Geoffrey W. Beard, *Upholsterers and Interior Furnishing in England, 1530–1840* (New Haven, Conn., 1997); Peter M. Thornton, *Seventeenth-Century Interior Decoration in England, France, and Holland* (New Haven, Conn., 1979); Valance (French or English, ca. 1570–1599), V&A Museum No. T.136-1991; Follower of Pieter van Roestraten, *Teapot, Ginger Jar, and Slave Candlestick* (oil on canvas, ca. 1695), V&A Museum No. P.2-1939. For engraved cutlery, see *The Daily Courant,* December 12, 1702, No. 205. For other objects with black figures, see Tazza (a standing dish used to hold sweetmeats or fruits) (prob. Austria, late sixteenth century), V&A Glass, Room 131; Globe Clock, V&A Exhibit Room 90. Scenes of imperial benevolence also decorated luxury objects. See, e.g., Francis Perigal, watchmaker, George Michael Moser, artist, Watch with Darius before Alexander (London, ca. 1770), V&A LOAN:MET ANON.2:1 to 3-1992.

44. In the 1750s and 1760s, e.g., David Garrick's *Lethe* appeared in textiles and Bow porcelain. Garrick, *Lethe: Or, Esop in the shades. As acted at the theatres in London, with universal applause* (London, 1745); *Lethe, or Aesop in the Shades* (linen and cotton, ca. 1766), Furnishing Fabric, V&A Museum No. T.75 to B-1914. Srinivas Aravamudan argues that Aphra Behn's novella *Oroonoko* (1688) translated Mignard's *Duchess of Portsmouth* into narrative form. Aravamudan, *Tropicopolitans,* 34. For scenes of a black page serving tea, see also Robert Hancock (trans-

fer print engraver), Bowl and Saucer (Worcester, 1756–1757), V&A Museum No. C.96&A-1948; Hancock (transfer print engraver), Cup and saucer displaying *The Tea Party* (Worcester, ca. 1765), V&A Museum No. C.93&A-1948; cf. T. H. Breen, "An Empire of Goods: The Anglicization of Colonial America, 1690–1776," in Stanley N. Katz, John M. Murrin, and Douglas Greenberg, eds., *Colonial America: Essays in Politics and Social Development,* 4th ed. (New York, 1993), 367–397.

45. See, e.g., the tapestry on the back wall in Romeyn de Hooghe, *Het hoog-en lager-huys van Engelandt* (interior view of William III seated on the throne in Westminster Hall) (1689), Guildhall Library, London, 21955; Gerhard Mercator, *Atlas or a geographicke description, of the regions, countries and kingdomes of the world, through Europe, Asia, Africa, & America,* vol. 2 (Amsterdam, 1641), frontispiece; George Glover, sculp., *Historia Mundi, or Mercator's Atlas (de Hondius)* (London, 1635), frontispiece. Many other representations of the continents can be found in the Warburg Institute, University of London, Menil Collection.

46. I thank Ronald Paulson for pointing out that the black servant is a satyr. Blake, *Anthony Van Dyck,* 62; Solkin, *Painting for Money,* 9–10.

47. John Ogilby, for instance, suggested that West African societies were much "addicted to Venus." Ogilby, *Africa* (1670), 318. Satyrs had been popular in European art since the fifteenth century, often appearing in Bacchanalian scenes or with Venus. See, for eg., John Hayls, *Portrait of a Lady and a Boy, with Pan* (oil on canvas, 1655–1659), Tate Britain, London, T06993; Lynn Frier Kaufmann, *The Noble Savage: Satyrs and Satyr Families in Renaissance Art* (Ann Arbor, Mich., 1984); Hall, *Things of Darkness,* 30–31, 59–61; Anthony Gerard Barthelemy, *Black Face, Maligned Race: The Representation of Blacks in English Drama from Shakespeare to Southerne* (Baton Rouge, La., 1987), chap. 1. A French intaglio, engraved with *An Offering to Venus,* displayed a Nubian boy who was black, wore a slave collar, and bore a large baroque pearl. See Intaglio engraved with *An Offering to Venus* (eighteenth century), Holburne Museum, Bath, England, Museum No. X376.

48. John June, *The Sailor's Fleet Wedding Entertainment* (1747), BM Satires 2875, Museum No. 1880,1113.3251.

49. See, e.g., Anon., *View of Monument* (engraving, ca. 1698), Guildhall Library, 4870 and 420 MON; Robert Smythier, Jewel Boxes (London, ca. 1680), V&A Sizergh Toilet Service; Jonathan Richardson, *Lady Mary Wortley Montagu* (oil on canvas, ca. 1725), private collection. For city views, see Mark Hallett, "The View across the City: William Hogarth and the Visual Culture of Eighteenth-Century London," in David Bindman, Frédéric Ogée, and Peter Wagner, eds., *Hogarth: Representing Nature's Machines* (Manchester, Eng., 2001), 146–162.

50. Janet Todd, ed., *The Works of Aphra Behn: Plays, 1682–1696* (Columbus, Ohio, 1996), 7:289.

51. The opening chapter of Behn's *Oroonoko* records the narrator's receipt of a gift of a plume of brightly colored feathers from the Surinam Indians: "Then we trade for Feathers, which they order into all Shapes, make themselves little short Habits of 'em, and glorious Wreaths for their Heads, Necks, Arms and Legs, whose Tincutres are unconceivable. I had a Set of these presented to me, and I gave 'em to the King's Theatre, and it was the Dress of the *Indian Queen*." These "glorious Wreaths" were used in Dryden's play *The Indian Queen,* where they were "infinitely

admir'd by Persons of Quality." Given that Bracegirdle never (it seems) played the role of Zampoalla in Dryden's play, the image must be of Sermenia, with the feathers simply imported from the other play. Aphra Behn, *Oroonoko,* ed. Joanna Lipking (London, 1997), 9; Michael Burden, "Aspects of Purcell's Opera," in Burden, ed., *Henry Purcell's Operas: The Complete Texts* (Oxford, Eng., 2000), 3–27. I thank Michael Burden for bringing this image to my attention, and Diana Solomon for discussions about Anne Bracegirdle. See also Margaret Ferguson, *Dido's Daughters: Literacy, Gender, and Empire in Early Modern England and France* (Chicago, 2003), 354; Amussen, *Caribbean Exchanges,* 186–187.

52. Indian Queen shop bill head (1737), for John Cotterell, tobacconist and chinawareman, City of London, London Metropolitan Archives; Indian Queen Shop Bill Head (1732), for Frederick Stanton and John Cotterell, BM Heal Collection 37.45; James Gillray, *A Sale of English-Beauties, in the East Indies* (London, 1786), BM Satire No. 7014, Museum No. 1868,0808.5532; H. W. Bunbury (after), *St. James's Park* (London, 1783), BM Satire No. 6344, Museum No. 1880,1113.2346.

53. Van Dyck had painted satyrs, whose facial resemblance to Gage's slave is striking, in earlier classical history paintings, including *Silenus Drunk* (ca. 1620) and *The Continence of Scipio* (1621). These satyrs appear to derive from Van Dyck's *Head of a Negro* (ca. 1618–1619). Another doppelganger appears in Jacob Jordaens's *An Allegory of Fruitfulness* (ca. 1620–1629), Wallace Collection, London, Inv. No. P120, and his other allegories of fertility. Given the timing of these paintings, the black model for all of these images may have been Gage's slave, providing a rare view into one enslaved man's entrance into European art. Larsen, *Paintings of Anthony Van Dyck,* 2:63–64.

54. *The Gentleman's Magazine,* London, February 1735, 91. See also Unknown Artist, *Soldier/Commander* (ca. 1640–1650), NPG Picture Library, Box "After Van Dyck." Perhaps the best-known images of black servants in hunting portraits are the Daniel Mytens portrait of Charles I and Henrietta Maria in which a slave wearing a leopard skin brings a horse, and the Diepenbeck engraving of William Cavendish's black grooms. See Hall, *Things of Darkness,* 5, 227–228, 237.

55. Hall, *Things of Darkness,* 215–217; Pagden, *Lords of All the World;* David Harris Sacks, "Discourses of Western Planting: Richard Hakluyt and the Making of the Atlantic World," in Peter Mancall, ed., *The Atlantic World and Virginia, 1550–1624* (Chapel Hill, N.C., 2007), 414–415. Historians often interpret these classical names as jokes, but they may have played a role in constructing these kinds of fantasies about the nature of British expansion. Compare with Fryer, *Staying Power,* 24.

56. Sir Joshua Reynolds, *Discourses,* ed. Pat Rogers (London, 1992), Discourse V (December 20, 1772), 140.

57. John Singleton Copley, *The Death of Major Pierson, 6 January 1781* (oil on canvas, 1783), Tate Collection, London, Inv. No. N00733; John Singleton Copley (after), *The Death of Major Peirson at St. Helier, Retaking Jersey from the French, 8 January 1781,* from *Illustrations of English and Scottish History,* vol. 2 (engraving), Private Collection, The Bridgeman Art Library International.

58. Unfortunately, the original painting could not be located. I thank Chrysanthe Constantouris at the V&A for her help. For a photograph of the work, see V&A Museum No. E.52-1887, showing Nobleman with black page, possibly after a painting by Titian.

59. Although Sir Godfrey Kneller produced some images of women in hunting scenes that included black servants, most depicted women in domestic spaces. For this gendering of space, see esp. Hall, *Things of Darkness,* 226.

60. Roxann Wheeler, *The Complexion of Race: Categories of Difference in Eighteenth-Century Britain* (Philadelphia, 2000); Dabydeen, *Hogarth's Blacks,* 64; David Bindman, "'A Voluptuous Alliance between Africa and Europe': Hogarth's Africans," in Bernadette Ford and Angela Rosenthal, eds., *The Other Hogarth: Aesthetics of Difference* (Princeton, N.J., 2001), 264–265. See also Bindman, *Ape to Apollo: Aesthetics and the Idea of Race in the 18th Century* (London, 2002).

61. Fryer, *Staying Power,* 82; James Walvin, *England, Slaves, and Freedom, 1776–1838* (London, 1986), 18.

62. Ignatius Sancho, *Letters of the Late Ignatius Sancho, an African,* ed. Vincent Carretta (New York, 1998), 73. For the grateful slave in British and American literature, see also George Boulukos, *The Grateful Slave: The Emergence of Race in Eighteenth-Century British and American Culture* (Cambridge, Eng., 2008).

63. For the considerable influence of Van Dyck on the English print trade, see Tim Clayton, *The English Print, 1688–1802* (New Haven, Conn., 1997), 69. John Riley (1646–1691), *Charles Seymour, 6th Duke of Somerset,* National Trust, Petworth House, England (reproduced in Dabydeen, *Hogarth's Blacks,* fig. 13).

64. Francis Hayman (attrib.), *Unknown Lady,* formerly called Margaret "Peg" Woffington (ca. 1745), NPG, No. 2177; Unknown professional workshop, Stoke Edith Hanging, 1710–1720, V&A, Museum No. T.568-1996.

65. James Laroche to Captain Richard [F?]rankard, January 29, 1733, Hobhouse Papers, Bristol University Library, Bristol, UK. See also Charles Malcolm MacInnes, *Bristol and the Slave Trade* (Bristol, 1963), 14; J. Harry Bennett Jr., *Bondsmen and Bishops: Slavery and Apprenticeship on the Codrington Plantations of Barbados, 1710–1838* (Berkeley, Calif., 1958), 47–48; *Williamson's Liverpool Advertiser,* April 20, 1756, cited in Dabydeen, *Hogarth's Blacks,* 30; Morgan, "British Encounters," 165–167.

66. *London Gazette,* January 10, 1761, excerpted in Horace Walpole, *Anecdotes of Painting in England,* ed. Frederick Hilles and Philip B. Daghlian (New Haven, Conn., 1969), 4:2; George Bickham, *An Introductive Essay on Drawing* (London, 1747), 17; Hall, *Things of Darkness,* 4–6.

67. Peter Paul Rubens, *Venus at a Mirror* (ca. 1615), Private Collection; Johann Zoffany (1733–1810), *The Triumph of Venus* (1760), Musée des Beaux-Arts, Bordeaux, France; Cornelius Cornelisz van Haarlem, *Toilet of Bathsheba,* Rijksmuseum, Amsterdam; Peter Paul Rubens, *Bathsheba at the Fountain* (oil on wood, ca. 1635), Gemäldegalerie Alte Meister, Dresden, Germany; Rembrandt, *Toilet of Bathsheba* (1643), Metropolitan Museum of Art, Acc. No. 14.40.651; Rubens, *Diana and Calisto* (1577–1640), Museo del Prado, Madrid; Hall, *Things of Darkness,* 217; Hall, "Object into Object?"

68. For color, see Solkin, *Painting for Money,* 9; Richard Ligon, *A True & Exact History of the Island of Barbados* (London, 1657), 43–44.

69. Behn, *Oroonoko,* 13–14; Daniel Defoe, *Robinson Crusoe: An Authoritative Text, Contexts Criticism,* ed. Michael Shinagel (New York, 1994), 148–149. English colonists used similar constructions of exceptionalism to differentiate between Native Americans and Africans. See, e.g., William Penn, "A Letter from William Penn, Proprietary and Governour of Pennsylvania in America, to the Committee of the Free Society of Traders of that Province Residing in London" (London, 1683), 5–8.

70. Sir Harry Beaumont [Joseph Spence], *Crito: Or, a Dialogue on Beauty* (London, 1752), 53–54. For relative notions of beauty see also Reynolds, *Discourses,* 358.

71. Cf. Folarin Shyllon, "Blacks in Britain: A Historical and Analytical Overview," in Joseph E. Harris, ed., *Global Dimensions of the African Diaspora,* 2nd ed. (Washington, D.C., 1993), 228; Scobie, *Black Britannia,* 9; Dabydeen, *Hogarth's Blacks,* chap. 1; Elliot H. Tokson, *The Popular Image of the Black Man in English Drama, 1550–1688* (Boston, 1982), ix.

72. Rembrandt, *Two Black Men* (1661), Mauritshuis, The Hague, Netherlands, Inv. No. 685; Seymour Slive, *Dutch Painting 1600–1800* (New Haven, Conn., 1995), 78–79; Van Dyck, *Four Negro Heads* (1625–1650), NPG Picture Library (Collection of the Earl of Danby); Antoine Watteau, *Sheet of Eight Heads* (ca. 1716), Musée du Louvre, Paris, reproduced in Robin Simon, *Hogarth, France and British Art: The Rise of the Arts in 18th-Century Britain* (London, 2007), pl. 63. See also Wallerant Vaillant, *Head of Black Man* (London, mezzotint, after 1658), V&A Museum No. E. 117-1998; John Singleton Copley, *Head of a Negro* (oil on canvas, ca. 1777–1778), Detroit Institute of Arts, Accession No. 52.118.

73. For "glossy countenances," see Chapter 4.

74. See also Follower of Sir Godfrey Kneller, *A Negro Retainer* (n.d.), NPG Picture Library, Box "Servants."

75. Earl of Fife, cited in Pointon, *Hanging the Head,* 2 ("uninteresting"); Anthony Ashley Cooper, Third Earl of Shaftesbury, *Characteristics of Men, Manners, Opinions, Times* (1711) 1:96 (face-paint[ing]); Daniel Defoe, *A Tour thro' the Whole Island of Great Britain,* ed. G. D. H. Cole (London, 1927); Solkin, *Painting for Money,* 2.

76. Solkin, *Painting for Money,* 10, 17–19; Jonathan Richardson and Samuel Johnson, cited in Alison Conway, "Private Interests: The Portrait and the Novel in Eighteenth-Century England," *Eighteenth-Century Life* 21.3 (1997): 7, 9; Bernard Mandeville, *The Fable of the Bees: Or, Private Vices, Publick Benefits,* ed. F. B. Kaye (Oxford, 1924 [1729]) 2:34–35.

77. Compare with Walvin, *Black and White,* 12.

78. For this dialectic, see J. G. A. Pocock, *Virtue, Commerce, and History: Essays on Political Thought and History, Chiefly in the Eighteenth Century* (Cambridge, Eng., 1985); Lawrence Eliot Klein, *Shaftesbury and the Culture of Politeness: Moral Discourse and Cultural Politics in Early Eighteenth-Century England* (Cambridge, Eng., 1994); Solkin, *Painting for Money,* 11–12 and chap. 1. See also Terry Eagleton, *The Ideology of the Aesthetic* (Oxford, Eng., 1990), 35.

79. Tobin, *Picturing Imperial Power,* chap. 1; Hall, *Things of Darkness,* chap. 5.
80. Schneider, *Art of the Portrait,* 20, 30.
81. Ibid., 12 ("intimate sense").
82. Frantz Fanon, *Black Skin, White Masks,* trans. Richard Philcox (New York, 2008), 94; Solkin, *Painting For Money,* intro.; Pears, *Discovery of Painting.*

2. IMAGINED ENDS OF EMPIRE

1. Ottobah Cugoano, *Thoughts and Sentiments on the Evil and Wicked Traffic of the Slavery and Commerce of the Human Species, Humbly Submitted to the Inhabitants of Great-Britain, By Ottobah Cugoano, A Native of Africa* (London, 1787), 33–34 (quotation on 34). I take the term "barbaric traffic" from Philip Gould, *Barbaric Traffic: Commerce and Antislavery in the Eighteenth-Century Atlantic World* (Cambridge, Mass., 2003).

2. For the emergence of a black discourse of Africanness, see James Sidbury, *Becoming African in America: Race and Nation in the Early Black Atlantic* (Oxford, Eng., 2007). See also Srinivas Aravamudan, *Tropicopolitans: Colonialism and Agency, 1688–1804* (Durham, N.C., 1999); Vincent Carretta and Philip Gould, eds., *Genius in Bondage: Literature of the Early Black Atlantic* (Lexington, Ky., 2001); Vincent Carretta, *Equiano, the African: Biography of a Self-Made Man* (Athens, Ga., 2005). For abolitionist strategies, see Christopher Leslie Brown, *Moral Capital: Foundations of British Abolitionism* (Chapel Hill, N.C., 2006); and the suggestive article by Kirsten Sword, "Remembering Dinah Nevil: Strategic Deceptions in Eighteenth-Century Antislavery," *Journal of American History* 97.2 (September 2010): 315–343.

3. Cugoano, *Thoughts and Sentiments,* 31.

4. For the image of the grateful slave, see George Boulukos, *The Grateful Slave: The Emergence of Race in Eighteenth-Century British and American Culture* (Cambridge, Eng., 2008).

5. For colonists' failures, see Brown, *Moral Capital,* chap. 1. For ship captains' failures, see Stephanie E. Smallwood, *Saltwater Slavery: A Middle Passage from Africa to American Diaspora* (Cambridge, Mass., 2007).

6. Brown, *Moral Capital,* chap. 1.

7. Richard Ligon, *The History of the Island of Barbados,* excerpted in Frank Felsenstein, *English Trader, Indian Maid: Representing Gender, Race, and Slavery in the New World: An Inkle and Yarico Reader* (Baltimore, Md., 1999), 63. For similar explanations of slave resistance, see James Grainger, *The Sugar Cane: A Poem. In Four Books* (London, 1764), book IV; Susan Dwyer Amussen, *Caribbean Exchanges: Slavery and the Transformation of English Society, 1640–1700* (Chapel Hill, N.C., 2007), 158–159. In 1688, Aphra Behn provided similar explanations for not enslaving the natives of Surinam: the English did not "dare" to "treat" them as "Slaves," "their Numbers so far surpassing ours in that Continent." Behn, *Oroonoko,* ed. Joanna Lipking (London, 1997), 11. All page numbers refer to this edition.

8. John Houghton, *A Collection for Improvement of Husbandry and Trade* (London, December 20, 1695), cited in Kay Dian Kriz, "Curiosities, Commodities,

and Transplanted Bodies in Hans Sloane's 'Natural History of Jamaica,'" *WMQ,* 3rd ser., 57.1 (January 2000): 42; Amussen, *Caribbean Exchanges,* 69–71, 147. On affective ties, see Victoria Kahn, "'The Duty to Love': Passion and Obligation in Early Modern Political Theory," *Representations* 68 (Fall 1999): 84–107.

9. Smallwood, *Saltwater Slavery,* 34. For enslaved resistance in the Caribbean, see Michael Craton, *Testing the Chains: Resistance to Slavery in the British West Indies* (Ithaca, N.Y., 1982); David Barry Gaspar, *Bondmen & Rebels: A Study of Master-Slave Relations in Antigua, with Implications for Colonial British America* (Baltimore, Md., 1985); Amussen, *Caribbean Exchanges,* 158–175.

10. See esp. Amussen, *Caribbean Exchanges,* 147.

11. Brown, *Moral Capital,* 47.

12. Kriz, "Curiosities, Commodities, and Transplanted Bodies"; Joseph Roach, *Cities of the Dead: Circum-Atlantic Performance* (New York, 1996), 2.

13. For new forms of social control, see esp. Gwenda Morgan and Peter Rushton, "Visible Bodies: Power, Subordination and Identity in the Eighteenth-Century Atlantic World," *Journal of Social History* 39.1 (Fall 2005): 39–64.

14. *The Daily Courant,* January 8, 1704, No. 540; *The Daily Courant,* June 20, 1704, No. 680; *The Daily Courant,* January 14, 1707, No. 1482; *The Daily Courant,* March 6, 1707, No. 1525; *The Daily Courant,* September 4, 1707, No. 1733.

15. Thomas Robinson, January 17, 1724, OBCR, Ref. No. t17240117-6; Jeffery Morat, February 16, 1737, OBCR, Ref. No. t17370216-20; Philip Walmsley, October 24, 1770, OBCR, Ref. No. t17701024-62; Joseph Brown, September 7, 1774, OBCR, Ref. No. t17740907-22; Norma Myers, *Reconstructing the Black Past: Blacks in Britain c. 1780–1830* (London, 1996), chap. 1; Philip D. Morgan, "British Encounters with Africans and African-Americans, circa 1600–1780," in Bernard Bailyn and Philip D. Morgan, eds., *Strangers within the Realm: Cultural Margins of the First British Empire* (Chapel Hill, N.C., 1991), 157–220.

16. Bennet Allen, Robert Morris, June 5, 1782, OBCR, Ref. No. t17820605-1.

17. Anne Smith, January 13, 1716, OBCR, Ref. No. t17160113-18.

18. Ordinary's Account, March 3, 1737, OBCR, Ref. No. OA17370303; Jeffery Morat, February 16, 1737, OBCR, No. t17370216-20.

19. Smallwood, *Saltwater Slavery,* 34.

20. Hakluyt, quoted in David Harris Sacks, "Discourses of Western Planting: Richard Hakluyt and the Making of the Atlantic World," in Peter Mancall, ed., *The Atlantic World and Virginia, 1550–1624* (Chapel Hill, N.C., 2007), 427.

21. Amussen, *Caribbean Exchanges,* chaps. 4–5. For the historical consequences of fear in a different context, see Linda Colley, *Captives: Britain, Empire, and the World, 1600–1850* (London, 2002); Colley, *Britons: Forging the Nation, 1707–1837* (New Haven, Conn., 1992).

22. Amussen, *Caribbean Exchanges,* 18–19; Brown, *Moral Capital,* 46–47; David Underdown, *A Freeborn People: Politics and the Nation in Seventeenth-Century England* (Oxford, Eng., 1996); J. G. A. Pocock, *The Ancient Constitution and the Feudal Law: A Study of English Historical Thought in the Seventeenth Century* (Cambridge, Eng., 1957).

23. A Lamentable Ballad of the Tragical end of a Gallant Lord and a Vertuous Lady, with the untimely end of their two children, wickedly performed by a hea-

thenish blackamoor their servant, etc. [With a woodcut.] (London, [1690?]), British Library, London, Shelfmark General Reference Collection Rox.I.220. The multiple editions of this ballad have slightly different titles and variations in the text. All quotations come from the 1690 version. Patricia Fumerton, "Transatlantic Crossings: The Makings of History, Aesthetics, and Blackness, 1570–1789" (paper presented at the Renaissance Literature Seminar, USC-Huntington Library Early Modern Studies Institute, January 30, 2010).

24. Alan Norman Bold, *The Ballad* (London, 1979), 24 ("intensely") and 24–25. Ballads often used this sense of the inevitable to create suspense.

25. For ballads and hyperbole, see ibid., 34.

26. Winthrop D. Jordan, *White over Black: American Attitudes toward the Negro, 1550–1812* (Chapel Hill, N.C., 1968).

27. Bold, *The Ballad,* 49.

28. *A lamentable ballad of the tragical end of a gallant lord and vertuous lady: together with the untimely death of their two children; wickedly performed by a heathenish and blood-thirsty black a-moor, their servant; the like of which cruelty and murder was never before heard of. To the tune of, The lady's fall, &c.* (London, [1750?]).

29. Although I am only concerned with the significance of the royal slaves' deaths (and primarily Oroonoko's), readers should be aware of the volume of modern scholarship on this tale, to which I cannot do justice here. For some of the most recent criticism, see Susan B. Iwanisziw, *Oroonoko: Adaptations and Offshoots* (Aldershot, Eng., 2006); Iwanisziw, ed., *Troping Oroonoko from Behn to Bandele* (Aldershot, Eng., 2004); Elliot Visconsi, "The Degenerate Race: English Barbarism in Aphra Behn's *Oroonoko* and *The Widow Ranter,*" *English Literary History* 69.3 (Fall 2002): 673–701; Todd, ed., *Aphra Behn* (New York, 1999); Aravamudan, *Tropicopolitans,* chap. 1; Todd, *The Critical Fortunes of Aphra Behn* (Columbia, S.C., 1998); Jonathan Goldberg, *Desiring Women Writing: English Renaissance Examples* (Stanford, Calif., 1997); Margaret W. Ferguson, "Juggling the Categories of Race, Class, and Gender: Aphra Behn's *Oroonoko,*" in Margo Hendricks and Patricia Parker, eds., *Women, "Race," and Writing in the Early Modern Period* (New York, 1994), 209–224; Catherine Gallagher, *Nobody's Story: The Vanishing Acts of Women Writers in the Marketplace, 1670–1820* (Berkeley, Calif., 1994), chap. 2; Heidi Hutner, ed., *Rereading Aphra Behn: History, Theory, and Criticism* (Charlottesville, Va., 1993); Laura Brown, *Ends of Empire: Women and Ideology in Early Eighteenth-Century English Literature* (Ithaca, N.Y., 1993), chap. 2. On Surinam, see Allison Blakely, "Historical Ties among Suriname, the Netherlands Antilles, Aruba, and the Netherlands," *Callaloo* 21.3 (Summer 1998): 472–478.

30. Iwanisziw, *Oroonoko,* xviii–xvi.

31. For the reception of Behn's novella, see Gallagher, *Nobody's Story,* 1–11.

32. For Behn's possible visit to Surinam, see Janet Todd, *The Secret Life of Aphra Behn* (London, 1996), 39–45.

33. For the narrator's attachment to Oroonoko, see Aravamudan, *Tropicopolitans,* chap. 1; Ferguson, "Juggling the Categories."

34. Several scholars have pointed out that Behn's tale criticized not slavery but the enslavement of a prince. Charlotte Sussman has also shown that imperial concern

over the demographic and racial character of the emerging English West Indies provides a crucial context in which to consider the symbolic value of the pregnant Imoinda's death. Iwanisziw, *Oroonoko,* xiii; Charlotte Sussman, "The Other Problem with Women: Reproduction and Slave Culture in Aphra Behn's *Oroonoko,*" in Hutner, *Rereading Aphra Behn,* 212–233. To my knowledge no scholar has dealt with the ideologies of mastery in *Oroonoko,* but for readings of the novella's politics see George Guffey, "Aphra Behn's *Oroonoko:* Occasion and Accomplishment," in George Guffey and Andrew Wright, eds., *Two English Novelists, Aphra Behn and Anthony Trollope: Papers Read at a Clark Library Seminar, May 11, 1974* (Los Angeles, 1975), 15; Aravamudan, *Tropicopolitans,* chap. 1; Visconsi, "The Degenerate Race"; Visconsi, *Lines of Equity: Literature and the Origins of Law in later Stuart England* (Ithaca, 2008); Richard Kroll, "'Tales of Love and Gallantry': the Politics of *Oroonoko,*" *Huntington Library Quarterly* 67.4 (December 2004): 573–605; Anita Pacheco, "Royalism and Honor in Aphra Behn's *Oroonoko,*" *Studies in English Literature* 34.3 (Summer 1994): 491–506; Iwanisziw, "Behn's Novel Investment in 'Oroonoko': Kingship, Slavery, and Tobacco in English Colonialism," *South Atlantic Review* 63.2 (Spring 1998): 75–98; Laura Brown, "The Romance of Empire: *Oroonoko* and the Trade in Slaves" in Todd, *Aphra Behn,* 180–228.

35. *Oxford English Dictionary.* All references are to Iwanisziw, *Oroonoko.*

36. Roach, *Cities of the Dead,* 154–155 (quotations on 155). For Imoinda's whiteness, see also Joyce Green MacDonald, "The Disappearing African Woman: Imoinda in *Oroonoko* after Behn," *English Literary History* 66.1 (Spring 1999): 71–86; Jenifer Elmore, "'The Fair Imoinda': Domestic Ideology and Anti-Slavery on the Eighteenth-Century Stage," in Iwanisziw, *Troping Oroonoko,* 35–58; Laura J. Rosenthal, "Owning Oroonoko: Behn, Southerne, and the Contingencies of Property," reprinted in Iwanisziw, *Troping Oroonoko,* 83–107.

37. The marked femininity of Aboan's body at first made me think that this print was of Imoinda's death and that the white woman was the narrator from Behn's novella. But the lines quoted beneath the print refer to the scene in which Aboan commits suicide and Oroonoko tells Imoinda that they must also die. The femininity of Aboan's body must be another mechanism of visually reducing his threat. Act V, Scene 1, Line 118.

38. Roach, *Cities of the Dead,* 159.

39. J. M. Bumsted, "'Things in the Womb of Time': Ideas of American Independence, 1633 to 1763," *WMQ* 31.4 (October 1974): 533–564.

40. James Harrington, *The Oceana and Other Works of James Harrington, with an Account of His Life by John Toland* (London: Becket and Cadell, 1771), 109.

41. Bumsted, "Things in the Womb of Time," 539.

42. Paul Edwards and Polly Rewt, eds., *The Letters of Ignatius Sancho* (Edinburgh, 1994), 7; William Ansah Sessarakoo, *Gentleman's Magazine* (London, June 1750), National Portrait Gallery, London.

43. For judgment of American slaveholders and Atlantic slave traders, see Brown, *Moral Capital,* 37.

44. Harrington, quoted in David Armitage, *The Ideological Origins of the British Empire* (Cambridge, Eng., 2000), 138, see also chap. 5.

45. Behn, *Oroonoko,* 27. For witnessing, see also Ian Baucom, *Specters of the Atlantic: Finance Capital, Slavery, and the Philosophy of History* (Durham, N.C., 2005), part II.

46. Similarly, the benevolent slave owner Mr. Edwards in Maria Edgeworth's 1804 "The Grateful Negro" wished "that there was no such thing as slavery in the world." See Sarah N. Roth, "The Mind of a Child: Images of African Americans in Early Juvenile Fiction," *Journal of the Early Republic* 25.1 (Spring 2005): 79–109. The device of the benevolent slaveholder would become important in slave narratives, including Olaudah Equiano's *The Interesting Narrative* and Frederick Douglass's *Narrative.*

3. ACCIDENTAL MONSTROSITIES

1. For seventeenth-century consumerism, see Linda Levy Peck, *Consuming Splendor: Society and Culture in Seventeenth-Century England* (Cambridge, Eng., 2005).

2. K. G. Davies, *The Royal African Company* (New York, 1957); Anthony Barker, *The African Link: British Attitudes to the Negro in the Era of the Atlantic Slave Trade, 1550–1807* (London, 1978); John Brewer and Roy Porter, eds., *Consumption and the World of Goods* (London, 1994). *Athenian Mercury,* London, October 16, 1694 ("Jamaica" coffeehouse), January 26, 1695 ("Blackamoorshead"), March 12, 1695 ("Barbados" coffeehouse), April 16, 1695 ("Turks-head" coffeehouse). For sale of West Jersey, see *London Gazette,* May 16–19, 1687, No. 2243. For lotteries, see [Anon.], *England's Genius, or Wit Triumphant* (London, 1734), 34–35 ("Adventurer"). For these coffeehouses as American spaces where colonists socialized and did business, see Julie Flavell, *When London Was Capital of America* (New Haven, Conn., 2010).

3. Edmund S. Morgan, *American Slavery, American Freedom: The Ordeal of Colonial Virginia* (New York, 1975), chap. 1; Ira Berlin, *Many Thousands Gone: The First Two Centuries of Slavery in North America* (Cambridge, Mass., 1998).

4. G. S. Rousseau and Roy Porter, eds., *Exoticism in the Enlightenment* (Manchester, Eng., 1990), 14; Roxann Wheeler, *The Complexion of Race: Categories of Difference in Eighteenth-Century British Culture* (Philadelphia, 2000). See also Philip D. Curtin, *The Image of Africa; British Ideas and Action, 1780–1850* (Madison, Wisc., 1964); Robert Hoopes, *Right Reason in the English Renaissance* (Cambridge, Mass., 1962); Barbara J. Shapiro, *Probability and Certainty in 17th Century England: A Study of the Relationships between Natural Science, Religion, History, Law, and Literature* (Princeton, N.J., 1983); Christopher Hill, *Change and Continuity in 17th Century England* (London, 1974); Lotte Mulligan, "Robert Boyle, 'Right Reason,' and the Meaning of Metaphor," *Journal of the History of Ideas* 55.2 (April 1994): 235–257; Richard Kroll, *The Material Word: Literate Culture in the Restoration and Early Eighteenth Century* (Baltimore, Md., 1991).

5. Two full-length studies of this journal exist, neither of which explore its representation of blacks or slaves. See Helen Berry, *Gender, Society and Print Culture in Late-Stuart England: The Cultural World of the Athenian Mercury* (Aldershot, Eng., 2003); Gilbert D. McEwen, *The Oracle of the Coffee House: John*

Dunton's Athenian Mercury (San Marino, Calif., 1972). For elite discussions of natural variety, see also David Bindman, *Ape to Apollo: Aesthetics and the Idea of Race in the 18th Century* (Ithaca, N.Y., 2002).

6. *Athenian Mercury,* London, March 17, 1691 ("curiosity"). For curiosity, see Barbara M. Benedict, *Curiosity: A Cultural History of Early Modern Inquiry* (Chicago, 2001); Katie Whitaker, "The Culture of Curiosity," in Nicholas Jardine, James A. Secord, and Emma C. Spary, eds., *Cultures of Natural History* (Cambridge, Eng., 1996), 75–90. Seventy-four periodicals were published in the years 1691 to 1697, but the *Athenian Mercury* was unique in its use of a question-answer format and its concern with issues beyond foreign and domestic news. For a breakdown of periodical publications in this period, see Berry, *Gender, Society and Print Culture,* 17–19.

7. Janet Todd, *The Critical Fortunes of Aphra Behn* (Columbia, S.C., 1998), 21, 29; Sarah Prescott, "Provincial Networks, Dissenting Connections, and Noble Friends: Elizabeth Singer Rowe and Female Authorship in Early Eighteenth-Century England," *Eighteenth-Century Life* 25.1 (Winter 2001): 29–42; Berry, *Gender, Society and Print Culture,* 6, 15, 21–22.

8. The word "pretend" is ambiguous in this context, as it did not necessarily mean "act as if" in eighteenth-century writings. Brown's later comments about this journal suggest that he believed it to be responding to questions from the general public. Thomas Brown, *The London and Lacedemonian Oracles,* in *The Works of Mr. Thomas Brown, Serious and Comical, In Prose and Verse,* 5th ed. (London, 1720), 354. See also Berry, *Gender, Society and Print Culture,* xii, 19. That some issues contained questions about subjects that the editors wrote about elsewhere may suggest that certain questions came from the editors themselves—or alternatively, that questions from the public inspired their interests in these subjects. The appearance of legitimacy, however, would have been hard to maintain if the majority of questions had been faked. The popularity of the journal more importantly suggests the readers' interest in these questions. See also McEwen, *The Oracle of the Coffee House,* ix; Prescott, "Provincial Networks, Dissenting Connections, and Noble Friends," 32.

9. *Athenian Mercury,* London, June 6, 1691. For the coffeehouse and cultures of curiosity, see esp. Brian William Cowan, *The Social Life of Coffee: The Emergence of the British Coffeehouse* (New Haven, Conn., 2005), 114.

10. Augustine Birrell, cited in E. St. John Brooks, *Sir Hans Sloane, the Great Collector and His Circle* (London, 1954), 181. For curiosity cabinets and museums, see Patrick Mauriès, *Cabinets of Curiosities* (New York, 2002); Horst Bredekamp, *The Lure of Antiquity and the Cult of the Machine: The Kunstkammer and the Evolution of Nature, Art, and Technology,* trans. Allison Brown (Princeton, N.J., 1995); Arthur MacGregor, *Sir Hans Sloane: Collector, Scientist, Antiquary, Founding Father of the British Museum* (London, 1994); Paula Findlen, *Possessing Nature: Museums, Collecting, and Scientific Culture in Early Modern Italy* (Berkeley, Calif., 1994); Thomas DaCosta Kaufmann, *The Mastery of Nature: Aspects of Art, Science, and Humanism in the Renaissance* (Princeton, N.J., 1993).

11. Berry, *Gender, Society and Print Culture,* 15; *Athenian Mercury,* London, November 21, 1691; Benjamin Franklin, *The Autobiography and Other Writings,*

ed. L. Jesse Lemisch (New York, 2001 [1961]), 61; Brooks, *Sir Hans Sloane*, 179. For museums and cultural knowledge, see James Clifford, *Routes: Travel and Translation in the Late Twentieth Century* (Cambridge, Mass., 1997), chap. 7; Eilean Hooper-Greenhill, *Museums and the Shaping of Knowledge* (London, 1992); Niels von Holst, *Creators, Collectors, and Connoisseurs: The Anatomy of Artistic Taste from Antiquity to the Present Day* (New York, 1967); J. Mordaunt Crook, *The British Museum* (London, 1972); Ivan Harp and Steven D. Lavine, eds., *Exhibiting Cultures: The Poetics and Politics of Museum Display* (Washington, D.C., 1991); Michael Ames, *Cannibal Tours and Glass Boxes: The Anthropology of Museums* (Vancouver, Canada, 1992). For Conyers and Salter, see Cowan, *The Social Life of Coffee*, 121, 125.

12. *Athenian Mercury*, London, October 20, 1691, April 21, 1694, April 24, 1694. For Native American art in London, see esp. Ruth B. Phillips, *Trading Identities: The Souvenir in Native North American Art from the Northeast, 1700–1900* (Seattle, Wash., 1998).

13. Donald Lupton, *Emblems of Rarities: or Choyce Observations Out of Worthy Histories of Many Remarkable Passages, and Renowned Actions of Divers Princes and Severall Nations. With Exquisite Variety, and Speciall Collections of the Natures of Most Sorts of Creatures: Delightfull and Profitable to the Minde* (London, 1636), A4–A5; [John White], *A Rich Cabinet with Variety of Inventions* (London, 1668), preface. Literature and curiosity cabinets often shared space in libraries and were both consumed as part of the larger collecting culture. I thank Andrew Cambers for drawing my attention to the physical locations of these objects.

14. John Dunton's interest in conveying these closets to the public continued. In 1707–1708, he published *The Phenix: or, A Revival of Scarce and Valuable Pieces from the Remotest Antiquity down to the Present Times. Being a Collection of Manuscripts and Printed Tracts, No Where to be Found but in the Closets of the Curious. By a Gentleman who has Made it his Business to Search after such Pieces for Twenty Years Past* (London, 1707–1708). For the definition of Athenianism, see McEwen, *The Oracle of the Coffee House*, 191.

15. Cf. Richard Steele and Joseph Addison, *The Tatler*, ed. Donald Bond (Oxford, Eng., 1987), preface.

16. For Renaissance discussions of blackness, see Kim F. Hall, *Things of Darkness: Economies of Race and Gender in Early Modern England* (Ithaca, N.Y., 1995); Winthrop Jordan, *White over Black: American Attitudes toward the Negro, 1550–1812* (Chapel Hill, N.C., 1968), chap. 1.

17. The *Athenian Mercury* did not link the biblical descendants of Lot's daughters (the peoples of Moab and Amon) and the nonwhite populations of the known world. *Athenian Mercury*, London, May 2, 1691.

18. Compare with Jordan, *White over Black*, 11.

19. For the imaginary power and the transfer of marks, see, for example, *Athenian Mercury*, London, May 11, 1691.

20. For Jacob's Rod and the power of fetal impression, see *Athenian Gazette* (London, 1691); *Athenian Mercury*, London, May 2, 1691. Compare to Wheeler, *The Complexion of Race*, 99–100.

21. Claude Quillet, *Callipædiæ; or, an art how to have handsome children* (London, 1710), 70; Dennis Todd, *Imagining Monsters: Miscreations of the Self in Eighteenth-Century England* (Chicago, 1995), 45–47.

22. For natural defects and the monstrous, see *Athenian Gazette* (London, 1691), vol. 1, no. 22.

23. *Athenian Mercury,* London, May 11, 1691, May 23, 1691; Berry, *Gender, Society and Print Culture,* 9. For Boyle, see Wheeler, *The Complexion of Race,* 26.

24. As Hobbes had remarked in *Leviathan,* "because Bodies are subject to change, that is to say, to variety of appearance to the sense of living creatures, is called Substance,[0] that is to say, Subject, to various accidents; as sometimes to be Moved, sometimes to stand Still; and to seem to our senses . . . of one Colour, Smel [*sic*], Tast [sic], or Sound, somtimes [*sic*] of another. And this diversity of Seeming, (produced by the diversity of the operation of bodies, on the organs of our sense) we attribute to alterations of the Bodies that operate, & call them Accidents of those Bodies." Thomas Hobbes, *Leviathan* (1651), ed. Richard Tuck (Cambridge, Eng., 1991), 270. *Athenian Mercury,* London, July 11, 1691. Despite John Norris, an occasional editor, having criticized Locke's *An Essay Concerning Human Understanding* for supposing "impression without consciousness," the journal nearly always propagated Locke's ideas. For a general overview, see McEwen, *The Oracle of the Coffee House,* 93–94.

25. *Athenian Mercury,* London, March 3, 1694, emphasis added.

26. The anatomical body derived from William Harvey's theory of the circulation of the blood, which the *Athenian Mercury* put forward on more than one occasion. The journal also included references to the newly emergent conceptions of the nervous system, of which Locke and Newton were proponents. For anatomy and race, see Wheeler, *The Complexion of Race,* 27. For the retention of a humoral model, see Berry, *Gender, Society, and Print Culture,* 9.

27. *Athenian Mercury,* London, April 30, 1695. For English degeneracy, see Joyce Chaplin, *Subject Matter: Technology, the Body, and Science on the Anglo-American Frontier, 1500–1676* (Cambridge, Mass., 2001).

28. *Athenian Mercury,* London, July 4, 1691. For the malleability of blackness, see Wheeler, *The Complexion of Race.*

29. Mulligan, "Robert Boyle, 'Right Reason,' and the Meaning of Metaphor," 235–257. For blackness as connate, see, for example, John Flavel, *Englands duty under the present gospel liberty* (London, 1689), Sermon III, 54; *Athenian Gazette* (London, 1691), vol. 1, no. 22.

30. For gender differences, see McEwen, *The Oracle of the Coffee House,* 172.

31. For the soul, see *Athenian Mercury,* London, Apr 11, 1691, March 17, 1691. For Reason, see also *Athenian Mercury,* London, April 21, 1691.

32. *Athenian Gazette* (London, 1691), vol. 3, no. 29.

33. *Athenian Mercury,* London, August 15, 1693, May 23, 1691.

34. *Athenian Mercury,* London, August 15, 1693. Thus Dabydeen's suggestion that it was not until the mid-eighteenth century that white Britons began to "consider the black view-point" on the beauty of blackness should be revised (Dabydeen was himself correcting an earlier belief that it was not until the nineteenth century that notions of the relativity of beauty became common). David Daby-

deen, *Hogarth's Blacks: Images of Blacks in Eighteenth-Century English Art* (Manchester, 1987), 42. See also John Green and Thomas Astley, eds., *A New General Collection of Voyages and Travels . . . in Europe, Asia, Africa, and America* (London, 1745–1747), 3:71.

35. *Athenian Mercury,* London, May 23, 1691; Hall, *Things of Darkness,* intro.; *Athenian Gazette* (London, 1691), vol. 3, no. 29.

36. For racial thought and skin color mutability, see Jordan, *White over Black;* David Brion Davis, *The Problem of Slavery in the Age of Revolution, 1770–1823* (Ithaca, N.Y., 1975); Paul Goodman, *Of One Blood: Abolitionism and the Origins of Racial Equality* (Berkeley, Calif., 1998); Joanne Pope Melish, *Disowning Slavery: Gradual Emancipation and "Race" in New England, 1780–1860* (Ithaca, N.Y., 1998); John Wood Sweet, *Bodies Politic: Negotiating Race in the American North, 1730–1830* (Baltimore, Md., 2003); Hall, *Things of Darkness,* 66–73; Srinivas Aravamudan, *Tropicopolitans: Colonialism and Agency, 1688–1804* (Durham, N.C., 1999), 1–4.

37. *Athenian Mercury,* London, July 28, 1691; Quillet, *Callipædiæ,* 70. For Elizabethan writers, see Jordan, *White over Black,* 15.

38. *Athenian Mercury,* London, November 23, 1695.

39. Ibid., May 16, 1691. For eastern origins, see also Colin Kidd, *British Identities before Nationalism: Ethnicity and Nationhood in the Atlantic World, 1600–1800* (Cambridge, Eng., 1999), conclusion.

40. Ibid., April 4, 1691, April 18, 1691; Father L. Thomassin, *A Method to Study and Teach Christianly and Profitably the Grammar, or the Tongues, with Relation to the Holy Scripture, Reducing Them all to the Hebrew* (Paris, 1690), excerpted and translated in *Athenian Gazette* (London, 1691), vol. 1, "The Supplement to the First Volume." For islands in British thought, see Richard H. Grove, *Green Imperialism: Colonial Expansion, Tropical Island Edens, and the Origins of Environmentalism, 1600–1860* (Cambridge, Eng., 1995); Kathleen Wilson, *The Island Race: Englishness, Empire, and Gender in the Eighteenth Century* (London, 2003).

41. Morgan Godwyn, *The Negro's & Indians Advocate, Suing for their Admission into the Church: or a Persuasive to the Instructing and Baptizing of the Negro's and Indians in our Plantations. Shewing, That as the Compliance Therewith Can Prejudice No Mans Just Interest; So the Wilful Neglecting and Opposing of It, Is No Less Than a Manifest Apostacy from the Christian Faith. To which is Added, a Brief Account of Religion in Virginia* (London, 1680), 42–44. Peter Heylyn reversed his position on Ham's curse and blackness several times. See Peter Fryer, *Staying Power: the History of Black People in Britain* (London, 1984), 143.

42. Wheeler, *The Complexion of Race,* 99–100.

43. Dabydeen, *Hogarth's Blacks,* 42 ("black viewpoint").

44. *Athenian Gazette* (London, 1691), vol. 1, no. 25.

45. Godwyn, *Negro's & Indians Advocate.*

46. Peter Stallybrass and Allon White, *The Politics and Poetics of Transgression* (Ithaca, N.Y., 1986), 40. See also Kay Dian Kriz, "Curiosities, Commodities, and Transplanted Bodies in Hans Sloane's 'Natural History of Jamaica,'" *WMQ,* 3rd Ser., 52.1 (January 2000), esp. 63–64.

47. *Athenian Gazette,* (London, 1691), vol. 2, no. 20. See also *Athenian Mercury,* London, February 27, 1694; McEwen, *The Oracle of the Coffee House,* 136. For the market in wonders, see Todd, *Imagining Monsters,* 44–45.

48. Mulligan, "Robert Boyle, 'Right Reason,' and the Meaning of Metaphor," 235–257.

49. J. A. I. Champion, *The Pillars of Priestcraft Shaken: The Church of England and Its Enemies, 1660–1730* (Cambridge, Eng., 1992); John Spurr, "'Rational Religion' in Restoration England," *Journal of the History of Ideas* 49.4 (October–December 1988): 563–585.

50. *Athenian Mercury,* London, November 21, 1691.

51. Kroll, *The Material Word,* 49 ("newly"). For scriptural interpretation and truth, see Justin Champion, *Republican Learning: John Toland and the Crisis of Christian Culture, 1696–1722* (Manchester, Eng., 2003), 13.

52. *Athenian Mercury,* London, May 11, 1691.

53. See, e.g., *Athenian Mercury,* London, April 4, 1691, May 16, 1691, August 4, 1691.

54. For early English images of North American natives, see P. H. Hulton, ed., *America, 1585: the Complete Drawings of John White* (Chapel Hill, N.C., 1984).

55. My thanks to Kathleen S. Murphy for drawing my attention to this comparison.

56. *Athenian Mercury,* London, August 19, 1691; Kroll, *The Material Word,* 51.

57. Benedict, *Curiosity,* 14–15.

58. Mulligan, "Robert Boyle, 'Right Reason,' and the Meaning of Metaphor," 248.

4. POLISHING JET

1. Charles Mosley, *The European Race Heat 1st Anno Dom* MDCCXXXVII (October 10, 1737), BM No. 1868,0808.3589; Mosley, *The European Race Heat IId Anno Dom* MDCCXXXVIII (November 26, 1738), BM No. 1868,0808.3606.

2. Linda Colley, *Britons: Forging the Nation, 1707–1837* (New Haven, Conn., 1992); Paul Langford, *The Eighteenth Century, 1688–1815* (London, 1976), 21; Eliga H. Gould, "Entangled Histories, Entangled Worlds: The English-Speaking Atlantic as a Spanish Periphery," Forum: Entangled Empires in the Atlantic World, *AHR* 112.3 (June 2007): 764–786.

3. John Brewer, *The Sinews of Power: War, Money, and the English State, 1688–1783* (Cambridge, Mass., 1988), xv; Edward Phillips, *Britons, Strike Home: Or, the Sailor's Rehearsal. A Farce* (London, 1739), 22; [William Pulteney], *A Short View of the State of Affairs, with relation to Great Britain, for Four Years Past* (London, 1730); Kathleen Wilson, *The Sense of the People: Politics, Culture, and Imperialism in England, 1715–1785* (Cambridge, Eng., 1995), 251; Colley, *Britons;* Paul Langford, *A Polite and Commercial People: England 1727–1783* (Oxford, Eng., 1989); Sylvia R. Frey and Betty Wood, *Come Shouting to Zion: African American Protestantism in the American South and British Caribbean to 1830* (Chapel Hill, N.C., 1998), 27; Jack P. Greene, *The Intellectual Construction of*

America: Exceptionalism and Identity from 1492 to 1800 (Chapel Hill, N.C., 1993); Peter Hulme, *Colonial Encounters: Europe and the Native Caribbean, 1492–1797* (London, 1986), 228.

4. The scholarship on the defense of New World *dominium* is extensive. See, e.g., Anthony Pagden, *Lords of All the World: Ideologies of Empire in Spain, Britain and France c. 1500–c. 1800* (New Haven, Conn., 1995); Pagden, *European Encounters with the New World: From Renaissance to Romanticism* (New Haven, Conn., 1993); David Armitage, *The Ideological Origins of the British Empire* (Cambridge, Eng., 2000); David Brion Davis, *The Problem of Slavery in the Age of Revolution* (Ithaca, N.Y., 1975); Orlando Patterson, *Slavery and Social Death: A Comparative Study* (Cambridge, Mass., 1982); David Eltis, *The Rise of African Slavery in the Americas* (Cambridge, Mass., 2000).

5. See also Kristen Block, "Faith and Fortune: The Politics of Religious Identity in the Seventeenth-Century Caribbean" (PhD diss., Rutgers University, 2007).

6. *Athenian Gazette* (London, 1691), vol. 3, no. 30. See also Anthony Barker, *The African Link: British Attitudes to the Negro in the Era of the Atlantic Slave Trade, 1550–1807* (London, 1978).

7. For travelogues and gaze, see Mary Louise Pratt, *Imperial Eyes: Travel Writing and Transculturation* (London, 1992).

8. *Athenian Gazette* (1691), vol. 3, no. 30. For cannibalism, compare with Roxann Wheeler, *The Complexion of Race: Categories of Difference in Eighteenth-Century British Culture* (Philadelphia, 2000). For cannibalism in travel accounts, see Hulme, *Colonial Encounters*. As a "dystopia of racist fantasy," see Joseph Roach, *Cities of the Dead: Circum-Atlantic Performance* (New York, 1996), 21.

9. *Athenian Gazette* (1691), vol. 3, no. 30.

10. Anthony Pagden, *The Fall of Natural Man: The American Indian and the Origins of Comparative Ethnology* (Cambridge, Eng., 1982), 3.

11. Colley, *Britons,* 31; *Athenian Mercury,* London, April 7, 1691.

12. *Athenian Gazette* (1691), vol. 3, supp., 20–24. For William III and imperial virtue, see *Athenian Mercury,* London, April 7, 1691.

13. Bartolomé de Las Casas, *A Short Account of the Destruction of the Indies* (London, 1999 [1542]); Edmund S. Morgan, *American Slavery, American Freedom: The Ordeal of Colonial Virginia* (New York, 1975), chap. 1; Edmund Gibson, *Two Letters of the Lord Bishop of London* (London, 1727), 11 ("Bondage").

14. *Athenian Mercury,* London, March 24, 1694.

15. *Athenian Mercury,* London, November 3, 1694; cf. Armitage, *Ideological Origins,* chap. 3, which discusses the similarity of biblical foundations for imperial ideologies across empires. For Barbadian planters' response to the 1675 attempted slave uprising, see Katharine Gerbner, "The Ultimate Sin: Christianising Slaves in Barbados in the Seventeenth Century," *Slavery and Abolition* 31.1 (March 2010): 57–73.

16. *Athenian Mercury,* London, November 14, 1691, November 3, 1694; Cotton Mather, *The Life and Death of the Reverend Mr. John Eliot* (London, 1694). For a Baptist response to the *Athenian Mercury,* see Benjamin Keach, *Pedo-baptism Disproved Being an Answer to Two Printed Papers (put forth by some gentlemen called the Athenian Society, who pretend to answer all questions sent to them of*

what nature soever) Called the Athenian Mercury, one put forth November 14, the other November 28, 1691: in which papers they pretend to answer eight queries about the lawfulness of infant-baptism: likewise divers queries sent to them about the true subjects of baptism, &c. (London, 1691); Keach, *An Appendix to the Answer unto Two Athenian Mercuries Concerning Pedo-baptism Containing Twenty Seven Syllogistical arguments Proving Infant-baptism a Mere Humane Tradition* (London, 1692); Keach, *Believers Baptism: Or, Love to the Antient Britains Displayed* (London, 1705).

17. *Athenian Gazette* (1691), vol. 3, no. 23.

18. Armitage, *Ideological Origins,* chap. 3; Gerbner, "The Ultimate Sin," 61.

19. Morgan Godwyn, *The Negro & Indian's Advocate* (London, 1680), dedication.

20. *Athenian Gazette* (1691), vol. 3, no. 23; *Athenian Mercury,* London, November 3, 1694.

21. Ibid.

22. Godwyn, *Negro & Indian's Advocate,* dedication; cf. Joyce Chaplin, *Subject Matter: Technology, the Body, and Science on the Anglo-American Frontier, 1500–1676* (Cambridge, Mass., 2001).

23. Henry Adis, *A Letter sent from Syrranam, to his Excellency, the Lord Willoughby . . .* (London, 1664), 4 ("atheistical"), 7 ("the sort"); George Berkeley, *A Proposal for the Better Supplying of Churches in Our Foreign Plantations, and For Converting the Savage Americans to Christianity* (London, 1725), 20; Robert Robertson, *A Letter to the Right Reverend the Lord Bishop of London, from an Inhabitant of His Majesty's Leeward-Caribbee-Islands* (London, 1727), 56. For planter degeneration, see also William Wall, *History of Infant-Baptism* (London, 1705), 1:309; Frank Felsenstein, ed., *English Trader, Indian Maid: Representing Gender, Race, and Slavery in the New World: An Inkle and Yarico Reader* (Baltimore, Md., 1999); Thomas Southerne, *Oroonoko,* ed. Maximillian E. Novak and David Stuart Rodes (Lincoln, Neb., 1976).

24. Kathleen Chater, *Untold Histories: Black People in England and Wales during the Period of the British Slave Trade, c. 1660–1807* (Manchester, Eng., 2009); Gerbner, "The Ultimate Sin."

25. *Athenian Mercury,* London, November 3, 1694.

26. David Brion Davis, *The Problem of Slavery in Western Culture* (Ithaca, N.Y., 1966), 6; Winthrop Jordan, *White over Black: American Attitudes Toward the Negro, 1550–1812* (Chapel Hill, N.C., 1968).

27. Godwyn, *Negro & Indian's Advocate,* 6. See also John Thornton, *Africa and Africans in the Making of the Atlantic World, 1400–1680* (Cambridge, Eng., 1992), chap. 1; Frey and Wood, *Come Shouting to Zion,* chap. 1.

28. Godwyn, *A Supplement to the Negro's [and] Indian's Advocate* (London, 1681); Thomas Bacon, *Four Sermons, upon the great and indispensible duty of all Christian masters and mistresses to bring up their Negro slaves in the knowledge and fear of God* (London, 1750), 44.

29. Bacon, *Four Sermons,* x, xvi, 37, 39, 44; *An Account of the Society For Promoting Christian Knowledge* (London, 1711); *The Gentleman's Magazine,* February 1731; Robert Brewster, *A Sermon Preach'd on the Thanksgiving Day*

(Newcastle, Eng., 1759), cited in Kathleen Wilson, "Empire of Virtue: The Imperial Project and Hanoverian Culture, c. 1720–1785," in *An Imperial State at War: Britain from 1689 to 1815,* ed. Lawrence Stone (London, 1994); Wilson, *The Sense of the People,* 137.

30. Morgan Godwyn, *The Revival, or, Directions for a Sculpture Describing the Extraordinary Care and Diligence of Our Nation in Publishing the Faith Among Infidels in America and Elsewhere* (London, 1682). As far as I can tell, this image was never made.

31. James Epstein, "Politics of Colonial Sensation: The Trial of Thomas Picton and the Cause of Louisa Calderon," *AHR* 112.3 (June 2007): 712–741. For bodily torture and nationalism, see Robert Markley, "Violence and Profits on the Restoration Stage: Trade, Nationalism, and Insecurity in Dryden's Amboyna," *Eighteenth-Century Life* 22.1 (1998): 2–17.

32. These informants, clearly not planters, were likely missionaries—an alignment that may reflect Dunton's connections in New England. *Athenian Mercury,* London, November 3, 1694.

33. Hugh Thomas, *The Slave Trade: The Story of the Atlantic Slave Trade, 1440–1870* (New York, 1997), intro.; Dilip Hiro, *Black British, White British* (New York, 1973), x; James Walvin, *Black Ivory: A History of British Slavery* (London, 1993), 3; Patrick Richardson, *Empire and Slavery* (New York, 1968), 10; Langford, *A Polite and Commercial People,* 336–352.

34. Joshua Gee, *The Trade and Navigation of Great-Britain Considered* (London, 1729), 25. For similar arguments, see Malachy Postlethwayt, *The National and Private Advantage of the African Trade* (London, 1746); Memorial From Merchants of Liverpool, 1762, British Library, Addtl. MS 38200, fol. 47; James Walvin, *Black and White: The Negro and English Society, 1555–1945* (London, 1973), 41.

35. Cited in Peter Fryer, *Staying Power: The History of Black People in Britain* (London, 1984), 17.

36. James Wallace, *A General and Descriptive History of the Ancient and Present State, of the Town of Liverpool . . . Together with a Circumstantial Account of the True Causes of Its Extensive African Trade . . .* (London, 1795); cf. Rachel Chernos Lin, "The Rhode Island Slave-Traders: Butchers, Bakers, and Candlestick-Makers," *Slavery and Abolition* 23.3 (December 2002): 21–38; Pagden, *Lords of All the World,* 11.

37. For abolitionist sentiment in the first half of the eighteenth century, see also Christopher L. Brown, *Moral Capital: Foundations of British Abolitionism* (Chapel Hill, N.C., 2006); Wylie Sypher, *Guinea's Captive Kings: British Anti-Slavery Literature* (Chapel Hill, N.C., 1942).

38. James Miller, *Art and Nature: A Comedy* (London, 1738), prologue.

39. Anon., *Yarico to Inkle: An Epistle* (London, 1736), in Felsenstein, *English Trader, Indian Maid,* 108–123 (quotation on 111); William Shakespeare, *The Tempest,* ed. Steven Orgel (Oxford, Eng., 1987); Alden T. Vaughan, *Shakespeare's Caliban: A Cultural History* (Cambridge, Eng., 1991).

40. Whether Bon Sáam's speech was fabricated has been the subject of debate among scholars. Thomas Krise argues that the complex route by which the letter

arrived in Hill and Popple's hands suggests a fabrication, and posits either Job Ben Solomon or Francis Williams as possible models for the character of Bon Sáam. On the other hand, Wylie Sypher argues for its authenticity. Contemporaries certainly responded to the speech as though there was no question of its validity. Thomas Krise, ed., *Caribbeana: An Anthology of English Literature of the West Indies, 1657–1777* (Chicago, 1999), 101–102. Various versions appeared in the *Gentleman's Magazine,* the *London Magazine,* and other publications.

41. Michael Craton, *Testing the Chains: Resistance to Slavery in the British West Indies* (Ithaca, N.Y., 1982), 77–78.

42. *Prompter,* London, January 10, 1735. Also printed, with some differences, in the *Gentleman's Magazine,* January 1735.

43. *Prompter,* London, January 10, 1735.

44. Ibid. For savagery and chaos, see Pagden, *European Encounters,* 14.

45. *Prompter,* London, January 10, 1735. For Calvinist discourses of resistance, see John R. D. Coffey, "England's Exodus: The Civil War as a War of Deliverance," in G. Burgess and C. Prior, eds., *England's Wars of Religion* (Farnham, Eng., forthcoming).

46. Ibid.; Rachel Weil, *Political Passions: Gender, the Family, and Political Argument in England, 1680–1714* (Manchester, Eng., 1999), 26.

47. *Prompter,* London, January 10, 1735; Thomas Hobbes, *Leviathan* (1651), ed. Richard Tuck (Cambridge, 1991), 226.

48. *Prompter,* London, January 3, 1735; John Oldmixon, *The British Empire in America* (London, 1708).

49. Ibid. See also "A True Account of a New Colony About To Be Establish'd in America, by Several Noblemen, Gentlemen, and Merchants," *Gentleman's Magazine* (February 1731), 80, 88. For Sir Josiah Child, see Krise, *Caribbeana,* 113. For colonial unrest, see *Gentleman's Magazine,* June 1733, 329; November 1733, 606; January 1734, 48; May 1734, 277; September 1734, 510.

50. For amelioration, see Christopher L. Brown, "Empire without Slaves: British Concepts of Emancipation in the Age of the American Revolution," *WMQ,* 3rd ser., 56.2 (April 1999): 273–306; George Boulukos, *The Grateful Slave: The Emergence of Race in Eighteenth-Century British and American Culture* (Cambridge, Eng., 2008).

51. *Gentleman's Magazine,* February 1735, 91–93. For Oldmixon's earlier rejection of metropolitan portrayals of planter cruelty, see Jack P. Greene, "Changing Identity in the British Caribbean: Barbados as a Case Study," in Nicholas Canny and Anthony Pagden, eds., *Colonial Identity in the Atlantic World, 1500–1800* (Princeton, N.J., 1987), 235.

52. *Gentleman's Magazine,* February 1735, 91–93.

53. Ibid.; Barker, *African Link,* 68; John Roberts, *Considerations On the Present Peace, as Far as It Is Relevant to the Colonies, and the African Trade* (London, 1763), 36–37; Thomas Jefferys, *The Natural and Civil History of the French Dominions in North and South America* (London, 1760), 187; Oldmixon, *British Empire in America,* 2:119–121; Sypher, *Guinea's Captive Kings,* 59; Laurens to Alexander Hamilton, April 19, 1785, in Harold C. Syrett, et al., eds., *The Papers of*

Alexander Hamilton (New York, 1961–1987), 3:605–608, cited in Robert Olwell, "A Reckoning of Accounts: Patriarchy, Market Relations, and Control on Henry Laurens's Lowcountry Plantations, 1762–1785," in Larry E. Hudson Jr., ed., *Working toward Freedom: Slave Society and Domestic Economy in the American South* (Rochester, N.Y., 1994), 33.

54. *Athenian Gazette* (1691), vol. 3, no. 25.

55. *Gentleman's Magazine,* February 1735, 91; Boulukos, *The Grateful Slave;* Olwell, "Reckoning of Accounts," 34; Philip D. Morgan, "Three Planters and Their Slaves: Perspectives on Slavery in Virginia, South Carolina, and Jamaica, 1750–1790," in Winthrop Jordan and Sheila Skemp, eds., *Race and Family in the Colonial South* (Jackson, Miss., 1987): 54–68.

56. *Gentleman's Magazine,* February 1735, 92.

57. Ibid. See also J. Harry Bennett, *Bondsmen and Bishops: Slavery and Apprenticeship on the Codrington Plantations of Barbados, 1710–1838* (Berkeley, Calif., 1958), 47.

58. *Gentleman's Magazine,* March 1737, 187. This letter was first published in *Fog's Journal.*

59. *Gentleman's Magazine,* March 1737, 187.

60. *Gentleman's Magazine,* April 1737, 216.

61. Ibid., 215, excerpt from *Fog's Journal,* no. 437, 438.

62. *Prompter,* January 3, 1735; "A True Account of a New Colony," 80, 88. See also *Gentleman's Magazine,* June 1733, 329; November 1733, 606; January 1734, 48; May 1734, 277; September 1734, 510.

63. *Gentleman's Magazine,* September 1746.

64. *Gentleman's Magazine,* July 1740.

65. *Gentleman's Magazine,* March 1741, 146. *The Speech of Campo-bell* (1736) was published anonymously, but Robertson claimed authorship in this letter to the *Gentleman's Magazine.* The proslavery polemicist John Tobin also attributed the *Speech* to Robertson in his 1785 counterattack on James Ramsay's abolitionist tracts. See Krise, *Caribbeana,* 108.

66. *Gentleman's Magazine,* March 1741; Krise, *Caribbeana,* 121–122.

67. Krise, *Caribbeana,* 109–112.

68. This is perhaps Alexander Campbell, who was associated with the Lord Bishop of London.

69. Krise, *Caribbeana,* 108–109.

70. *Gentleman's Magazine,* March 1741, 146; Krise, *Caribbeana,* 114, 116. See for similar colonial criticism of the metropole, Letter from Benjamin Franklin to Anthony Benezet, August 22, 1772, in Albert Henry Smyth, ed., *The Writings of Benjamin Franklin* (New York, 1907), 5:431–432; William M. Wiecek, "Somerset: Lord Mansfield and the Legitimacy of Slavery in the Anglo-American World," *University of Chicago Law Review* 42.1 (Autumn 1974): 88.

71. Krise, *Caribbeana,* 110, 135.

72. Ibid., 127, 134, 136.

73. *Gentleman's Magazine,* April 1741, 136; Krise, *Caribbeana,* 116–119.

74. Krise, *Caribbeana,* 120.

75. Ibid., 136, 138.

76. Ibid., 127, 139–140. See also Robertson, *Letter* (London, 1727), 70.

77. *Gentleman's Magazine,* March 1741, 145.

78. Robertson, *Letter,* 20, 85; Krise, *Caribbeana,* 136–137.

79. Robertson, *Letter,* 60.

80. *Gentleman's Magazine,* April 1741, 188.

81. Brown, *Moral Capital.*

82. *Athenian Gazette* (London, 1691), vol. 3, no. 30.

83. For the contradiction between slavery and liberty, see James Walvin, *England, Slaves, and Freedom, 1776–1838* (London, 1986); Walvin, *The Black Presence: A Documentary History of the Negro in England, 1555–1860* (New York, 1972); Walvin, *Black and White;* Walvin, *Black Ivory;* Barker, *The African Link;* Edward Scobie, *Black Britannia: A History of Blacks in Britain* (Chicago, 1972); Davis, *The Problem of Slavery in the Age of Revolution;* Folarin Shyllon, *Black Slaves in Britain* (London, 1974); Dilip Hiro, *Black British, White British* (New York, 1973); Norma Myers, *Reconstructing the Black Past: Blacks in Britain c. 1780–1830* (London, 1996). See also *Gentleman's Magazine,* July 1740, 341.

84. Another impression of this print can be found at Mosley, "The European Race, Heat IIId" (London, April 9, 1739), BM Satire No. 2431.

85. Charles Mosley, "European Race for a Distance" (London, February 26, 1740), BM Satire No. 2455.

5. PLEASURABLE ENCOUNTERS

1. *The Intelligencer; Or, Merchants Assistant* (London, 1738).

2. This chapter builds on scholarship that has stressed the contingency of representations of blacks and the fluidity of British notions of race. See Introduction, note 19.

3. For the tobacco trade, see Fernando Ortiz, *Cuban Counterpoint: Tobacco and Sugar* (New York, 1947); Jacob M. Price, *France and the Chesapeake: A History of the French Tobacco Monopoly, 1674–1791, and of Its Relationship to the British and American Tobacco Trades* (Ann Arbor, Mich., 1973), 1:509–671; Edmund S. Morgan, *American Slavery, American Freedom: The Ordeal of Colonial Virginia* (New York, 1975); T. H. Breen, *Tobacco Culture: The Mentality of the Great Tidewater Planters on the Eve of Revolution* (Princeton, N.J., 1985); Allan Kulikoff, *Tobacco and Slaves: The Development of Southern Cultures in the Chesapeake, 1680–1800* (Chapel Hill, N.C., 1986). For tobacco and consumption, see Marcy Norton, *Sacred Gifts, Profane Pleasures: A History of Tobacco and Chocolate in the Atlantic World* (Ithaca, N.Y, 2008); Sarah A. Dickson, *Panacea or Precious Bane: Tobacco in Sixteenth-Century Literature* (New York, 1954); Jordan Goodman, *Tobacco in History: The Cultures of Dependence* (London, 1993); John Brewer and Roy Porter, eds., *Consumption and the World of Goods* (New York, 1994); Jordan Goodman, Paul E. Lovejoy, and Andrew Sherratt, eds., *Consuming Habits: Drugs in History and Anthropology* (London, 1995); Richard Kroll, "Pope and Drugs: The Pharmacology of *The Rape of the Lock,*" *English Literary History* 67.1 (Spring 2000): 99–141; Charlotte Sussman, *Consuming Anxieties: Consumer Protest, Gender, and British Slavery,*

1713–1833 (Stanford, Calif., 2000). For coffee, see Brian Cowan, *The Social Life of Coffee: The Emergence of the British Coffeehouse* (New Haven, Conn., 2005).

4. The British Museum Heal and Banks Collections together contain about 15,000 items. Tobacco advertisements amount to more than 400 items, of which about 200 include black figures. Similar advertisements can be found at the Victoria and Albert Museum, the London Metropolitan Archive (where the Guildhall Library's print collections have been relocated), the Bodleian Library at Oxford University, and the Samuel Pepys Collection at Cambridge University. For a full description of the British Museum's tobacco advertisements, see Catherine Molineux, "Pleasures of the Smoke: 'Black Virginians' in Georgian London's Tobacco Shops," *WMQ*, 3rd ser., 64.2 (April 2007), fn5. The 530 items with similar imagery in the Arents Collection at the New York Public Library are catalogued in Dickson, *Tobacco*, 4:194–201; Ambrose Heal, *The Signboards of Old London Shops: A Review of the Shop Signs Employed by the London Tradesmen during the XVIIth and XVIIIth Centuries. Compiled from the Author's Collection of Contemporary Trade-Cards and Billheads* (1947; repr., New York, 1972).

5. The exception to this statement is Elizabeth Kim's essay, which sees a distinction between Native Americans and Africans in tobacco trade cards and argues for a broader racial hierarchy in trade cards as a whole. Kim, "Race Sells: Racialized Trade Cards in 18th-Century Britain," *Journal of Material Culture* 7.2 (July 2002): 137–165. For Native American–African hybridity, see esp. Benjamin Bissell, *The American Indian in English Literature of the Eighteenth Century* (New Haven, Conn., 1925); Wylie Sypher, *Guinea's Captive Kings: British Anti-slavery Literature of the XVIIIth Century* (Chapel Hill, N.C., 1942); David Brion Davis, *The Problem of Slavery in Western Culture* (Ithaca, N.Y., 1966), 10–13; Hugh Honour, *The New Golden Land: European Images of America from the Discoveries to the Present Time* (New York, 1975), 21; Jean Devisse and Michael Mollat, *From the Early Christian Era to the "Age of Discovery,"* pt. 2, *Africans in the Christian Ordinance of the World (Fourteenth to the Sixteenth Century)*, trans. William Granger Ryan, vol. 2, *The Image of the Black in Western Art* (New York, 1979); David Dabydeen, *Hogarth's Blacks: Images of Blacks in Eighteenth-Century British Art* (Athens, Ga., 1987); Peter Hulme, *Colonial Encounters: Europe and the Native Caribbean, 1492–1797* (London, 1986); Margaret W. Ferguson, "Feathers and Flies: Aphra Behn and the Seventeenth-Century Trade in Exotica," in *Subject and Object in Renaissance Culture,* ed. Margreta De Grazia, Maureen Quilligan, and Peter Stallybrass (Cambridge, Eng., 1996); Srinivas Aravamudan, *Tropicopolitans: Colonialism and Agency, 1688–1804* (Durham, N.C., 1999); Frank Felsenstein, *English Trader, Indian Maid: Representing Gender, Race, and Slavery in the New World: An Inkle and Yarico Reader* (Baltimore, Md., 1999); Beth Fowkes Tobin, *Picturing Imperial Power: Colonial Subjects in Eighteenth-Century British Painting* (Durham, N.C., 1999), chap. 1; Stephanie Pratt, "From Cannassatego to Outalissi: Making Sense of the Native American in Eighteenth-Century Culture," in Geoff Quilley and Kay Dian Kriz, eds., *An Economy of Colour: Visual Culture and the Atlantic World, 1660–1830* (Manchester, Eng., 2003), 60–82; Roxann Wheeler, "Colonial Exchanges: Visualizing Racial Ideology and Labour in Britain and the West Indies," in Quilley and Kriz, eds., *An Economy of Colour,* 36–59.

6. David Bindman, "'A Voluptuous Alliance between Africa and Europe': Hogarth's Africans," in Bernadette Fort and Angela Rosenthal, eds., *The Other Hogarth: Aesthetics of Difference* (Princeton, N.J., 2001), 261. For the use of race to market goods, see Kim, "Race Sells," 7. For black servants, see Ronald Paulson, *Hogarth's Graphic Works*, 3rd ed. (London, 1989). See also Tobin, *Picturing Imperial Power,* chap. 1; Dabydeen, *Hogarth's Blacks,* 86–100. For coffee's association with slaves, see Cowan, *Social Life of Coffee,* 131–132.

7. Robert Rogers, *A Concise Account of North America: Containing a Description of the Several British Colonies on that Continent* . . . (London, 1765), 122 (quotation); Patrick Richardson, *Empire and Slavery* (New York, 1968), 3–8. For the tobacco shop, see George Chapman, *Al Fooles: A Comedy, Presented at the Black Fryers, And lately before his Maiestie* (London, 1605). For "Clowdie Tobaccoshops," see [Thomas Tomkis], *Albumazar. A Comedy presented before the Kings Maiestie at Cambridge, the ninth of March, 1614. By the Gentlemen of Trinite Colledge* (London, 1615), fol. L2r. For contemporary views of the tobacco trade, see John Nicoll, *The Advantage of Great Britain Consider'd in the Tobacco Trade. With Reasons for Destroying the Tobacco Stalks, Home Consumption; Is most Humbly Offered to the Parliament of Great Britain* (London, 1727); John Lacy, *Observations on the Nature, Use and Trade of Tobacco* (1733), in Dickson, *Tobacco,* 3:250–251. For the tobacco store, see T. M. Devine, *Tobacco Lords: A Study of the Tobacco Merchants of Glasgow and Their Trading Activities, c. 1740–90* (Edinburgh, Scotland, 1975). Cf. T. H. Breen, "An Empire of Goods: The Anglicization of Colonial America, 1690–1776," *Journal of British Studies* 25.4 (October 1986): 467–499; Breen, "'Baubles of Britain': The American and Consumer Revolutions of the Eighteenth Century," *Past and Present* no. 119 (May 1988): 73–104.

8. My thanks to Jonathan Goldberg for pointing out "The Armes of the Tobachonists" (London, 1630). For tobacco's social disruption, see [Thomas Lodge], *VVits Miserie, and the VVorlds Madnesse: Discovering the Devils Incarnat of this Age* (London, 1596); Thomas Nash, *Haue vvith you to Saffron-vvalden; Or, Gabriell Harueys Hunt is vp* (1596), in Dickson, *Tobacco,* pt. 3: 107 (cat. no. 103); Philaretes [pseudonym of L., or J. H.], *Work for Chimny-Sweeper: Or, A Warning for Tabacconists* . . . (London, 1602); [James I], *A Counterblaste to Tobacco* (London, 1604); [Samuel Rowlands], *Hvmors Antiqve Faces. Drawne in proportion to his seuverall Antique ilestures* (London, 1605); [Rowlands], *The Knave of Clubbes* (London, 1609); [Joshua Sylvester], *Tobacco Battered* (1616–1617), in Dickson, *Tobacco,* 2:31–36; [James I], *The Peace-Maker: Or, Great Brittaines Blessing* (London, 1619); [John Taylor], *The World Runnes on VVheeles: Or, Oddes, betwixt Carts and Coaches* (London, 1623); [John Hancock], *The Touchstone; Or, Trial of Tobacco* (London, 1676).

9. Many of the tobacco papers have been shorn of their packaging borders, making it difficult to distinguish between them and trade cards. In most cases, I have used Ambrose Heal's identification of tobacco papers (see Index of Trades and Products represented in the Heal and Banks collections of Tradecards, Department of Prints and Drawings, BM).

10. For puzzles, see "I. Michalski," Heal Collection, 117.117; "J. Steward," 1836, Heal Collection, 117.151; Sheila O'Connell, *The British Museum: London*

(London, 2004). For an enlargement of the inscriptions of "PE" and "ER," see http://www.historycooperative.org/journals/wm/64.2/molineux.html.

11. For medieval and Renaissance origins of these hybrid figures, see Honour, *New Golden Land;* Devisse and Mollat, *From the Early Christian Era;* Peter Erikson and Clark Hulse, eds., *Early Modern Visual Culture: Representation, Race, and Empire in Renaissance England* (Philadelphia, 2000); T. F. Earle and K. J. P. Lowe, eds., *Black Africans in Renaissance Europe* (Cambridge, Eng., 2005). Several scholars have discussed the Native American–African hybrid figure. See note 5; Wheeler, "Colonial Exchanges," 36–59.

12. Kathleen Wilson, "Empire of Virtue: The Imperial Project and Hanoverian Culture, c. 1720–1785," in Lawrence Stone, ed., *An Imperial State at War: Britain from 1689 to 1815* (London, 1994); Kroll, "Pope and Drugs"; Michael Ziser, "Sovereign Remedies: Natural Authority and the *Counterblaste to Tobacco*," *WMQ*, 3rd ser., 62.4 (October 2005): 719–744.

13. Morgan, *American Slavery, American Freedom,* chap. 1; Anthony J. Barker, *The African Link: British Attitudes to the Negro in the Era of the Atlantic Slave Trade, 1550–1807* (London, 1978); Roxann Wheeler, *The Complexion of Race: Categories of Difference in Eighteenth-Century British Culture* (Philadelphia, 2000); Winthrop Jordan, *White over Black: American Attitudes to the Negro, 1550–1812* (Chapel Hill, N.C., 1968), 162–163. For black royalty, see "Brice's Best Virginia," Heal Collection, 117.16; "Martin's Best Virginia," Heal Collection, 117.114; "Wilson's Best Virginia," Heal Collection, 117.164.

14. Hulme, *Colonial Encounters,* 228 ("persistently"); *The Case of the Merchants Who Export Tobacco* (London, 1714), 1 ("formidable abroad"); Christopher Smart, *Poems on Several Occasions* (London, 1752), 211–213; Dr. Everard, *Panacea; Or, The Universal Medicine* (London, 1659), 1–4; Catherine Molineux, "Hogarth's Fashionable Slaves: Moral Corruption in Eighteenth-Century London," *English Literary History* 72.2 (June 2005): 495–520. For tobacco and Britain's rivalry with France, see [John Raymond], *Folly In Print; Or, A Book of Rymes* (London, 1667); *Advice to New-Married Husbands in Hudibrastick Verse* (1712), in Dickson, *Tobacco,* pt. 10: 602–603. For the growing importance of trade to the British state, see Thomas Short, *Discourses on Tea, Sugar, Milk, Made-Wines, Spirits, Punch, Tobacco, etc.* (London, 1750); Joyce Oldham Appleby, *Economic Thought and Ideology in Seventeenth-Century England* (Princeton, N.J., 1978), 152; Anthony Pagden, *Lords of All the World: Ideologies of Empire in Spain, Britain and France c. 1500–c. 1800* (New Haven, Conn., 1995); Erin Mackie, *Market à la Mode: Fashion, Commodity, and Gender in* The Tatler *and* The Spectator (Baltimore, Md., 1997), 45.

15. Henry Crosse, *Vertves Common-vvealth; Or, The High-way to Honovr* (London, 1603), fol. 12v ("smoakie gallant"); [William King], *The Furmetary. A Very Innocent and Harmless Poem. In Three Canto's* (London, 1699), 9; Alden T. Vaughan, "John Smith Satirized: The Legend of Captaine Iones," *WMQ* 45.4 (October 1988): 712–732.

16. For nudity and race, see Wheeler, *The Complexion of Race,* 1–48.

17. William Vaughan, *The Arraignment of Slander Perivry Blasphemy, and other malicious sinnes, shewing sundry examples of Gods Iudgements against the*

Ofenders . . . (London, 1630), 81 (quotation). For another tobacco advertisement similar to Fawkners's, see Anonymous, Heal Collection, 117.175.

18. Raphael Thorius, *Tobacco. A Poem. In Two Books,* trans. Henry Player (London, 1716), 1.

19. Pipe makers had the tobacco plant for their coats of arms; it may be that the tobacco shop owners had crossed pipes. See *A General Description of All Trades, digested in Alphabetical Order: by which Parents, Guardians, and Trustees, may, with greater Ease and Certainty, make choice of Trades agreeable to the Capacity, Education, Inclination, Strength, and Fortune of the Youth under their Care* (London, 1747). For boats, see "Brice's Best Virginia," Heal Collection, 117.16; "Hyland's Best Virginia," Heal Collection, 117.83.

20. [Joseph Addison], (London) *Freeholder,* May 14, 1716, in *The Free-Holder: Or Political Essays* (London, 1716), 243 ("it is our Business"). For the benevolence of trade, see Everard, *Panacea,* 1–4; [George] Lillo, *The London Merchant; Or, The history of George Barnwell. As it is Acted at the Theatre-Royal in Drury-Lane. By His Majesty's Servants* (London, 1731), 28; R[ichard] Norris, "Memoirs of the Reign of Bossa Ahadee . . . and a short Account of the African slave trade, 1789," in James Walvin, *The Black Presence: A Documentary History of the Negro in England, 1550–1860* (London, 1971), 54–60; Wilson, "Empire of Virtue"; Pagden, *Lords of All the World,* chap. 1. For other examples of colonial plantations, see "Bullock's Best York-River Mild Tobacco," Heal Collection, 117.19; "Field," Heal Collection, 117.53; "Hyland's Best Virginia," Heal Collection, 117.83; "N. Pooles Superfine," Heal Collection, 117.130; "Simper's Best Virginia," Heal Collection, 117.147; "Wood's Best Virginia," London (before 1703), Heal Collection, 117.168; Anonymous, Heal Collection, 117.180; Anonymous, Heal Collection, 117.181; "Shaw," 1785, Banks Collection, 117.155; "John Walker's Best Virginia," Banks Collection, 117.174; "Watkinson's Best Virginia," 1781, Banks Collection, 117.177; "Weekley's Best Virginia," Banks Collection, 117.179; "The Best Tobacco Under the Sun," Banks Collection, 117.191; "Edward Bury," Guildhall Library, City of London; Breen, *Tobacco Culture,* chap. 1, plate 9; "c. 1730 Tobacco Label," reproduced in John Lewis, *Printed Ephemera* (New York, 1962), no. 520.

21. Lillo, *London Merchant,* 28 ("by Love and Friendship"); Addison, *Freeholder,* May 14, 1716, in *The Free-Holder; Or Political Essays,* 243 ("reap the Advantages"). For other examples of independent black traders, see "Robt Smith's Best Virginia," Banks Collection, 117.165; "Brice's Best Virginia," Heal Collection, 117.16; "James Elliott's Best Virginia," Heal Collection, 117.45; "Martin's Best Virginia," Heal Collection, 117.114; "Newman's Best Virginia," Heal Collection, 117.121; "Wilson's Best Virginia," Heal Collection, 117.164.

22. Vaughan, *Arraignment of Slander Perivry Blasphemy,* 81 ("supernaturall reuelations"). For candles and pipes, see John Dryden, *Amboyna: A Tragedy* (London, 1673), 62; T[homas] Brown, *A Collection of Miscellany Poems, Letters, &c* (London, 1699), 184. For conversion, see *The Athenian Gazette; Or, Casuistical Mercury* (London, 1691), vol. 3, no. 30. The phoenix is part of the shop sign, but it had also been used as an allegory of the experience of smoking. See, e.g., [Thomas Middleton], *The Blacke Booke* (London, 1604). For Noah, see Marcus Wood, *Blind Memory: Visual Representations of Slavery in England and America, 1780–1865* (New York,

2000), 111. I thank Wood for pointing out this comparison. The satirical possibilities in representations of tobacco consumption raise questions about Robinson Crusoe's conversion experience, which was effected while he was under the influence of a large amount of nicotine. See Daniel Defoe, *The Life and Adventures of Robinson Crusoe,* ed. Angus Ross (1719; repr. London, 1985), 108–110. For other tobacco papers that emphasize the shared delight in smoking across racial and ethnic lines, see "Escourt's" (ca. 1700) and "R. Mascall's Best Virginia" (ca. 1700), reproduced in Lewis, *Printed Ephemera,* nos. 521, 530.

23. Karen O'Brien, "Imperial Georgic, 1660–1789," in *The Country and the City Revisited: England and the Politics of Culture, 1550–1850,* ed. Gerald Maclean, Donna Landry, and Joseph P. Ward (Cambridge, Eng., 1999), 160–179 (*"destination* of rural production," 160). I thank Kay Dian Kriz for pointing me to this essay. Alexander Pope, "Windsor Forest" (1712) in Pat Rogers, ed., *Alexander Pope* (Oxford, Eng., 1993), 49–62 ("bend before," 60). For scenes similar to "Baylis," see "Sweet-Scented Virginia," Heal Collection, 117.178; "Richardson's Best Virginia," Banks Collection, 117.141; "Ring's Best Virginia," Banks Collection, 117.142.

24. [Robert Beverley], *The History and Present State of Virginia, in Four Parts* (London, 1705), 146 ("chiefly upon the *English*"); Short, *Discourses on Tea, Sugar, Milk,* 251–252 ("Multitudes have sold"). For the god of Native Americans, *see Advice to New-Married Husbands,* in Dickson, *Tobacco,* pt. 10: 602–603. For Equiano, see Vincent Carretta, "Olaudah Equiano or Gustavus Vassa? New Light on an Eighteenth-Century Question of Identity," *Slavery and Abolition* 20.3 (December 1999): 96–105; Olaudah Equiano, *The Interesting Narrative and Other Writings,* ed. Vincent Carretta (New York, 1995), 40. For Africans enslaved in their own countries, see, e.g., T[homas] Gisborne, *On Slavery and the Slave Trade* (London, 1792). For travel accounts of African addiction, see Dickson, *Tobacco,* pt. 1: 149.

25. James I, *Counterblaste to Tobacco* (quotation). For paganism, see Richard Blome, *The Present State of his Majesties Isles and Territories In America* (London, 1687), 155, 170; Labat, *Nouveau Voyages* (1724), trans. in Dickson, *Tobacco,* pt. 3: 141–146; Hans Sloane, *A Voyage to the Islands Madera, Barbados, Nieves, S. Christophers, and Jamaica, with the Natural History of the Herbs and Trees, Four-Footed Beasts, Fishes, Birds, Insects, Reptiles, &c. Of the last of those Islands ...* (London, 1707), 1: 146–149; Sieur de Diéreville, *Relation du Voyage Du Port Royal De L'Acadie* (1708), in Dickson, *Tobacco,* pt. 10: 586–588; Michael Bernhard Valentini, *Museum Museorum* (1704), in Dickson, *Tobacco,* pt. 10: 570–576; Willem Bosman, *An Accurate Description of the Coast of Guinea, Divided into the Gold, Ivory and the Slave Coasts ...* (London, 1705), 306–307.

26. Taylor, *World Runnes on VVheeles,* 20 ("mischiefe or mischances"); *Poems on Several Occasions. Published by Subscription ...* (Manchester, Eng., 1733), 129 ("Fiends and Devils"). See also Lawrence Spooner, *A Looking-Glass For Smoakers* (1703), in Dickson, *Tobacco,* pt. 3: 39–41; Vaughan, *Arraignment of Slander Perivry Blasphemy,* 81; Richard Verstegen [alias of Richard Rowlands], *A Hundred Witty Characters* (1735), in Dickson, *Tobacco,* pt. 3: 264–265. For names for tobacco, see Edmund Spenser, *The Faerie Qveene ...* (London, 1590), 471; R[ichard] Steele, *Poetical Miscellanies, Consisting of Original Poems and*

Translations. By the Best Hands (London, 1714), 208–210. For tobacco's plea-
sures, see John Phillips, *The Whole Works of Mr. John Phillips* (London, 1720), 45;
Thomas Brown, *The Works of Mr. Thomas Brown, In Prose and Verse; Serious,
Moral, and Comical* (London, 1707), 1:130–131. For demonic possession, see Dar-
ren Oldridge, *The Devil in Early Modern England* (Phoenix Mill, Eng., 2000),
141–145. For descriptions of English smokers, see Edward Ward, *A Compleat and
Humorous Account of all the Remarkable Clubs and Societies in the Cities of Lon-
don and Westminster* (London, 1756).

27. George Cheyne, *An Essay of Health and Long Life* (London, 1724), 65
("foreign Weed"); [John Philips], *Cyder. A Poem* (1708), 21 ("Indian weed");
Steele, *Poetical Miscellanies,* 208–210 ("Virtues"); "John Hardham," Heal Collec-
tion, 117.76 ("Cures"); *Advice to New-Married Husbands,* in Dickson, *Tobacco,*
pt. 10: 602–603 ("Divine," 602). For turning gold into smoke, see [Thomas Dekker],
The Pleasant Comedie of Old Fortunatus (London, 1600). For health benefits, see
Nicolás Monardes, *Joyfvll Newes Out of the Newfounde Worlde,* trans. John
Frampton (London, 1580), in Dickson, *Tobacco,* pt. 2: 71–73; Roger Marbecke, *A
Defence of Tabacco* (London, 1602); [William Byrd], *A Discourse Concerning the
Plague, with some Preservatives Against it* (London, 1721), 13, 15; *Of the Use of
Tobacco Tea, Coffee, Chocolate and Drams* (London, 1722); Lacy, *Observations
on the Nature,* in Dickson, *Tobacco,* pt. 3: 25–51; *The Vintner and Tobacconist's
Advocate* (London, 1733), 9. For the conversion of luxury items into social neces-
sities, see Christopher J. Berry, *The Idea of Luxury: A Conceptual and Historical
Investigation* (Cambridge, Eng., 1994), 18.

28. John Beaumont, *The Metamorphosis of Tabacco* (London, 1602), fol. Br
("earthly pleasure"); Vaughan, *Arraignment of Slander Perivry Blasphemy,* 81
("belching"); Steele, *Poetical Miscellanies,* 208–210 ("Bacchus his Herb"); [Isaac
Hawkins Browne], *A Pipe of Tobacco: In Imitation of Six Several Authors* (Lon-
don, 1736), 8 ("Happy Mortal!"). For examples of this Bacchus figure, see "Allen
and Pardoe's," Heal Collection, 117.2; "Cary Hampton's Virginia," Heal Collec-
tion, 117.74; "Robert Nash," Heal Collection, 117.120; "N. Pooles Superfine,"
Heal Collection, 117.130; "Abraham Simmons," Heal Collection, 117.146; "The
Best Virginia," Heal Collection, 117.174. For tobacco's pleasures, see also Philips,
Cyder, 21–22; [John Phillips], *The Splendid Shilling* (London, 1705); *Whipping-
Tom; Or, a Rod for a Proud Lady,* 4th ed. (London, 1722), 8.

29. Samuel Rowlands, *The Night-Raven* (London, 1634), fol. E2v ("like
Moores"); William Fennor, *The Compters Common-Wealth* (London, 1617), 15
("Indian whore"); Ward, *Compleat and Humorous Account,* 62 ("puffing"). For
comparisons of English and exotic smokers, see John Taylor, *The Nipping or Snip-
ping of Abvses; Or, The vvoolgathering of VVitte* (London, 1614), fol. D3r; [Rich-
ard Brathwaite], *Whimzies: Or, A New Cast of Characters* (London, 1631); Samuel
Rowlandson, *The Melancholy Cavalier* ([London], 1654), 5. For Hogarth's trade
cards and those based upon his print, see Hogarth, Richard Lee shop card, Heal
Collection, 117.105; "Midnight Conversation," after Hogarth, Heal Collection,
117.106; Hogarth, Richard Lee shop card, Heal Collection, 117.107; Hogarth,
Richard Lee shop card, Heal Collection, 117.108; Anonymous, after Hogarth, Heal
Collection, 117.176. For similar fraternal scenes, see "Bennetts Fumigations," Heal

Collection, 117.9; "F. Griszell's Best Virginia," Heal Collection, 117.71; "Kingston's Best Virginia," Heal Collection, 117.93; "Knightly's Mild Virginia," Heal Collection, 117.96; "La Croix's," Heal Collection, 117.97; "B. Ries," Heal Collection, 117.134; "Scarfe's Best Virginia," Peterborough, Banks Collection, 117.153; "Willm White's Best London Virginia," Leachdale, 1786, Banks Collection, 117.182. For the original print, which did not include this image of a black boy, see Paulson, *Hogarth's Graphic Works,* 296, fig. 128. Ronald Paulson traces Hogarth's parodies of London consumption habits in Paulson, *Hogarth,* vol. 1, *The "Modern Moral Subject," 1697–1732* (New Brunswick, N.J., 1991). For a play that described blacks on tobacco shop signs as "blacke Indian," see [William Davenant], *The Triumphs of the Prince D'Amovr* (London, 1635), 3.

30. Brathwaite, *Whimzies,* 10 ("Now you"); M. Corneille le Bruyn, *A Voyage to the Levant; Or, Travels in the Principal Parts of Asia Minor, the islands of* Scio, Rhodes, Cyprus, *&c.,* trans. W. J. (London, 1702), 95 ("pay Visits"); Lahontan, *New Voyages to North America,* in Dickson, *Tobacco,* pt. 3: 35–38 ("Flag," 36); "Sarah Greenland Tobacco Pipe Maker," Heal Collection, 117.69 ("Let Brotherly"). For the Native American peace pipe, see Dickson, *Tobacco,* pt. 1: 24–25. For sociability of tobacco, see L[ouis] Hennepin, *A New Discovery of a Vast Country in America . . .* (London, 1698), pt. 2: 336–338; Beverley, *History and Present State of Virginia,* 20–21; [Pierre-François Xavier de Charlevoix], *Journal of a Voyage to North-America* (1744; repr., London, 1761), 1:322. For images similar to Chance's, see "Adlington's Best Virginia," Heal Collection, 117.1; "Rippin," 1782–1783, Banks Collection, 117.143; "Scrimshire's Best Virginia," Southwark, Banks Collection, 117.154; "Robt Smith's Best Virginia," Banks Collection, 117.165; "Spearman's Mild Virginia," Banks Collection, 117.166; "Burdon's Virginia" (ca. 1750) and "Jones his Virginia" (ca. 1675), reproduced in Lewis, *Printed Ephemera,* nos. 517 and 521.

31. Short, *Discourses on Tea, Sugar, Milk,* 250 ("the greatest Inconvenience"). See also Cotton Mather, *Manuductio ad Ministerium . . .* (Boston, 1726), 133. For patriotic imagery, see "Tomlinson and Shereson's Best Virginia," Heal Collection, 117.155 ("Pro Patria"); "Edward's Best Virginia," Heal Collection, 117.44 ("For Our Country"); "N. Pooles Superfine," Heal Collection, 117.130 ("omnes vinco"); "Harper's Best Virginia," Heal Collection, 117.79; "Poole and Co.," Heal Collection, 117.129; "Turner's Old Tobacco," Heal Collection, 117.157; "Willis, Tobacconist," Heal Collection, 117.163; "Cha. Wood," Heal Collection, 117.169; "Weekley's Best Virginia," Banks Collection, 117.179.

32. O'Brien, "Imperial Georgic, 1660–1789," 160–161 ("social self-understanding"), 172–173. See also Geoff Quilley, "Pastoral Plantations: The Slave Trade and the Representation of British Colonial Landscape in the Late Eighteenth Century," in Quilley and Kriz, *An Economy of Colour,* 106–128.

33. Thomas Nash, *Pierce Penilesse His Supplication to the Diuell* (1592), in Dickson, *Tobacco,* pt. 3: 105–106 ("divine drugge," 105); *Poems on Several Occasions,* 129 ("One known"); James Duport, *Musae Subsecivae* (1676), in Dickson, *Tobacco,* pt. 8: 414–415 ("seems black," 415); Philaretes, *Work for Chimny-Sweepers,* 1 ("chimny-sweepers"). For coffeehouse sociability, see Aytoun Ellis, *The Penny Universities: A History of the Coffee-Houses* (London, 1956); Tim

Hitchcock, *English Sexualities, 1700–1800* (New York, 1997), chap. 2. For a foreign view of the English smoking brotherhood, see *Centi-Folium Stultorum In Quarto* (1709), trans. in Dickson, *Tobacco*, pt. 10: 588–593. For the raven, see Ovid, *Metamorphoses* (New York, 1965), 45.

34. Wheeler, *The Complexion of Race,* 90–136 (quotations, 91). For masculinity and empire, see Felicity A. Nussbaum, *Torrid Zones: Maternity, Sexuality, and Empire in Eighteenth-Century English Narratives* (Baltimore, Md., 1995); Merril D. Smith, ed., *Sex and Sexuality in Early America* (New York, 1998).

35. *The Mens Answer to the Womens Petition against Coffee, Vindicating Their own Performances, and the Vertues of that Liquor, from the Undeserved Aspersions lately cast upon them by their Scandalous Pamphlet* (London, 1674), 5 ("Citizens Academy"), 3 ("little Houses"); *Advice to New-Married Husbands,* in Dickson, *Tobacco*, pt. 10: 602–603 ("Pipe and wonted Freedom," 602). For complaints about tobacco, see M[atthew] Stevenson, *Norfolk Drollery* (London, 1673), 53; S. H. [Charles Leslie], *Misodolus, Do No Right, Take No Wrong: Keep what you have, Get what you can . . .* (London, 1711), 139–140. Women also smoked, though it remained a private activity for some time, and to smoke publicly was to risk being labeled a wench. The Restoration brought greater participation by women, and they could frequently be found smoking on the stage. For sexualized discourses of tobacco, see William Prynne, *Histrio-Mastix. The Players Scovrge; Or, The Actors Trag'die, Divided into Two Parts* (London, 1633); John Jones, *Adrasta: Or, The Womans Spleene, and Loves Conquest* (1635), in Dickson, *Tobacco*, pt. 6: 253; Samuel Rowlands, "Poetical Manuscript Commonplace Book" (ca. 1638), in Dickson, *Tobacco*, pt. 6: 258–259; Thomas Durfey, *The Bath; Or, the Western lass. A Comedy* (London, 1701); *To the Retailers of Strong-Drinks* (London, 1706); George Farquhar, *The Beaux Stratagem* (London, 1707); Steele, *Poetical Miscellanies,* 208–210; Thorius, *Tobacco; Whipping-Tom,* 8; Browne, *A Pipe of Tobacco;* Elizabeth Harrison, "Choosing a Wife by a Pipe of Tobacco," in *Miscellanies on Moral and Religious Subjects, in Prose and Verse* (London, 1756), 346–347. For effeminacy and empire, see Wilson, *Sense of the People,* 185–205. For Turkishness and the coffeehouse, see Cowan, *The Social Life of Coffee,* chap. 5.

36. Fennor, *Compters Common-Wealth,* 15 ("Indian whore"); [Thomas Tomkis], *Lingua: Or, The Combat of the Tongue, and the fiue Sences. For Superiority. A pleasant Comædy* (London, 1622), fol. Hr ("King of Trinidado"); John Cotta, *A Short Discoverie* (London, 1612), 5 ("strange Indian"); Lamb, "Farewell to Tobacco," in Dickson, *Tobacco*, pt. 4: 206.

37. Dickson, *Tobacco*, pt. 1: 3–173, esp. 17.

6. HOGARTH'S ATLANTIC LONDON

1. E[lisha] Kirkall (after Hogarth), *Harlot's Progress,* pl. 2 (London, ca. 1733–1742), CCHV vol. 10, fol. 34 ("High Keeping"). For Hogarth's engravings, see Ronald Paulson, *Hogarth's Graphic Works* (London, 1965; 2nd rev. ed. 1970; 3rd rev. ed. 1989); citations are from the third edition. For *Harlot's Progress,* see Paulson, *Hogarth's Graphic Works,* 76–83. See also G[iles] King (after Hogarth), *Harlot's Progress,* pl. 2 (London, ca. 1732), CCHV vol. 10, fol. 45; Anonymous (after

Hogarth), *Harlot's Progress*, pl. 2 (London: printed by John Bowles at the Black Horse in Cornhill, mid-eighteenth century), CCHV vol. 10, fol. 47. My thanks to Craig Hartley and Elenor Ling of the Fitzwilliam Museum for their help with this collection.

2. Theophilus Cibber, *The Harlot's Progress; or, the Ridotto Al'Fresco* (London, 1733), 8 ("Black-Boy"); *The Jew Decoy'd; or, the Progress of a Harlot. A New Ballad Opera of Three Acts. The* AIRS *set to Old Ballad Tunes* (London, 1735). For the black servant's connection to exotica, see Marcus Wood, *Slavery, Empathy, and Pornography* (New York, 2002), 404; Srinivas Aravamudan, *Tropicopolitans: Colonialism and Agency, 1688–1804* (Durham, N.C., 1999), 2, 33–38; Beth Fowkes Tobin, *Picturing Imperial Power: Colonial Subjects in Eighteenth-Century British Painting* (Durham, N.C., 1999), chap. 1; David Dabydeen, *Hogarth's Blacks: Images of Blacks in Eighteenth-Century English Art* (Athens, Ga., 1986), 23.

3. Ephraim Knox, Letter to Hogarth, October 20, 1763, British Library, Add MS 27995, fol. 21. For another response to a Hogarth print in a bookseller's window, see "Jonathan Antihypocrita," Letter to Hogarth, Morpeth, April 19, 1762, British Library, Add 27995, fol. 17b. For Hogarth's biography, see Ronald Paulson, *Hogarth: His Life, Art, and Times* (New Haven, Conn., 1971) or the revised edition, *Hogarth* (New Brunswick, N.J., 1991–1993), 3 vols; Jennifer S. Uglow, *Hogarth: A Life and a World* (London, 1997). For Hogarth's shop, see John Nichols, *Biographical Anecdotes of Hogarth,* 3rd ed. (London, 1785), 10. For the international success of Hogarth's prints, see Robin Simon, *Hogarth, France and British Art: The Rise of the Arts in 18th-Century Britain* (London, 2007), 38.

4. Race has become a critical category of analysis in Hogarth studies. David Dabydeen's influential reading of Hogarth's black characters argues that the engraver's antiauthoritarian leanings enabled him to identify with the plight of African slaves; their subversive or transgressive roles in his prints provided evidence of the *longue durée* of antislavery sentiment in preabolitionist Britain. Growing understanding of Hogarth's social circle and its political concerns, however, has suggested a less critical position toward the Atlantic slave trade, while appreciation of engravers' financial pressures has led to reconsideration of Hogarth's radicalism. Most critics, though, agree that black characters are disruptive forces in his graphic narratives. This overall softening of Dabydeen's argument for radicalism reflects a broader turn within Hogarth studies toward a newer material culture school that locates him within a difficult art market and broader graphic culture. The larger debate about Hogarth is beyond this book's scope, but my interpretation of his black characters suggests that he used mainstream ideas to ideologically subversive and aesthetically radical ends. For previous work on Hogarth that thinks through his use of race and slavery, see David Bindman, "A Voluptuous Alliance between Africa and Europe: Hogarth's Africans," in Bernadette Fort and Angela Rosenthal, eds., *The Other Hogarth: Aesthetics of Difference* (Princeton, N.J., 2001); Tobin, *Picturing Imperial Power,* chap. 1; Mark Hallett, *The Spectacle of Difference: Graphic Satire in the Age of Hogarth* (New Haven, Conn., 1999); Dabydeen, *Hogarth's Blacks;* Sean Shesgreen, *Hogarth and the Times-of-the-Day Tradition* (Ithaca, N.Y., 1983). For the art market, see David Solkin, *Painting for Money: The Visual*

Arts and the Public Sphere in Eighteenth-Century England (New Haven, Conn., 1993); Diana Donald, *The Age of Caricature: Satirical Prints in the Reign of George III* (New Haven, Conn., 1996); Timothy Clayton, *The English Print, 1688–1802* (New Haven, Conn., 1997); Vincent Carretta, *The Snarling Muse: Verbal and Visual Political Satire from Pope to Churchill* (Philadelphia, 1983); Carretta, *George III and the Satirists from Hogarth to Byron* (Athens, Ga., 1990).

5. Paulson, *Hogarth: His Life, Art, and Times,* 1:215.

6. This print responded to French engraver Charles Antoine Coypel's illustration of the same subject, which accompanied the 1731 English edition of Cervantes's *Don Quixote.* Hogarth extended the scene to the right, to incorporate the group of servants including the black slave. For *Sancho's Feast,* see Paulson, *Hogarth's Graphic Works,* 271. For Coypel's illustration, which was engraved by Gerard Vandergucht (who would later work for Hogarth), see Miguel de Cervantes Saavedra, *The History of the Valorous and Witty Knight-Errant Don Quixote of the Mancha,* trans. Thomas Shelton (London, 1731), 4, pl. 41.

7. Henry Fielding, cited in Nichols, *Biographical Anecdotes,* 41. For the carnivalesque, see Peter Stallybrass and Allon White, *The Politics and Poetics of Transgression* (Ithaca, N.Y., 1986), intro.

8. Nichols, *Biographical Anecdotes,* 15, 17 ("on the spot"). For Rose Tavern, see Nichols, *Biographical Anecdotes,* 213. For *A Rake's Progress,* see Paulson, *Hogarth's Graphic Works,* 89–98; *A Rake's Progress III* (oil on canvas, 1732–1733), Soane's Museum, London.

9. For Hogarth's black characters and moral laxity, see esp. Tobin, *Picturing Imperial Power,* chap. 1, and Bindman, "A Voluptuous Alliance." For Hogarth's emphasis on self-delusion, see Diana Donald, "'This Truly Natural and Faithful Painter': Hogarth's Depiction of Modern Life," in David Bindman, Frédéric Ogée, and Peter Wagner, eds., *Hogarth: Representing Nature's Machines* (Manchester, Eng., 2001), 173. For Hogarth's links to Continental art, see Simon, *Hogarth;* Frederick Antal, *Hogarth and His Place in European Art* (New York, 1962).

10. William Hogarth, *Analysis of Beauty. Written with a view of fixing the fluctuating ideas of taste* (London, 1753), 5.

11. An excised portion of Hogarth's *Analysis of Beauty* cites John Bulwer's *Anthropometamorphosis* (1658), which showed the "sometimes cruel methods of moulding and forcing the human form out of its natural figure and collour" (Hogarth, *Analysis,* 127). For Bulwer, see also William Oldys, *The British Librarian* (London, 1738), 364–365. For the hoopskirt, see Erin Mackie, *Market à la Mode: Fashion, Commodity, and Gender in* The Tatler *and* The Spectator (Baltimore, Md., 1997), chap. 3. Perhaps the best-known portrayal of the aesthetic of miniaturization is Alexander Pope, *The Rape of the Lock: An Heroi-Comical Poem,* in Pat Rogers, ed., *Alexander Pope* (Oxford, Eng., 1993). Hogarth made illustrations for this literary piece.

12. Anon., *The Character of a Town Misse* (London, 1675), 7. By the 1720s, the lady and her black slave had become notable, though not common in literary satire. For these satires and their association of blacks with pets, see, e.g., John Bulteel, *Collection of Apothegmes or Sayings of the Ancients* (London, 1686), 95; Edward Ward, *The Writings of Edward Ward,* 3rd ed. (London, 1706), 1:13; *The*

Annual Register, or a View of the History, Politics, and Literature, for the Year 1763, 5th ed. (London, 1782), 233. For "petting," see Aravamudan, *Tropicopolitans,* 33–38; Dabydeen, *Hogarth's Blacks,* 21–26; Wood, *Slavery, Empathy, and Pornography,* 404; Tobin, *Picturing Imperial Power,* chap. 1. For a revision of the concept of petting and a longer discussion of maternity, see Catherine Molineux, "Hogarth's Fashionable Slaves: Moral Corruption in Eighteenth-Century London," *English Literary History* 72.2 (Summer 2005): 495–520. Daniel Defoe's *Robinson Crusoe* also describes Crusoe's relationship to Friday in terms of father and son. See Defoe, *The Life and Adventures of Robinson Crusoe,* ed. Angus Ross (1965; repr., London, 1985), 212. For the circumstances behind the production of *Taste in High Life,* see Simon, *Hogarth,* 41.

13. As far as I have been able to discover, Kneller's work resided at Audley End and no mezzotints were made. Yet these motifs bear such striking resemblance that it seems plausible that Hogarth had seen either this portrait or one very similar to it. It is the only portrait that I have seen which elevates the black child in this way. Because no direct evidence seems to exist of Hogarth having visited Audley End, however, I focus here on his parody of the woman's gesture, which was common to many portraits. I am grateful to the staff of the National Portrait Gallery for their help with the Kneller portrait.

14. Leo Steinberg, *The Sexuality of Christ in Renaissance Art and in Modern Oblivion* (Chicago, 1996), 116 ("a visual text"). Cf. Paulson's reading of the bawd's chin-chuck of the harlot in *Harlot* 1. Ronald Paulson, *Hogarth's Harlot: Sacred Parody in Enlightenment England* (Baltimore, Md., 2003), chap. 1. Dabydeen argues that Hogarth's woman and black slave motif tie, through English portraits, to the iconography of the Madonna and Child (Dabydeen, *Hogarth's Blacks,* 32). For idolatry, see Paulson, *Hogarth's Graphic Works,* 76–83; Simon, *Hogarth,* 203–205.

15. Hogarth's marriage was childless, and he and his wife compensated by adopting orphans; this experience and his own tumultuous childhood could explain the concerns expressed in his prints. For the decline of matrimony, see *The Universal Spectator,* February 13, 1731, April 3, 1731; *Gentleman's Magazine,* February 1731, 60, April 1731, 146. Hogarth's *The Lottery* (1724) offered an image of Avarice "hugging his Mony" that strikingly resembles a woman holding a child. *The Distressed Poet* (1740) explained the gritty realities of a poet's impoverished home by his infatuation with the idea of Peruvian gold mines. A gin-drinking, syphilitic woman's desire for snuff causes her child to tumble to its death in *Gin Lane.* Hogarth, *The Lottery* (London, 1724), in CCHV vol. 19, fol. 6. For *Distressed Poet* and *Gin Lane,* see Paulson, *Hogarth's Graphic Works,* 50–51, 101–103, 145–148. For Hogarth's childhood, see Paulson, *Hogarth,* vol. 1. For a brief but provocative analysis of Hogarth's child portraiture, see Simon, *Hogarth,* 167–170.

16. Thomas Brown, *The Fifth Volume of the Works of Mr. Thomas Brown* (London, 1721), 149 ("nothing but themselves"). For copies, see Hogarth, *Analysis,* 18–20, 74.

17. Cf. Tobin, *Picturing Imperial Power,* chap. 1.

18. See Chapter 4.

19. Molineux, "Hogarth's Fashionable Slaves."

20. Hogarth, *Analysis,* 18 ("see"); John Bender, "Matters of Fact: Virtual Witnessing and the Public in Hogarth's Narratives," in Bindman, Ogée, and Wagner, eds., *Hogarth: Representing Nature's Machines,* 64 ("classless"). For Hogarth and democratic sight, see also Paulson, *Hogarth's Harlot,* 23, 61–63; Solkin, *Painting for Money,* intro.

21. Hogarth, *Analysis,* 107 ("Shacklings"); Mackie, *Market à la Mode,* 7. For Hogarth's emphasis on containment and its relationship to his father's imprisonment, see Ronald Paulson, *The Art of Hogarth* (London, 1975), chap. 1. For debates over luxury, see John Sekora, *Luxury: The Concept in Western Thought, Eden to Smollett* (Baltimore, Md., 1977), 23–62; J. G. A. Pocock, *Virtue, Commerce, and History: Essays on Political Thought and History, Chiefly in the Eighteenth Century* (Cambridge, Eng., 1985); Christopher Berry, *The Idea of Luxury: A Conceptual and Historical Investigation* (Cambridge, Eng., 1994); Solkin, *Painting for Money,* esp. chap. 2.

22. For Old Testament justice and *Harlot* 2, see Ronald Paulson, "Some Thoughts on Hogarth's Jew," in Bindman, Ogée, and Wagner, eds., *Hogarth: Representing Nature's Machines,* 250; Paulson, *Hogarth's Harlot,* 83–84. For biographical portraits of Colonel Charteris (the rapist) and Mother Needham (the bawd), see Nichols, *Biographical Anecdotes,* 188–191. For copiers who supplied explanatory texts centralizing the bawd's behavior, see, e.g., Kirkall, *Harlot's Progress,* pl. 6, CCHV fol. 38.

23. For Kate Hackabout, see *Grubstreet Journal,* August 6, 1730; Samuel Richardson, *Pamela* (London, 1742), 3:308 ("He has made"); *Weekly Register,* January 16, 1731, also cited in *Gentleman's Magazine,* January 1731 ("mother of scandal"); Thomas Otway, *Caius Marius* (London, 1680), quoted in the *Oxford English Dictionary* ("I'm an honest"); Louis Philippe Boitard, in Sheila O'Connell, *London 1753* (London, 2003), 143; Boitard, *The Sailor's Revenge, or The Strand in an Uproar* (London, 1749), British Museum, Department of Prints and Drawings, No. 1868,0808.3895; Nichols, *Biographical Anecdotes,* 209. This print recorded a riot that broke out in a brothel in the Strand on July 2, 1749, when a group of sailors sought revenge for having been robbed by the prostitutes. For the kettle's association with sexuality, see John Winstanley, *Poems Written Occasionally by John Winstanley* (Dublin, 1742), 307–309; William Gordons, *A Dictionary of Sexual Language and Imagery in Shakespearean and Stuart Literature* (London, 1994).

24. George Vertue, quoted in Bender, "Matters of Fact," 65; John Breval, *The Lure of Venus: Or, A Harlot's Progress. An Heroi-Comical Poem* (London, 1733; Dublin, 1739), frontispiece ("Females!").

25. For the boy's metaphorical connotations of slavery, see Paulson, *Hogarth's Harlot,* 84. For Turkishness, see Kathleen Wilson, *The Sense of the People: Politics, Culture, and Imperialism in England, 1715–1785* (Cambridge, Eng., 1995), 111. Because political authority derived its model from the patriarchal household, the Grand Turk's keeping of women became emblematic of the tyranny that Britons perceived in Eastern societies. Descriptions of Christian enslavement in Muslim societies associated Eastern despotism with an unacceptable form of bondage, making it available as a trope with which to investigate

tyranny at home. For Christian enslavement, see Linda Colley, *Captives: Britain, Empire and the World, 1600–1850* (London, 2002). *Athenian Mercury*, London, August 15, 1693.

26. Cibber, *Harlot's Progress*, 12 ("Ladies"); Breval, *Lure of Venus*, 2, 11.

27. Paulson, *Hogarth's Graphic Works*, 79 ("made a monkey of"). For the fop, see Mackie, *Market à la Mode*, 78; Miles Ogborn, "Locating the Macaroni: Luxury, Sexuality, and Vision in Vauxhall Gardens," in Mary Peace and Vincent Quinn, eds., *Luxurious Sexualities: Effeminacy, Consumption, and the Body Politic in Eighteenth-Century Representation* (London, 1997), 445–462; Solkin, *Painting for Money*, 48–49; Pocock, *Virtue, Commerce, and History*, 114; Susan Staves, "A Few Kind Words for the Fop," *Studies in English Literature* 22.3 (Summer 1982): 413–428; Philip Carter, "An 'Effeminate' Nation or 'Efficient' Nation? Masculinity and Eighteenth-Century Social Documentary," in Peace and Quinn, *Luxurious Sexualities*, 433 ("simplicity and customs"); Brown, *The Works of Mr. Thomas Brown* (London, 1707), 1:89–90. For bondage to luxury in *Harlot* 2, see also Paulson, "Some Thoughts on Hogarth's Jew," 250. For luxury and avarice as defining attributes of the age, see *Gentleman's Magazine*, February 1731, 58–59. For verbalization, see Paulson, *Hogarth's Harlot*, 55. For the ape's signification, see Carretta, *The Snarling Muse*, 161; David Solkin, "The Excessive Jew in *A Harlot's Progress*," in Bindman, Ogée, and Wagner, eds., *Hogarth: Representing Nature's Machines*, 221–222; Paulson, *Hogarth's Harlot*, 85. In Cibber's dramatic production of this series, the black boy is absent from this scene of destruction, but the harlot reintroduces the racial commentary as she, laughing at the Jew's humiliation, sings, "Farewell, good Mr. Jew; / Now I hate your tawny Face; I'll have no more to do / With you or any of your Race" (Cibber, *Harlot's Progress*, 10). For another story of a man who fashions himself into a master by acquiring a slave, see Defoe, *Robinson Crusoe*, 157, 240–241.

28. *Athenian Mercury*, London, November 14, 1693 ("Intention of them"). For blackness and sin, see Winthrop Jordan, *White over Black: American Attitudes towards the Negro, 1550–1812* (Chapel Hill, N.C., 1968). Casting hypocrisy in binary oppositions of black and white was not new: in R.B., *Choice Emblems, Divine and Moral, Ancient and Modern* (London, 1684; reissued 1732), 108, an image that critiques feminine dissimulation includes a caption: "But more (yea most of all) my soul dispiseth / A heart that in Religious Forms disguiseth / Prophane Intentions, and arrays in white / The coal-black intentions of a Hypocrite." Hogarth's *The Four Times of the Day: Morning* reworked the figure associated with these verses. See Mark Hallett, "The View across the City: William Hogarth and the Visual Culture of Eighteenth-Century London," in Bindman, Ogée, and Wagner, eds., *Hogarth: Representing Nature's Machines*, 149; Hallett, *Spectacle of Difference*, 7–8. For examples of the "pot calling the kettle black," see Aphra Behn, *The Feign'd Curtizans, or, A Nights Intrigue a Comedy* (London, 1679), 43; Henry Fielding, *Shamela* (London, 1741), Letter IV.

29. For transportation, see Dabydeen, *Hogarth's Blacks*, 80. For *A Rake's Progress* and *The Discovery*, see Paulson, *Hogarth's Graphic Works*, 89–98, 112. For relationships between black women and white men, see Samuel Foote, *The Cozeners, a Comedy, of three acts, as it was performed at the Theatre Royal in the*

Hay-Market (London, 1778), 58–59; William Bingfield, *The Travels and Adventures of William Bingfield, Esq* (London, 1753), vol. 2, chap. XVIII; Kathleen Chater, *Untold Histories: Black People in England and Wales during the Period of the British Slave Trade, c. 1660–1807* (Manchester, Eng., 2009), 44; Paul Griffiths, *Lost Londons: Change, Crime, and Control in the Capital City, 1550–1660* (Cambridge, Eng., 2008), 73–74.

30. Subsequent copiers of *Harlot* 4 again offered varied interpretations of this scene. Some believed Bridewell to be a restorative space for fallen women. Others compared Moll's "Sighs" with her maid's lack of "remorse" to conclude that only some would find a "Reformation in the mind." Still others focused on the warden: the earliest pirated copy of this series remarked that "The Keeper" conveyed "a look that's sourer, / Than Turk or Devil standing o'er her." See E[lisha] Kirkall, *Harlot's Progress* (London, before 1742), pl. 4; Breval, *Lure of Venus*, 43; Kirkall, *Harlot's Progress*, pl. 4. For the earliest, pirated edition, see Nichols, *Biographical Anecdotes,* 197.

31. Ephraim Knox, letter to Hogarth, October 20, 1763, British Library, Add MS 27995, fol. 21 ("Licentiousness"). For male authority figures and absent church, see Paulson, *Hogarth's Harlot,* 28. For negotiation of commerce within the visual arts, see Solkin, *Painting for Money,* chap. 3.

32. *Marriage A-la-Mode: An Humorous Tale, in Six Canto's, in Hudibrastic Verse; being an Explanation of the Six Prints Lately Published by the Ingenious Mr. Hogarth* (London, 1746), 3 ("Two shackled Slaves"), 29–30 ("crafty black"); Nichols, *Biographical Anecdotes,* 273. Paulson argues that Hogarth's *Taste in High Life* inspired his *Marriage A-la-Mode*. Paulson, *Hogarth,* 2:203–206. For baroque parody, see Dabydeen, *Hogarth's Blacks,* 73–80. For the child's awareness, see Bindman, *Ape to Apollo: Aesthetics and the Idea of Race in the 18th Century* (London, 2002), 41.

33. His location in the bottom left of the print suggests this reading: many of Hogarth's prints depict characters at the bottom left or right whose behaviors and expressions echo the social relations of the central characters. For the varied meanings of blackness, see Chapter 3. For the anatomical origins of skin color, see Hogarth, *Analysis,* 88. For the origin of blackness with Lot, see *Athenian Mercury,* May 2, 1691. Felicity Nussbaum has highlighted the commentary on monstrosity and sexual aberrance in plate 3 of this series (Nussbaum, *The Limits of the Human: Fictions of Anomaly, Race, and Gender in the Long Eighteenth Century* (Cambridge, Eng., 2003), 14–16). For sodomy and Italian castrati, see Mackie, *Market à la Mode,* 78.

34. David Bindman made the important revision of Dabydeen's argument that Hogarth was an antislavery advocate. Bindman argues that Hogarth's perception of black slavery was in agreement with Daniel Defoe's—meaning that he accepted it. I believe Bindman is correct in connecting Hogarth's blacks to Defoe's popular discussion of slavery in his journal, *Review*. But Defoe's perception of slavery was more complicated than Bindman's characterization: he certainly accepted the slave trade, but his *Review* suggests a more conflicted perception of Caribbean slavery, which supported an excess that did not fit neatly into his expostulation on trade's

civilizing benefits. That concern did agree with Hogarth's commentary. Cf. Bind-man, "A Voluptuous Alliance."

35. Hogarth, *The Power of Custom,* British Library, Add. MS. 27, 992, ("Something of a first Intended Introduction," fol. 12b), reproduced in Hogarth, *Analysis,* 115–116 ("prejudices"); Kroll, *The Material Word: Literate Culture in the Restoration and Early Eighteenth Century* (Baltimore, Md., 1991), 52; Bender, "Matters of Fact," 52, 65.

36. William Warburton, cited in Nicholas Hudson, "'Britons Never Will Be Slaves': National Myth, Conservatism, and the Beginnings of British Antislavery," *Eighteenth-Century Studies* 34.4 (Summer 2001): 562.

37. Bender, "Matters of Fact," 55 ("reflexivity").

38. Michael Burden, "Aspects of Purcell's Opera," in Burden, ed., *Henry Purcell's Operas: The Complete Texts* (Oxford, Eng., 2000), 16 ("the personage"); for partial types, see Hogarth, *Analysis,* 17. Ephraim Knox, letter to Hogarth, October 20, 1763, British Library, Add MS 27995, fol. 21. Richard Kroll argues that Hogarth's contemporaries thought that metonymy, analogy, and synecdoche, as partial examples or comparisons, made the reader aware of the author's act of inference or comparison. See Kroll, *Material Word,* 120–127.

39. Nichols, *Biographical Anecdotes,* 259 ("Her Familiarity").

40. John Hill, *The Actor: A Treatise on the Art of Playing. Interspersed with theatrical anecdotes, critical remarks on plays, and occasional observations on audiences* (London, 1750), 70.

41. Anon. (1726), BM Satire 47.20, 47.21; CCHV. Collet's inclusion of the black servant in *May Day* may have played with the customary practice for milkmaids to dance with their beaus who were chimney sweeps blacked up for the occasion. I thank the anonymous reader for Harvard University Press for pointing this out.

42. Brown, *The Works.* The image is included in editions from 1700, 1708, 1715, 1730, and 1760. See also Thomas Brown, *Amusements Serious and Comical, and other Works,* ed. Arthur L. Hayward (London, 1927), 12; Rick Allen, *The Moving Pageant: A Literary Sourcebook on London Street-Life, 1700–1914* (London, 1998), 29. For a discussion of the parallel uses of the figure of the savage and the disinterested gentleman, see Iain Pears, *The Discovery of Painting: The Growth of Interest in the Arts in England 1680–1768* (New Haven, Conn., 1989), chap. 2.

43. Dabydeen noted that the black footman's expression replicated that of Hogarth's depiction of Caliban. See Dabydeen, *Hogarth's Blacks,* 78–79.

44. Bindman, *Ape to Apollo,* 41; *Marriage A-la-Mode: An Humorous Tale,* 36.

45. Dabydeen, *Hogarth's Blacks,* 41.

46. For Hume's concept of beauty, see Pears, *Discovery of Painting,* chap. 2. Pears argues that the eighteenth century witnessed debates over beauty that recognized its subjective nature, but nevertheless sought to hold onto the idea that beauty was absolute by arguing for the refined observer whose judgment was more authoritative than vulgar opinion. The debate he reconstructs, however, is only one part of the discussions of beauty. For Shaftesbury, see Solkin, *Painting for Money,* 11. Francis Hutcheson, *Inquiry Into the Original of our Ideas of Beauty* (London, 1738); Paulson, *Hogarth,* 1:xvii, 1, 4. For eighteenth-century notions of beauty, see

also David Bindman, *Ape to Apollo: Aesthetics and the Idea of Race in the 18th Century* (London, 2002), chap. 1.

47. Hogarth, *Analysis,* 115 ("prejudices"). For Hogarth and Mandeville, see Diana Donald, "'This Truly Natural and Faithful Painter,'" 166–167; see also 176. For curiosity, see Amal Asfour, "Hogarth's Post-Newtonian Universe," *Journal of the History of Ideas* 60.4 (1999): 693–716. W[illiam] Warburton, letter to Hogarth, March 28, 1752, British Library, Add. 27995, fol. 6 ("that worthless crew"). For further fan mail, see P[hillip] Yonge, letter to Hogarth, November 28, 1753, British Library, Add. 27995, fol. 10; Rouquet, letter to Hogarth, Paris, March 22, 1753, British Library, Add. 27995, fol. 12; B[enjamin] Wilson, letter to Hogarth, n.d. [ca. 1754], British Library, Add. 27995, fol. 14; "An Englishman," letter to Hogarth, December 12, 1759, British Library, Add. 27995, fol. 16; *Monthly Review,* London, February 1754, vol. 10, 100; John Nichols and George Steevens, *The Genuine Works of William Hogarth* (London, 1808), 210–245.

48. Hogarth, *Analysis,* 88, 123, 129.

49. Joyce Chaplin, "Race," in David Armitage and Michael Braddick, eds., *The British Atlantic World, 1500–1800* (New York, 2002), 154–172; Wheeler, *The Complexion of Race.* See also Dror Wahrman, *The Making of the Modern Self: Identity and Culture in Eighteenth-Century England* (New Haven, Conn., 2004).

50. Hogarth, *Analysis,* 1.

51. For this series, see Paulson, *Hogarth's Graphic Works,* 328; Shesgreen, *Hogarth and the Times-of-the-Day Tradition.*

52. For *Morning,* see CCHV vol. 14, fol. 28. For *Noon,* see CCHV vol. 14, fol. 31.

53. For the satyr/nymph, see Dabydeen, *Hogarth's Blacks,* 52.

54. John Ireland gave this interpretation of the kissing women in the later eighteenth century. Paulson, *Hogarth's Graphic Works,* 105; Carretta, *The Snarling Muse,* 27.

55. Brown, *Amusements,* 9th ed. (London, 1760), 97 ("passing from"); Nichols, *Biographical Anecdotes,* 60 ("old toothless"), 250 ("crying boy"); Simon, *Hogarth,* 3, 276. Hogarth had also invoked the story of the Sabine women in *A Rake's Progress II,* where he attributed an imaginary opera on the subject to Handel.

56. *Athenian Gazette,* London, vol. 1, no. 2 (n.d.). For the name of the meeting-house, see Simon, *Hogarth,* 93.

57. *Athenian Mercury,* London, November 1, 1692, October 24, 1693. For other examples of questions about bodily adornment, see Hallett, *Spectacle of Difference,* 7–8.

58. Defoe, *Robinson Crusoe,* 14; Shakespeare, cited in James Walvin, *Black and White: The Negro and English Society, 1555–1945* (London, 1973), 25.

59. Hallett, *Spectacle of Difference,* preface. For the Hottentot, see Linda Evi Merians, *Envisioning the Worst: Representations of "Hottentots" in Early-Modern England* (Newark, N.J., 2001).

60. Brown, *Amusements Serious and Comical,* 12.

61. Shaftesbury, cited in Dennis Todd, *Imagining Monsters: Miscreations of the Self in Eighteenth-Century England* (Chicago, 1995), 175–176 ("humanistic commonplace").

62. John Eliot Hodgkin, *Rariora* (London, 1902), 58; Nichols, *Biographical Anecdotes,* 32–33; Theophilus Cibber, *The Harlot's Progress* (1733) and *The Rake's Progress* (MS., ca. 1778–1780), ed. Mary F. Klinger, The Augustan Reprint Society, pub. no. 181 (Los Angeles, 1977), I; Dabydeen, *Hogarth's Blacks,* n1.

63. For Bickham, see Simon, *Hogarth,* 265. See also Carretta, *The Snarling Muse,* 201; Paulson, *Rowlandson: A New Interpretation* (New York, 1972), 13–14.

64. J. Smith, *Miss* MACARONI *and her* GALLANT *at a Print Shop* (London: Printed for John Bowles, April 2, 1773), BM Satire No. 5220. The boy's dress is not of the Harlequin, but the white surrounding his eyes suggests blackface. John O'Brien, *Harlequin Britain: Pantomime and Entertainment, 1690–1760* (Baltimore, 2004).

65. Bender, "Matters of Fact," 52.

66. Roxann Wheeler has demonstrated a shift in eighteenth-century British thought from an idea that blackness derived from exterior causes, such as the climate or God, to one in which blackness arose from an interior and inferior state of being. Kim Hall, however, has shown that English men and women associated darkness with an internal state in the Renaissance, suggesting that even if early Georgian Britons did not link the blackness of skin with internal corruption, they did have the language with which to do so. Wheeler, *Complexion of Race;* Kim F. Hall, *Things of Darkness: Economies of Race and Gender in Early Modern England* (Ithaca, N.Y., 1995).

7. BRITAIN'S REBEL SLAVES

1. Charles James Fox, *Substance of the Speech of the Right Honorable Charles James Fox, on Monday, December 1, 1783, upon a Motion for the Commitment of the Bill for . . .* (London, 1783).

2. See Chapter 5. For Defoe, see Roxann Wheeler, *The Complexion of Race: Categories of Difference in Eighteenth-Century British Culture* (Philadelphia, 2000), 46–89.

3. L. W. Cowie, "The Prince Regent's Cook: Louis Weltje," *History Today* 28.8 (1978): 523.

4. See Chapter 6.

5. There are a number of scholarly works that focus on racial imagery in this period, but only brief commentaries on Mungo. See esp. Felicity Nussbaum, *The Limits of the Human: Fictions of Anomaly, Race, and Gender in the Long Eighteenth Century* (Cambridge, Eng., 2003), intro. and 226–227; Gretchen Gerzina, *Black London: Life before Emancipation* (New Brunswick, N.J., 1995), 10. For black characters in the theater, see Herbert Marshall and Mildred Stock, *Ira Aldridge, the Negro Tragedian* (Carbondale, Ill., 1958); Peter J. Kitson and Debbie Lee, eds., *Slavery, Abolition, and Emancipation: Writings in the British Romantic Period* (London, 1999), vol. 5, introduction. For other work on race and visual culture in this period, see esp. Marcus Wood, *Blind Memory: Visual Representations of Slavery in England and America, 1780–1865* (Manchester, Eng., 2000); Wood, *Slavery, Empathy, and Pornography* (Oxford, Eng., 2002).

6. Tracing the international and transatlantic expropriations of Mungo is beyond the scope of this chapter. Isaac Bickerstaff, *The Padlock* (1768). For the opera's success in Britain, see Thomas Davies, *Memoirs of the Life of David Garrick,*

Esq. Interspersed with Characters and Anecdotes of His Theatrical Contemporaries (Dublin, 1780), 123–124.

7. Miguel de Cervantes, "The Jealous Old Man from Extremadura," in *Exemplary Stories,* trans. Lesley Lipton (Oxford, Eng., 1998), 150–184.

8. Ibid., 155, 157 ("fortress"), 174 ("Unless I guard"), 183 ("thought").

9. Bickerstaff, *The Padlock,* advertisement.

10. Cervantes, "The Jealous Old Man," 181; Bickerstaff, *The Padlock,* Act II, Scene the Last.

11. Bickerstaff, *The Padlock,* Act 1, Scene VI (p. 11).

12. For allusions to Turkish tyranny, see Bickerstaff, *The Padlock,* Act I, Scene VII, Scene VIII.

13. Ibid., Act I, Scene VII.

14. Ibid., Act I, Scene VI. This aria was reprinted in *Roundelay or the New Siren, a Collection of Choice Songs Including the Modern* (London, [1785?]) and *The American Songster: Being a Select Collection of the Most Celebrated American, English, Scotch, and Irish Songs* [*Two lines from Virgil*] (New York, 1788). It was also, potentially, the basis of Mozart's *Figaro.*

15. Bickerstaff, *The Padlock,* Act II, Scene VI.

16. Ibid., Act II, Scene the Last.

17. Jack P. Greene, "Changing Identity in the British Caribbean: Barbados as a Case Study," in Nicholas Canny and Anthony Pagden, eds., *Colonial Identity in the Atlantic World, 1500–1800* (Princeton, N.J., 1987), 223.

18. British satire increasingly moved toward caricature in the second half of the century. See Vincent Carretta, *The Snarling Muse: Verbal and Visual Political Satire from Pope to Churchill* (Philadelphia, 1983), 201; Mark Hallett, *The Spectacle of Difference: Graphic Satire in the Age of Hogarth* (New Haven, Conn., 1999); Timothy Clayton, *The English Print, 1688–1802* (New Haven, Conn., 1997); Diana Donald, *The Age of Caricature: Satirical Prints in the Reign of George III* (New Haven, Conn., 1996); Carretta, *George III and the Satirists from Hogarth to Byron* (Athens, Ga., 1990); Ronald Paulson, *Rowlandson: A New Interpretation* (New York, 1972), 13–14.

19. "Mungo," designed and engraved for the *Political Register* (London, April 1768), BM, Department of Prints and Drawings, Satire No. 4267; Butles Clowes (Mungo), (London, January 1, 1769), BM Satire No. 38.29.

20. Eliga H. Gould, *The Persistence of Empire: British Political Culture in the Age of the American Revolution* (Chapel Hill, N.C., 2000), xviii. See also Gary B. Nash, *The Unknown American Revolution: The Unruly Birth of Democracy and the Struggle to Create America* (New York, 2005); Timothy H. Breen, *The Marketplace of Revolution: How Consumer Politics Shaped American Independence* (Oxford, Eng., 2004); Greene, *Understanding the American Revolution: Issues and Actors* (Charlottesville, Va., 1995).

21. See, e.g., *American Songster,* 174–175.

22. See also Anon., *Lord North robbing the Exchequer* (London, 1776), John Carter Brown Library.

23. Horace Walpole, cited in F. G. Stephens and M. D. George, eds., *Catalogue of Political and Personal Satires* (London, 1954–1978), No. 4267.

24. Anon., *Britannia's treatment from her sham Friends* (1770), BM Satire No. 4436; Anon., *The Infernal Sloop, Chasing the Good Ship Britannia* (etching, 1770), BM Satire No. 4842; Anon., *The State Cotillon 1773* (etching, 1773), BM Satire No. 5106. For other Mungo-Dyson prints, see Anon., *Mungo* (etching and engraving, 1769), BM Satire No. 4267; Anon., *The Pageant, Exhibiting the Characters of Despotism Marching in Procession to the Cock Pit* (etching and engraving, 1769), BM Satire No. 4316; Anon., *Political Electricity; or, An Historical & Prophetical Print in the Year 1770* (etching, 1770), BM Satire No. 4422; Anon., *The Courtiers Assembled, on Hearing the News of the Death of Rt. Honbl. Wm. Beckford* (hand-colored etching and engraving, 1770), BM Satire No. 4393; Anon., *Alas: Poor Mungo* (woodcut, 1772), BM Satire No. 4936; Anon., [Hibernia in Distress] (etching, 1772), BM Satire No. 4942; Anon., *The Premier Distributing the Loaves and Fishes to the Labourers in his Vineyard* (etching and engraving, 1772), BM Satire No. 4955; Anon., [Six Remarkable Heads] (etching, 1772), BM Satire No. 4962; Anon., *The State Hackney-Coach* (etching, 1773), BM Satire No. 5098; Anon., *The State Jugglers* (etching, 1773), BM Satire No. 5109; Anon., *The Assembly of the Grinders* (etching and engraving, 1773), BM Satire No. 5132.

25. For Hogarth and his copiers, see Chapter 6. For another Opposition print that utilized this trope, see Anon., *The Fetter Manufactory* (London, May 19, 1784), reproduced in Carretta, *George III,* fig. 114. For Blake, see Carretta, *George III, 262.*

26. Anon., *The State Hackney-Coach* (1773), BM Satire No. 5098.

27. Such derogatory commentary evolved in other sexualized forms: in 1771, for instance, an anonymous print mocked Dyson-Mungo's infatuation with a prostitute. Anon., *Mungo* (1771), BM Satire No. 4907.

28. Bridget Hill, *Servants: English Domestics in the Eighteenth Century* (Oxford, Eng., 1996), 2.

29. William Humphrey (after Johan Fredrik Martin), *High Life Below Stairs, or Mungo Addressing My Ladys Maid* (London, 1772), BM Museum No. 2010,7081.1136. For the rise of white servants in late eighteenth-century novels, plays, and prints, see Hill, *Servants,* 2.

30. Gerzina, *Black London,* 42; Hill, *Servants,* 2, 89, 104–105. For a critique of the social control thesis, see Thomas Haskell, *Objectivity Is Not Neutrality: Explanatory Schemes in History* (Baltimore, Md., 1998), chaps. 8–9. Mary Beth Norton, "The Fate of Some Black Loyalists of the American Revolution," *Journal of Negro History* 58.4 (October 1973): 402–426; Cassandra Pybus, *Epic Journeys of Freedom: Runaway Slaves of the American Revolution and Their Global Quest for Liberty* (Boston, 2006).

31. Anon., *A Mungo Macaroni* (London, pub. by M. Darly, September 10, 1772), BM Satire No. 5030.

32. Philip Carter, "An 'Effeminate' Nation or 'Efficient' Nation? Masculinity and Eighteenth-Century Social Documentary," in Mary Peace and Vincent Quinn, eds., *Luxurious Sexualities: Effeminacy, Consumption, and the Body Politic in Eighteenth-Century Representation* (Glasgow, 1997), 430–431; see also 429–444.

33. William Austin, [The Duchess of Queensberry and Soubise] (London, May 1, 1773), BM Satire No. 5120. Cf. Nussbaum, *Limits of the Human,* introduction.

34. Charles, Third Duke of Queensberry, to Julius Soubise, Ambresbury, November 8, 1772, box 7, Soubise Folder, Miscellaneous American Letters and Papers, Schomburg Center for Research in Black Culture, New York Public Library. I thank James Sidbury for this reference. For criticism of servants that was directed at their masters, see Pamela Horn, *Flunkeys and Scallions: Life below Stairs in Georgian England* (Stroud, Eng., 2004), 8–10.

35. Ignatius Sancho, *The Letters of Ignatius Sancho,* ed. Paul Edwards and Polly Rewt (Edinburgh, 1994), Letters 13, 66; George Colman, the Younger, *Inkle and Yarico: An Opera, in Three Acts* (London, first staged and pub. in 1787), in Frank Felsenstein, *English Trader, Indian Maid: Representing Gender, Race, and Slavery in the New World: An Inkle and Yarico Reader* (Baltimore, Md., 1999), 167–233.

36. Samuel Johnson, *Taxation No Tyranny: An Answer to the Resolutions and Address of the American Congress* (London, 1775); Anon., *AMERICA!* (London, ca. 1760), Lewis Walpole Library, 760.0.2. For the Sierra Leone expedition, see esp. Stephen J. Braidwood, *Black Poor and White Philanthropists: London's Blacks and the Foundation of the Sierra Leone Settlement, 1786–1791* (Liverpool, Eng., 1994).

37. Gerzina, *Black London,* 10.

38. Hill, *Servants,* 136–137; Sir John Fielding, *Extracts from Such of the Penal Laws, as Particularly Relate to the Peace and Good Order of This Metropolis* (London, 1769), 142–144.

39. Gould, *Persistence of Empire;* Kathleen Wilson, *The Sense of the People: Politics, Culture, and Imperialism in England, 1715–1785* (Cambridge, Eng., 1995); *Norfolk Chronicle,* January 17, 1778, cited in Kathleen Wilson, "Empire of Virtue: The Imperial Project and Hanoverian Culture, c. 1720–1785," in Lawrence Stone, ed., *An Imperial State at War: Britain from 1689 to 1815* (London, 1994), 128. My understanding of the internalization of the war is indebted to Carretta's analysis of the satires of George III. William Mason, *An Epistle to Dr. Shebbeare,* cited in Carretta, *George III,* 186; *The Triumph of Liberty and Peace with America: A Poem. Inscribed to General Conway* (London, 1782), cited in Carretta, *George III,* 186. See also [Wesley], *Reflections on the Rise and Progress of the American Rebellion* (London, 1780), 3.

40. For an example of England being cannibalized, see Anon., *The Parricide. A Sketch of Modern Patriotism* (London, 1776), reproduced in Carretta, *George III,* 187, for Blake, see also chap. 4.

41. For abolitionism and the "crisis of liberty," see Christopher L. Brown, *Moral Capital: Foundations of British Abolitionism* (Chapel Hill, N.C., 2006).

42. See, for example, James Gillray, *Philantropic Consolation, after the Loss of the Slave-Bill* (etching, 1796), BM Museum Nos. 1868,0808.13657, 1868,0808.6512, 1851,0901.787. For black women and disorder in Renaissance writings, see Hall, *Things of Darkness.*

43. Bickerstaff, *The Padlock,* Act 1, Scene VI (p. 11).

44. Anon., *The Hibernian Attempt* (London, April 1, 1785), BM Satire No. 6787.

45. Mungo, Padlock-Keeper of Drury Lane, *The Padlock Open'd: or, Mungo's Medley. Being a Choice Collection of the Miscellaneous Pieces in Prose and Verse,*

Serious and Comic, of Mungo the Padlock-Keeper of Drury Lane (London, 1771), dedication. On the abolitionist movement, see the Introduction, note 22.

46. *Gentleman's Magazine,* October 1787, 913–914; Sarah Trimmer, *The Family Magazine; or, a Repository of Religious Instruction, and Rational Amusement* (London, 1788–1789), 1:344 ("proper"), 346–347 (Mungo's epilogue).

47. Cedric J. Robinson, *Black Marxism: The Making of the Black Radical Tradition* (Chapel Hill, N.C., 2000), 81.

48. Wood, *Blind Memory;* Wood, *Slavery, Empathy, and Pornography;* Srinivas Aravamudan, *Tropicopolitans: Colonialism and Agency, 1688–1804* (Durham, N.C., 1999), 5.

49. Carretta, *George III,* 326, fig. 143.

50. Trimmer, *Family Magazine,* 1:129 ("worse"), 2:779 (Hawkins). Sarah Trimmer also authored *The Œconomy of Charity* (1787) and other works on education, particularly of children. Her concerns lay with the depravity that she saw in England, especially but not exclusively among the laboring poor. Trimmer, *Family Magazine,* 1:129; Trimmer, *The Two Farmers, an Exemplary Tale: Designed to Recommend the Practice of Benevolence, Towards Mankind, and All Other Living Creatures; and the Religious Observance of the Sabbath-Day* (London, 1787); Trimmer, *The Œconomy of Charity; or, an Address to Ladies Concerning Sunday-Schools; the Establishment of Schools of Industry under Female Inspection . . .* (London, 1787). For the conservative nature of the abolitionist movement, see Brown, *Moral Capital.*

CONCLUSION

1. For June and Catton, see also Sheila O'Connell, *London 1753* (London, 2003), figs. 1.10, 1.28, pp. 64–65; Celina Fox, *Specimens of Genius truly English: An exhibition of eighteenth-century designs for London signboards from the collection of the late Lord Clark* (New York, 1984). My thanks to Sheila O'Connell and Celina Fox for their assistance with these images. I was not allowed to acquire a reproduction of the lord mayor's coach panel, but readers can see the entire coach online at www.bridgemanart.com.

2. *Figures Representing the Four Continents,* printed for Robert Wilkinson, possibly an invitation or membership card (early nineteenth century), V&A Museum No. 14620, S17a.

3. Wyatt MacGaffey, "Dialogues of the Deaf: Europeans on the Atlantic Coast of Africa," in Stuart B. Schwartz, ed., *Implicit Understandings: Observing, Reporting, and Reflecting on the Encounters between Europeans and Other Peoples in the Early Modern Era* (Cambridge, Eng., 1994), 249–267. For encounters in the New World, see, e.g., Ned Blackhawk, *Violence over the Land: Indians and Empires in the Early American West* (Cambridge, Mass., 2006); Joyce Chaplin, *Subject Matter: Technology, the Body, and Science on the Anglo-American Frontier, 1500–1676* (Cambridge, Mass., 2001); Peter C. Mancall and James H. Merrell, eds., *American Encounters: Natives and Newcomers from European Contact to Indian Removal, 1500–1850* (New York, 2000); Anthony Pagden, *European Encounters with the New World: From Renaissance to Romanticism* (New Haven,

Conn., 1993); James H. Merrell, *Into the American Woods: Negotiators on the Pennsylvania Frontier* (New York, 1999); Richard White, *The Middle Ground: Indians, Empires, and Republics in the Great Lakes Region, 1650–1815* (Cambridge, Eng., 1991).

4. See Srinivas Aravamudan, *Tropicopolitans: Colonialism and Agency, 1688–1804* (Durham, N.C., 1999), introduction and chap. 4.

5. For a theoretically similar approach to encounters with the Orient during the Romantic period (and a similar revision of Edward Said's *Orientalism* [New York, 1978]), see Nigel Leask, *British Romantic Writers and the East: Anxieties of Empire* (Cambridge, Eng., 1992).

6. For documentation of slave abuse and a related sense of witnessing, see, e.g., Ian Baucom, *Specters of the Atlantic: Finance Capital, Slavery, and the Philosophy of History* (Durham, N.C., 2005); Christopher L. Brown, *Moral Capital: Foundations of British Abolitionism* (Chapel Hill, N.C., 2006); Marcus Wood, *Blind Memory: Visual Representations of Slavery in England and America, 1780–1865* (Manchester, Eng., 2000).

7. Brown, *Moral Capital;* Philip Gould, *Barbaric Traffic: Commerce and Antislavery in the Eighteenth-Century Atlantic World* (Cambridge, Mass, 2003); Thomas Bender, ed., *The Antislavery Debate: Capitalism and Abolitionism as a Problem in Historical Interpretation* (Berkeley, Calif., 1992); David Eltis, *Economic Growth and the Ending of the Transatlantic Slave Trade* (New York, 1987); Seymour Drescher, *Capitalism and Antislavery: British Mobilization in Comparative Perspective* (New York, 1987); David Eltis and James Walvin, eds., *The Abolition of the Atlantic Slave Trade: Origins and Effects in Europe, Africa, and the Americas* (Madison, Wisc., 1981); David Brion Davis, *The Problem of Slavery in the Age of Revolution* (Ithaca, N.Y., 1975); Wylie Sypher, *Guinea's Captive Kings: British Anti-Slavery Literature of the XVIIIth Century* (Chapel Hill, N.C., 1942).

8. For the role of popular consumerism in abolition, see also Charlotte Sussman, *Consuming Anxieties: Consumer Protest, Gender, and British Slavery, 1713–1833* (Stanford, Calif., 2002); J. R. Oldfield, *Popular Politics and British Anti-Slavery: The Mobilization of Public Opinion against the Slave Trade, 1787–1807* (Manchester, Eng., 1995); Seymour Drescher, "Whose Abolition? Popular Pressure and the Ending of the British Slave Trade," *Past and Present* 143 (May 1994): 136–166.

9. Thomas L. Haskell, *Objectivity Is Not Neutrality: Explanatory Schemes in History* (Baltimore, Md., 1998), 235–279.

10. Ottobah Cugoano, *Thoughts and Sentiments on the Evil and Wicked Traffic of the Slavery and Commerce of the Human Species, Humbly Submitted to the Inhabitants of Great-Britain, By Ottobah Cugoano, A Native of Africa* (London, 1787), 114.

11. Sampler, V&A Museum No. T.289–1886.

12. David Simpson, *A Discourse on Dreams and Night-Visions, with Numerous Examples Ancient and Modern* (Macclesfield, Eng., 1791), 69–71.

13. For a brilliant and more extended analysis of this print, to which this reading is indebted, see Kay Dian Kriz, *Slavery, Sugar, and the Culture of Refinement: Picturing the British West Indies, 1700–1840* (New Haven, Conn., 2008), chap. 3.

14. For his impoverishment, see ibid., 89.

15. Aphra Behn, *Oroonoko,* ed. Joanna Lipking (London, 1997), 13–14. For this print as a satire of the slave auction, see also Kriz, *Slavery, Sugar, and the Culture of Refinement,* 89.

16. For the black man in loincloth as an image of a West Indian slave, see ibid., 90.

17. Ronald Paulson, *Rowlandson: A New Interpretation* (Oxford, Eng., 1972), 25. For pornography, see Marcus Wood, *Slavery, Empathy, and Pornography* (New York, 2002); Ian Moulton, *Before Pornography: Erotic Writing in Early Modern England* (Oxford, Eng., 2000); Lynn Hunt, *The Invention of Pornography: Obscenity and the Origins of Modernity, 1500–1800* (New York, 1993); Peter Wagner, *Eros Revived: Erotica of the Enlightenment in England and America* (London, 1988).

18. For black military participation and its importance to claims to citizenship, see, e.g., Sylvia R. Frey, *Water from the Rock: Black Resistance in a Revolutionary Age* (Princeton, N.J., 1991); John Wood Sweet, *Bodies Politic: Negotiating Race in the American North, 1730–1830* (Baltimore, Md., 2003).

19. For the emergence of biological understandings of racial difference, see Valerie Traub, "Mapping the Global Body," in Peter Erikson and Clark Hulse, eds., *Early Modern Visual Culture: Representation, Race, and Empire in Renaissance England* (Philadelphia, 2000), 44–97; Joyce Chaplin, "Race," in David Armitage and Michael J. Braddick, eds., *The British Atlantic World, 1500–1800* (New York, 2002), 154–172; Roxann Wheeler, *The Complexion of Race: Categories of Difference in Eighteenth-Century British Culture* (Philadelphia, 2000); Dror Wahrman, *The Making of the Modern Self: Identity and Culture in Eighteenth-Century England* (New Haven, Conn., 2004).

20. Ignatius Sancho, Letter 108 (to Mr. R[ush]), September 7, 1779, in *The Letters of Ignatius Sancho,* ed. Paul Edwards and Polly Rewt (Edinburgh, 1994), 186. For a black discourse on Africanness, see James Sidbury, *Becoming African in America: Race and Nation in the Early Black Atlantic* (Oxford, Eng., 2007). See also Vincent Carretta and Philip Gould, eds., *Genius in Bondage: Literature of the Early Black Atlantic* (Lexington, Ky., 2001).

ACKNOWLEDGMENTS

I have been carrying this book, in various forms, around with me for nearly a decade. It lived in Baltimore, Providence, Los Angeles, and Nashville in the United States. It hung out in my aunt and uncle's house in Cambridge, England, and above a fried chicken shop in South London. It visited Bristol, Bath, York, Paris, Florence, Venice, and many other cities, acquiring images and new material from the archives, museums, and churches of these urban spaces. Country estates and castles maintain the visual and sensory experience of eighteenth-century parlors and bedrooms. But recovering a visual sense of the London street required sitting on floors of graciously accommodating print rooms, rummaging through boxes of ephemera, and wandering endlessly through more organized material and visual remnants of the early modern past.

This book is thus as much a reflection of how we collect, display, and think about artifacts today as it is an exploration of how Britons perceived African slavery in the seventeenth and eighteenth centuries. I thank the numerous archivists, curators, and library staff who facilitated research and helped with photography, especially Susi Krasnoo, Carolyn Powell, Kevin Miller, Joyce Ziman, Juan Gomez, and the staff of the Huntington Library; Craig Hartley and Elenor Ling at the Fitzwilliam Museum; Sheila O'Connell, Angela Roche, and Alice Moschetti at the British Museum; Pamela Bromley at Warwick Castle; Maria Singer at the Yale Center for British Art; Mary Guyatt and Chrysanthe Constantouris at the Victoria and Albert Museum; Sally McKay at the Getty Research Institute; Mark Bills at the Museum of London; Jeremy Smith at the London Metropolitan Archives; Emma Butterfield and Alexandra Ault at the National Portrait Gallery in London; the staff of the John Carter Brown Library; the staff of the William Andrews Clark Memorial Library; Elizabeth Saluk at the Cleveland Art Gallery; Peter Brush at Vanderbilt University; and Rick Watson at the Harry Ransom Center at the University of Texas at Austin. I am particularly grateful to museums that have created virtual databases of their collections for public use, especially the British Museum and the Victoria and Albert Museum. Many additional images cited but not reproduced here can be found online. I invite readers to explore, alongside this book, these new resources.

Woven into the text and the thought process are the voices of numerous readers and friends who have shared this project with me over the years. My deepest

debt is to Jack P. Greene and Philip D. Morgan, who have been involved in this project since its inception and whose support has deeply shaped both the book and its author. James Walvin, Betty Wood, and David Bindman offered useful advice in the early stages of research. Various chapters also benefited from discussions with Christopher L. Brown, William Caferro, Andrew Cambers, Tina Campt, Laura M. Carpenter, Celso T. Castilho, Julia P. Cohen, Katherine B. Crawford, James A. Epstein, Sylvia R. Frey, Teresa A. Goddu, Eliga H. Gould, Alexander Joskowicz, Sarah Knott, Peter Lake, Michael and Gill Richardson, Nicholas C. Rogers, Anne Stiles, Arleen Tuchman, and Marcus Wood. Vincent Carretta, Richard Blackett, and Ronald Paulson read and commented on the entire manuscript, for which I am eternally grateful. A group of literary critics and art historians working on race and slavery in early modern Britain have been remarkably generous and supportive of this project. I especially thank Kay Dian Kriz, whose scholarship intersects in fruitful ways with my own. Audiences and organizers of multiple conferences, workshops, and talks offered insightful comments on and clarifications of parts of this book: I thank Dror Wahrman and the Center for Eighteenth-Century Studies at Indiana University; Carole Shammas, Peter C. Mancall, and the USC-Huntington Early Modern Studies Institute; Trevor Burnard and Warwick University; Michael Meranze and the UCLA/Clark Library's Core Program; Guy Saupin and Cécile Vidal; the Omohundro Institute of Early American History and Culture; and Sean X. Goudie and the Society for Early Americanists. This book is a constellation of deep friendships, excellent mentoring, wonderful colleagues, and a lot of random conversations; it reflects the generosity of archivists, librarians, editors, donors, and scholars from a variety of institutions.

An amicable scholarly atmosphere at Vanderbilt University, which sustains a real commitment to interdisciplinary scholarship, rendered the process of research and writing personally rewarding. I am especially indebted to my colleagues in the history department and to our office staff (Brenda H. Hummel, Jane A. Anderson, and Heidi Welch), who have collectively inspired, supported, and—at times—fed the author. The members of two faculty seminars ("Beyond Word and Image" and "Black Europe") hosted by Mona C. Frederick and the Robert Penn Warren Center for the Humanities offered thoughtful interventions into the revision process and critical encouragement in my preoccupation with the role of the young black pageboy in this story. Two research assistants aided the construction of this book: Alex Hood helped to compile references to Africans in London newspapers, and Elizabeth Barnett made the complicated task of acquiring images for reproduction much less onerous.

An earlier version of Chapter 5 appeared in the *William and Mary Quarterly* (2007). I thank Christopher Grasso (and the outside readers for the *Quarterly*) for helping to craft this part of my book and permitting me to reproduce this material. I am also grateful to *English Literary History* for allowing me to use in Chapter 6 portions of an article that I published in that journal in 2005.

This book was made possible by generous financial and institutional support from Vanderbilt University, Johns Hopkins University, the Barbara Thom Postdoctoral Fellowship and the Huntington Library, the Andrew W. Mellon Foundation Fellowship in Humanistic Studies and the Woodrow Wilson Foundation, the

Barbara S. Mosbacher Fellowship and the John Carter Brown Library, the National Endowment for the Humanities, American Society for Eighteenth-Century Studies, the William Andrews Clark Memorial Library, and Harvard University's Atlantic World Program. I am especially indebted to Robert C. Ritchie and the Huntington Library for supporting, in conjunction with Vanderbilt, a sabbatical year of research in the library's wonderful collections. The scholars and staff who shared this year with me provided a rich intellectual community in which to complete revisions.

I offer special thanks to my editor at Harvard University Press, Kathleen McDermott, for her support of this project and for her recognition of the value of its visual component. I am also grateful to her editorial assistant, Sophia Kahn, who offered expert help in organizing images. The two anonymous readers for Harvard University Press made incisive comments and suggestions that helped to turn this book into its final form; I am very grateful to them for taking the time to read the manuscript so carefully.

The peripatetic process of making this book spun a far-flung web of mentors, readers, and friends. I thank my brother, Charles Molineux, for valiantly moving my stuff each time I moved to another city. For their friendship and intellectual support, I also extend personal gratitude to Michael Bess, Kristen Block, Colin Dayan, Joel Harrington, Jane High, Carina Johnson, Amanda Krauss, Lars Maischak, Emily Nacol, Tom Neilson, Joy Ramirez, Samira Sheikh, Jessica Stern, and Eddie Wright-Rios. Jane G. Landers, Katherine D. Moran, Mary Terrall, Daniel H. Usner, and Molly A. Warsh have left their creative fingerprints all over this book and my life as they read and reread its pages. Many of the scholars whose thoughts are reflected and engaged in this book are grappling with issues of racial prejudice and human bondage in their own work; others became witnesses to this difficult past through my own. I could not have explored the mentality of a slaving nation without their encouragement. It is a view of the world that we would perhaps rather forget. Doing so, however, risks not understanding the power of fantasy to refashion acts of human abuse.